The Art of Jazz

The Art of
Jazz

A Visual History

Alyn Shipton

Foreword by John Edward Hasse

imagine!

An Imagine Book
Published by Charlesbridge
9 Galen Street
Watertown, MA 02472
(617) 926-0329
www.imaginebooks.net

ISBN 978-1-62354-504-8 (hc)
ISBN 978-1-63289-233-1 (epub)

Editorial Director: Will Steeds
Project Editor: Tom Seabrook
Cover Design: Paul Palmer-Edwards
Interior Design: Paul Palmer-Edwards
Picture Researcher: Sally Claxton

Library of Congress Cataloging-in-Publication Data available upon request.

Printed in China
(hc) 10 9 8 7 6 5 4 3 2 1

Contents

The look of jazz.

How does jazz look? The answer is difficult to pinpoint, as few writers have addressed this question comprehensively.

Jazz appeals most directly to the ear, but also engages the eye. Yet the visual dimension of jazz is often overlooked. There are books about jazz photography, specific record labels, album cover design, and museum exhibitions, but almost nothing has been published taking on the overall picture of the music.

This is the first book to offer a 360-degree look—in the literal meaning of that word—at the history of jazz, from its nineteenth-century roots to its twenty-first-century eclecticism. Paintings and drawings. Portrait, studio, and documentary photography. Sheet music covers, record albums, posters, and advertisements. Imagery of musicians' clothing, hair, eyeglasses, and facial expressions. Visualizations of the musicians, their milieu, and their music as metaphor.

This pioneering book links the art together in a narrative, contextualizes each element in the broader history of jazz, and names and explores some of the lesser-known illustrators, designers, and artists who shaped our perception of the music in an almost subconscious way. The artists were products of their times, and the author points to several instances of stereotyping, underscoring the fact that not all the artwork depicting African American musicians was flattering or racially sensitive.

Just as jazz has influenced poetry, fiction, dance, fashion, and vernacular language, so has the music affected the visual arts. And jazz can be strikingly visual, creating unforgettable and vivid sonic paintings such as Ellington's eerie "The Mooche," Miles Davis and Gil Evans's piercing "Saeta," or Charles Mingus's raucous "Wednesday Night Prayer Meeting."

From the realm of jazz came some of the era's leading creative artists, pursuing instantaneous, high-level communication and expression. The brilliance of these artists affirms some of the most admirable values of our time: originality, individuality, risk-taking, cultural diversity, creative collaboration, and innovation.

All were basking in the freedom that jazz affords and encourages. "If jazz means anything," wrote Duke Ellington, "it is freedom of expression."

That leeway to experiment, to find and put forward one's personal voice and style, bursts from the pages of this book, whether implied by the music and musicians or evident in the illustrations that adorn this volume.

I first met Alyn Shipton in 1987, when he was producing an annual symposium at the Festa New Orleans Music in Ascona, Switzerland. He invited me to present a talk on ragtime, the subject of my book *Ragtime: Its History, Composers, and Music*, which he had published in the UK. I immediately admired his eloquence, breadth of knowledge, versatility, and musical chops. I realized that Alyn Shipton is a polymath of music: writer, historian, editor, publisher, radio host, and bassist. It was with keen pleasure I renewed his acquaintance in person in London, and again in 1989, in Ascona, where, at his invitation, I delivered a lecture on Duke Ellington, later the topic of my *Beyond Category: The Life and Genius of Duke Ellington*. I came to regard Alyn's *New History of Jazz*, his books with Danny Barker, and his biographies of such figures as Cab Calloway, Fats Waller, and Dizzy Gillespie as essential jazz reading.

As do I, Alyn has a deep curiosity about jazz and a profound passion to share his learning with the public. All of us are fortunate to benefit from his erudition and insights, in his work to date and in this new book, *The Art of Jazz*.

John Edward Hasse
Curator Emeritus of American Music
Smithsonian Institution
Washington, DC

Foreword

BELOW: **Recalling 1930s New York, critic Stanley Dance wrote, "Charles Peterson's photographs capture the spirit of those days better than any others." Artful monochrome shots like this, from a 1939 party, bring the swing era vividly to life. Here we see (left to right) Sister Rosetta Tharpe, Duke Ellington (playing her guitar), cornetist Rex Stewart, Cab Calloway, an anonymous French jazz fan, and singer Ivie Anderson.**

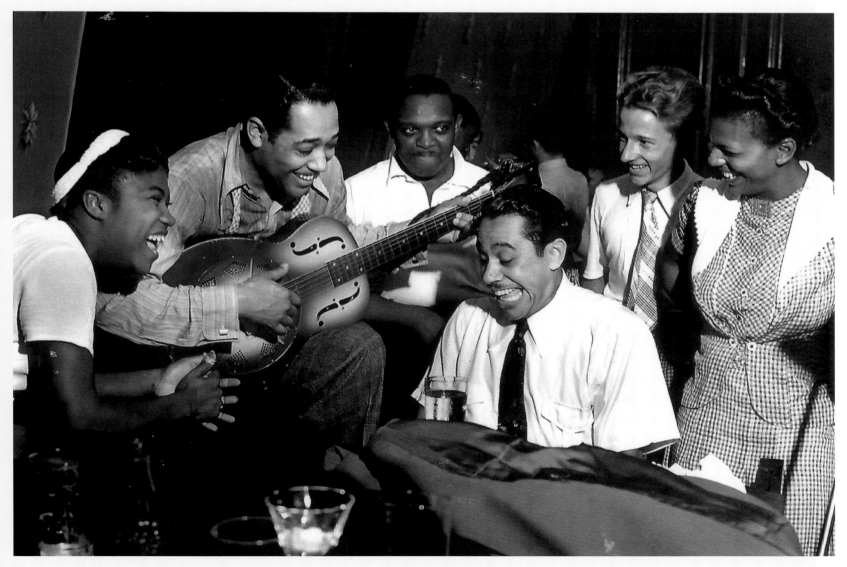

It took until 1933 for the word "jazz" to make its way into the first Supplement to the *Oxford English Dictionary*, having been missing from the full twelve-volume work when it appeared in 1928, at the height of the "Jazz Age." In that earliest entry, the precise origin of the term "jazz" is said to be "unknown," but the article confirms that it was being used widely by the end of World War I on both sides of the Atlantic.

The dictionary is helpful because its linguistic sleuths have combed through a huge variety of printed material to log some of the earliest appearances of every word it includes, placing each in a context that would help readers understand its meaning. Thus, alongside reports of an anonymous jazz band playing in 1917, are mentions of another group called John Lester's Frisco Five, and a year or so later we see accounts of bathers doing a "jazz dance" on the beach. Although couched in the racist language of the time, we go on to read that the first jazz musicians, mainly African American, "slur the notes, they syncopate, and each instrument puts in a lot of little fancy bits on its own." Most interesting, however, is that almost immediately after the word was coined, and in parallel with descriptions of music and dance, it was used to describe art, design, and clothing.

Newspapers reported "jazz patterns in dress"; they mentioned "jazz-colored silks," that "jazz stockings are the latest thing," and that a famous artist "jazzed up" a color scheme. So, even if the word itself is now believed to have first appeared in the San Francisco *Bulletin* in March 1913 to describe a dance full of "vigor" and "pep," the wider ramifications of jazz—as a syncopated, exotic music, garish and vivid, that broke rules, with more than a hint that the name also described the act of sex—rapidly transferred itself into the visual and graphic arts.

Given the rather approximate nature of the etymology of the word "jazz," it would be hard to say exactly when a music that we might recognize as jazz began. What we can see, however, is that a century on from those obscure beginnings, its symbiotic relationship with the visual arts has been celebrated internationally in a series of major exhibitions. First out of the starting blocks was "La Siècle du Jazz," curated by the Musée du quai Branly in Paris, and which ran there, and in Rovereto in Italy and Barcelona in Spain, between late 2008 and 2009. Then came

"I Got Rhythm: Art and Jazz Since 1920" at the Kunstmuseum in Stuttgart from 2015 to 2016, closely followed by "The Jazz Age: American Style in the 1920s" at the Cleveland Museum of Art and the Cooper Hewitt, Smithsonian Design Museum in New York in 2017. In early 2018, London followed suit with "Rhythm and Reaction" at Two Temple Place, the Thameside museum in the former Astor family mansion.

What all these shows had in common was an awareness that jazz permeated almost every layer of art and design—starting in the United States, to be sure, but followed quickly thereafter at a fully international level. At one end of the stylistic spectrum were fine artists depicting jazz subjects, just as classical composers such as Ravel, Milhaud, and Stravinsky absorbed ideas from jazz into their work. Equally, there were photographers inspired by the challenge of depicting the daring, improvisational nature of the music. And there were graphic artists producing sheet-music covers, posters, programs, calling cards, and, eventually, designs for record sleeves and packaging.

Just as jazz itself did not suddenly appear overnight—and more of its emergence is covered in the first chapter—many of the tropes of how the music would be represented visually had already appeared in the late nineteenth century or the very early years of the twentieth. In particular, these center on the depiction of African or African American figures, involved in turn-of-the-century music forms that were among the ingredients of jazz. These include gospel or spiritual vocalists such as the Fisk, Dixie, and Williams Jubilee Singers; works of musical theater; and vaudeville artists such as the comedians Williams and Walker. An additional area of representation was that of dance, which included not only African American dances but also the social or ballroom dance steps pioneered in the United States by the white Anglo-American duo Vernon and Irene Castle.

In contrast to minstrelsy, in which many acts had originally been white musicians in blackface, the gospel "Jubilee" groups were traveling troupes of African American concert performers. We know that they used sheet music because, for example, much of the library of the Fisk singers, who began touring from their home base of Nashville in 1871, has survived intact. The imagery surrounding them was of sophisticated, serious musicians, formally attired or carefully posed, maybe around a

Introduction: Before Jazz

BOTTOM: The Harlem Renaissance artist Aaron Douglas (1899–1979) brilliantly captured aspects of African American history in his large-scale paintings. This mural, from *Aspects of Negro Life*, commissioned as four wall panels for the Countee Cullen (Harlem) branch of the New York Public Library (now the Schomburg Center) in 1934, symbolizes the era "From Slavery Through Reconstruction," just before the birth of jazz.

TOP: From 1871, the Fisk Jubilee Singers, organized by George L. White, took their music across the United States to raise money for their African American University in Nashville, Tennessee. In 1874, they traveled to Europe. Contemporary concert programs reveal that they mainly sang spirituals, or what one British reviewer called "wild plaintive hymns," including "Steal Away," "Go Down Moses," and "Didn't My Lord Deliver Daniel."

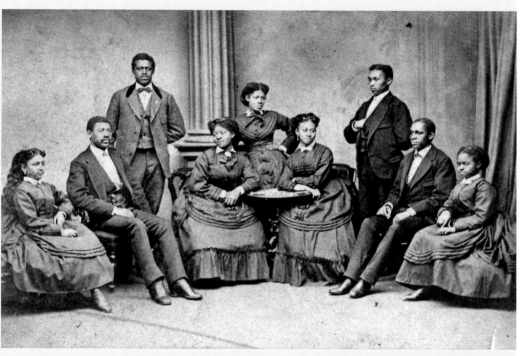

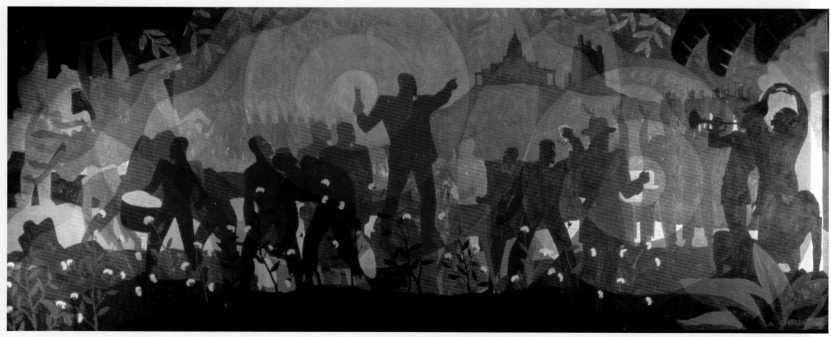

Introduction: Before Jazz

9

harmonium, or with guitars and banjos laid out in the foreground. The Williams group, who followed the Fisk singers to Europe, made much of their international travels, and were photographed in smart suits, dresses, and hats, alongside the much-labeled baggage of seasoned intercontinental voyagers.

Although the Fisk Jubilee Singers originally traveled the path of the so-called Underground Railroad of safe houses and relatively secure routes through the segregated Southern states, they eventually became experienced international travelers. The image they—and similar groups—wished to project complemented the appearance of middle-class affluence with comparable intellectual and artistic attainments. By contrast, the visual representation of black Americans in vaudeville and stage shows often emphasized their "primitive" and African roots.

Take, for example, the stage show In Dahomey. Premiered in New York on February 18, 1903, the comedy was the first full-length Broadway musical to be written and performed predominantly by African Americans. (The same librettist and composer, Paul Laurence Dunbar and Will Marion Cook, had produced the one-act Clorindy: The Origin of the Cakewalk in 1898, for a roof-garden production.) In Dahomey's somewhat flimsy plot, in which the comedians Bert Williams and George Walker play the lead roles of Shy and Rareback, involves a fraudulent attempt to raise money to repatriate America's black down-and-outs to a promised land in Africa. The principal talking points about the show were two cakewalk dance sequences—"That's How the Cake Walk's Done" and "Chocolate Drops"—and the routines in which the suave, sophisticated Walker swindles the naïve Williams out of his savings. This relationship was the hallmark of the duo's long-term success. Walker, in immaculate costume, and despite his dubious financial probity, was an aspirational figure—someone for African Americans to want to identify with, in terms of apparent prosperity and smart attire—while Williams was the epitome of the everyday hardworking black American.

Although it had lost its independence to France in 1894, the West African state of Dahomey symbolized one of the last free black African countries to withstand colonialism, and so carried a huge significance for American descendants of the slave trade—despite the fact that in earlier wars, Dahomey had sold its captives into slavery in return for trade with white colonialists. So, at one extreme of the visual imagery of the show, we find song covers like Al Johns's "In Dahomey" (not originally part of the musical), which depicts Zulu warriors doing a cakewalk, whereas Will Marion Cook's title song for the show itself was shown as part of a cake decoration, with African American dancers in tailcoats and ball gowns high-kicking their way around the icing. This cake became even more significant when, after In Dahomey played in London following its Broadway run, there was a Royal Command Performance for the ninth birthday of Edward, Prince of Wales (later Edward VIII). For this, according to Cook's biographer, Marva Carter, a new finale was added, with a "huge cake over six feet in height and illuminated by one hundred electric lights." The performers adjudged by the audience to have danced the best cakewalk were presented with a check for $50 (a sum worth almost $1,500 today).

Images of Dahomey itself were not all about frivolity, however. The Victorian press on both sides of the Atlantic ran stories about the country's Amazonian army of women, in feathered battledress and armed with spears, and stories abounded of human sacrifice and fetish worship. Indeed, after the war with France ended, troupes of Dahomey women were brought to Europe to reenact battles against the French army in stage spectaculars. Against this backdrop, it was significant that the best-remembered song of the musical show was "Emancipation Day," a collaboration between Dunbar and Cook that put African Americans in a position of advantage over whites:

On Emancipation Day
All you white fo'ks clear de way . . .
When dey hear dem ragtime tunes
White fo'ks try to pass fo' coons.

Williams and Walker had begun their stage partnership by adopting the personae of real Dahomey immigrants; they then went on to tour as "Tabasco Senegambians." But as the cakewalk vogue took off, prior to In Dahomey, they became its preeminent practitioners, even (in a publicity stunt) rolling up at the door of the Vanderbilt mansion on 52nd Street in Manhattan and challenging the millionaire William Henry Vanderbilt to a

"The cakewalk is characteristic of a race, and in order to understand it, it is necessary to keep your mind upon especially what the cakewalk really is—a Gala dance."
Aida Overton Walker interviewed in the *Tatler*, July 1903

BOTTOM LEFT: A scene from *In Dahomey*, with (left to right) George Walker, his wife Aida Overton Walker, and Bert Williams. Walker and Williams are in blackface, a practice that continued for some African American performers right into the 1920s. This shot contrasts Walker's characteristic sharp-suited appearance with Williams's workman's attire.

TOP: As mentioned in the introduction, soon after the word "jazz" appeared, it was applied to fashion, as in this cover from the March 1925 "Art, Goût, Beauté" haute couture catalog from Paris, showing "pictures of feminine excellence." The dresses and fans designed by Drecoll and Paul Poiret epitomize Jazz Age fashion, underlined by the stylized jazz drummer and guitarist accompanying the dancing.

BOTTOM RIGHT: In old age, the "Father of the Blues," W. C. Handy (1873–1958) confronts a slightly younger version of himself on the sheet music for his "Yellow Dog Blues," first published in 1914. The original editions carried colorful illustrations of baying hounds, or a banjo-playing minstrel. The suited, debonair Handy had come a long way from his birthplace, the log cabin in Florence, Alabama, that is preserved as a museum.

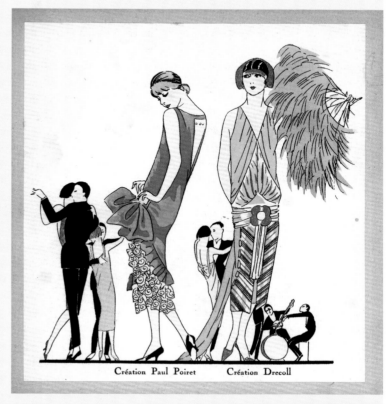

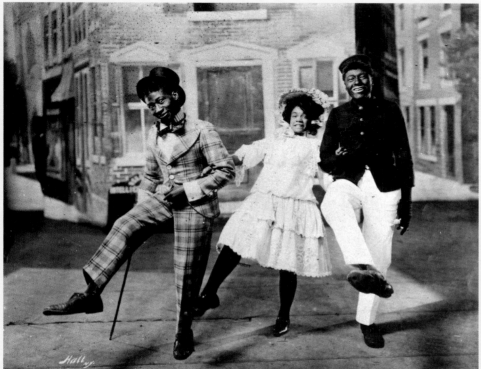

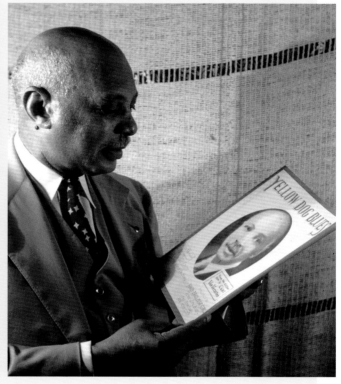

dance competition. They were pioneers of recording, too, and made their first discs of spoken-word routines and songs in 1901. Walker died prematurely in 1909, but Williams continued to star in shows, including five years in the *Ziegfeld Follies*, until he died in 1922. Their contrasting appearance—the tattered Williams, often in blackface, and the suave Walker—was a visual device that would reappear over and over again once jazz had begun, for example in Duke Ellington's 1929 short film *Black and Tan*. In that movie, the suave Ellington, composing at the piano in his garret, resembles the sharp-suited Walker, while the two furniture movers who come to repossess Ellington's piano, in lieu of rent, epitomize Williams's working-class character, not least as they are bought off with a ready supply of gin.

The composer of *In Dahomey*, Will Marion Cook, was a schooled musician who had graduated from Oberlin College, but who found that the color bar prevented him from following a classical music career. He had, however, studied with Dvořák, and photographs of him from the time he was Williams and Walker's musical director show a mustachioed musical patriarch, while the sheet-music cover designs for his numerous hit songs encompass a huge range of visual styles. Cook will reappear in this narrative in the period after World War I, as a significant character in the spread of jazz to Europe, but prior to that he was successful enough to live on "Strivers' Row," an elegant row of Harlem brownstones on 139th Street that epitomized African American success.

Cook's near neighbor was another musical patriarch, W. C. Handy, who collected and published authentic blues songs. In many cases Handy claimed composing rights. As a cornetist he also led an early African American recording group, cutting discs of rags and blues in September 1917. He had started out as a qualified teacher, but he found a musical life more to his liking, and he traveled widely, although his period of collecting blues songs coincided with a post as instructor at the Alabama Agricultural and Mechanical College for Negroes from 1900 to 1902. A strong musical memory and the knack of later writing down what he heard led Handy to publish many a blues song, establishing the format of the twelve-bar blues in print, and he eventually became known as the "Father of the Blues."

Handy's "Memphis Blues" inspired Vernon and Irene Castle to create a universally popular jazz dance known as the "foxtrot." Vernon Castle, from Norwich in the United Kingdom, met and married Irene Castle, from New York, in 1911. Neither was particularly successful until later that same year, when they were employed for a season in Paris to demonstrate the latest American dance crazes. Back in America, dancing to the ragtime and proto-jazz of the New York bandleader James Reese Europe, the Castles were hugely influential in bringing the burgeoning sounds of jazz to white audiences. Vernon, who left dancing to serve with distinction in the British Royal Flying Corps during World War I, was killed in an accident at a flying training camp in Texas in 1918, but the Castles' influence—on dance, music, and the design of clothes and promotional literature—was intimately bound up with the early development of jazz.

All the ingredients so far mentioned—ragtime, blues, dance, and traveling far and wide to bring the results to new audiences—would mingle to form both the music and the industry that we would recognize as jazz. In charting this story, although everything is underpinned by the history of jazz, the focus is on how that story was illustrated or how it inspired artists and designers at the time. Much of what we now recognize as musically, racially, and geographically important in the development of jazz was not always given the same degree of attention in the visual and plastic arts. In particular, the vital contribution of African American musicians in many eras of the music was frequently obscured by a focus on white artists and the greater spending power of white-owned music publishers, theatrical entrepreneurs, broadcasters, and record companies.

"To see this healthy, energetic young couple swooping and swirling and kicking around the floor made audiences' hearts race. Younger people wanted to emulate them and older people felt their ennui fall away."

Eve Golden, *Vernon and Irene Castle's Ragtime Revolution* (University Press of Kentucky, 2007)

TOP LEFT: According to Paul Laurence Dunbar, the entire score for *Clorindy* was written and composed in a single night in Washington DC, at the house of John Cook, Will Marion Cook's brother. Will hummed the tunes, John thumped them out on the piano, and Dunbar added words, assisted by two dozen bottles of beer, a quart of whisky, and a raw porterhouse steak!

BOTTOM LEFT: The double act of George Primrose and Billy West launched their own minstrel troupe in the late 1870s. They were both white, and they and their dancers performed in blackface. This poster from the 1890s proves that white performers smeared in burnt cork adopted the cakewalk, but Primrose and West steered minstrelsy away from stereotypical "Southern low-life" toward sophistication and class.

BELOW RIGHT: "Dancing with Vernon was as easy as swimming with water wings," recalled Irene Castle. This sheet music cover shows them in action, and also demonstrates the interracial alliance of white dancers with the African American Society Orchestra led by Will Marion Cook, who composed this and several other dance tunes that they popularized.

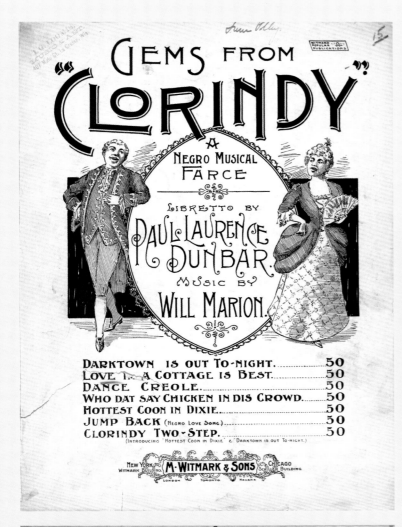

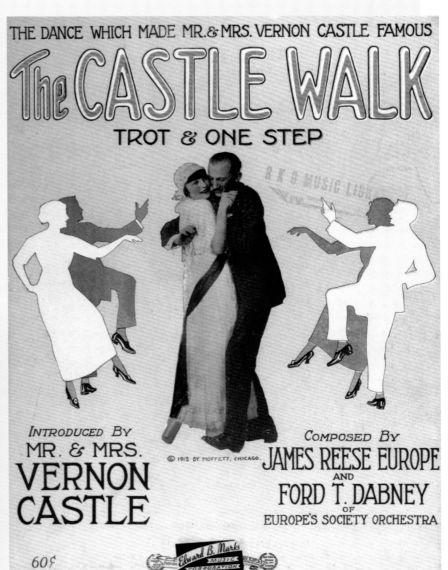

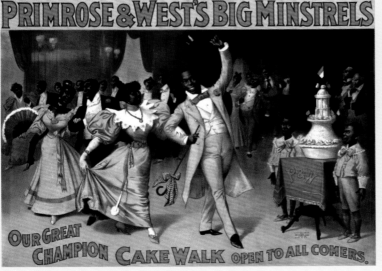

Jazz Begins

"We must begin with its roots"

When jazz finally came together, in the period between 1913 and 1917, it was an amalgam not only of some of the elements discussed already—including cakewalk, other forms of dance, and blues—but also of brass bands, string bands, and piano ragtime, together with the "classic blues" songs of women such as Bessie Smith and Ma Rainey.

Early jazz histories conflate the existence of military brass bands during the American Civil War with the creation of African American brass bands in and around New Orleans, which allegedly took up instruments abandoned by white soldier-musicians. As this story was further investigated by historians, however, it became evident that even before the Thirteenth Amendment to the Constitution was passed in January 1865, abolishing slavery, a brass-band tradition was already firmly rooted in the New Orleans black community. Within a short while, it was being actively encouraged by the acting state governor, P. B. S. Pinchback, the first black governor in American history, who urged his fellow African Americans to form benevolent societies and hold regular meetings, of which music became part.

Jazz pianist Jelly Roll Morton (born in 1890) recalled how these societies became embedded in the city's social fabric. "New Orleans was very organization-minded. I have never seen such beautiful clubs as they had there—the Broadway Swells, the High Arts, the Orleans Aides, the Bulls, the Bears, the Tramps, the Iroquois, the Allegroes—that was just a few of them, and those clubs would parade at least once a week. They'd have a great big band."

Pinchback's predecessor, the controversial Henry Clay Warmouth, who was white, retired from politics after his impeachment in 1872 to run the sizeable Magnolia sugar plantation and factory in Plaquemines Parish, the long promontory to the southeast of New Orleans that straddles the Mississippi shipping lane out to the Gulf. He engaged the Creole musician Professor James Humphrey to tutor several brass bands drawn from his workforce, and not only did some of these musicians ultimately form the first generation of New Orleans jazz brass-band players, but Humphrey's descendants—trumpeter Percy, clarinetist Willie, and trombonist Earl Humphrey—would much later be among the founding fathers of the music played at Preservation Hall.

The brass bands adopted a uniform of peaked caps (with white tops for celebrations and dark ones for funerals), white shirts, dark ties, black trousers, and additional black tunics for funerary processions. This mode of dress can be seen in the earliest photographs right through to the present day, so that the jazz musicians in the twenty-first-century HBO series *Tremé* are attired just as their predecessors were almost a century earlier. The grand marshals who preceded the bands wore decorated sashes, and for some parades the accompanying Mardi Gras Indian marching societies (formed in the nineteenth century by African Americans to commemorate the days when escaped slaves found sanctuary among Native Americans, and which had their own secret creole language) sported elaborate costumes sewn with feathers and bright colors. In funeral parades, members of the benevolent or friendly societies to which the deceased may have belonged wore elaborate costumes and carried elaborately embroidered banners.

Several of the nascent brass bands had associated string groups—usually a guitar, mandolin, and bass, and sometimes a violin as well. These played in the smaller New Orleans dance halls in the late nineteenth and early twentieth centuries, performing cakewalks and rags but also the polkas, quadrilles, and waltzes that might be heard at society balls. The origins of these string bands go back to plantation music from the days of slavery, when "privileged" slaves who had learned instruments performed for their owners' dances at the big house; they also played blues and popular tunes for their fellows. This dual musical life had a lot to do with the cross-fertilization of genres that led to jazz. More importantly, in terms of the visual arts, string and ragtime bands played in a variety of dance halls in New Orleans. These ranged from the elaborate Spanish Fort, in its amusement park on Beauregard Avenue, to tiny clapboard structures. Yet even the most modest venues were often decked out with porticos, porches, gables, and balconies, in a huge variety of vernacular architectural styles.

The music that evolved into jazz was by no means restricted to New Orleans. There were comparable brass bands in many parts of the United States, but even more important was the network of touring productions that crisscrossed the country, through which word about new musical ideas—and the ideas themselves—could be spread rapidly among performers. These ranged from traveling tent and medicine shows (in which blues singers such as Bessie Smith and Ma Rainey began their careers) to vaudeville troupes that trekked between the growing number

Jazz Begins

PREVIOUS SPREAD: Composer James Weldon Johnson wrote that Aida Overton Walker "had a low-pitched voice with a natural sob to it, which she knew how to use with telling effect in putting over a song." She was also a most accomplished dancer and was one of the great stars of the era that preceded jazz.

TOP: Photographed around 1913, this is the Onward, a pioneer African American New Orleans brass band. The leader was cornetist Manuel Perez (extreme left). Several musicians here continued into illustrious jazz careers. Peter Bocage (third from left) and Lorenzo Tio (next to him) took Crescent City jazz to New York in the 1920s with Armand Piron's band, and horn players Adolphe Alexander and Isidore Barbarin (either side of the drummers) later recorded with Bunk Johnson (below).

BOTTOM: Bunk Johnson's Brass Band, the first New Orleans parade band to record, photographed by producer Bill Russell in the backyard of clarinetist George Lewis's house on May 18, 1945. Bunk is on the left, and third and fourth from the left are Isidore Barbarin (father of drummer Paul Barbarin, see page 44) and Adolphe Alexander.

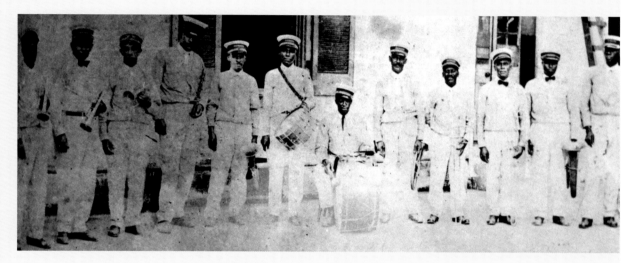

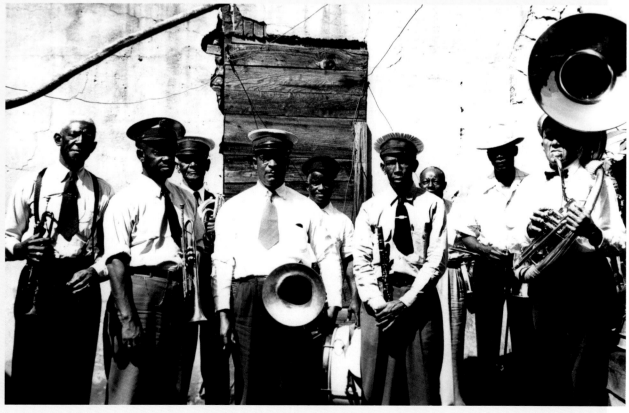

of theaters that catered to African American audiences. Chief among these was the network of black-owned theaters set up through the efforts of the comedian and entrepreneur Sherman H. Dudley. Starting in Washington, DC, he expanded into the South and Midwest, operating twenty playhouses by 1914, and creating a circuit that stretched as far south as Atlanta. In 1920, this evolved into the Theatre Owners Booking Association (TOBA), and before the Wall Street Crash of 1929 it peaked at around a hundred venues.

We can get a vivid impression of the sartorial fashions of the audience in such a theater from the cultural commentator Henry Louis Gates, Jr., who has described the "cloudlike tulle, hatbands of the finest grosgrain ribbon, wool suits and pants in neon shades There is a blue velvet fedora here, electric blue trousers there, a Superfly hat and overcoat on a man escorting his magenta clad wife." And, in many a painting and photograph from the dawn of the twentieth century well into the late 1920s, we can see exactly this rich variety of smart attire, complementing the sets and costumes of the performers on stage in TOBA theaters, or the black ties and tuxedos of the bands that played for dancing.

If there was one city apart from New Orleans where most of the ingredients that contributed to the creation of jazz were present, it was New York. There were theaters, cabarets, and dance halls in many sections of the city, and, in the summer, brass bands played everything from Sousa's marches to cakewalks on Manhattan Beach and Coney Island. Ragtime piano was popular, and would eventually develop into the city's own unique style of "stride" in the hands of players like Willie "The Lion" Smith and James P. Johnson. But more important was the way in which African American musicians gradually organized themselves and created what would become known as "syncopated orchestras."

The driving force behind the organization of these ensembles was James Reese Europe, from Mobile, Alabama, who initially worked in a similar role to that of Will Marion Cook, as musical director of the revue *Shoo Fly Regiment*. He knew that black Harlem musicians were dramatically underpaid compared to their white downtown counterparts. He believed that an umbrella organization to unite musicians and help improve the conditions in which they worked was essential, and after the failure of his first attempt, the New Amsterdam Musical Association, he became founding president of the Clef Club in April 1910. The end of May that year saw the club's band of New York's finest black musicians make their first public appearance, at the Manhattan Casino. "Never," reported the *New York Age*, "has such a large and efficient body of colored musicians appeared together in New York City." In later histories of jazz, much is made of Benny Goodman's Carnegie Hall concert in 1938. In fact, James Reese Europe took ragtime and early jazz into that hallowed classical venue for the first time on March 11, 1914.

Europe accompanied Vernon and Irene Castle with his Society Orchestra, and gradually began performing (very lucratively) at white society events in Manhattan. He left the Clef Club (which also involved such pioneers as bandleader Dan Kildare, ragtime composer Joe Jordan, and the composer and bandleader William H. Tyers) and formed the rival Tempo Club. As Irene Castle spearheaded new women's fashions, with bobbed hair and loose dresses that foreshadowed the "flapper" style of the 1920s, Europe's band was usually in the background of the pictures. Racial collaboration was being advertised almost by stealth, but the combination of dance and ragtime was potent, especially when war clouds were gathering. In 1915, Europe took over $100,000 in bookings, made piano rolls, and by late 1914 had already made records for the Victor Record Company. We will catch up with his fortunes during the war later, but Europe set the stage for jazz to develop apace, and his work across the color bar in Manhattan meant that a good pictorial record exists of his golden period.

"The colored American is finding himself ... his inexhaustible wealth of folklore legends and songs furnish him with material for compositions that will establish a great school of music."

Will Marion Cook, *New York Age*, September 21, 1918

The Art of Jazz

BELOW LEFT: **Songwriters Robert Cole (standing) and J. Rosamond Johnson (at the piano) were both pioneers of African American musical theater, but also toured the United States and Europe as a cabaret act, featuring their most popular song, "Under the Bamboo Tree." Cole committed suicide in 1911, while Johnson continued in show business until the 1950s, creating the role of Frazier in Gershwin's** *Porgy and Bess.*

TOP RIGHT: **James Reese Europe conducts a band of Clef Club musicians in 1914 that he led as his Society Orchestra. At this point, his ragtime pieces and dances were played on banjos of various sizes, plus cello, piano, and drums. Songwriter Noble Sissle is immediately under Europe's left elbow (fourth from right).**

BOTTOM RIGHT: *The Casino Girl* **had a short Broadway run in 1900, totaling 105 performances. The songs— as was customary—were by several composers, including Will Marion Cook, and numerous lyricists, including Paul Laurence Dunbar. The pair wrote alongside white composers for this show, prior to their 1903 success with the all-black** *In Dahomey.*

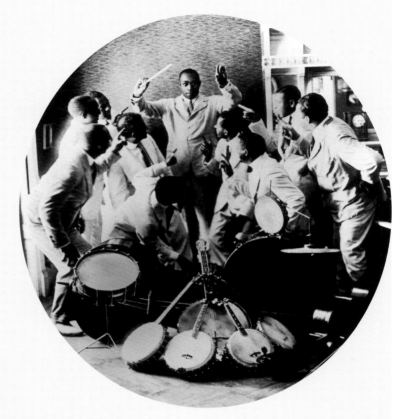

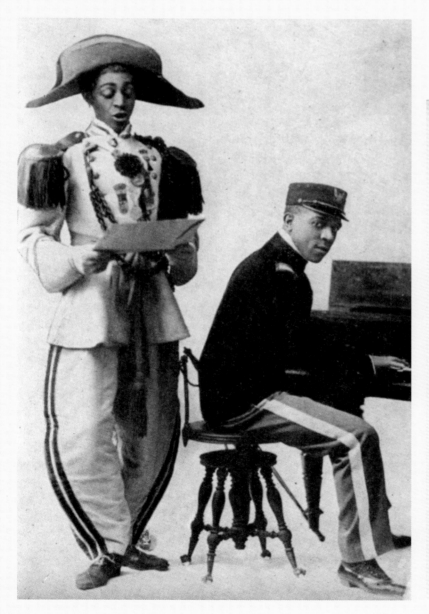

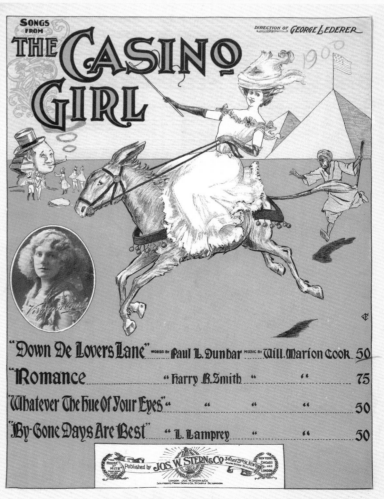

BELOW LEFT: **Eubie Blake (at the piano) and Noble Sissle**, who progressed from the early rags and blues composed by Blake to writing together. They created popular songs (that became jazz standards) and full-length revues. The pair met in 1915 and went on to perform as the "Dixie Duo." They later took over musical direction of James Reese Europe's band after his murder.

TOP RIGHT: **In this piece Blake immortalized his birthplace, Baltimore, a city of honky-tonks and "houses of ill repute,"** where he had gotten his start as a pianist. He became recognized there as a "piano professor" before going on the road in 1901 at the age of fourteen. (He claimed to be older, and when he died, aged ninety-six, in 1983, was widely believed to have been over one hundred.)

BOTTOM RIGHT: **"I'm Just Wild About Harry"** was one of the hit songs from the musical *Shuffle Along*, written for the comedians Miller and Lyles by Sissle and Blake. This was to be the first African American revue on Broadway since *In Dahomey* and was a far greater success, leading to a touring production and an eventual sequel, *Keep Shufflin'*.

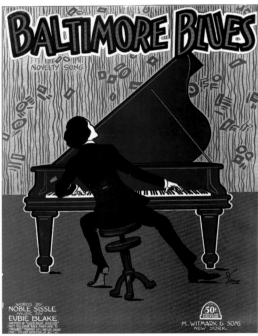

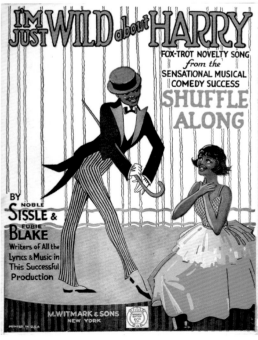

The Art of Jazz

TOP LEFT: "Alexander's Ragtime Band" from 1911, written by Russian-born Irving Berlin, helped to spark the dance craze spearheaded by Vernon and Irene Castle, and was an international success. He later wrote the revue *Watch Your Step* for the pair. Emma Carus, who launched this song, was a well-known Broadway chanteuse.

BOTTOM LEFT: **The New Jersey–born ragtime composer Joseph Lamb was published by the St. Louis–based John Stark, and this typifies the style of sheet music cover that Stark used for his stable of ragtime composers including Scott Joplin (see overleaf) and James Scott.**

BELOW RIGHT: **Stark's imaginative covers often made the most of inexpensive printing techniques, so this highly effective front page uses just two printing plates— black and blue, contrasting with the three-color process used on the other two examples on this page. The back of each edition usually carried advertisements for more of Stark's ragtime publications.**

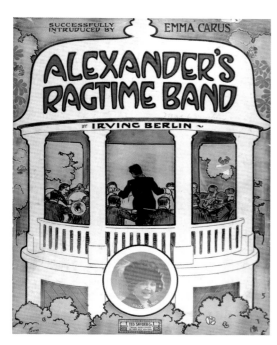

The pianist and composer Scott Joplin was the single most influential figure in ragtime. His success ensured that the genre was widely known, and also that it became one of the best-documented building blocks of jazz. The inventiveness of design on the covers of his published music is outstanding, even in an era when popular music was still almost universally communicated to the world via the printed page. Several of his pieces drew on autobiographical experiences, or events that he witnessed or were widely reported in the press. As a result, a sense of currency, of moving with the times, coexists with graphics evoking nostalgia, African American stereotypes, and, most importantly, quite discreet attempts, by subtle use of Joplin's portrait, to cement his place in the public imagination as a serious composer.

Born to musical parents in 1868, Scott took up both singing and the banjo, but although the family had no piano, he showed most promise as a pianist. He was taught to play by several local teachers in the town of Texarkana, Arkansas, including the multi-instrumentalist J. C. Johnson and the German-born Julius Weiss. As a teenager, Joplin composed and sang for a vocal quartet, performing throughout the local area. In his travels, he encountered many folk songs and dances, and some of what he heard found its way into his compositions.

In his twenties, Joplin traveled increasingly farther afield. He visited Chicago and St. Louis and Syracuse, New York, before settling around 1896 in Sedalia, Missouri. There, he published his first compositions, including "Crush Collision March," which referred to a notorious event that took place in September 1896 as a publicity stunt for the Missouri, Kansas, and Texas Railroad. Two steam locomotives were sent speeding toward each other for a headlong collision, in front of thirty thousand spectators. Their boilers exploded, and contrary to the expectation of the organizer, William C. Crush (after whom the site was subsequently named), two people were killed and dozens badly injured by flying metal. Joplin's thrilling music appeared in various editions, and it marked one of his earliest forays into publishing what would become the new ragtime genre.

In Sedalia, Joplin briefly studied music at George R. Smith College, and he passed on playing and compositional tips to his fellow ragtimers Scott Hayden (1882–1915) and Arthur Marshall (1881–1968). He also lodged with the family of Marshall, who later recalled that Joplin "was an inspiration to us all. We always treated him as daddy to the bunch of piano players here in Sedalia." Joplin played at a Sedalia club called the Maple Leaf, and in 1899, according to legend, he immortalized both the club and himself by publishing his "Maple Leaf Rag." The original artwork for the cover shows two couples, in a sketch borrowed from an American Tobacco Company cigarette card: Williams and Walker, and their wives, Lottie Thompson and Aida Overton. The image would have been familiar to all fans of the comedians.

"Maple Leaf Rag" sold half a million copies by 1909, becoming the best-known ragtime composition, studied by pianists all over the United States. Subsequently, Joplin published numerous other pieces, including "Original Rags" (1899) and his famous "Entertainer" (1902). His publisher, John Stark, paid Joplin a royalty on every copy sold—an extremely fair but also extremely unusual arrangement at a time when most popular tunes were sold for a single cash payment. Stark would continue to publish much of Joplin's work, as well as rags by other composers recommended to him by Joplin.

Joplin's later rags include slow drags, waltzes, and Hispanic rhythms. He also continued to represent events in music, such as "The Cascades," which depicts an ornamental watercourse at the 1904 World's Fair in St. Louis. Another of his published rags, "The Ragtime Dance," condenses a miniature ballet from 1899 into a single piece, retaining the foot-taps and tempo changes from the longer piece. He traveled widely as the "King of Ragtime Composers" and with some of the money he earned formed a succession of small touring companies to present his theatrical works. He later moved to St. Louis and New York, increasingly (and relatively unsuccessfully) throwing his energies into trying to create operas, but he became ill from syphilis and grew increasingly unstable. He died in a mental ward of Manhattan State Hospital in 1917.

Joplin's legacy is remarkable. He helped the careers of many other pianists and composers, black and white, including Louis Chauvin (1881–1908) and Joseph Lamb (1887–1960). His compositions inspired other ragtimers, including one of the first women composers of popular tunes, May Aufderheide (1890–1972), whose "Dusty Rag" of 1908 is a perennial favorite.

Scott Joplin and Ragtime

"Of the higher class of ragtime, Scott Joplin is an apostle and authority. Joplin doesn't like the light music of the day, he is delighted with Beethoven and Bach, and his compositions, though syncopated, smack of the higher cult."

American Musician and Art Journal editorial, December 1911

TOP LEFT: "The Entertainer" (1902) would eventually overtake "Maple Leaf Rag" as Joplin's best-known composition, not least because of its use as the theme to the 1973 multi-Oscar-winning movie *The Sting*. Stark's cover shows an African American vaudeville performer, much as "Maple Leaf" had portrayed Williams and Walker.

BOTTOM LEFT: This edition of "The Ragtime Dance" followed an unsuccessful 1902 version conceived as a mini-ballet. Stark issued this 1906 piano reduction of the score, aimed directly at Joplin's normal buying public. Yet as well as the African American dancers it depicts, the sheet music still contains the composer's instructions for "foot stamps," carried over from the original ballet.

BELOW RIGHT: It was customary in 1904 to include a classical composer's portrait in vignette on music covers, ranging, for example, from engravings of J. S. Bach on the *Anna Magdalena Notebook*, to dramatic photographs of Russian pianist Anton Rubinstein, but this was a rare honor for an African American composer (the crown subtly reinforcing the "King of Ragtime" image).

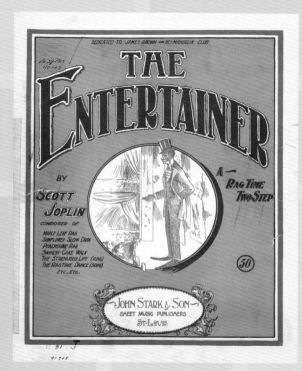

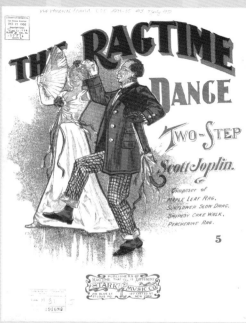

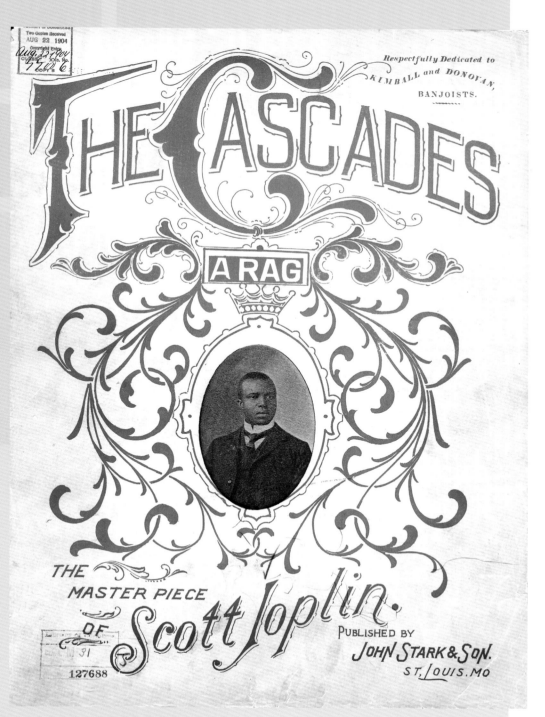

BELOW LEFT: **Although John Stark continued to publish some of Joplin's rags after the composer moved to New York in 1907, he sold rags to other publishers. On these two pages we see how Manhattan firms targeted the white audience with graphics that focus on Caucasian subjects, such as the huntsman and hound seen here.**

TOP RIGHT: **One of two collaborations between Joplin and his protégé Arthur Marshall, "Lily Queen" dates from 1907, after Marshall had fallen out with John Stark. Marshall would live for a further half-century beyond Joplin, dying at the age of eighty-six in 1968, by which time he had witnessed the dawn of the ragtime revival.**

BOTTOM RIGHT: **"Sugar Cane," like "Lily Queen," uses feminine charms to sell ragtime sheet music. The image of the well-coiffured woman wandering happily in the sugar plantation is slightly at odds with Joplin's direction on the sheet music that it should be played at a "Slow March Tempo"!**

OPPOSITE: **This illustration foreshadows the ethos of the Cotton Club, where well-heeled white audiences listened to African American music. Here the conductor might be African American, and Joplin's portrait reinforces the idea, but everyone else in the picture is white— suggesting, again, that the Seminary Music Co. was targeting white customers.**

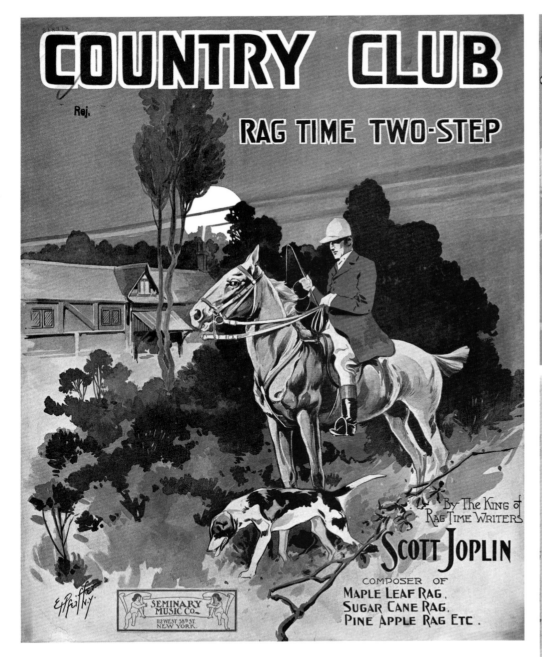

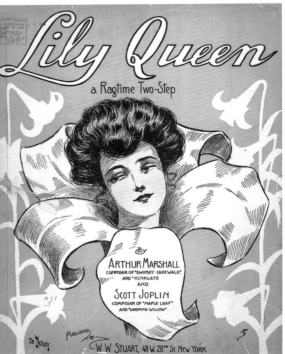

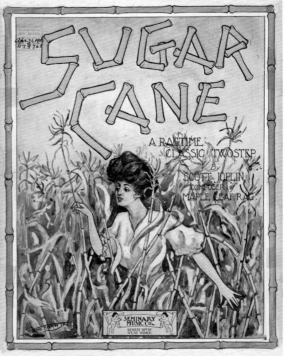

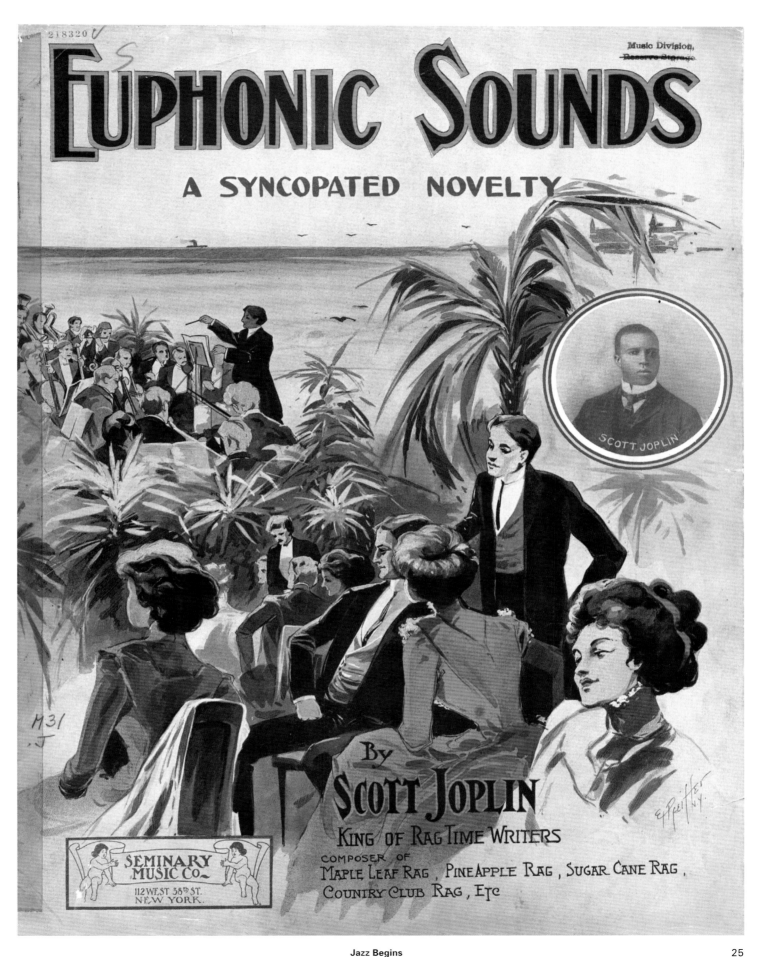

While Europe was in the grip of the World War I, North America was undergoing something of an economic boom. In the summers from 1914 to 1916, the country's greatest ragtime pianists—including such luminaries as Eubie Blake and Willie "The Lion" Smith—gathered to provide live entertainment at the East Coast mecca for dancing, gambling, and licentious behavior, Atlantic City. "Everybody wanted to go there," recalled Smith, "because A.C. moved fast. There was plenty of money floating round for the smart guys to grab. You'd run into all your friends down there in July, digging the salt water and the sun." Simultaneously, in New York City, the vogue for "syncopated orchestras" of the types led by James Reese Europe and Will Marion Cook firmly took hold.

When the United States entered the war in 1917, it was natural that these entertainments would follow the troops to Europe. Some Clef Club musicians arrived well before the US joined the war. Dan Kildare and other African American entertainers set about raising the morale of war-weary audiences in London. In 1917, a new wave of black Americans arrived in France—the men of the 369th Infantry Regiment, whose bandmaster was James Reese Europe. They earned the nickname the Harlem Hellfighters for their fearlessness in battle, and they subsequently made some records, including the evocative "On Patrol in No Man's Land." Their "Memphis Blues" gives some idea of how the band sounded as they barnstormed across France, playing to Allied forces. The band had photographs taken to keep morale high among African American soldiers, and some of these are beautifully evocative, posed shots.

Europe's was not the only army band playing early jazz. Lieutenant Tim Brymn led the 350th Field Artillery band, which included Willie "The Lion" Smith, cornetist Russell Smith (who later played with Fletcher Henderson), and trumpeter Addington Major, who later recorded with blues singer Mamie Smith. Brymn's African American band played at the 1919 Versailles Peace Conference and was acknowledged—along with Europe's Hellfighters—as having brought jazz to France.

After the war, James Reese Europe was seen as a great prospect for jazz, but in May 1919 he was murdered by one of his drummers after an altercation in Boston. Brymn led bands and recorded in New York, but it was Will Marion Cook who brought the first peacetime band to Europe in this pre-jazz style. His Southern Syncopated Orchestra (including the New Orleans clarinet virtuoso Sidney Bechet) arrived in Britain in 1919, and subsequently played several tours of Britain, Ireland, and continental Europe, before a shipwreck in 1921 ended their career.

Harlem Hellfighters and Will Marion Cook

"The most celebrated enlisted men were Europe's bandsmen, who included some of the best and best-known brass players and drummers in the country."

Richard Slotkin, *Lost Battalions: The Great War and the Crisis of American Nationality* (Holt, 2006)

BELOW LEFT: The sheet music for Sissle and Blake's song (cowritten with James Reese Europe) shows the full strength of the Hellfighters band in their formal group photograph, and also makes clear that (prior to his murder) Europe was continuing to front the band after returning from France.

TOP RIGHT: The Hotel Tunis in Paris had been converted into a convalescent hospital for wounded soldiers, and in 1918 James Reese Europe conducted a concert by the Hellfighters band in the street outside. A touching sight in this and other photographs of the event is the injured men leaning out of their windows to applaud the players.

BOTTOM RIGHT: James Reese Europe directing a marching version of the 369th Infantry band on parade outside a Paris railway station (possibly the now-demolished old Gare Montparnasse) to welcome other US troops to the city.

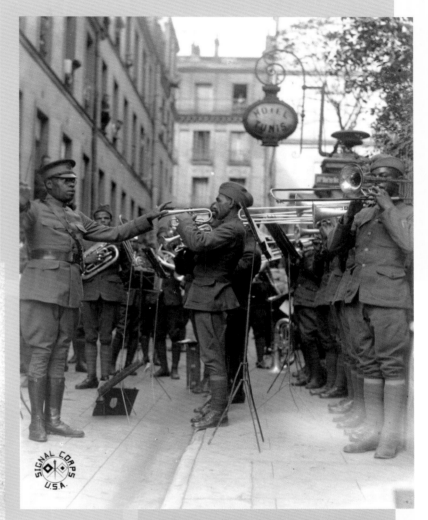

GOOD NIGHT ANGELINE

ADDISON AMUSEMENTS Inc. *Presents*
Lieut. JAMES REESE EUROPE
AND HIS FAMOUS
369th U.S. INFANTRY "HELL FIGHTERS" BAND

GOOD NIGHT ANGELINE . 50
ON PATROL IN NO MAN'S LAND 50
By Lieut. James Reese Europe, Noble Sissle
and Eubie Blake

M. Witmark & Sons
New York · Chicago · Philadelphia · Boston · San Francisco · London

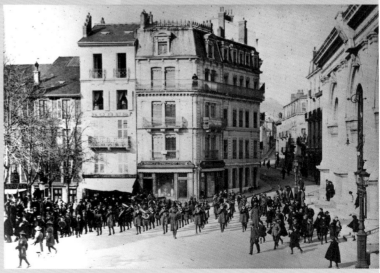

TOP: **Will Marion Cook's Southern Syncopated Orchestra on their visit to Britain in 1919, spreading the message of jazz to new audiences, including Swiss conductor Ernest Ansermet, who reviewed Sidney Bechet's clarinet solo with the band as "perhaps the way the whole world will swing in the future."**

BOTTOM: **According to legend, the "first man of jazz" was New Orleans cornetist Buddy Bolden, seen here in this photograph belonging to trombonist Willie Cornish from the very end of the 1890s. Posing for the photographer, bassist Jimmie Johnson and guitarist Brock Mumford hold their instruments left-handed!**

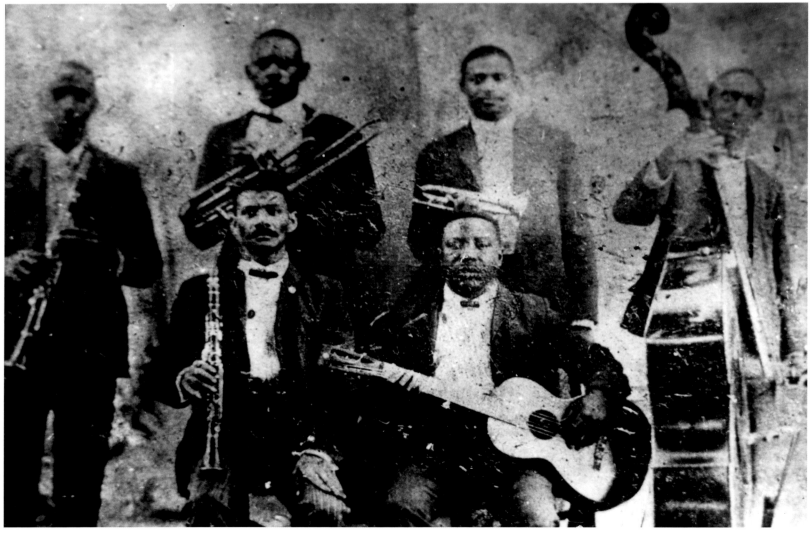

The Art of Jazz

BELOW: *Night* was painted by the British artist Thomas Cantrell Dugdale RA in 1926, and few pictures have ever as brilliantly shown African American musicians entertaining a lively nightclub audience in Europe. A former war artist, Dugdale's eye for detail brings the Jazz Age tableau vividly alive, from the clothes and fashions to the mixed ages and social backgrounds of the audience.

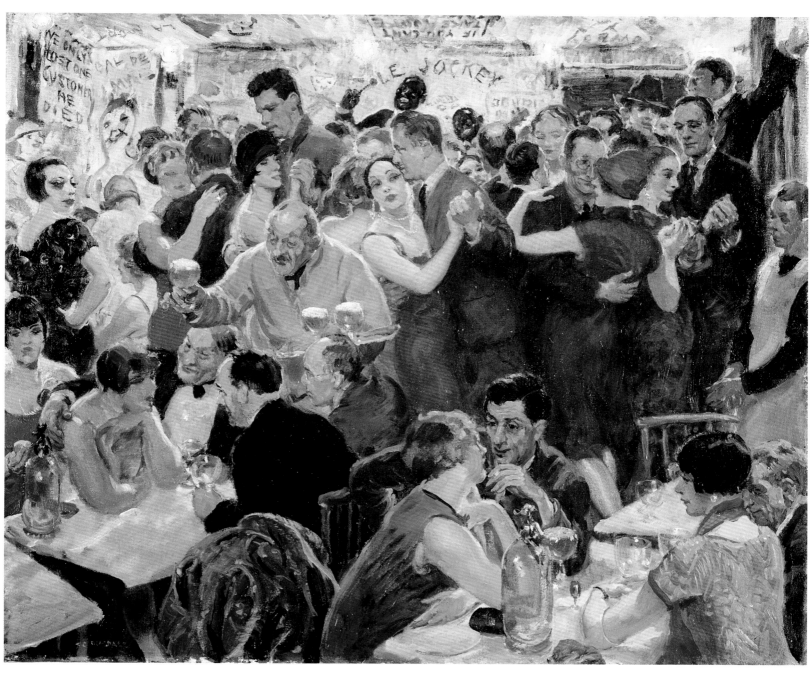

As jazz began to coalesce, fine artists—always attuned to the latest happenings in the arts—began to reflect what was going on musically. The subjects that first inspired a visual reaction were ragtime; the dance craze inspired by the Castles and James Reese Europe; the African American clubs where patrons danced to jazz; and, at a broader level, the whole risqué atmosphere conjured up by the word "jazz" itself.

Such inspiration worked in two ways. Artists attempted either to represent—with varying degrees of realism—the experience of witnessing jazz being played, or to abstract the sounds into a graphic equivalent to jazz itself. From the period immediately after World War I, two striking examples chart both routes.

First, Pablo Picasso produced a fluid, linear sketch of a banjoist and a violinist for the front cover of Stravinsky's *Ragtime*, initially composed as a piano solo and premiered in Lausanne, Switzerland, in November 1919, before being expanded for eleven instruments. *Ragtime* (finished on the morning the World War I armistice was signed) borrows Joplinesque clichés and incorporates elements from a set of ragtime sheet music brought back from the United States to Stravinsky in France by the conductor Ernest Ansermet. In a similar way, Picasso, who had painted musicians such as *The Man with the Blue Guitar* during his Blue and Rose periods of the early 1900s, combined elements of African American imagery into his own visual aesthetic.

Second, the Dutch artist Theo Van Doesburg, who together with his compatriot Piet Mondrian founded the movement known (after its magazine) as *De Stijl* in 1917, began creating minimalist canvases with lines and tones arranged in rectangles. An early work is *Composition in Gray (Rag Time)* from 1919. Here we see the rhythmic propulsion of ragtime inspiring a purely graphic interpretation, and between them, Van Doesburg and Mondrian would go on to produce a widely imitated imagery that was inexorably bound up with piano ragtime and boogie-woogie.

Just as Mondrian and Van Doesburg explored similar territory (until they fell out over Mondrian's disapproval of diagonal lines), so too did the American artists Stuart Davis and Jan Matulka, the latter arriving in the Bronx from what is now the Czech Republic in 1907. Davis trained under Robert Henri in New York, and, until he later moved into cubism, was part of the social realist "Ashcan School" movement, portraying real life in poor neighborhoods, including his *Negro Dance Hall* of 1915. Matulka, who would sublet his Paris studio to Davis, formalized similar images into an angular art-deco setting, for example in his 1926 monochrome *Negro Jazz Band*, which nods in the direction of Georges Braque's cubism in a piece like *Le Jour*. There are similar concerns in the graphic work of the German-born American painter Winold Reiss, notably his pen-and-ink drawings of Harlem in 1924–1925, although the photorealism of his portraits of such luminaries as the poet and writer Langston Hughes shows a keen eye for the details of black intellectual life.

The California-based printmaker James Blanding Sloan, whose portfolio ranged from Romanticism to abstract modernism, took a different line from Matulka in his *Jazz—The New Possession*, showing the silhouettes of jazz musicians conjuring up the images not only of wayward musical notes but also of a naked couple enjoying a frenzied and clearly erotic dance. Such images of eroticism, interracial mixing, uninhibited dancing, and other "licentious" behavior were an artistic response to the widespread disapproval of jazz in the conservative press. One critic described it as "the most dreary, the most brainless, the most offensive form of music that the earth has ever known," while another proclaimed "jazz is not music," and the British author Aldous Huxley railed, "The jazz players were forced upon me; I regarded them with a fascinated horror." The *Musical Courier* added a racist element to the criticism: "Ragtime-evolved music is symbolic of the primitive morality and perceptible moral limitations of the Negro type. With the latter, sexual restraint is almost unknown, and the widest latitude of moral uncertainty is conceded."

European artists including Otto Dix, in his triptych *Metropolis* (notably in the risqué sketch for the final painting), and George Grosz left little to the imagination in depicting customers enjoying the fleshpots of the jazz world. By contrast, African American artists were at pains to stress exactly the opposite. Aaron Douglas, in his *Aspects of Negro Life* series, sought to dignify the development of the music by tracing its African roots pictorially. The sculptress Malvina Hoffman aimed at a similar stress on the *African* in African American, and the paintings of Archibald J. Motley, Jr., brought the story up to date with black citizens dressed in their finest clothes, enjoying dance halls, tea salons on Strivers' Row, church meetings, and music in the streets.

Artists Inspired by Jazz

"Mondrian loved jazz and his paintings might be seen as improvisations on the basic theme of color—like the riff of a trumpeter, devised and executed in an instant but part of an unending series of free variations."

Susanne Deicher, *Mondrian 1872–1944: Structures in Space* (Taschen, 1999)

RIGHT: **If ever an artist used ideas from jazz in his work, it is this visual improvisation by Picasso, which, just like a jazz solo, is executed in a single line, starting under the banjoist's arm on our right and finishing on the left-hand side of his hat, yet perfectly depicting the two ragtime musicians.**

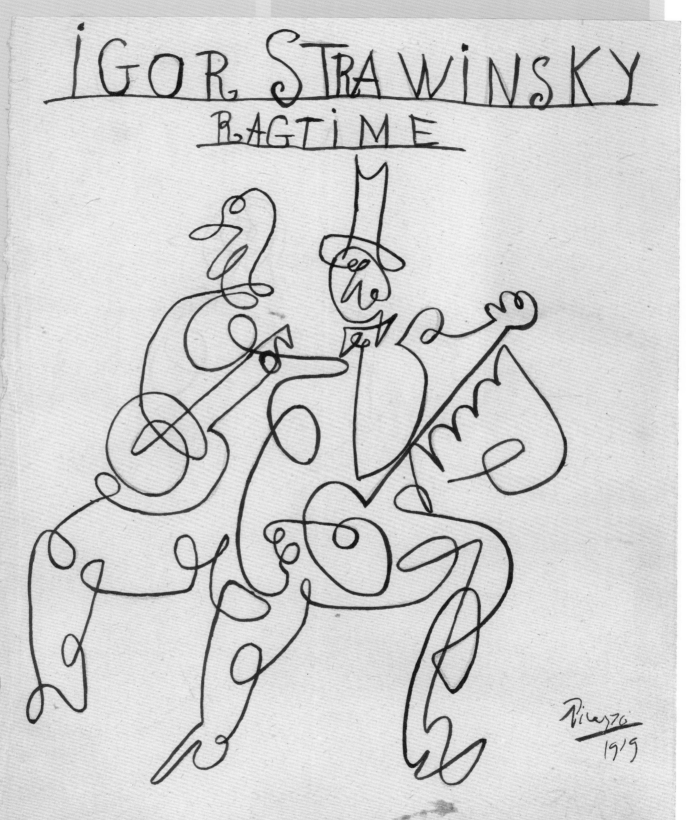

BELOW LEFT: Theo Van Doesburg's *Composition in Gray (Rag Time)* (1919) is at first sight as different as possible from Picasso's interpretation of a similar theme on the previous page. But just as Picasso unfolds a melodic line via the path of his pencil, Van Doesburg tackles the multipart formal structure of a rag, its themes and bridge passages, plus hints of musical notation.

BELOW RIGHT: The central panel of *Metropolis*, Otto Dix's European nightclub scene with American jazz musicians, is very different from Dugdale's. Instead of the joy and energy of a crowded club, this is debauchery in slow motion, the loveless clinch of the dancers echoing the passionless stares of the model and musicians.

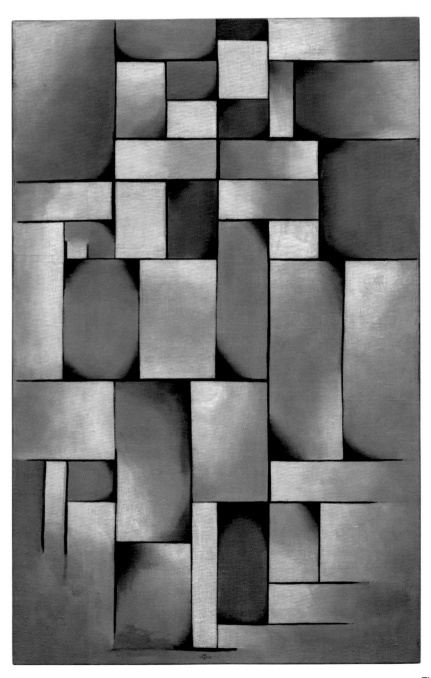

The Art of Jazz

BELOW: **Piet Mondrian's** *Broadway Boogie Woogie* **(1942–1943) is his best-known jazz-related painting, made after his escape from Nazi Germany to the United States. He referred to it as "dynamic rhythm," but it also catches the grid pattern of Manhattan, the larger rectangles representing buildings between the brightly lit streets.**

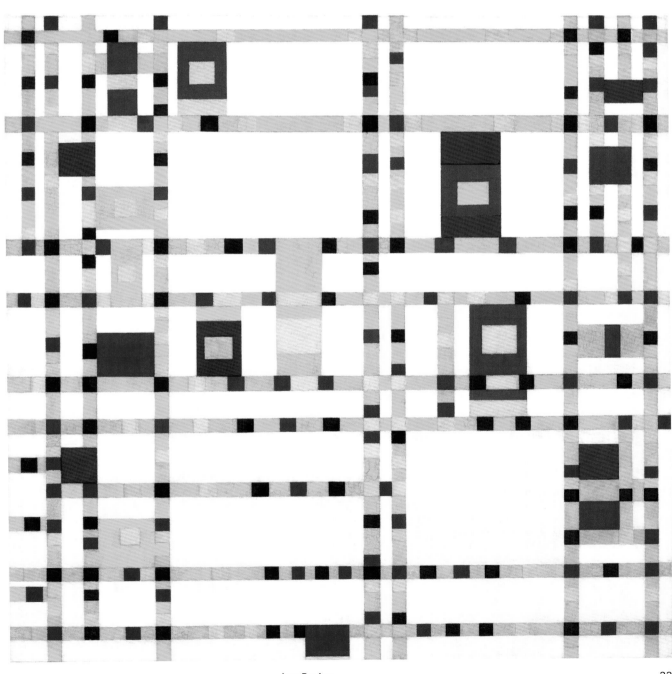

BELOW: **It was not just jazz music that traveled from the United States to Europe, but jazz dance, too. In this 1920s Paris nightclub advertisement, we see a jazz band on the left accompanying the floor show, in which the bare-breasted, banana-clad female dancer is undoubtedly intended to represent the African American Josephine Baker.**

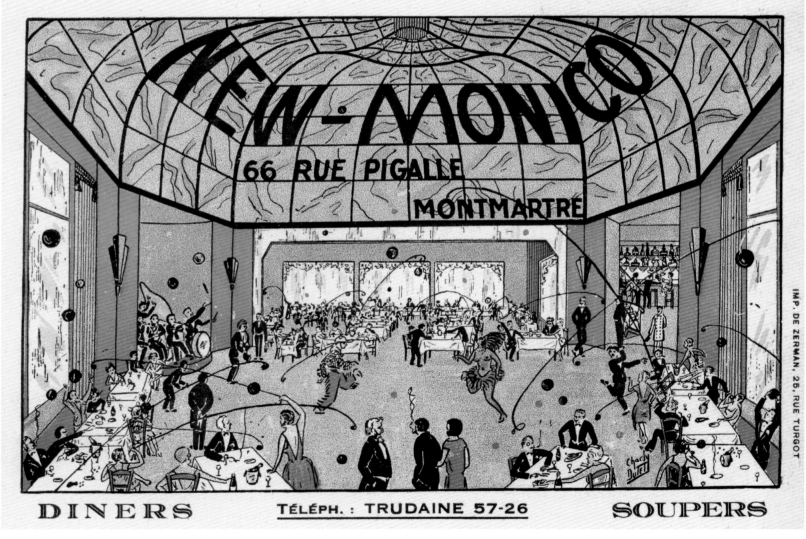

BELOW: In another scene from his large-scale paintings *Aspects of Negro Life* from 1934, Aaron Douglas (based at the time in Harlem) shows very similar dance moves in the panel entitled "The Negro in an African Setting," underlining the African ancestry of jazz and blues.

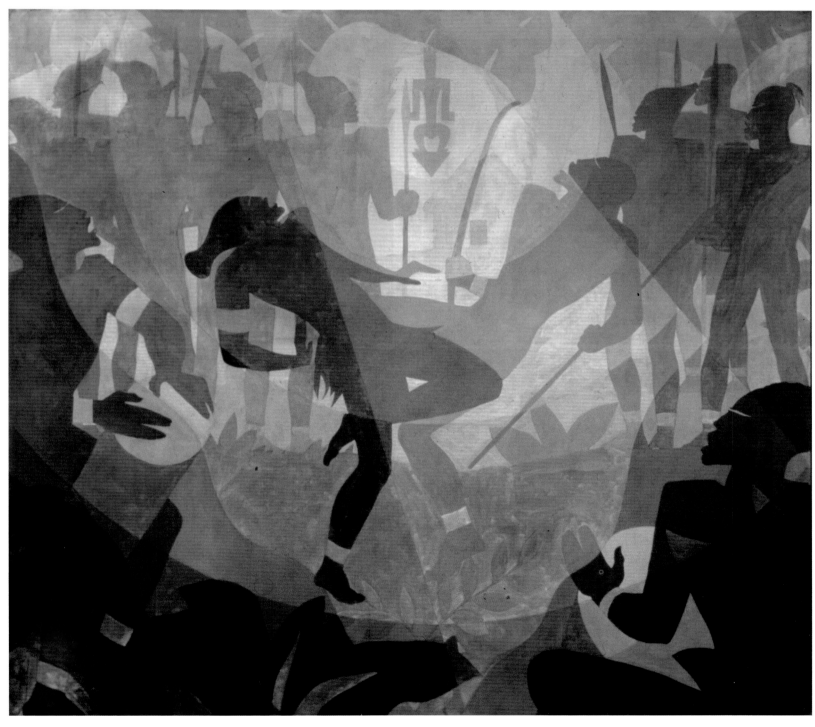

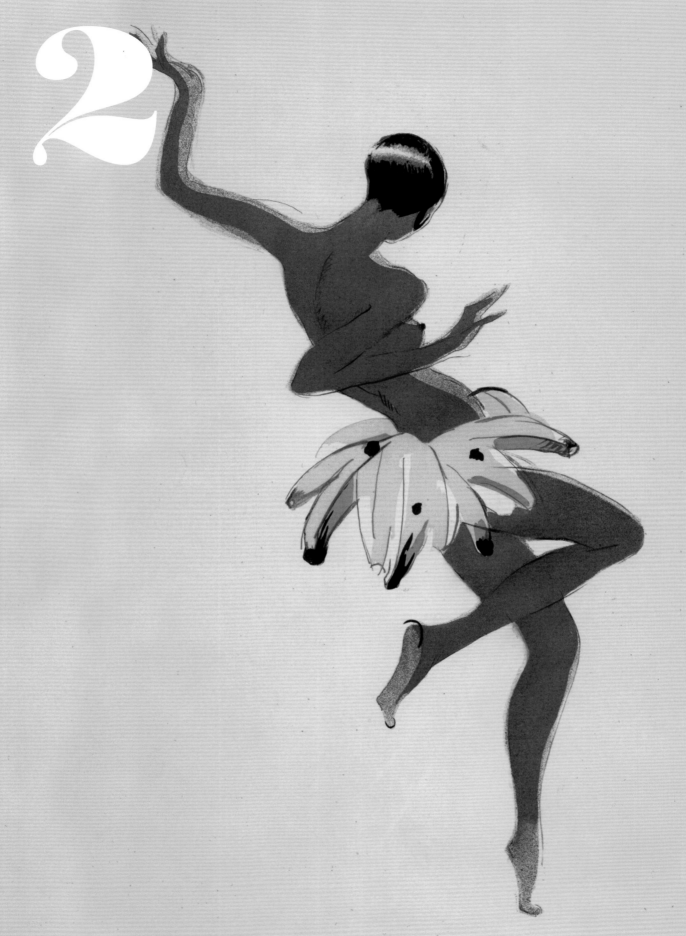

The Jazz Age

"The key to mass appeal"

It was the desire of the city authorities in Chicago to crack down on prostitution, on fraternizing between performers and audiences, and on the effects of alcohol on social dancing, that inadvertently fueled the start of the Jazz Age and the immense popularity of a five-piece white band from New Orleans—the Original Dixieland Jazz Band. From 1910, the Chicagoan heiress and civic leader Louise DeKoven Bowen had produced reports that railed against dances that involved "indecent" movements, "wriggling the shoulders, shaking the hips and twisting the body . . . [and] the 'Dip' (during which the man bent his partner backward until her head touched the floor, at which moment the woman would kick up one leg 'so that her privates were shown')."

The Chicago City Council, however, needed the revenue from licensed dance halls, and it recognized the popularity of social dance. So, while taking action against some of the cabarets and bars in the city, it simultaneously gave the nod to the creation of specialized dance venues and specifically exempted instrumental music from being banned. Singing—in particular with suggestive lyrics—was not encouraged, but "noisy ragtime, the jangle of the jazz band and the tom-tom" was permitted, notes Chicago's cultural historian, William Howland Kenney.

As these rules were brought in, a number of small instrumental groups from New Orleans—including Tom Brown's Band from Dixieland, and Stein's Band from Dixie—began to attract attention in Chicago with their syncopated, ragtime-inflected jazz and slapstick antics. In March 1916, Stein's band was playing at the New Schiller Café on the South Side, when, following in Bowen's footsteps, the women of the Anti-Saloon League (at the time the most powerful prohibition lobby in the United States) arrived with the intention of revealing just what a den of iniquity the place was. Their taxicabs blocked the streets, and news of the event quickly spread; the place was soon rammed with curious customers, while the struggling doorman held back a mass of further would-be participants. When the *Chicago Herald* ran the headline "Sixty Women Rip Mask Off Vice" and described "the blatant scream of the imported New Orleans Jass (*sic*) Band" and "men and women . . . arms about each other, singing, shouting, making the night hideous," it delivered a publicity bonus that immediately made the music the hot topic of the day. The person who made most capital out of this was Stein's cornetist, Nick LaRocca. Soon after the article appeared, Stein's band split up, and LaRocca moved to further his career on the back of this notoriety.

The personnel of LaRocca's group was fluid for a few months, but after being heard and praised by the up-and-coming star Al Jolson, LaRocca and his Original Dixieland Jazz Band were booked in January 1917 to play at Reisenweber's Café in New York City. With Larry Shields (clarinet), Eddie Edwards (trombone), Henry Ragas (piano), and Tony Sbarbaro (drums), this band was hugely popular. Within a few days of their arrival, their fee had risen to $1,000 a week—a fortune in 1917! Quickly, the band became the subject of photographs, posters, and paintings, spearheading the growth of traditional jazz across the United States, and, after traveling to Britain in 1919, in Europe as well.

Until the Original Dixieland Jazz Band appeared in New York and recorded what were widely regarded as the first jazz records, "Livery Stable Blues" and "Dixie Jass Band One-Step," in February 1917 for Victor (actually, the band had recorded a couple of sides for Columbia earlier, but they were not immediately issued), there were virtually no images of the musicians. But suddenly they were in vogue: photographed around a fake piano, with LaRocca and Edwards popping up from inside the frame; standing against a full-length concert grand; onstage with hats spelling out the word "D-I-X-I-E," or in a variety of slightly comedic poses, making much of the physicality of the group's stage act. There was sheet music, too, and there were panel advertisements in the press. No African American band had managed this degree of publicity. When the band came to England, with two replacements—the ragtime composer J. Russel Robinson on piano and Emile Christian on trombone—they played at the Hammersmith Palais de Danse, before going on to appear at the London Palladium. The band's period in England was successful, and it led to further recordings being made there, including some with the British pianist Billy Jones, who took Robinson's place when the band's stay was extended, becoming one of the first non-American jazz musicians to record.

While the ODJB was in London, the vogue for Dixieland bands, largely modeled on LaRocca's group, continued in New York. There were bands such as Earl Fuller's Famous Jazz Band, Ladd's Black Aces (who were in fact white), the Louisiana Five, the Original Indiana Five, and the Original Memphis Five. These groups (some of whom shared personnel) led to plenty of press advertisements, and their recordings are plentiful, showing that a generation of accomplished white players had taken up jazz in Manhattan, with some success. But the white band that made the biggest strides musically in the very early 1920s, the New Orleans

The Jazz Age

PREVIOUS SPREAD: **This was the cover drawing of dancer and singer Josephine Baker from a set of lithographs by the celebrated French graphic artist Paul Colin (1892–1986). He first saw her in** *La Revue Nègre* **in Paris during late 1925, which inspired him to create forty-five prints of the cast, which he published in 1927 as** *Le Tumulte Noir.*

TOP LEFT: **The Original Memphis Five were one of the "Fabulous Fives"— white bands modeled on the Original Dixieland Jazz Band. Here they are being promoted on sheet music composed by violinist Armand J. Piron, who brought his African American Band to New York in 1923, and published by the black musician Clarence Williams.**

TOP RIGHT: **A multiple exposure photograph of 1920s Charleston dancing, showing the characteristic "flapper" dress, bobbed hair, and hand moves of the dance, plus an African American saxophonist in a pose that prefigures the poster on page 94.**

BOTTOM: **The Original Dixieland Jazz Band in London in 1919. Left to right: J. Russel Robinson (piano), Larry Shields (clarinet), Nick LaRocca (cornet), Emile Christian (trombone), and Tony Sbarbaro (drums).**

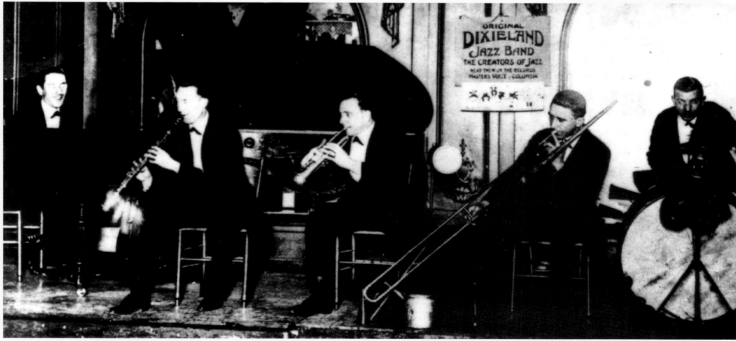

Rhythm Kings, consisted of musicians who, like the ODJB, had moved from New Orleans to Chicago. Led in the Windy City by trumpeter Paul Mares, and with the trombonist George Brunies and clarinetist Leon Rappolo, they appeared in artfully posed photographs, built around their virtuoso double bassist Steve Brown, taken at the time of their first records in 1922. Brown would go on to an illustrious career with the larger bands of Jean Goldkette and Paul Whiteman, but the group's initial pianoless rhythm section—buoyed by his (or Arnold Locoyano's) bass playing and a banjo—had a lighter, more swinging feel than that of its New York counterparts.

More significantly for the future of jazz, the band made one of the first interracial recording sessions in July 1923, when, over a couple of days, they cut a handful of sides with Jelly Roll Morton on piano. Earlier in the year, the band had recorded his "Wolverine Blues," and below their photograph on the sheet music is Morton's name as composer. On the record labels of the sides they made together, he is not credited as a musician, only as a composer, but his presence—notably in the relaxation of the beat and in his little compositional touches, like suddenly speeding up into a double-time sequence—immediately marks out these recordings from the more frantic style of most 1920s white Dixieland bands up to this point. These discs predate Morton's own first band recordings by some months, but they suggest that he already knew how he wanted his piano compositions to sound when a full band played them.

As the 1920s progressed, bands (both African American and white) took the music forward. Chicago and New York both saw developments, and, from 1923 on, Chicago became the principal locus for the rapid development of African American bands, in terms of both recordings and live performances. But as a stimulus to the visual arts, it was New York that had the edge. The circle of musicians around cornetist Red Nichols and trombonist Miff Mole recorded prolifically, as did the musically more adventurous groups that involved Bix Beiderbecke. But it was the leviathan orchestra of Paul Whiteman, who styled himself the "King of Jazz," that arguably had the greatest effect on art and design.

Like LaRocca, Whiteman was an effective self-publicist. By 1920, he was achieving record sales in the millions. His band—which with the help of the composer Ferdé Grofé created what would become the template for big-band arranging—was promoted with ingenuity, and he also published an influential short book in 1926, simply called *Jazz*. Whiteman realized that he could reach a vast market of white Americans by presenting a somewhat sanitized version of jazz. His band bombed in Chicago, where their stilted syncopations were no match for the hot rhythmic playing of African American musicians like King Oliver, but elsewhere in the United States his music was received as acceptable dance music, with the frisson of daring associated with the word "jazz" itself. By the middle of the 1920s, he had assumed the role of favorite society bandleader in New York that James Reese Europe had enjoyed prior to his murder. "All I did," Whiteman later claimed, "was to orchestrate jazz. If I hadn't done it, somebody else would."

His efforts culminated in the Aeolian Hall concert of February 12, 1924, dubbed "An Experiment in Modern Music," in which he gave the first performance of George Gershwin's *Rhapsody in Blue*. Gershwin's music borrowed elements from jazz, to be sure, but it sits parallel to rather than being part of the jazz tradition. The visual trappings, stage sets, and posters—even cartoons showing Whiteman dragging a reluctant "Jazz" into the concert hall—cemented his image as the King of Jazz, and this was further enhanced by the 1930 movie of that name, where his orchestra played the *Rhapsody* atop a giant forty-foot piano, with five pianists operating its huge keys.

This is the jazz of the fast set, the moneyed white hedonists portrayed by F. Scott Fitzgerald in *The Great Gatsby*. It is no coincidence that the music playing at Gatsby's second party at West Egg is Whiteman's "Three O'Clock in the Morning." Fitzgerald and his wife, Zelda, often heard Whiteman's band at the Palais Royal on Broadway, where Zelda described him as "the significance of amusement." Greeted on his return from his first European trip by skywriting airplanes and floating musicians in New York Harbor, Whiteman truly seemed to be the King of Jazz. His band floundered somewhat in the late 1920s, but then bounced back as the repository of an immense well of future talent, including Bunny Berigan, the Dorsey Brothers, Jack Teagarden, and vocalist Bing Crosby. Even the mercurial Bix Beiderbecke was in Whiteman's ranks for a time. Hence, even when he was no longer leading any area of jazz development, Whiteman's regal presence at the head of his thirty-piece orchestra in 1937, plus a cadre of vocalists, preserved the image among some sections of the white record-buying public that he personified the new music.

"All I knew was that you were the best band in the country."

Bix Beiderbecke in a letter to Nick LaRocca of the Original Dixieland Jazz Band, November 20, 1922

RIGHT: A sheet-music album collecting the best-known pieces by the Original Dixieland Jazz Band, featuring the publicity photograph in which Larry Shields, Eddie Edwards, and Nick LaRocca stand inside the shell of a fake piano (a trick Ringo Starr would reuse in his 1972 movie *Born to Boogie*, where Marc Bolan sings inside Elton John's piano on "Children of the Revolution").

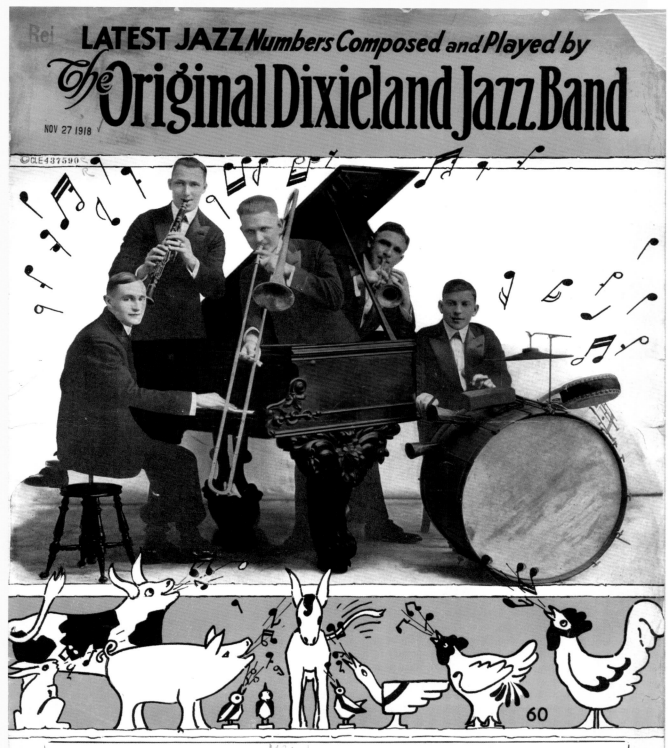

BELOW LEFT: A Swedish poster for Paul Whiteman's 1930 movie *King of Jazz*, which would help to cement his reputation in that regal role for a generation of record-buyers and filmgoers unaware of other developments in the music.

BELOW RIGHT: The scene from *King of Jazz* in which Whiteman's giant orchestra is atop a piano set, with five "pianists" miming to Gershwin's score for *Rhapsody in Blue*.

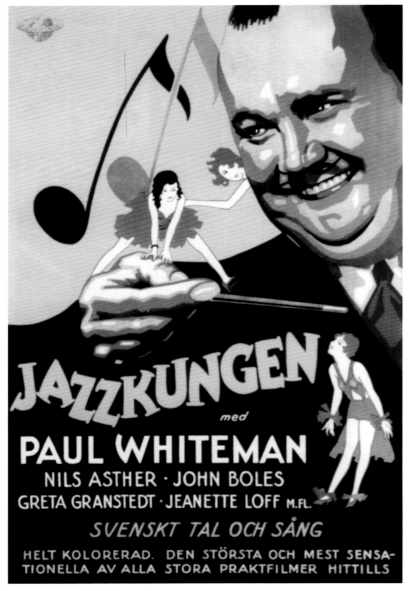

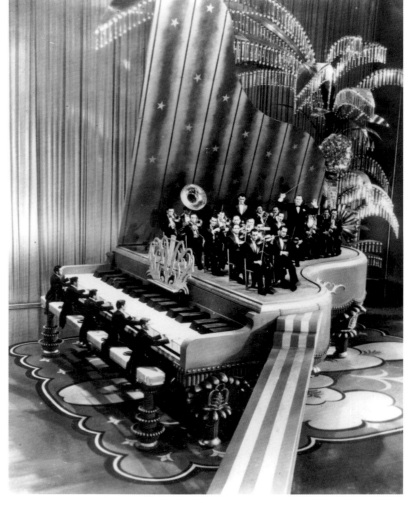

The Art of Jazz

BELOW LEFT: **The UK issue of the original recording of Gershwin's** *Rhapsody in Blue,* **arranged for Paul Whiteman's Orchestra by Ferdé Grofé, and featuring Gershwin himself at the keyboard. Whiteman's three reed players doubled on a total of seventeen instruments, which showed remarkable virtuosity. "Nipper" (the dog) was a trademark of RCA in the United States and the British company HMV.**

BELOW RIGHT: **A beautifully drawn cover from publisher Leo Feist, but featuring a panel (bottom right) where details of artists who had recorded the song could be overprinted. In this case, the Paul Whiteman caricature is one that he would use consistently as his marketing image.**

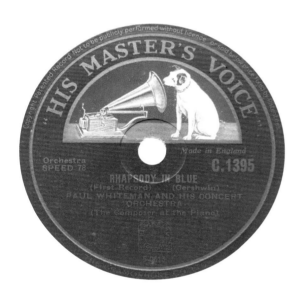

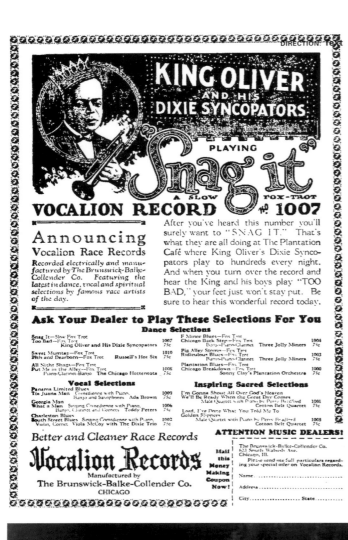

TOP: A panel advertisement from the *Chicago Defender* during the period from 1925 to 1927, when King Oliver's Dixie Syncopators played at Chicago's Plantation Café at 335 East 35th Street. The band lost this popular residency when the club burned down. Oliver's "crown" as "king" of the cornet is in view, and the ad targets the African American or "race" market.

BOTTOM: This Chicago studio portrait photograph of the Dixie Syncopators during their run at the Plantation was given by Albert Nicholas ("Nick") to drummer Paul Barbarin (son of Isidore, shown on page 17). King Oliver is second from the left. By this time, Oliver was beginning to suffer from dental problems, so Bob Shoffner (third from left) often took the cornet solos.

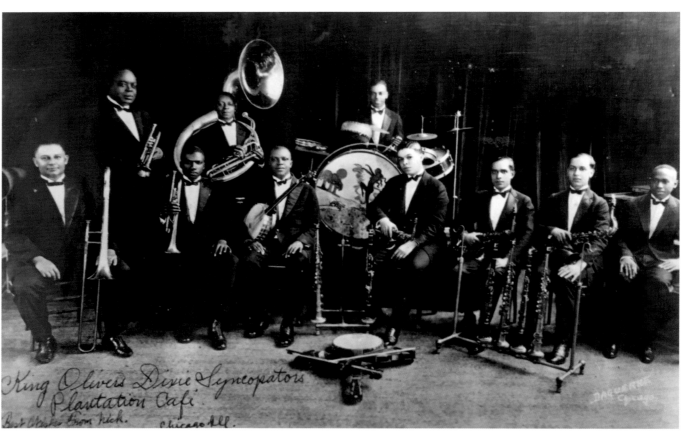

BOTTOM: Louis Armstrong's recording group the Hot Five, formed in 1925, on returning to Chicago after he played with Fletcher Henderson in New York. As the legend makes clear, the band was exclusively signed to Okeh records, a "race" label. Left to right: Johnny St. Cyr, Kid Ory, Armstrong, Johnny Dodds, and Lil Hardin Armstrong.

Get "Heebie Jeebies"
with Louis Armstrong and his Hot Five
OKeh Record No. 8300

MORE wild jazz than you ever thought could be packed into one record is unpacked by Louis Armstrong and his Hot Five when they let loose with "Heebie Jeebies." This blazing fox trot is Okeh Record No. 8300. On the other side, Louis and his ragtime boys give you "Muskrat Ramble," a fox trot that makes you just up and dance!

OKeh Race Records
© GENERAL PHONOGRAPH CORPORATION
25 West 45th Street, New York City

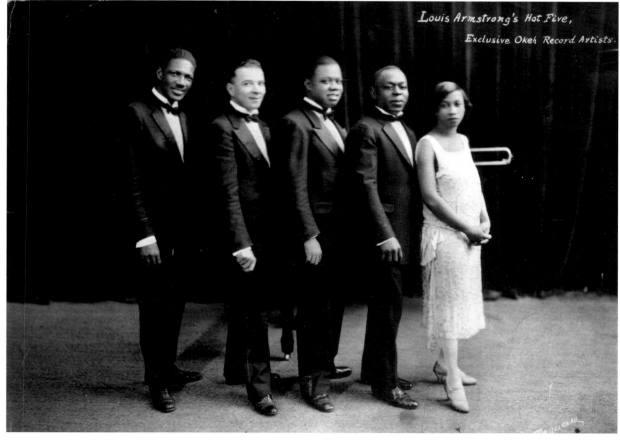

Louis Armstrong's Hot Five, Exclusive Okeh Record Artists.

White jazz musicians of the Jazz Age initially attracted most media attention for their work. By the mid-to-late 1920s, African American musicians (such as Oliver and Armstrong on the previous pages), who had been primarily responsible for the music's development, were getting comparable coverage in photographs, publicity, and sheet-music covers. At opposite ends of the spectrum were two pianists, bandleaders, and composers: Jelly Roll Morton and Duke Ellington.

In Morton's heyday in Chicago, supported by Victor records and the Melrose publishing company, he was presented as a sharp-suited piano "professor," lecturing his men from the keyboard with a pointing finger. After several fluctuations in his career, particularly following a move to New York, later images from the time of his 1939 recordings for the Bluebird label portray him as a working musician, in shirtsleeves at the piano, directing proceedings in the studio, or playing solo. Ellington, by contrast, was consistently represented as an *artist*. His manager, Irving Mills, took pains to ensure that even the smallest detail of the way Ellington was promoted was to be planned and executed by the Mills office. So we see him presented as a quasi-classical conductor, or, in the film *Black and Tan*, as a musical poet composing in his garret, a world away from the aforementioned illiterate workmen who wish to repossess his piano.

Morton himself claimed to have "invented" jazz in the early twentieth century, but others dismissed this claim, seeing him as a loudmouthed Creole with a diamond tooth, fashionable clothes, and an overinflated opinion of himself. But he and Ellington were two of the first musicians in history to foresee the potential of the phonograph record and to tailor their writing and arranging precisely to the demands of the new medium. Morton's evocative records, like "Sidewalk Blues" or "Steamboat Stomp," were perfectly formed pieces of program music, with suitable sound effects. Similarly, Ellington works such as "Black and Tan Fantasy" or "Misty Morning," which convey a funeral and a pastoral scene, respectively, show his mastery of the recorded form.

After a period in Los Angeles, Morton moved to Chicago in 1923 after falling out with his Californian publishers, the Spikes Brothers, who muscled their way into joint ownership of his compositions. His recording career began that same year, and he worked for several different labels until securing his lucrative Victor contract in 1926. As each disc appeared, his new publisher, Walter Melrose, brought out the music, both for piano and in band arrangements. He was initially credited as "Ferd" Morton (an abbreviation of his given name, Ferdinand), but once Victor began issuing his discs as by "Jelly Roll Morton's Red Hot Peppers Orchestra," the sheet music followed suit.

Morton tried to exploit each of his compositions very thoroughly, and in the 1920s Melrose assisted in this, until Morton fell out with the firm for nonpayment of royalties. In contrast to Ellington, whose business was almost entirely in the hands of Irving Mills, Morton independently fought for his rights, and in 1940 he took both Melrose and ASCAP (the American Society of Composers, Authors, and Publishers, who administer royalties) to court, to get what he considered his due. By then, however, Melrose had sold his copyrights to another company, and Morton's claim got nowhere. After a lot of correspondence, ASCAP raised him by one ranking, increasing his payment that year by a mere sixty-five dollars.

In due course, Ellington would fall out with Mills over similar financial concerns, but from the mid-1920s until 1939, his public image, recordings, publishing, club appearances, concerts, and tours were all controlled by Mills's management company. Mills had first marketed Ellington and his Cotton Club Orchestra as purveyors of "Jungle Music," but by 1931 Mills realized he could do much more with the band, and his publicist, Ned Williams, produced a comprehensive manual for marketing what was now branded "Duke Ellington and His Famous Orchestra." Superlatives abounded concerning "Harlem's Aristocrat of Jazz," and over the next four years the word "genius" was liberally sprinkled through the band's promotional material. Mills was later to say, "I made his importance as an artist the primary consideration." Part of this was complete attention to the way the band appeared onstage. The drummer Sonny Greer recalled, "Every time we opened up we had boutonniere flowers . . . every show we had a different uniform, top to bottom."

This emphasis on smart attire and artistic genius helped Ellington to bridge the color bar, creating an integrated audience for his records and broadcasts. His band began to appear where hitherto only white orchestras had played, and the Mills company's panel advertisements listed his sheet music alongside that of their white composers. Novelty advertisements in the shape of records, or elegant artwork of Ellington and his band, completed the process. Ellington was the first African American bandleader whose commercial success was at least partly achieved through skillful manipulation of his visual image.

Jelly Roll Morton and Duke Ellington

"Duke Ellington was a composer, but instead of a written score he used the recording studio as his tool."

Pekka Gronow and Ilpo Saunio, *An International History of the Recording Industry* (Cassell, 1998)

The Art of Jazz

TOP: "Flamingo" was one of the first publications from Ellington's Tempo Music firm, which he founded in the early 1940s on splitting from Irving Mills, but it maintains Mills's policy of presenting Ellington as a suave sophisticated bandleader, in contrast to Morton's workmanlike image.

BOTTOM LEFT: After moving to New York, Jelly Roll Morton would lecture all and sundry on how he "invented" jazz. Here he is, as photographed by fellow New Orleans musician Danny Barker, outside the Rhythm Club (a musicians' organization), holding forth while waving a slice of watermelon in his right hand.

BOTTOM RIGHT: Written in 1910 and first published in 1915, this sheet music for "Jelly Roll Blues" shows how Morton's nickname was not used to publicize his work as composer at the start of his career, with a shortened version of his forename, Ferdinand, used instead. The images hark back to the days of the cakewalk and early publications by African Americans.

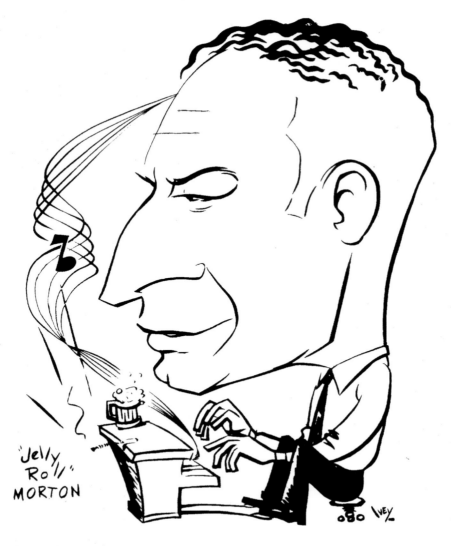

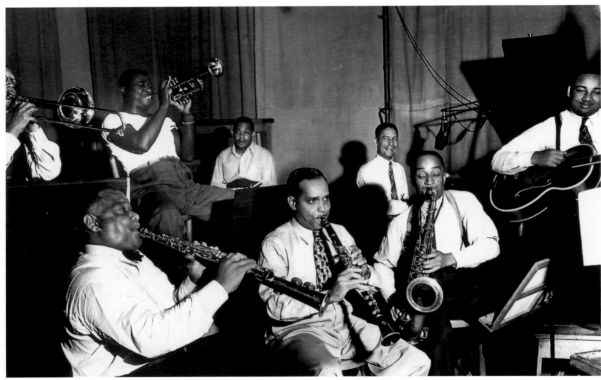

The Art of Jazz

TOP LEFT: **One of the images of Duke Ellington that the Irving Mills Agency used as part of its campaign to standardize Ellington's appearance. This poster would have local appearance details overprinted below the image, which focuses on Duke's face, much like "Flamingo" on the previous pages.**

BOTTOM LEFT: **The Ellington band's theme was actually written by Duke's long-term associate Billy Strayhorn. This sheet music cover shows a typical New York subway scene: the crowd jumps aboard the express service, which as the lyric says was "the quickest way to Harlem," rather than the slow "local" train on the adjacent platform.**

BELOW RIGHT: **The poster for the 1929 movie *Black and Tan* shows how Irving Mills portrayed Ellington as an "artist," despite his band members being depicted as crude African American stereotypes. Mills believed Duke had to stand out to be different, and the classical conductor's garb matches his artistic persona in Dudley Murphy's screenplay for the film.**

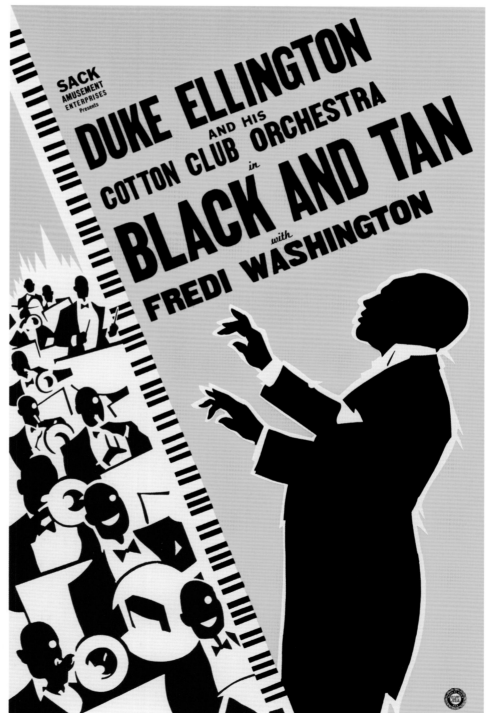

BELOW LEFT: The *Big Broadcast* of 1932 was unusual for its era in that it presented both white and black stars, although their acts were filmed separately. Bing Crosby replaces an imposter singing his hit song "Please"; the Mills Brothers show incredible vocal virtuosity in "Tiger Rag"; and Cab Calloway sings "Kicking the Gong Around," loaded with coded references to opium addiction.

BELOW RIGHT: In September 1936, the Cotton Club moved downtown from Harlem to Broadway. But this brochure shows the new club was no less about purveying an image of "primitive" black culture to white patrons than the earlier uptown branch had been. The African American poet Sterling Brown criticized the artists who took part in this "exotic entertainment," seeing them and their art as being "purchased" by rich white patrons.

BELOW LEFT: A fine 1947 portrait of Cab Calloway, shortly after his Cotton Club days, taken at the Columbia Records studio in New York by jazz photographer William Gottlieb. Although newer types of jazz were arriving—some of which Cab satirized in songs like "I Beeped When I Shoulda Bopped"—Calloway still focused on the feel-good songs that made his reputation.

BELOW RIGHT: That same year, Calloway starred in this full-length musical comedy directed by Josh Binney. In a flimsy plot designed to give Cab and his band the maximum opportunity to perform their latest songs, his girlfriend Minnie (Jeni Le Gon) is suspicious of his new female manager, and enlists gangland help to keep Cab for herself.

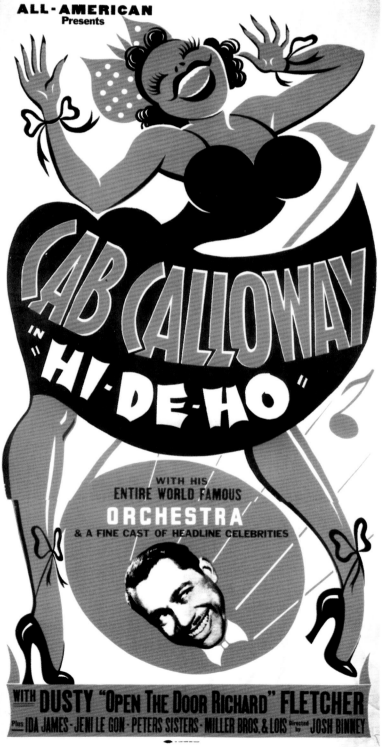

TOP: **This "papercut" artwork by American graphic artist Hal Rammel (also a composer and improviser) was inspired by Fletcher Henderson's 1931 "Radio Rhythm." It is part of a series covering Don Redman, Al Cooper, and George Russell, among others, and cleverly mingles big-band musicians, music stands, birds, and instrumental shapes.**

BOTTOM: **The Fletcher Henderson Orchestra was hugely significant in establishing the big band in jazz, and this shot catches them on the boardwalk at Atlantic City, New Jersey, where New Yorkers went to dance and gamble in the summer season. Stars of the band included saxophonist Coleman Hawkins (second left) and bassist John Kirby.**

The Art of Jazz

Virtually all of the musicians discussed so far have been male, but several women played a significant role in early jazz. Best-known are the vocalists, but several of the unsung heroines of the music were instrumentalists, who are only now, in the twenty-first century, beginning to be properly recognized for their contributions. These included the pianists Lil Hardin Armstrong and Lovie Austin, both of whom recorded in Chicago in the mid-1920s, and pianist and arranger Mary Lou Williams, who cut her first records with Andy Kirk's Clouds of Joy in Kansas City in November 1929.

Before 1920, tenor saxophonist Isabelle Spiller began playing in the Musical Spillers, the band she co-led with her husband, the bass saxophonist William Hezekiah Spiller, and in which—in addition to a number of female saxophonists—she later employed the reed player Willie Lewis (who would be famous in Europe) and a very young Rex Stewart. One of the musicians who encountered the Spillers on the African American touring circuit was the dancer and singer Valaida Snow, then just beginning her career, who would, according to Willie "The Lion" Smith, the pianist in one of her traveling revues, "step out of the line and stop the show playing her trumpet." She went on to become one of the first significant female jazz trumpeters, making a considerable reputation (and numerous recordings) in Europe.

Yet in the iconography of jazz it is not the female players but the female vocalists who stand out. There are early images of blues singers such as Ma Rainey and Bessie Smith, from shortly after they had toured with the Rabbit's Foot Minstrels. Rainey, with her characteristic headband, is shown posing with the members of her Georgia Jazz Band, and her portrait has even adorned a US postage stamp. But with greater popularity than Rainey—and a contract with Columbia that lasted from February 1923 to November 1933, producing 159 recordings—Smith was a different order of artist. Dubbed the "Empress of the Blues," she was photographed during most stages of her career. Following a few early, anonymous snapshots, the first important portraits of Smith were by the pioneering African American photographer Edward Elcha, who by 1923 had moved from his original premises in Harlem to his Progress Studio in midtown Manhattan, at 220 West 46th Street, where he set about taking as many pictures as he could of the luminaries of jazz.

Elcha's portraits of Smith are dazzling examples of his work. His earliest picture of her, taken around the time of her recording debut, has her in a lace dress with floral decorations and a bobbed wig. His signature is a type of chinoiserie, the characters of his name looking like Chinese lettering. Later in the year, he produced some masterly shots of her in a tasseled robe, with a jeweled headdress and a huge ostrich feather, and these images are signed with what became his normal flowing signature. Elcha produced more portraits of Smith in the 1920s, including a famous close-up of her face framed by black ostrich plumes and a dark pageboy wig.

But if Elcha captured the youthful Smith with a joie de vivre that matches her pieces like "Tain't Nobody's Biz'ness if I Do" or "Nobody in Town Can Bake a Sweet Jelly Roll Like Mine," then the majesty of the mature Smith was captured by the music critic and novelist Carl Van Vechten. He acquired a 35mm Leica camera around 1930, which he used to document Harlem show business. His talent as a photographer blossomed in the early 1930s, before Smith's tragic death in a road accident in 1937. Yet he was still surprised—given her fame—that she was such a willing subject, given that he viewed himself as a Johnny-come-lately to photography, writing, "She could scarcely have been more amiable or cooperative. She was agreeable to all my suggestions and even made changes of dress."

A singer and actress who garnered almost as many images as Smith in her short life was Florence Mills, the "Queen of Happiness," who died unexpectedly from tuberculosis in 1927, at the age of thirty-one. A star of the Plantation Revue, which traveled to Britain, where she also returned in the impresario Lew Leslie's Blackbirds show of 1926, Mills was photographed for Vogue and Vanity Fair. She advertised her own brand of sepia stockings, and she paved the way for subsequent stars such as Adelaide Hall, who starred in the 1928 edition of Blackbirds.

Although Mills and Hall were beautifully photographed, the African American singer who stimulated the most graphic art was undoubtedly Josephine Baker. Valaida Snow had witnessed her star quality when a very young Baker appeared in Sissle and Blake's 1924 musical In Bamville. But it was Baker's move to France, to star in La Revue Nègre, that really inspired artists. From Alexander Calder's wire sculptures to Paul Colin's drawings and prints of her banana and feather costumes, and a panoply of creative photographs, Baker stimulated visual artists to catch just a glimpse of the risqué glamour she portrayed onstage and on record.

The Women of Early Jazz

"Socially acceptable roles for women in jazz have been primarily restricted to vocalists, sometimes pianists … yet woman musicians have played every instrument in every style and era of jazz history."

Encyclopedia of Women in American History (Routledge, 2015)

TOP LEFT: Edward Elcha's late-1923 portrait of Bessie Smith, complete with her headdress and ostrich feather, created an image of the singer that would persist throughout her early recording career, and she was often later to be photographed with similar accouterments.

BOTTOM LEFT: Carl Van Vechten's portraits of Smith in later life for the most part have a serious, introspective, or downcast quality, but this February 1936 photograph catches the *joie de vivre* of such records from her mature work as "Gimme a Pigfoot," which she recorded two and a half years earlier.

BELOW RIGHT: This very first portrait of Smith by Edward Elcha in 1923 catches the young performer in her prime, the woman whom jazz pianist Teddy Wilson recalled "had the dynamic range of an opera singer, and the same control and power of voice . . . she certainly was the 'Queen of the Blues.'"

BELOW LEFT: **Although Josephine Baker was a fine singer, and would go on to do remarkable charitable work for orphan children in her adopted country of France, she acquired her fame and notoriety through her risqué dancing in such stage shows as *La Revue Nègre* and at cabarets such as this one, and the one shown on page 34.**

BELOW RIGHT: **Not only did the banana costume inspire Paul Colin's prints of Josephine Baker, but in 1928, her dancing, while she was clad in a similarly edible costume, saw her expelled from Vienna and her work permit withdrawn. "She will not," wrote Parisian columnist Claude Vautel, "appear dressed only in a couple of bananas in *that* city."**

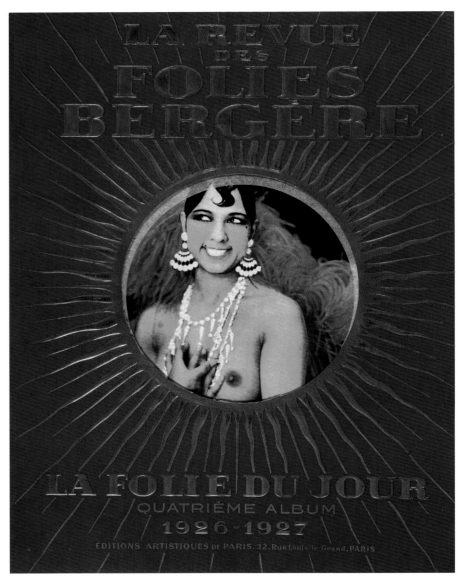

The Art of Jazz

BELOW LEFT: **According to cornetist Rex Stewart, the Musical Spillers were "one of the first big-time colored acts in show business." Nominally led by William Spiller (left), their "straw boss" was his wife, Isabelle (second left), who not only played the tenor saxophone but drilled the musicians in playing and dancing at the same time.**

BELOW RIGHT: **Valaida Snow was, by the time of this graphic portrait from the 1930s, well known in Europe as the "Queen of the Trumpet," under which name she recorded in London with Billy Mason and in Stockholm with Lulle Ellboj. She had previously starred on Broadway in Lew Leslie's *Rhapsody in Black* alongside Ethel Waters.**

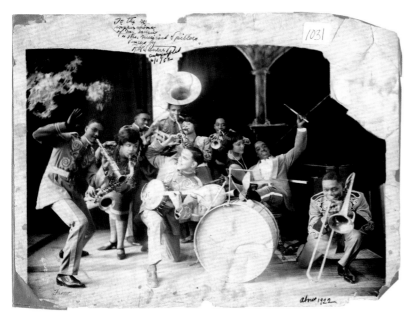

BELOW: **The Harlem Renaissance was a movement of African American intellectuals based in that part of New York City. The artworks collected by Arturo Schomburg, seen here in the office of curator Lawrence D. Reddick, follow Harlem writer Alain Locke's dictum that Africa should inspire "a characteristic school of expression in the plastic and pictorial arts."**

OPPOSITE: **This painting, *Street Musicians,* by the Harlem-born African American painter Norman Lewis, marks his transition from a social realist painter to an abstract expressionist, yet in this image there are plenty of visual clues to the saxophones being played and the stance of the players.**

The Art of Jazz

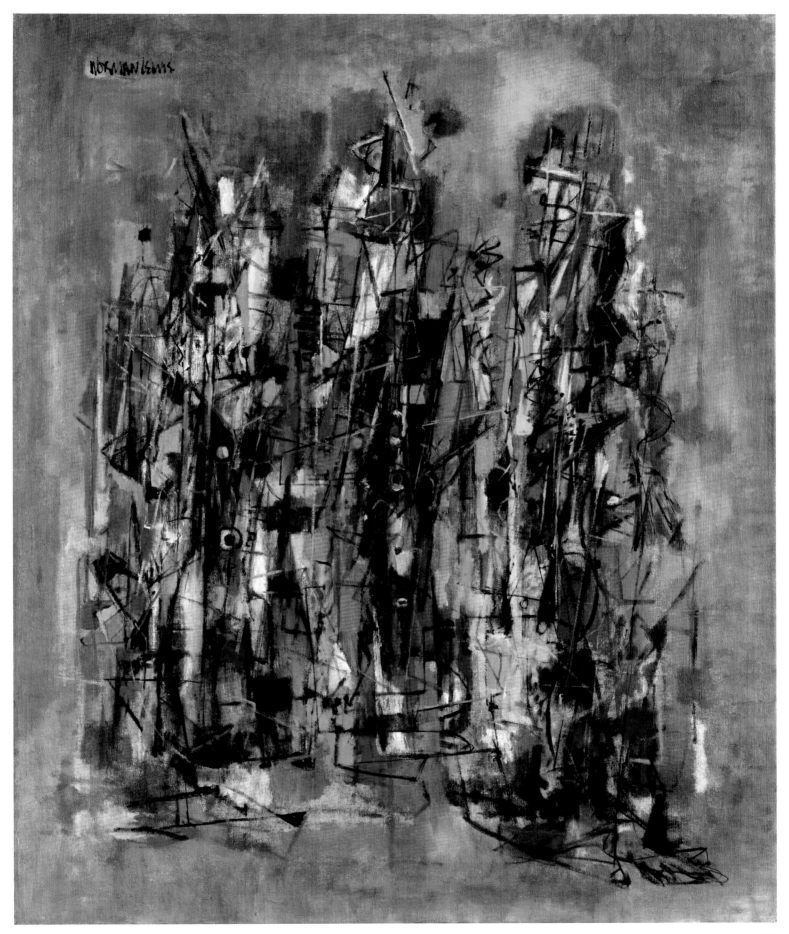

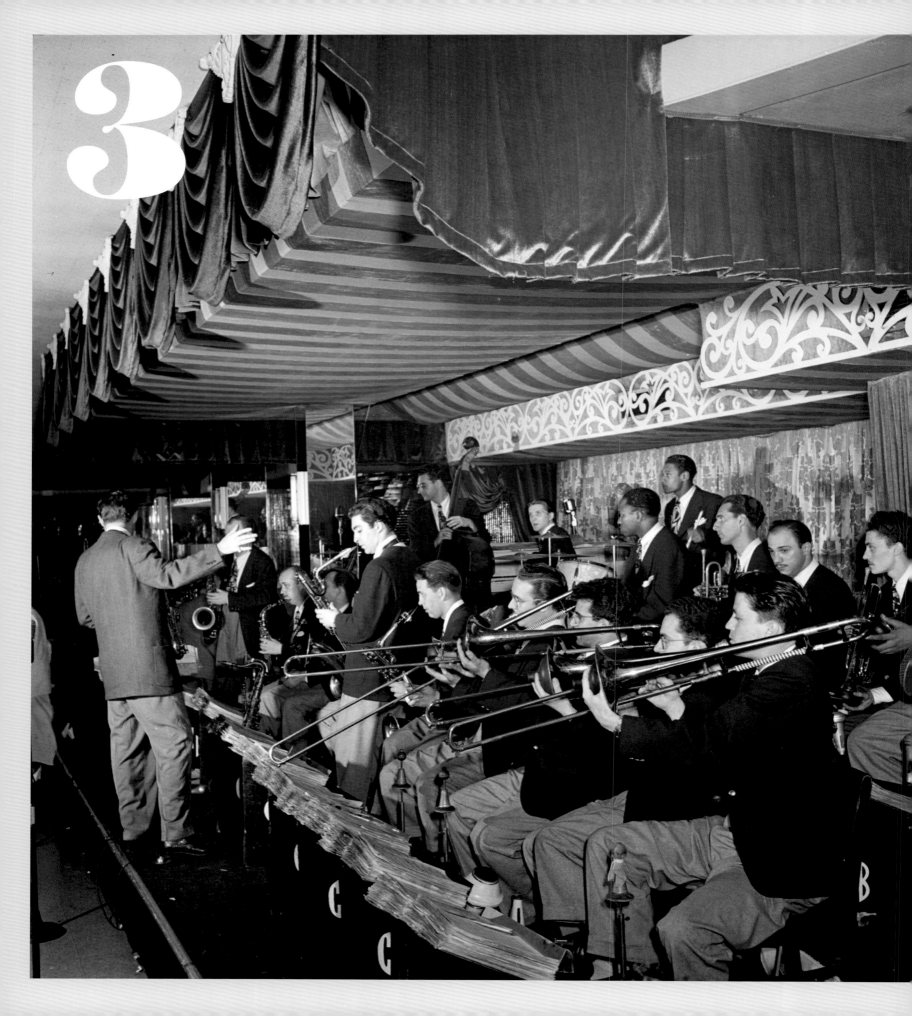

The Swing Era

"Jazz was synonymous
with popular music"

One major event formed the backdrop of the transition from the Jazz Age of the 1920s to the "swing era" of the 1930s. This was the Wall Street Crash of October 1929, which triggered the Great Depression. Across the United States in the years that followed, many lost their jobs and often whatever savings they had as well, and until Roosevelt's New Deal began to take effect in 1933–1934, unemployment hit a record high. The rest of the decade witnessed a seesaw of economic circumstances, during the ups and downs of which state-run job-creation projects were gradually replaced by genuine employment until, slowly, consumer confidence returned.

Prohibition, which had been in force since the start of January 1920, was repealed at the end of 1933, and as a population greatly in need of good cheer turned to jazz and popular music for entertainment, the dives and speakeasies of the 1920s gradually transformed into legal jazz clubs where live music was on offer and alcohol on sale. Meanwhile, theaters across the country presented the burgeoning big bands, either in full concert programs—often with several houses a day—or playing live music between the showings of the latest movies. (In Manhattan alone, seventeen theaters closed in the winter of 1929–1930 and were converted to movie houses, films being a far cheaper form of entertainment to provide than fully staged revues or plays.) The imagery associated with these big bands was predominantly upbeat, presenting them in smart apparel and well-lit stages, or even on the boardwalk at Atlantic City, projecting messages of escapism and hope.

The African American big bands of the late 1920s largely survived the Depression, among them Duke Ellington's orchestra, the Fletcher Henderson Orchestra, Louis Armstrong's Big Band, and the Detroit-based McKinney's Cotton Pickers. From February 1931, Cab Calloway's band (formed out of an earlier group known as the Missourians) joined this roster, taking Ellington's place at the Cotton Club in New York when Duke went on tour. The year 1930 saw the formation of Jimmie Lunceford's band in Memphis, Tennessee; he too came to New York to play at the Cotton Club in 1934, before his group became one of the most widely traveled bands in jazz, often playing strings of one-night engagements many miles apart from one another.

Just as Ellington and Henderson's bands projected suave sophistication, Lunceford had a distinctive image as well. His neatly uniformed band performed well-practiced moves onstage, the reed and brass sections swinging their instruments together as they played, his musicians stepping forward to take close harmony vocals. Overall, the orchestra presented a complete show. Though they were unkindly nicknamed "performing seals" by other acts, much of this very individual visual presentation is captured for posterity in photographs, posters, and paintings of the band.

Another band from the South that made a great impression was Erskine Hawkins's orchestra, from Birmingham, Alabama. Fronted by a flamboyant trumpeter who was known as the "Twentieth Century Gabriel," they were initially called the 'Bama State Collegians, and they recorded under that name before simply becoming Erskine Hawkins and His Orchestra in the late 1930s, when they arrived in New York as one of the major acts at the Savoy Ballroom. The group's big hit number was to be "Tuxedo Junction." In most pictorial material of the band, it is Hawkins, pointing his trumpet skyward, living up to his reputation as a latter-day Gabriel, who catches the eye.

In the long-term history of jazz, maybe the most influential swing band to hail from an area outside the East Coast was the Count Basie Orchestra, which started life in Kansas City, Missouri. Billed in some publicity as being led by the "Sepia Swing Sensation," the band had honed their skills playing long, jam-session style evenings in Kansas City's nightclubs, under the regime of politician Tom Pendergast, who turned a blind eye to Prohibition and had effectively turned the city into a personal fiefdom. Mary Lou Williams recalled, "The night spots were run by politicians and hoodlums, and the town was wide open for drinking, gambling and pretty much every form of vice." This was the ideal setting in which a jazz band could flourish.

Heading for New York, Basie's men stopped off in Chicago, where their brand of blues-inflected Midwestern swing did not go down well at the Grand Terrace, at which most bands played complex arrangements for the floor show. Their journey almost ended in disaster. "It was not the kind of show they thought they were coming there to play for, and they just didn't want to do it," Basie said of his musicians. However, once they arrived in New York—with a Decca recording contract and the support of entrepreneur John Hammond—they became hugely popular. With tenor saxophonist Lester Young holding his sax out at a horizontal angle; the trumpet rivalry between Buck Clayton and Harry Edison; the cohesive rhythm of the implacable Basie, guitarist Freddie Green, bassist Walter Page, and drummer Jo Jones; plus the vocals of "Mr. Five by Five" Jimmy Rushing, there was plenty for photographers and artists to home in on.

White big bands were also crucial to the growth in popularity of swing. In most cases, these groups followed on musically from the innovations of the black orchestras and their arrangers, who in turn had absorbed the initial ideas of Paul Whiteman and Ferdé Grofé. As the Depression took hold, a number of key white players were in New York. At the recently opened Park Central Hotel on Seventh Avenue, Ben Pollack's band was resident (drawing crowds despite the hotel having achieved a certain instant notoriety owing to the murder there of gangster Arnold Rothstein in 1928). Pollack's Park Central Orchestra contained a galaxy of future swing musicians, including at various times the bandleaders-to-be Benny Goodman, Jack Teagarden, and Glenn Miller, plus such fine sidemen as drummer Ray Bauduc and saxophonists Eddie Miller, Matty Matlock, and Gil Rodin. All of these players freelanced extensively, and their copious

The Swing Era

PREVIOUS SPREAD: The Charlie Barnet Orchestra at the Aquarium restaurant in New York in the latter years of the swing era. Barnet was one of the first swing bandleaders to front a racially integrated group (from 1935), and here we see African Americans, trumpeter Al Killian and drummer George Jenkins, taking center stage. Barnet's long-term baritone saxophonist Bob Dawes is about to take a solo.

BOTTOM: The 1938 Count Basie orchestra squeezed into the Famous Door, decorated with a collage of posters, at 66 West 52nd Street (known as "Swing Street" because a host of similar jazz clubs opened there, following the repeal of Prohibition). Here, Basie's famous rhythm section with Walter Page, Freddie Green, and Jo Jones accompany trumpet soloist Buck Clayton.

TOP: Maybe, as well as billing Basie as the Sepia Swing Sensation, the designers of this poster thought they would grab the public's attention by using no fewer than five different fonts, from the three-dimensional blocks of Count's name to the outlined name of the venue!

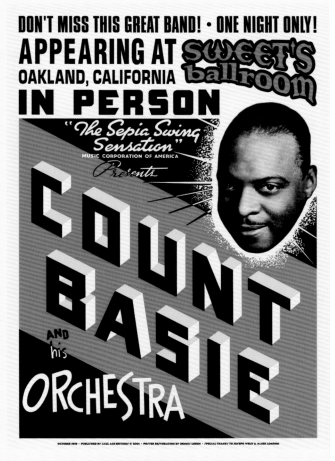

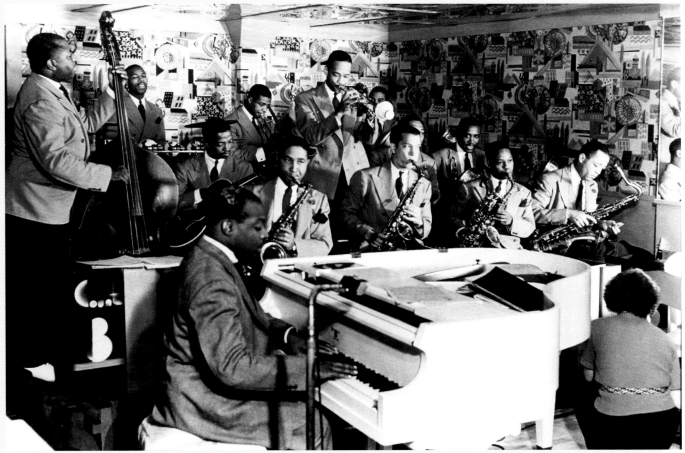

recordings moved jazz on from 1920s Dixieland to the more riff-based swing style. Before and after the Wall Street Crash, Paul Whiteman's band was broadcast regularly on the *Old Gold Hour*, launched in February 1929, with the rather optimistic slogan that there was nothing harmful in these cigarettes, and "not a cough in a carload"!

Compared to location airshots that eavesdropped on New York clubs and dance halls where African American nightclub acts from Duke Ellington and Cab Calloway to Teddy Hill and Fats Waller were networked to the nation, sponsored radio advertising like Whiteman's shows brought several other white bands to public attention. Whereas it took until 1937 before Louis Armstrong led the way for African American groups in sponsored shows, appearing weekly on *Fleischmann's Yeast Hour*, Glen Gray and the Casa Loma Orchestra had been advertising cigarettes on the *Camel Caravan* from December 1933—a role subsequently taken up by Benny Goodman's band in 1936, by which time Goodman was already well experienced in broadcasting. His band had begun playing on air several times a week from Billy Rose's Music Hall in New York on June 21, 1934, and his *Let's Dance* show became a major element in promoting the swing era. The trumpeter Red Nichols led a band sponsored by Kellogg's cereals on the *College Prom* radio show on the NBC Blue network from 1935. Tommy Dorsey, the "Sentimental Gentleman of Swing," started out advertising Raleigh and Kool cigarettes, before taking Goodman's place on *Camel Caravan* in the late 1930s. By June 1940, his radio show was advertising Pepsodent toothpaste. Until 1942, Glenn Miller's band played thrice weekly on the *Chesterfield Hour*, again advertising cigarettes. Shortly afterward, Woody Herman fronted a show sponsored by Wild Root hair products, and a song was added to his repertoire using the name of the grooming cream.

All this goes to show that white leaders of swing-era big bands had a level of advertising and media money behind them that was seldom available for African American bands. The disparity in visual representation between black and white groups in the 1930s and early 1940s is at least to some extent due to this financial backing. Musically, it is clear that most of the white bands were picking up on advances made earlier by African American players, a contrast nowhere better exemplified than in the radical overhaul of Tommy Dorsey's orchestra that occurred when he recruited the black arranger Sy Oliver in 1939. From a stilted band that had previously attempted orchestrated Dixieland, and was mainly successful at ballads, Oliver brought across his experience in writing for Jimmie Lunceford and completely transformed Dorsey's group into a hard-swinging outfit, capable (for a brief period) of rivaling the best African American bands. Many white bandleaders profited similarly from advances made by African American musicians, who more often than not struggled to achieve a comparable level of success.

Radio advertising brought with it plenty of visual imagery, and so too did the opportunity to endorse musical instruments. Gene Krupa, Ray McKinley, and Buddy Rich were posed at their most photogenic behind Slingerland drums. Tommy Dorsey posed with a King trombone, while Harry James was caricatured with his favored Selmer trumpet. Les Brown, leader of the "Band of Renown," posed with a Conn clarinet, and Woody Herman went a shade more specialist by endorsing Otto Link woodwind mouthpieces. Bob Crosby (Bing's bandleader brother) dressed as Santa Claus to advertise chocolates, and Benny Goodman toasted his tuxedo-clad friends with Haig whisky. Such commercial endorsement was not exclusively confined to white players, and Roy Eldridge, for example, championed Couesnon trumpets. Later, players such as Wes Montgomery were featured by Gibson guitars.

This period of the 1930s and early 1940s subsequently provided an unexpected visual bonus in the form of a wave of quasi-biographical movies, starting with *The Fabulous Dorseys* in 1947, which charted the tempestuous relationship between Tommy and Jimmy Dorsey, who played themselves, with a famous guest appearance by pianist Art Tatum. James Stewart starred alongside June Allyson in *The Glenn Miller Story* in 1954, with both Louis Armstrong and Gene Krupa making cameo appearances. In 1956, Benny Goodman played himself on the musical soundtrack of *The Benny Goodman Story*, but his role onscreen was taken by the television host and erstwhile composer Steve Allen, who looked slightly incongruous, miming alongside Gene Krupa, Teddy Wilson, and Lionel Hampton in the Goodman quartet.

Small groups like these were the other side of the swing-era story, and the bands that played in Harlem or downtown in the small clubs of New York's 52nd Street were hugely important. Bassist Ray Brown recalled just how extraordinary this street was. He told me, "I came round the corner and there were all these clubs, sitting right there, one after another, and the signs outside said, 'Art Tatum, Billie Holiday, Coleman Hawkins, Don Byas, Slam Stewart, Stuff Smith.' And I say to myself, 'Wow! This is it!'" The small swing bands featuring these and other stars—including Fats Waller's Rhythm, Louis Prima, the Spirits of Rhythm String Band, and John Kirby's Sextet—all contributed to the rich visual imagery of small-group swing at its height.

"Above all their music provided an alluring escape from the often depressing real world—into that other romantic world of dancing feet, twirling bodies and tapping toes."

Gunther Schuller, *The Swing Era* (Oxford University Press, 1989)

BELOW LEFT: The Lunceford band appeared at the Lido Casino in Larchmont, New York, in June 1937, after a trip to Europe. This engagement was significant in that the band broadcast from the venue twice weekly over the NBC network. The poster lists all the orchestra's stars, including Sy Oliver, who would soon jump ship to Tommy Dorsey.

TOP RIGHT: In this record sleeve image, trumpeter Erskine Hawkins is more restrained than in some of the 1930s photos of him playing one-handed and pointing his trumpet skyward. As well as "Tuxedo Junction," his big hit, the disc includes the band's other great success, the slow boogie-woogie "After Hours" featuring pianist Avery Parrish.

BOTTOM RIGHT: "Angry" was first published in 1925, but by then the Coon Sanders Night Hawks had already established themselves (from 1922) as the first band in jazz to broadcast nationally, from their base in Kansas City. Western Union installed a ticker tape on the bandstand in order to take live requests during their shows.

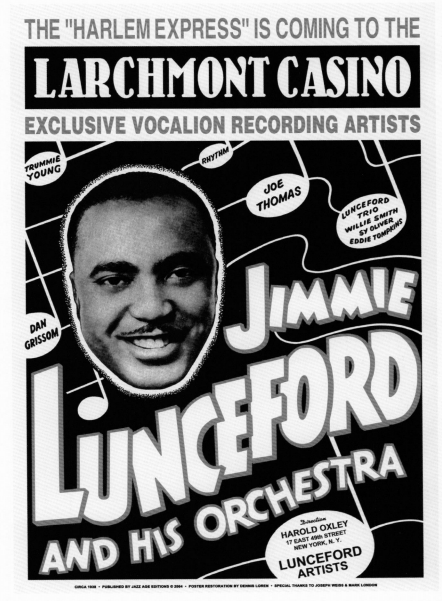

BELOW LEFT: Of all the biopics, *The Glenn Miller Story* was one of the most evocative, not only portraying the wartime era (covered in the next chapter) but with contributions from Miller's real-life swing-era colleagues, including drummer Ben Pollack, plus a cameo from Louis Armstrong.

TOP RIGHT: Sal Mineo, who portrayed Krupa in 1959, was not a drummer, but he had a brief career as a pop singer after winning an Oscar nomination in 1955 for his role as Plato Crawford opposite James Dean in *Rebel Without a Cause*. The film includes sequences with the Benny Goodman and Tommy Dorsey Orchestras.

BOTTOM RIGHT: Musically the best of the biopics, with Benny Goodman playing himself on the soundtrack, this film included a first-rate musical score. With colleagues Ziggy Elman, Harry James, and Gene Krupa complemented on the soundtrack by African American players such as Buck Clayton, the music made up for Steve Allen's shortcomings as an actor.

RIGHT: Oscar Micheaux was the first significant African American filmmaker. He shot movies in Harlem and depicted black life in most of his pictures. *Swing*, from 1938, follows the heroine, Mandy Jenkins (played by Cora Smith), from Birmingham, Alabama, to her nightclub and Broadway successes in New York.

TOP LEFT: Louie Bellson first conceived of the double bass-drum kit idea in his teens and was encouraged to use it after joining Tommy Dorsey in 1947. Initially, the Gretsch drum company made his bespoke kit, but then Rogers took over, and his final Rogers kit had gold fittings. It was given to Sammy Davis Jr. and still survives.

BOTTOM LEFT: The Radio King model was Slingerland's contribution to the swing era, manufactured from 1936. The snare drum involved a revolutionary design using a maple wood shell and became a mainstay of the jazz scene after being adopted by such stars as Gene Krupa.

TOP RIGHT: Ludwig was the biggest drum manufacturer in the world during the 1920s, until the firm was taken over at the end of the decade by Conn (which predominantly made wind instruments). Here, Buddy Rich—who had initially used Ludwig drums as a child star in the 1920s—is endorsing the brand in a blatantly sexist ad.

BOTTOM RIGHT: Swing trumpeter Roy Eldridge was initially associated with Martin trumpets, particularly the "Committee" model from the late 1930s. On traveling to Paris after World War II, he endorsed the French Couesnon model, and handwritten comments on similar photos to this say, "At last I found a trumpet that has everything one would want."

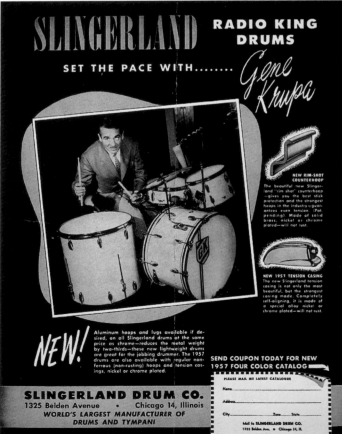

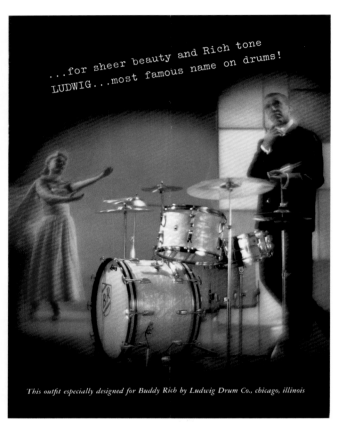

The Art of Jazz

TOP LEFT: Bandleader Tommy Dorsey's radio career followed on from taking over comedian Jack Pearl's show sponsored by Raleigh/Kool cigarettes. By the mid-1940s, after his band had fronted several other commercial campaigns, he was (as seen here) recording a weekly disc-jockey show, which was nationally syndicated.

BOTTOM LEFT: Saxophonist Jimmy Dorsey (left) and his trombonist brother Tommy (right) co-led a studio band from 1928, which began recording for Okeh. They worked for numerous other budget labels, and then signed a major-label deal with Decca in 1934. This lasted until they fell out the following year, although they were sporadically reunited in the 1940s and 1950s.

BELOW RIGHT: This 1927 painting known as *Jazz*, by the Czech-American artist Jan Matulka, harks back to when the word "jazz" often referred just to the drum kit. This painting marks the point when disparate elements came together to form the swing-era "trap set" seen in the advertisements opposite with bass drum pedal, temple bells, woodblock, and cymbals.

The two clarinetists who became household names during the swing era had remarkably similar backgrounds. Arthur Arshawsky was born on May 23, 1910, to Jewish immigrant parents, Russian-born Harold and Austrian-born Sarah, who worked in the garment business on New York's Lower East Side. The family then moved to New Haven, Connecticut, where young Arthur encountered anti-Jewish prejudice but persevered at learning the saxophone, followed by the clarinet. After dropping out of high school at fifteen, he went on the road. He learned to arrange and to play the clarinet flawlessly, with extraordinary control and range. Adopting the name Artie Shaw, he left behind his poor background, and, in a dance orchestra in Cleveland, Ohio, worked ceaselessly with the future big-band arranger Claude Thornhill on developing his musical facility. After working in a radio band, honing his jazz abilities in a Harlem nightclub with pianist Willie "The Lion" Smith, and then spending a period living on a farm trying to be a writer, Shaw launched his career as a bandleader in 1936, helped by matinee-idol good looks and his formidable clarinet technique.

Meanwhile, Benjamin David Goodman, born on May 30, 1909, had been growing up in what was then known as the "Maxwell Street Ghetto," a predominantly Jewish neighborhood in Chicago. Benny was the ninth of Warsaw-born David Goodman and Lithuanian-born Dora Rezinsky's twelve children. Like Harold Arshawsky, David Goodman was a tailor, working in the sweatshops that supplied the garment trade. The Goodman family moved from tenement to tenement as their financial circumstances fluctuated. When Benny was ten, David enrolled him, along with his slightly older brothers Freddy and Harry, in the Kehelah Jacob Synagogue band, where they got free instruments and free lessons (augmented in the Goodmans' case by paid private lessons during the week). When the synagogue lessons ended, the boys moved to the Hull House Settlement and continued in its band. From there, Goodman had lessons with Franz Schoepp, a well-known classical teacher who gave him the foundations of his exceptional technique, and instilled in the boy an assiduous practice regime. He also introduced him to the great African American clarinetists Jimmie Noone and Buster Bailey, who both came to Schoepp for lessons. At thirteen, Goodman (still in short pants) was jamming with the traditional jazz players known as the Austin High School Gang, and that same year he joined the American Federation of Musicians (AFM) and began playing professionally in Chicago. He left school at fourteen and became a full-time clarinetist. He came to New York with Ben Pollack's band, freelanced extensively from 1929 (including making his first records), and in 1934 he launched his own band.

The parallels in these two careers are interesting, in that from the moment they became successful bandleaders, Shaw and Goodman effectively erased their past. The ways they were presented in photographs, posters, and advertisements reveal nothing of their backgrounds. Goodman was seen in white tie and tails, or the traditional black evening attire of a classical conductor or soloist. When he later commissioned classical works from Bartok, Copland, and Malcolm Arnold, he had already seen to it that he was pictured in classical settings, such as William Gottlieb's famous photograph of him with the conductor Leonard Bernstein. Goodman pioneered interracial groups (as Shaw was also to do), but for the American record market, aiming at both white and black customers, the covers by Alex Steinweiss, a pioneer of album design (albums, as the name suggests, then being collections of 78 rpm singles), simply showed the instruments involved and not the participants. Later designs by the prolific Jim Flora include caricatures of the band that are racially neutral. Significantly, posters and sheet music made much of Goodman's unofficial title as "King of Swing." It was a remarkable attainment for a poor boy from one of Chicago's poorest areas.

Shaw's rise to fame was equally exceptional, helped by his 1938 hit record of "Begin the Beguine." As mentioned, it is notable that both he and Goodman—having grown up in a minority community themselves, and having firsthand experience of prejudice in the United States—were among the first white bandleaders to bring African American musicians into their bands. Goodman featured vibraphonist Lionel Hampton and pianist Teddy Wilson in his small groups, whereas Shaw featured singer Billie Holiday and trumpeters Hot Lips Page and Roy Eldridge in his big band.

Shaw was also in the news often thanks to his string of marriages, garnering most press coverage for his third and fifth wives, the film stars Lana Turner and Ava Gardner. Portraits of Shaw showed him in smart suits and tuxedos, frequently posing with his clarinet, but maybe the most telling image is David Stone Martin's 1955 design for Shaw's small group, the Gramercy Five, which shows a pierced heart, a woman in scanty attire apparently leaving, and the clarinet as the central focus. It is in many ways a metaphor for Shaw's life, and it would certainly have been seen as such by the public. Similarly, Alex Steinweiss's design for the 1956 LP *Artie Shaw with Strings* places the instrument center stage, in a linear design that presages Bridget Riley.

Benny Goodman ("King of Swing") versus Artie Shaw

"We listened to Artie Shaw instead of Benny Goodman. Goodman swung but Shaw was more modern."

Trumpeter Benny Harris interviewed in *Metronome*, 1961

BOTTOM LEFT: **In 1947, William Gottlieb photographed this classical rehearsal at Carnegie Hall with Benny Goodman and an orchestra conducted by Leonard Bernstein. They would work together on future occasions, notably when Goodman recorded Bernstein's "Prelude, Fugue, and Riffs" (originally written for Woody Herman) in 1955.**

TOP RIGHT: **Gottlieb also photographed Artie Shaw in 1946. This image conveys the message that Shaw has escaped his background. His splendid attire of suit, handmade shirt, and tie deliberately evokes but also contrasts with his upbringing by poor parents in the garment business. It also showed his public that he was affluent and successful at a time when postwar inflation saw garment prices rise dramatically.**

BOTTOM RIGHT: **When this fourth volume of music by Shaw's small group, the Gramercy Five, appeared in 1955, he was on the seventh of eight marriages, by which time his colorful personal life was more famous even than his jazz playing. David Stone Martin's cover (one of a series for Clef) subtly suggests Shaw's true love was the clarinet.**

BOTTOM LEFT: **Benny Goodman** pioneered leading interracial groups and performing with them onstage rather than confining their activities to the recording studio. Seen here with Lionel Hampton (vibes), who was in his original mixed-race trio and quartet, this version of his sextet also included the short-lived guitar genius Charlie Christian, who died in 1942.

TOP RIGHT: **Jim Flora's 1950s** cartoon cover (one of two of his designs used) for a compilation of Goodman's hits, dating back to 1938, deracializes the group by using caricatures. This targeted sales to white audiences in areas of the United States where (prior to 1960s civil-rights legislation) integrated groups were not encouraged.

BOTTOM RIGHT: **The sleeve for** this 1956 album by Shaw and strings was by Alex Steinweiss, a major pioneer of record-cover design. He focuses on Shaw's hands in a graphic that prefigures by over four years the "op art" pioneered by the British painter Bridget Riley from 1961, in which geometric patterns are used to produce a sense of movement and focus.

THIS IS BENNY
GOODMAN
and his orchestra

SWINGTIME IN THE ROCKIES
SUGARFOOT STOMP
CHANGES
BIG JOHN SPECIAL
CAMEL HOP
RIFFIN AT THE RITZ
WRAPPIN' IT UP
LIFE GOES TO A PARTY

artie shaw

LG 1006

Japanese Sandman
A Pretty Girl Is Like A Melody
Sugar Foot Stomp
Thou Swell
Sobbin' Blues
Copenhagen
My Blue Heaven
Sweet Lorraine

with strings

EPIC

RIGHT: **This book of sheet music features a 1930s portrait of Teddy Wilson taken while he was a star of Benny Goodman's integrated quartet and leader of dozens of record sessions with Billie Holiday. By the 1950s, Wilson was running a piano school in New York City. This anthology brings his improvisational treatment to thirteen songs of the time.**

BELOW LEFT: **Martha Tilton was one of a series of high-profile female vocalists who sang with the Benny Goodman band. She was with him from 1937 to 1939 and appears on his hit record of "And the Angels Sing." This 1947 publicity shot from CBS promoted her guest appearance on singer Dick Haymes's radio show.**

BELOW RIGHT: **Other female singers with Goodman included Helen Forrest and (later) Helen Ward, but his most famous vocalist was Peggy Lee, who joined in 1941 for two years. They had a million-selling hit together with "Why Don't You Do Right?" She left the band in 1943 but was reunited with Goodman on record in 1957.**

The Art of Jazz

TOP: **Ella Fitzgerald** came to fame as the singer with drummer **Chick Webb's** orchestra, and she is seen here performing with them at Asbury Park Casino, New Jersey, in 1938. She had a major success that same year with "A-Tisket, A-Tasket," and went on to take over the band when Webb died in June 1939, becoming one of jazz's first high-profile female bandleaders.

BOTTOM: **Sister Rosetta Tharpe** recorded with **Lucky Millinder** and toured with **Cab Calloway**, as well as making gospel records with boogie-woogie legend **Sammy Price**. After focusing more on gospel work, her jazz career was revived in Britain with **Chris Barber's** band in 1957, following which she starred on the blues circuit, touring with **Muddy Waters** and **Cousin Joe**.

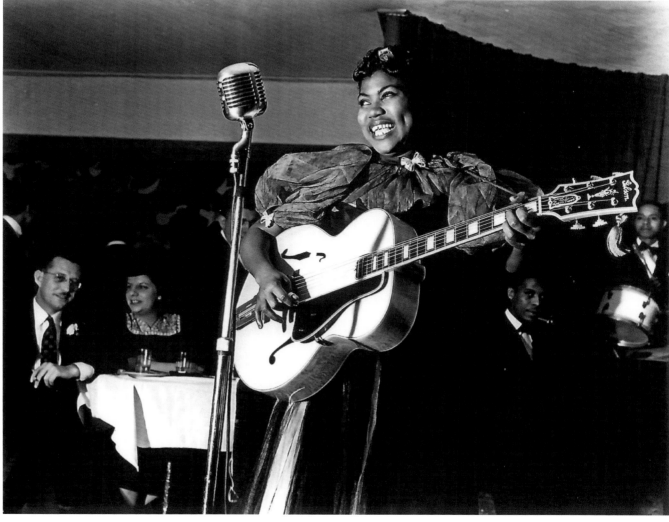

Following World War I, European musicians began to play jazz alongside or in imitation of visiting Americans. It would take time for truly individual jazz voices to emerge among these European musicians, but undoubtedly the principal and most original soloist to appear in the interwar period was the Manouche guitarist Django Reinhardt. The Manouche were one of the subsections of the early twentieth-century European gypsy community, and there were musicians to be found in similar groupings known as Romani (or Roma), *gitanes* (or *tsiganes*), and *gadjos* (the latter living outside the Romani culture but with close connections to it). However the guitar tradition was most developed—and remains so in the twenty-first century—among the Manouche.

Born on the Belgian-French border in 1910, Reinhardt later lived in an encampment outside Paris. He was a promising guitarist as a teenager, but in 1928 he was badly burned in a caravan fire. As a result, with two fingers of his left hand almost unusable, he adapted his guitar technique, and by the early 1930s, through assiduous practice, he had—despite the handicap—become a virtuoso player. Gradually recognized in Paris for his talent, Django was encouraged to record by Pierre Nourry, the secretary of a jazz enthusiasts' society called the Hot Club of France. The group would also have two rhythm guitarists and a bass, plus the violinist Stéphane Grappelli.

Nourry had trouble persuading a record company to sign the band. He thought he had a deal with the Odéon firm, only for it to reject the quintet's first test discs as "too modern." Eventually, in December 1934, the Ultraphone company accepted the group through the encouragement of critic, writer, and painter Charles Delauney, who—after stumping up a hundred sous for enough fuel to get the impoverished bassist's ancient van and its load of players and instruments to the record date—recalled, "On a foggy morning the musicians wended their way into the enormous ill-lit hangar on the Avenue du Maine that served as a studio." And the Quintet of the Hot Club of France was born.

Partly because of a lineup of musicians that was unusual in jazz, and partly because of the visual symmetry of a band with three guitars—yet also the need to emphasize Stéphane and Django, the principal soloists—the group's image was established early, and persisted during the five years up to World War II. Django would sit centrally to the front, Stéphane standing to the left as we view the photographs, the two rhythm guitarists (usually including Django's brother, Joseph) seated behind Django and slightly to the right, with the bassist Louis Vola at the rear of the configuration. This was not just a question of still photography, because when the British impresario Lew Grade brought them to London for their first UK concerts in 1938, he produced a short promotional film *Le Jazz Hot*. This follows the band from a cigarette-smoke-filled dressing room to a darkened stage on which the musicians, in just this setup, are picked out by spotlights as they play "J'Attendrai."

Throughout his short life, Django cut a romantic figure, and the combination of his gypsy background and wayward personality was an inspiration to artists, including the filmmaker Jean Cocteau, who provided a cartoon of Django for the 1937 *Hot Club* brochure, describing him as "a son of the air." Django's image was also at the center of advertising campaigns for Swing Records, set up by Charles Delauney with fellow critic Hugues Panassié in 1937, and for Selmer guitars, who made the distinctive steel-string acoustic instrument (designed by Mario Maccaferri) that Django played.

The quintet was in Britain when World War II began in September 1939. Stéphane stayed in London, but Django fled home to France (taking with him a new car that had just been bought for him by Lew Grade, on the basis it would be paid for out of Django's British earnings!) Amazingly for a man of his heritage, Django survived in Nazi-occupied France, and his celebrity increased. He replaced Stéphane with a clarinetist and swapped one of the backing guitars for drums. This group was quite regularly photographed during the war, and the pictures were used to create the musical imagery in Etienne Comar's 2017 biographical film *Django*, which lovingly recreates these wartime scenes in its fastidious production design. This was also a period when Django was drawn or painted by his colleagues, including Delauney and guitarist and sometime quintet member Roger Chaput. Django also took up art himself, and, when not working, relaxed by painting in oils or fishing.

When France was liberated, Django was a welcome guest of the US Air Transport Command Band, and in 1946 he traveled to North America to play with Duke Ellington. Both of these associations produced some fine photographs, as did his final years in Paris, where, prior to his death in 1953, he adopted the electric guitar and worked with the pianist Martial Solal and vibraphonist Fats Sadi.

Django Reinhardt and the Quintet of the Hot Club of France

"Django adopted American jazz. He assimilated the blue notes, smears, microtonalities, New Orleans accents and universal emotions. And then he played his own version at once enriched and unique and new."

Michael Dregni, *Django Reinhardt and the Illustrated History of Gypsy Jazz* (Fulcrum, 2006)

TOP RIGHT: **This 1970 issue of a collection of Django Reinhardt and Stéphane Grappelli's recordings with the Quintet of the Hot Club of France features a pen-and-wash illustration by Dave Dragon, then in the Decca design department, whose subsequent cover artwork ranges from Jimmy Cliff's** *Struggling Man* **to the Albion Band's** *Prospect Before Us.*

BOTTOM: **The Quintet of the Hot Club of France in action at the Casanova Club in Paris in 1937, lined up as described in the text. Left to right: Stéphane Grappelli (violin); Eugene Vees, Django Reinhardt, and Joseph Reinhardt (guitars); plus Louis Vola (bass).**

SWING '35-'39
The Quintet
of the Hot Club of France

BOTTOM LEFT: **This poster shows French actor Reda Kateb as Django Reinhardt in Etienne Comar's movie about the guitarist's wartime career. In scenes such as the one shown here, Reinhardt is accompanied by his later band, with clarinet in place of violin and usually with drums added to the rhythm section.**

TOP RIGHT: **One feature of the *Django* movie that worked brilliantly was the music, with Reda Kateb miming to a soundtrack by the dazzling Stochelo Rosenberg. Here Kateb (with Rosenberg off camera) is jamming with a real-life Manouche guitarist from Alsace, Hono Winterstein, in a gypsy camp that is about to be rounded up by the Germans.**

BOTTOM RIGHT: **The art of the film imitated real life, as in this photograph from earlier years in which Django's brother Joseph is playing guitar, with gypsy wagons and children in the background. Comar's production designer paid assiduous attention to detail in similar reconstructed scenes where music is being played.**

The Art of Jazz

RIGHT: **A poster for the biggest star on the French Swing label, founded by Charles Delauney and Hugues Panassié in 1937. Not only did the company issue many of the Quintet of the Hot Club of France's recordings, but it also teamed Django with American visitors to France, including trumpeter Bill Coleman and saxophonists Coleman Hawkins and Benny Carter.**

So far we have focused on how jazz musicians or more abstract notions of the music itself have been portrayed in the visual arts. But several of the generation of players who graduated from traditional jazz to swing were accomplished visual artists in their own right. The catalyst was the drummer George Wettling, who was a friend and student of the painter Stuart Davis. After his early days, mentioned in the previous chapter, portraying African American social issues, Davis had moved on to what the *New York Times* described as "a whole new universe of jazzy patterns and blazing colors, a landscape defined not by signs but by sensations: sound, rhythm, friction." It was this visual world, fully explored by Davis from the late 1930s through his teaching at the New York School for Social Research, that inspired Wettling.

One of the most hard-swinging and energetic of all jazz drummers, Wettling's rhythmic energy explodes on his canvases. Aside from Davis, the other obvious influence in Wettling's use of line and semiabstract figures is the Spanish painter Joan Miró. "George's technique was quite sophisticated," writes his musical colleague Bob Wilber, who organized a posthumous presentation of Wettling's paintings, with music, at Wilkes College in Wilkes-Barre, Pennsylvania, in 1986. Also included in that exhibition in the college's Sordoni Art Gallery was work by two of Wettling's jazz contemporaries, the clarinetist Pee Wee Russell and the bassist and composer Bob Haggart.

Russell had known Wettling's circle of painter friends since the 1930s, hanging out with Davis, Jackson Pollock, and Willem de Kooning, but had never shown the slightest interest in making art himself. Then, in 1965, despite having won the Downbeat critics' poll as clarinetist of the year, Russell had few gigs, and he spent increasing periods of time at home, slumped in front of the television. His wife, Mary, exasperated at his inertia, bought him a set of paints. "Now paint!" she instructed, and he did.

Although never a forthcoming interviewee about music, Russell did occasionally talk about his artwork. He wanted to express rhythm, and he used bright colors in a similar way to Davis and Wettling. Painting with his canvases flat on his lap as he sat in an easy chair, he thought hard about design. "If attention is drawn to the middle of a painting, then I put something else in the middle or the corner to divert the eye," he said. "I put in a bright red, maybe, or a yellow, to immediately spread the viewer's vision."

By contrast, although Bob Haggart mixed in the same musical milieu, and had composed jazz standards such as "South Rampart Street Parade" and the bittersweet ballad "What's New?," he was not a modernist painter. His representational landscapes of Brooklyn Bridge and other city views, and his painstaking still lifes—which show considerable technical skill in his handling of reflections on polished surfaces and in mirrors—were crowned by his paintings of musicians at work, including a late self-portrait, showing a concert by the World's Greatest Jazz Band (which he co-led), with fellow musicians Bob Wilber, Maxine Sullivan, Ralph Sutton, and Gus Johnson clearly in view, accurately and recognizably depicted.

Swing-era Jazz Musicians Who Also Painted

"A prospective customer once asked Pee Wee why his paintings were so expensive. Pee Wee replied, 'Well, you know, they're all handmade.'"

Bill Crow, *Jazz Anecdotes, Second Time Around*
(Oxford University Press, 2005)

The Art of Jazz

TOP LEFT: **William Gottlieb's portrait of George Wettling** shows him in his habitual neat attire, but instead of sitting at the drums he is shown against the backdrop of one of his paintings.

TOP RIGHT: **Pee Wee Russell at the time he took up art.** Although he was a lifelong traditional jazz player, in 1966, the year after he began painting, Russell made a dramatic modernist recording with trumpeter Henry Red Allen. On their *College Concert* (recorded at MIT in Cambridge, Massachusetts), they interpreted tunes by Thelonious Monk and John Lewis.

BOTTOM: **A typical artwork by George Wettling,** with obvious affinities to the work of his friend Stuart Davis. This 1948 painting, *Cool*, hints at a face and also a bandstand. The "Baldwin" reference is to the piano firm, and there's also a visual clue to Wettling's fondness for a tot of whiskey: a bottle from the Minneapolis Panther distillery.

World War II
"Jazz epitomized a spirit of rebellion"

In the years leading up to the Pearl Harbor attacks, swing music continued to develop. In particular, Duke Ellington attained a new creative peak, notably the dazzling tenor saxophone playing of Ben Webster and the band's rhythm section innovations underpinned by the bassist Jimmie Blanton. It would not be until the 1956 Newport Jazz Festival that Ellington achieved a comparable mixture of national fame and artistic perfection to match the so-called "Blanton-Webster" band of 1939–1941. Other African American bands were also in the forefront of development, notably Earl Hines's Chicago-based orchestra, which achieved hit records with vocalist Billy Eckstine and also laid the foundation for Hines's more modernistic 1942–1943 group, which included Dizzy Gillespie, Charlie Parker, and Sarah Vaughan.

Once the United States entered the war, the draft affected most big bands, and there were constant fluctuations of personnel. It was not unusual for musicians serving in the armed forces to return and sit in with their former colleagues when the opportunity arose.

From 1939 until 1942, the most commercially successful of the white swing bands was Glenn Miller's. A trombonist who had worked his way through New York's freelance scene in the 1930s with Ben Pollack, Red Nichols, and the Dorsey Brothers, among others, Miller launched his own band in 1937. Initially, it was not a success, but after regrouping in 1938, Miller capitalized on both regular radio play and appearances at some of the country's leading venues to create a national reputation. His aforementioned *Chesterfield Hour* show ran on the national CBS network from December 27, 1939. "Three times a week," said the press ads, "because fans everywhere said 'Give Us More Miller!'" He had previously broadcast from both the Glen Island Casino on Long Island Sound, just south of New Rochelle, New York, and from the Meadowbrook Inn in New Jersey—venues that allowed the band members to remain living in New York, but which created far wider regional exposure via the national radio networks.

The *Chesterfield* shows, backed by press advertisements and billboards showing Miller and his trombone alongside "Milder / Cooler" cigarette packs, quickly moved him from radio personality to household name. This shift was helped by the strict discipline of his band, which played on an impressive number of records with brisk precision. He also conjured up an air of fun and "jazz atmosphere" on his broadcasts, with carefully timed shouts of enthusiasm from his musicians—for example, greeting the tenor saxophone solos of Tex Beneke, as can be heard on the opening "Little Brown Jug" from their very first *Chesterfield* broadcast. Playing songs that name-checked local communities, with mentions of places like Kalamazoo, Chattanooga, Boulder, and "Dreamsville"—the nickname for the towns of Dennison and Uhrichsville in Ohio—Miller sanitized the raw excitement of bands like Basie's and Ellington's and

produced a smooth, saccharine swing that appealed to white Middle America. His music was easy to dance to, and the melodies were never far away, even in the jazzier solos. This was the recipe for his appearances in the musical movies *Sun Valley Serenade* in 1941 and *Orchestra Wives* the following year.

Consequently, when Miller broke up his band in September 1942 and enlisted in the US Army—in short order being promoted to captain in the Army Air Force and given a service band to lead—he was able to capitalize on his popular appeal so that performing was seen as his patriotic duty. He reached out to entertain troops abroad and those on the home front as well. As one soldier said, he created "an avenue leading to the thing you want most of all, your home and all your loved ones and all that they stood, stand and will stand for." Miller had a marching band, a dance orchestra, and various other groups under his command, and even though the army's top brass were not convinced by his efforts to bring jazz rhythms to the parade ground, he undertook a relentless itinerary of concerts at military bases, rallies to raise money for war bonds (many of which were broadcast), and the making of "V-Discs." These were records aimed at the armed forces, which were allowed to be made despite the 1943–1945 AFM strike, which prevented members of the Musicians' Union from making commercial records.

Miller's contemporaries remember a man who was tall and commanding yet "bespectacled and scholarly looking." This image, enhanced by his captain's uniform and cap, found its way onto magazine covers, billboards, and sheet-music editions. Miller looked militaristic but unthreatening, and within a short time after its foundation, his USAAF band was being photographed in various military settings, from playing in aircraft hangars to improvised stages on sports fields. In his repertoire, alongside prewar hits and songs that deliberately conjured up images of home in small-town America ("Don't Sit Under the Apple Tree," for example), Miller now added wartime messages to the numbers the band played, notably their radio theme, "I Sustain the Wings," which built on the US Air Force's Latin motto *Sustineo Alas* and began with the words, "For the land that I love, I sustain the wings / In the sky above where they fight to victory."

Miller's USAAF band was one of the American swing orchestras that came to Europe to entertain the Allied troops, and in 1944 they played several hundred concerts in Britain. General James H. Doolittle, commanding officer of the Eighth Army Air Force, told Miller during one of the UK events that, "next to a letter from home, your organization is the greatest morale builder in the European Theater of Operations." The band also recorded extensively at HMV's Abbey Road Studios in London. Several of these recordings were used as propaganda and beamed to Germany via the clandestine American Broadcasting Station in Europe. In his introductions, Miller speaks hesitant phonetic German, while singers

World War II

PREVIOUS SPREAD: Chief Petty Officer Artie Shaw leading his "Rangers," the Band of the US Navy Liberation Forces, on board ship in the Pacific. He fronted this orchestra for eighteen months, playing up to four concerts a day for sailors and marines involved in frontline duties.

TOP LEFT: Saxophonist and arranger Don Redman fronted his own big band until 1940. This band, founded in 1931 and seen here playing a casino engagement, was typical of the swing-era groups that continued to entertain in the United States, well after the war in Europe had begun.

TOP RIGHT: Duke Ellington's "Blanton-Webster" band (1939–41) was one of his most creative. On pieces like "Jack the Bear," Blanton redefined the accuracy and precision of jazz bass playing, adding a dramatic sense of swing. Tenor saxophonist Webster, equally adept at ballads and up-tempo swing, sits centrally in front of Sonny Greer's drums.

BOTTOM: When the United States went to war after Pearl Harbor in 1941, recording sessions brought together musicians of different style, as in Sir Charles Thompson's September 1945 group. Here, beboppers Dexter Gordon (tenor) and Charlie Parker (alto) are with swing veterans, including Danny Barker (guitar) and Buck Clayton (trumpet—on a pass from his military service at Camp Kilmer, New Jersey).

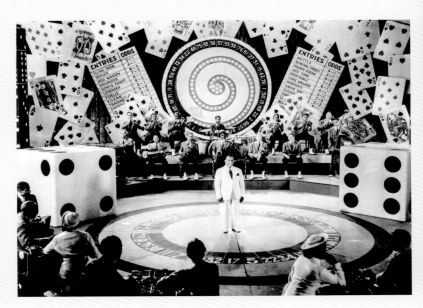

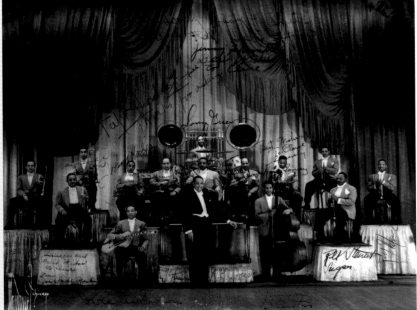

Johnny Desmond and Artie Malvin (the lead of the band's close harmony singers, the Crew Chiefs) do an admirable job of singing standard song lyrics in German translation. When Miller's plane disappeared over the English Channel in December 1944, his band was temporarily led by drummer Ray McKinley, one of the big stars of prewar swing, plus arranger Jerry Gray, who had worked on and off with Miller since leaving Artie Shaw in 1939.

Miller's disappearance and presumed death at the height of his popularity gave his band legendary status, but there were other equally important military bands during the war that harnessed the energy and commitment of jazz musicians to help boost morale. Because of his well-publicized personal life, Chief Petty Officer Artie Shaw's navy band, the Rangers, founded in 1942, attracted plenty of publicity. Unlike Miller, who was posted to Europe, Shaw was sent to the Pacific, where his band entertained the forces on the Japanese front. He was invalided out in late 1943, suffering from constant migraines, brought about, he said, by "any number of air raids." His trumpet star, Max Kaminsky, recalls in his memoir, "They sent us out by plane to play at camps near the fighting zone." He then gives a graphic description of playing to "thousands and thousands" of men on the *USS Saratoga*, a giant aircraft carrier, and talks of feeling the waves of homesickness flood out of the crowded audience as he played the "St. Louis Blues." "I blew like a madman," he writes. "Dave [Tough, the drummer,] started to swing the beat, and when I picked up my plunger mute and started to growl, those three thousand men went stark, raving, crazy." His most poignant reminiscence is of playing in military hospitals and watching the power of music bring broken men back to life.

There were other bandleaders who contributed equally to the war effort, including Claude Thornhill and the Canadian Robert Farnon, who went on to be one of the most celebrated arrangers and composers in popular music after the war. But unlike during World War I, when the Hellfighters of James Reese Europe played a significant part on the development of jazz, African American musicians had a far less prominent role in 1941–1945. The World War I black regiments had been prohibited from engaging in combat with the white enemy while under American command. General Pershing's solution was to amalgamate the black units under French command, and in due course Europe's men were collectively awarded the Croix de Guerre for their bravery. In World War II, Jim Crow was at large again, and the racist nature of the American forces prevented black musicians from making a morale-boosting contribution comparable to that of Miller or Shaw. Nonetheless, several bands for African Americans were set up by the US Navy, and at the Great Lakes Naval Station, not far from Chicago, such celebrated musicians as Ernie Royal, Clark Terry, Gerald Wilson, Willie Smith, Jerome Richardson, and

Buddy Collette were enrolled in these various groups. Collette (later one of the musicians who broke the color bar in the Hollywood studio orchestras) saw out the war in the Topflighters band at the St Mary's Pre-Flight School in Moraga, California. The other band at the same base was led by Count Basie's future alto saxophonist Marshal Royal, who later wrote, "We played performances for soldiers, sailors and marines in various towns where they'd have a place to go and dance." Yet it rankled with Royal that even though he was the bandleader, as a first class seaman (the highest permitted rank for an African American), he had to defer conducting duties to a white chief petty officer.

It was not just in the United States that the services promoted jazz and swing ensembles. In Britain, the Royal Air Force employed the swing saxophonist Buddy Featherstonehaugh to lead its Radio Rhythm Club Sextet, which included several big names in British prewar jazz. It also formed a big band known as the Squadronaires. This band included many of Britain's finest swing players, including the trumpeter Tommy McQuater and the trombonist George Chisholm. The war also created opportunities for two bands that benefited from the absence of many regular musicians who had been conscripted or joined up voluntarily. First, Ken "Snakehips" Johnson's West Indian Orchestra played at London's fashionable Café de Paris from late 1939. This twelve-piece group had recorded for Decca just before the war and then made discs for HMV in 1940. Their driving natural swing made them one of the most accomplished of British-based jazz groups, as is evident in a surviving broadcast from their London residency. Sadly, this was to come to a sudden, tragic end when the café suffered a direct hit from a German bomb on March 8, 1941, killing Johnson and thirty-three other members of the band and audience. For a brief period, however, Johnson and his Caribbean musicians had set the pace for big-band jazz in London, and many of the survivors went on to successful careers in British jazz.

The war also advanced the fortunes of Britain's best-known all-female band, Ivy Benson and her Ladies' Dance Orchestra (later known as her All Girl Band), which became one of the BBC's resident groups in 1942. They topped the bill at the London Palladium in 1944 several times, and were invited to play at the VE celebrations in Berlin. They also toured in Germany and the Middle East immediately after the war, entertaining for the Entertainments National Service Association (ENSA). Benson, however, had fought the war on two fronts. The first was the war against Germany, but the second, far tougher war was against her professional colleagues and the musical press in Britain, who complained loud and long that no woman should be allowed to prevail in the all-male preserve of jazz. She ultimately weathered what the *Melody Maker* (itself a long-term critic of her work) described as "a professional storm that would have frightened even the toughest men."

"Major Miller through excellent judgment and professional skill, conspicuously blended the abilities of the outstanding musicians comprising the group, into a harmonious orchestra whose noteworthy contribution to the morale of the armed forces has been little less than sensational."

Citation for Glenn Miller's posthumous award of the Bronze Star

BELOW LEFT: **Glenn Miller at the height of his fame, just before he joined the army in the fall of 1942. According to his biographer, Dennis M. Spragg, Miller was earning well over $750,000 a year as a civilian bandleader—an almost unimaginable fortune for the early 1940s, worth over $12 million today.**

TOP RIGHT: **Marshal Royal (Seaman, First Class) conducting the African American Pre-Flight School band, which he was allowed to do at its home navy base on the St. Mary's college campus at Moraga, California. But when the band played public concerts elsewhere, he had to make way for a white conductor.**

BOTTOM RIGHT: **An atmospheric shot of Major Glenn Miller directing his USAAF band at a concert for the armed forces in the United Kingdom in 1944—one of more than three hundred performances given that year to raise morale among Allied troops.**

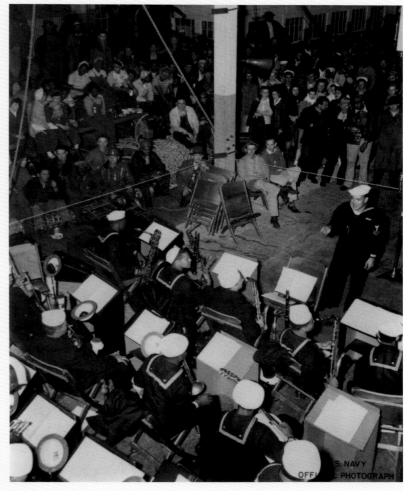

Glenn Miller

VICTOR'S TOP-RANKING ARRANGER-MUSICIAN

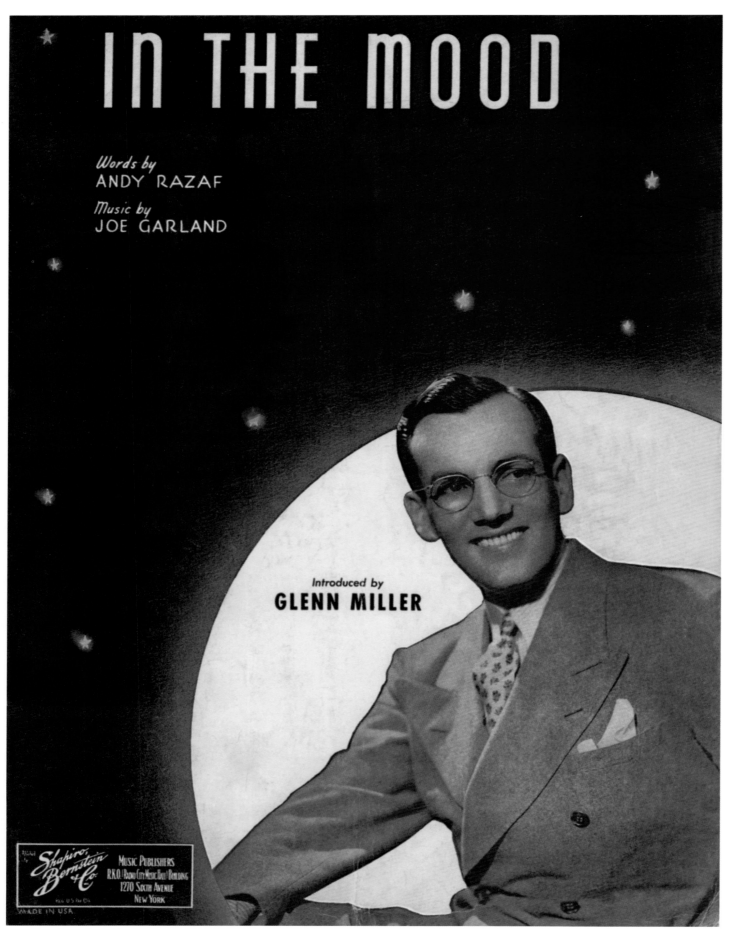

OPPOSITE: **The sheet music for one of Glenn Miller's biggest prewar hits and a staple of his USAAF band's repertoire. The melody has a cloudy history, and even before Joe Garland copyrighted it, the riff had appeared in New Orleans trumpeter Wingy Manone's 1930 record "Tar Paper Stomp."**

BELOW LEFT: **The program for events at a London services club, which included one of Glenn Miller's British concerts, sponsored by the aviation company AVRO—makers of the Lancaster heavy bomber. The planes' success against the German battleship Tirpitz was deemed to be as morale-boosting as Miller's music.**

TOP RIGHT: **Music featuring bandleader Ivy Benson, whose all-girl orchestra was one of the BBC's resident bands in the war years, despite sexist opposition from male musicians and trade unions. She was similarly barred from appearing in early TV broadcasts owing to her contract with a theater company who thought the new medium would be "detrimental" to live audiences.**

BOTTOM RIGHT: **Drummer Ray McKinley (who took over Glenn Miller's band) at New York's Commodore Hotel in 1946. This double-exposure shot by William Gottlieb parallels further experimental jazz photography of the time, including work by Gjon Mili, who pioneered stop-action strobe lighting for similar shots.**

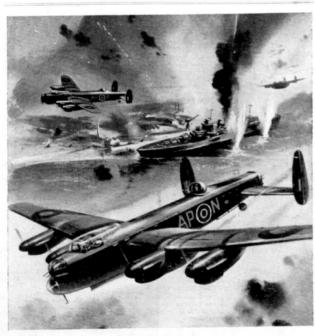

BELOW LEFT: The future Chief Petty Officer Artie Shaw achieved considerable prewar screen success in this 1939 movie, which went on the remain a wartime favorite. His orchestra is the backdrop to a dancing competition for college girls that is suspiciously won by Lana Turner, who is not a student but a professional dancer.

BELOW RIGHT: Glenn Miller's two motion pictures built up the legend that enhanced his wartime career. The 1941 movie *Sun Valley Serenade* achieved racially integrated scenes, something that the Office of War Information would try and fail to achieve two years later (see page 96). Here, African American dancers the Nicholas Brothers join Glenn Miller's band and singer Dorothy Dandridge in a set-piece version of "Chattanooga Choo-Choo."

RIGHT: *Orchestra Wives* was released in September 1942, the month that Glenn Miller secretly joined the army, the news being publicly announced before he reported for duty in early October. The plot about romance and the pressure on touring musicians made this a successful wartime movie, dealing with themes of separation made acute as conscription broke up families.

The official position of the Nazi regime in Germany was to denounce jazz as degenerate music. The image that is most closely identified with the regime, because it is such a powerful piece of propaganda, is Hans Ziegler's 1939 poster "Entartete Musik" ("Degenerate Music"), with its black saxophonist decked out in evening dress, wearing gloves and a badge showing the Star of David. Yet this poster, and the denouncing of jazz in general, stood at odds with a well-entrenched German nightclub culture that, from the dawn of the Weimer era to the outbreak of World War II, had favored jazz. Enthusiasm for the sounds of the music, with varying degrees of visibility, persisted after 1939, not only in clandestine gatherings in Germany itself, but in many parts of occupied Europe. This ambivalence was also true of the visual arts, which, after Hitler's rise to power in 1933, saw twenty thousand works removed from state-owned museums and galleries for being "degenerate." But just as customers continued to hear "degenerate" music in clubs, many attended an exhibition of 740 "Degenerate Art" works held in Munich in 1937. The idea of inviting the populace to view material that the regime thought ought not to be shown was a bizarre one; the exhibition included pictures by Max Beckmann, Ernst Ludwig Kirchner (whose *Berlin Street Scene* showed prostitutes consorting with gentlemen), Henri Matisse, André Derain, Paul Klee, and Oskar Kokoshka.

Ziegler's poster itself drew on visual ideas that had already been expressed in German painting by artists who depicted the country's nightlife. The slightly awkward pose, for example, had appeared with a similarly attired white saxophonist in Volker Böhringer's 1935 *Saxofonespeiler in Kugels Saal*, and, even earlier, in the 1928 pen-and-ink drawing *Jazzband*, by George Grosz. This shows a black saxophonist, who, although seen side-on, raises his right shoulder in just the manner of Ziegler's caricature. Grosz (whose son Marty became an internationally famous jazz musician after the family moved to the United States just before World War II) turned a merciless eye on the excesses of German prewar nightclub life, showing leering male customers, prostitutes in scanty attire, dancers locked in loveless embraces, and—more often than not—some form of jazz in the background. (He is similarly unflinching in his first Harlem paintings from the 1930s.) Grosz and Otto Dix (whose work is discussed earlier in this book) were part of a movement known as the *Neue Sachlichkeit* ("New Objectivity"), whose artists depicted interwar Germany with forensic clarity, with a particular fascination for the country's nightlife.

The ambivalence toward jazz felt by many Germans is expressed by Harry Haller, the protagonist of Herman Hesse's 1927 novel *Steppenwolf*, when he observes, "From a dance hall there met me, as I passed by, the strains of lively jazz music, hot and raw as the steam of raw flesh. I stopped a moment. This kind of music, much as I detested it, had always had a secret charm for me. It was repugnant to me, and yet ten times preferable to all the academic music of the day. For me too, its raw and savage gaiety reached an underworld of instinct and breathed a simple, honest sensuality." And Christopher Isherwood's *Mr. Norris Changes Trains*, his novel of late-1930s Berlin, gives us a hint of the musical heart of the city's nightlife when Mr. Norris tells the narrator, William Bradshaw, to avoid their favorite restaurant, because "my sensitive nerves revolt against the thought of an evening of jazz."

The musicians who had played in Berlin before the war included (in the 1920s) numerous African Americans, notably Sam Wooding's Orchestra, which was based there for some time; Sidney Bechet and Josephine Baker, in *La Revue Nègre*; and trombonist Herb Flemming's International Rhythm Aces. Compared to the African American players, there was a bewildering variety of white bands, both American and European. In his memoir, the white American banjoist Mike Danzi recalls working with Alex Hyde's New York Jazz Band, Mac's Merry Macs, and Eddie Woods's Kentucky Serenaders, all of whom had predominantly American lineups, with a few German players added. As Danzi moved into the 1930s, there were more purely German groups, and he went on to work with the Virginians and Otto Stenzel's bands.

Remarkably, two of the most popular bands that had shaped German tastes were from the British Isles. First, Henry Hall's BBC Dance Orchestra, which performed in Berlin regularly in the period after Hitler took power, made their final appearances in February 1939, having undertaken to drop all Jewish musicians and composers from their ranks and repertoire. Second, and maybe more remarkable, was the fact that one of the biggest stars of prewar jazz in Berlin, who stayed on during the war to play private functions for "SS Clubs, Officers' parties and upmarket brothels," as Michael Russell later put it, was the Irish saxophonist Zandra Mitchell, who led her all-female Queens of Jazz. It is not known if she played in the propaganda jazz broadcasts beamed at Britain from wartime Germany by a swing-inflected band known as Charlie and His Orchestra, but she was definitely a central part of the milieu from which the players were drawn. And just as jazz either went underground or was adapted for propaganda, wartime artists continued to use this notionally prohibited music as the basis for inspiration, including Böhringer, whose *Jazzmachine*, painted secretly in 1944 (before he contracted a serious lung ailment), envisions a strange saxophone being played partly by robot gramophone arms and partly by a ghostly figure—maybe, indeed, the spirit of jazz past?

Jazz and Germany

"The anti-cabaret and anti-jazz measures unfolded in the midst of the Goebbels-led campaign against degeneracy in the visual arts."

Alan E. Steinweis, *Art, Ideology, and Economics in Nazi Germany* (University of North Carolina Press, 2017)

BELOW: The 1937 "Entartete Kunst" ("Degenerate Art") exhibition in Munich was the most popular modern-art exhibition in history. Despite the Nazi regime's opposition to the content, two million people saw it in Munich and a further million when it toured Germany and Austria. It was five times more popular than the "Great German Art" show of art approved by the regime.

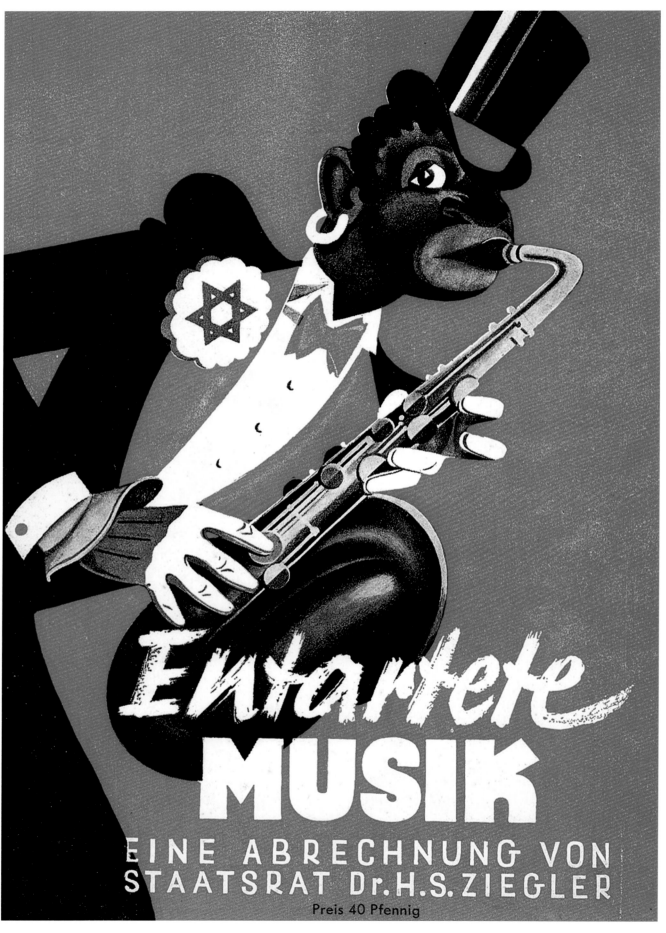

Entartete
MUSIK

EINE ABRECHNUNG VON
STAATSRAT Dr. H.S. ZIEGLER

Preis 40 Pfennig

This is the original catalog for the "Degenerate Art" exhibition in Munich, which was held in the covered arcades running alongside the Hofgarten from July to October 1937. The booklet was published by the Reich Propaganda Directorate.

TOP RIGHT: **The "degenerate" artworks were culled from various museums and collections across Germany, and would be destroyed after the touring exhibition closed. In Munich, the displays were imaginative, with captions painted on the gallery walls, and here "jazz rhythm" comes in for criticism, with the sombrero-clad Calloway look-alike central to the main picture.**

BOTTOM: **Many Jewish musicians died at the hands of the Nazis, but trumpeter Eddie Rosner fled east from Warsaw and arrived in Russian-occupied Białystok, where he formed this jazz orchestra, which spent the early wartime years touring all over the Soviet Union. Known as the "White Louis Armstrong," he was successful until denounced by Stalin in 1946 and sent to a gulag.**

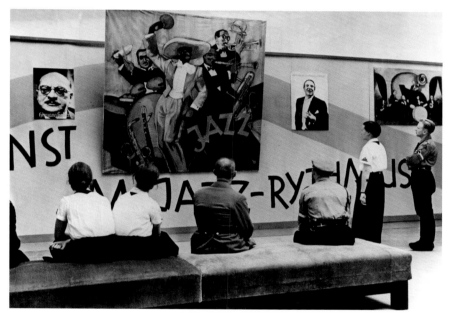

In 1943, the United States Office of War Information set about tackling the divisive racial mores in American society, aiming to take action to unite both its armed forces and the home front against the common enemies of Germany and Japan. It planned to create entertainment that—in contrast to the *de facto* segregation of prewar movies and shows—bridged the racial divide, and it intended to begin with Hollywood. This aim had been proposed by Walter White, executive secretary of the National Association for the Advancement of Colored People (NAACP), who pressed studio bosses and screenwriters to "use our media to build a world free of racial and religious hatred, a world free of vicious and fictitious notions of the superiority of one race over another."

Before this, movies from major Hollywood studios that included jazz had largely overlooked African Americans. Where black citizens were acknowledged, it was usually in brief cameos, such as Fats Waller's as a furniture mover (accompanying dancers Bill Robinson and Jeni Le Gon and a group of children) in RKO's 1935 *Hooray for Love*, or short set pieces in otherwise all-white movies such as the 1941 *Hellzapoppin'* jam session and dance scene with, among others, Slim Gaillard, Slam Stewart, and Rex Stewart.

White's aspiration was helped by one of the most powerful agents in the business. In 1942, Irving Mills had begun introducing his stable of African American jazz artists to Hollywood studio moguls. Getting his artists established on celluloid took somewhat longer than Mills would have liked, and in 1943 the results were not even a compromise, in that they unwittingly reinforced racial division. Rather than achieving general, informal integration, with black and white actors given equal billing, what the studios did instead was to make all-black movies for mainstream distribution. As a result, both *Cabin in the Sky* and *Stormy Weather* went into production for release in 1943. The posters show how the films were marketed to general audiences.

In the build-up to *Stormy Weather*, Irving Mills placed press pieces on all his stars that kept them in the public eye. This was particularly important for musicians such as Cab Calloway, while his band was on the road, because, owing to a long-running union dispute with the main record companies, he was unable to make records after late 1942, and was often off the radio airwaves while out on tour.

Stormy Weather and *Cabin in the Sky* remained anomalies in Hollywood's output, which remained white-focused for years to come, despite the occasional recognition of African American musical heroes such as when Nat King Cole starred in 1958 as W. C. Handy in *St. Louis Blues*, which also featured Pearl Bailey. It took until the 1980s with Bertrand Tavernier's *Round Midnight* (1986), starring Dexter Gordon, and a score masterminded by Herbie Hancock and including (as well as himself and Gordon) Wayne Shorter, John McLaughlin, and Pierre Michelot, who were also seen playing on screen, to achieve the ideals of integration set out in 1943.

Two years later, Clint Eastwood's *Bird* focused on Charlie Parker, but the score, which attempted to merge some of Parker's original solos with a re-recorded rhythm section, was a musical desecration, and the film lacked the sense of veracity that oozed from every frame of Tavernier's picture.

All-Black Movies

"Federal incentive for studios to mobilize African Americans for the war effort led to the production of all-black musicals."

Sheri Chinen Biesen, *Blackout—World War II and the Origins of Film Noir* (Johns Hopkins University Press, 2005)

BELOW LEFT: **This poster shows several scenes from *Stormy Weather*, with Lena Horne (top left), Cab Calloway in his yellow zoot suit and hat, dancer Katherine Dunham (top center, in the "storm" sequence), and fellow dancer Bill Robinson in his straw hat singing "you should see that chick and me." Fats Waller appears in the musical note, beside another picture of Dunham.**

TOP RIGHT: **An abstract dance scene features in this *Cabin in the Sky* poster, but the blue zoot suit mirrors Calloway's garb and that of the Dunham troupe in *Stormy Weather*. Lena Horne again stars, alongside musical giants Ellington and Armstrong.**

BOTTOM RIGHT: **One of the publicity shots for *Stormy Weather*, with (left to right) Bill Robinson, Lena Horne, and Cab Calloway.**

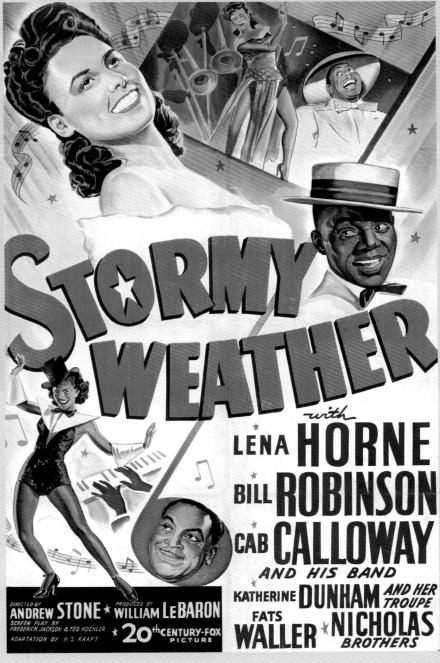

The Art of Jazz

BELOW LEFT: **Fats Waller singing "Got My Fingers Crossed,"** in the movie *King of Burlesque*, is one of the few moments in films of the 1930s where an African American musician is given proper star treatment, and, from the moment the stage revolves to reveal Fats, with white piano and white-suited band, he makes the most of it.

TOP RIGHT: **The British magazine** *Storyville* compiled the first comprehensive discography of Fats Waller, and for its cover Trog (a strip cartoonist for the *Daily Mail* in London and an acerbic political cartoonist for the *Observer* newspaper) produced this affectionate caricature of Waller in action. Trog was the pen name of Canada-born jazz clarinetist Wally Fawkes.

BOTTOM RIGHT: **In his most famous scene from** *Stormy Weather*, Waller leads his small band in a nightclub. But for this 1943 Hollywood edition of the group, filmed not long before his premature death, he included some special stars, including drum virtuoso Zutty Singleton, trumpeter Benny Carter, and bassist Slam Stewart.

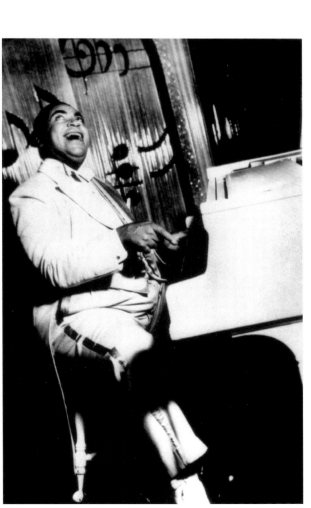

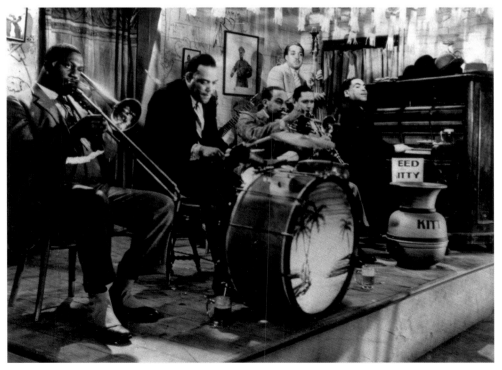

In the film *Stormy Weather*, "The Jumpin' Jive" is perhaps the most dazzling dance sequence ever shot, featuring the Nicholas Brothers with Cab Calloway's band. For this number, Cab wears a conventional black-and-white tail suit, as do the dancing brothers. Elsewhere in the movie, notably in the song "Geechie Joe," Cab wears a zoot suit—a long, loose, light-colored jacket stretching down to his knees with padded shoulders and broad lapels, broad trousers, a giant watch chain, and a floppy hat. This look—of which he was the main pioneer—was to spark a fashion revolution, or more accurately a revolutionary fashion.

In the summer of 1943, race riots broke out in Harlem and Detroit. These were followed, just before the July release of *Stormy Weather*, by the so-called "zoot suit" riots, which began in Los Angeles a month before the premiere. Starting on June 3 as scuffles between white sailors and Latino youths from East Los Angeles—the latter clad in Calloway-style garments—the unrest escalated rapidly. Over the next few days, what was estimated at the time to be thousands of soldiers, sailors, and roughneck civilians marched through the streets, beating up any zoot-suited youths they encountered, be they Latino, African American, or Irish American (all groups that had adopted the clothing as a symbol of identity). According to Professor Eduardo Pagán, one of the hosts of the *History Detectives* series on PBS, the hipster ideology of the zoot-suited teenagers from similar minority groups in the East, whom the Californians emulated, was "live for the moment," a philosophy that chimed with this age group at a period of wartime conscription.

A hurriedly issued city council ordinance briefly banned the wearing of zoot suits in LA, and after almost a week of clashes, all military personnel were confined to their bases. These two actions put a halt to the disturbances. Margarita Engle's 2018 novel *Jazz Owls* is set in this period of unrest, and Rudy Gutierrez's cover artwork vividly captures the atmosphere.

Given this backdrop of civil disobedience, releasing an all-black movie in which Calloway was prominently featured, wearing forbidden attire, could be seen as provocative. But the Twentieth Century Fox Studios were undeterred from the wider mission, and *Stormy Weather* was put on general release. In the majority of the posters, Cab's zoot suit can be clearly seen.

On the other side of the Atlantic, at virtually the same time, suits modeled on Cab's were the costume of choice for the Zazous (predominantly Parisian youths disaffected with the Vichy regime in occupied France). Their long check jackets, loosely fitting trousers, watch chains, and hats were fashioned after Calloway's, and their name derived directly from his song "Zaz Zuh Zaz." The link came via the *chansonnier* Johnny Hess, who, before the war, had recorded a song in 1938 called "Je Suis Swing," which—in imitation of Cab—had the repeated chorus line, "Za-zou, za-zou, za-zouzé." The boys' long jackets and baggy trousers thumbed their noses at Nazi instructions to limit the amount of fabric used in clothing, as did the girls' pleated skirts and large shoulder pads. (Ironically, the soldiers' and sailors' dislike of the Latino zoot-suit wearers in Los Angeles was based on a similar criticism of the lavish use of scarce material in their clothing, which was seen by the military as unpatriotic.) The Zazous' behavior, appearance, and "don't give a damn" attitude were aimed to be publicly at odds with the Vichy propaganda and its role models of clean-cut youths.

In opposition to any notion of the "clean-cut," the Zazous also wore their hair long. Cab Calloway's long locks and habit of tossing his head back to flick the hair from his face were again an inspiration. And, just as was the case in clothing, the youth movement adopted this in the face of Nazi instructions that all hair from barbers' shops and women's hair salons should be collected and used for blanket-making and pillow-filling as part of the war effort. This edict was issued on March 27, 1942, and those who disobeyed, as the Zazous so publicly did, were accused of unpatriotic behavior and selfishness. Cartoons and drawings depicting them in a very unfavorable light appeared in propagandist papers such as *Je suis partout* and *Le cri du peuple*.

Hess himself (although he was of Swiss nationality and therefore technically neutral) became the recipient of offensive barbs about his hair and costume. Yet the pervasive influence of the zoot suit as a symbol of rebellion is an excellent example of African American jazz culture creating a visual language for youth on both sides of the Atlantic.

Zoot Suits

"The zoot suit riots represented a defining moment. In the years following, as Latinos steadily gained political and economic power, as they asserted rights previously denied, and fought against prejudice and racial hurdles, those wartime memories . . . burrowed deeply in their culture."

Roger Bruns, *Zoot Suit Riots* (ABC Clio, 2014)

BELOW LEFT: **Many books have been published on the zoot suit riots, including Margarita Engle's verse novel for children,** *Jazz Owls*. **But few images more graphically capture the image of the zoot-suited teenager than the cover of Mauricio Mazón's academic study.**

BELOW RIGHT: **Few better images exist of a Parisian Zazou than this shot, which shows exactly the identification with the Los Angeles zoot suit cult. Compare the pose and the dancing style to Cab Calloway on the next page and the connections are obvious, despite this being photographed in Nazi-occupied Paris.**

BELOW: **Cab Calloway's feature song, "Geechie Joe," from** *Stormy Weather*, **with zoot suit and hat rather than the conductor's tail suit he wears in other scenes. We see a moment from the stage act where Cab points skyward as trumpeter Jonah Jones hits a high note. Jones recalled that one night he played with his eyes closed and missed the cue, prompting Calloway's wrath!**

RIGHT: **Calloway's British counterpart was bandleader Ken "Snakehips" Johnson, born in British Guiana (now the independent nation of Guyana) but schooled in the United Kingdom. His dancing appears in the 1935 movie** *Oh Daddy*, **and he led a band in wartime central London. His West Indian musicians were a hard-swinging bunch who rivaled American groups, but the band came to an end in an air raid in 1941 in which Johnson was killed.**

The Art of Jazz

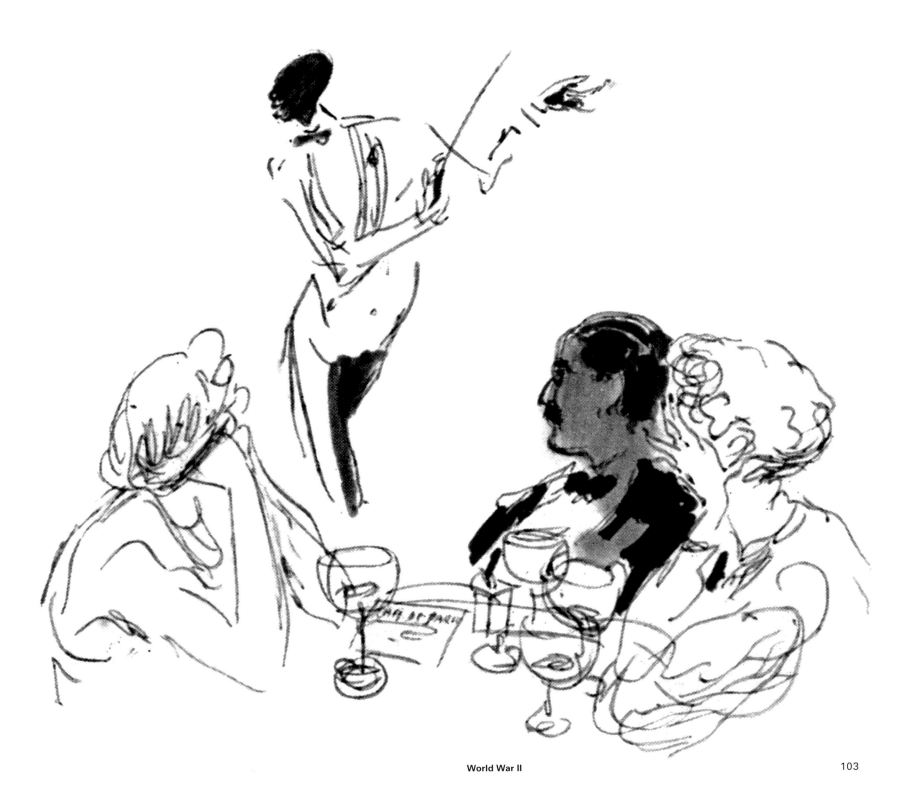

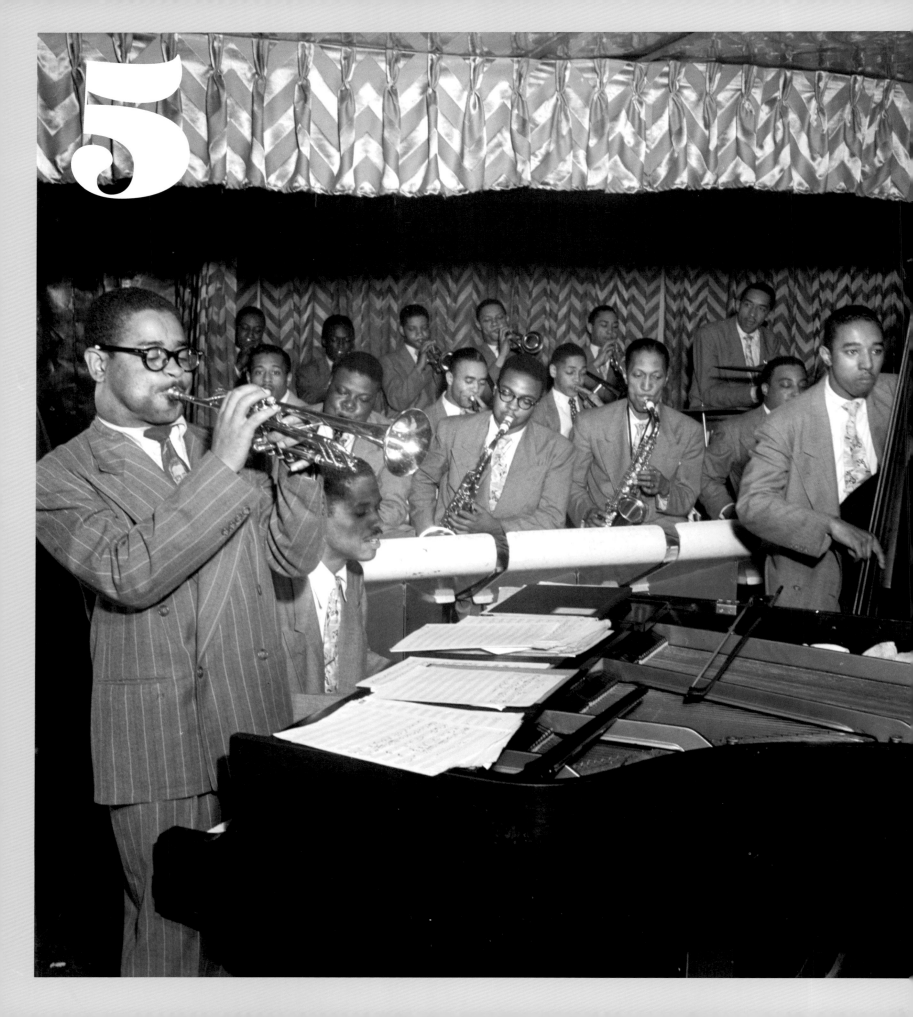

Bebop and Modern Jazz Versus the New Orleans Revival

"Fistfights . . . even lawsuits took place between the two camps"

Characterized by American historian Barry Ulanov as "moldy figs" versus modernists, the postwar scene polarized into two rival groups of jazz fans, each with a distinctive visual sense. One group—the "figs"—followed the older, traditional styles of jazz, whereas the other camp allied themselves with the new "bebop" sounds of Charlie Parker, Dizzy Gillespie, Thelonious Monk, and Bud Powell. The beboppers favored goatees, berets (or in Monk's case a range of exotic headgear), and horn-rimmed spectacles. Traditional jazz players either dressed in garb reminiscent of the 1920s, or (particularly in Europe) adopted the anarchic clothes of beatniks. Among the revivalists there was also a fair degree of dressing up, so that in the United States the Hollywood animators, who became the Firehouse Five Plus One, adopted the uniforms of firefighters and were often photographed on a vintage fire engine, while the British band the City Gents, led by clarinetist Dick Charlesworth, adopted the pinstripe suits and bowler hats worn by those who worked in the heart of the City of London's financial district.

The traditional jazz revival began in the United States in the late 1930s and very early 1940s. Initially, this renewed interest in the music from the dawn of jazz grew out of one or two groups of musicians doing more or less what they had always done. In Chicago, at the Panther Room of the Sherman House Hotel, on Clark and Randolph, the band of the hour was the Muggsy Spanier Ragtimers, a seven- and later eight-piece band that, in a residency from April to September 1939, played the Dixieland they had all grown up with, rather than the prevalent big-band swing of the day. The exotic decor of the Panther Room was itself something of an anachronism: a sizeable nightclub with wall hangings and soft furnishings apparently made of the hides of leopards and panthers. Although the swing bands of Count Basie, Bunny Berigan, and Gene Krupa played there, Spanier's men—with their jaunty, old-style Dixieland collective improvisation—were the ones the people flocked to. "They seemed to like our music best for dancing," recalled clarinetist Rod Cless. "And no matter what other band was playing they always had us play for the floor show. We . . . could handle the acts without orchestrations."

In New York, a similar movement coalesced around the guitarist and soon-to-be club-owner Eddie Condon. Helped by the agent Ernie Anderson, Condon was to present traditional jazz in concerts at New York Town Hall and Carnegie Hall, but before this, in the late 1930s, he had

been playing regularly at Nick's Steakhouse in Greenwich Village. This club, presided over by jazz fan Nick Rongetti, became the epicenter for small-group traditional jazz in Manhattan. Condon's lineup contained a number of traditional jazz pioneers, including the clarinetist Pee Wee Russell, and then, from 1938, the tenor saxophonist Bud Freeman. Bud had recently quit the Benny Goodman band, which he described as being like a "big-band factory," in order to "play the music I loved and as much of it as I wanted." He then assumed the titular leadership of Condon's band, which for two years was known as Freeman's Summa Cum Laude band. Ironically, when Spanier and his men came to New York, it was Freeman who took their place for a season at the Panther Room.

A few months after arriving in New York, Spanier broke up the Ragtimers, and for some time in 1940–1941 he played with Bob Crosby's Bob Cats, who traced their lineage back to Ben Pollack's 1920s group, and also had stylistic links to early traditional jazz. As saxophonist Eddie Miller recalled, "We used Dixieland as more or less a trade name."

Yet these bands were very much maintaining, rather than reviving, earlier styles of jazz. The "revival" involved two distinct and to a large extent separate movements, one of which was about trying to recreate the past with older players rescued from retirement or obscurity, whereas the other was concerned with young (usually white) players deliberately recreating recordings from the 1920s.

In terms of visual art, both triggered a response. The French critic Hugues Panassié inspired a range of photography and cover designs when he produced a series of records by jazz pioneers for RCA in 1938–1939 in New York. Bringing the former trumpet star of Fletcher Henderson and Sam Wooding's orchestras, Tommy Ladnier, back to the microphone, alongside Sidney Bechet, is perhaps the best example. But other record producers had similar ideas. In particular, the American Music records made in New Orleans in the early 1940s by William Russell created their own visual aesthetic. Russell sought to put early pioneers like trumpeter Bunk Johnson back in the spotlight, but also to record much of the living tradition in New Orleans itself, which had gone largely ignored by other record companies.

The pioneers were photographed in sensuous black-and-white, by Russell himself but also by news photographers such as the future film director Stanley Kubrick. His pictures for *Look* magazine in 1950 capture the George Lewis Band playing both a club session and an informal jam

Bebop and Modern Jazz Versus the New Orleans Revival

PREVIOUS SPREAD: The Dizzy Gillespie Big Band, squeezed on to the stage at the Downbeat Club, a brownstone basement at 66 West 52nd Street, New York. Future Modern Jazz Quartet members John Lewis and Ray Brown are on piano and bass, and the band's gray suits and patterned ties contrast with Dizzy's pinstripe and bebop uniform of horn-rimmed spectacles and goatee.

BELOW LEFT: Immaculate in his suit and bow tie, French record producer Hugues Panassié supervises a "revivalist" session by clarinetist Mezz Mezzrow, "stride" pianist James P. Johnson, and veteran trumpeter Tommy Ladnier.

TOP RIGHT: The Selmer catalog reaches both sides of the jazz divide—"beboppers" and Dixieland "moldy figs"—as well as classical or "straight" players. Most of the names are drawn from the American and European jazz scenes, with such classical virtuosi as the Paris Conservatoire trumpeter Raymond Sabarich and clarinetist Ulysse Delécluse tucked away at the bottom.

BOTTOM RIGHT: Leading bebop piano pioneer Bud Powell suffered from mental illness, and painter Marshall Arisman's sleeve design for this trio recording seeks to uncover the torment in Powell's life. Born in 1937 and originally a graphic designer for General Motors, Arisman gained a reputation for his illustrations, fine-art paintings, and installations, which explored the darker side of human nature.

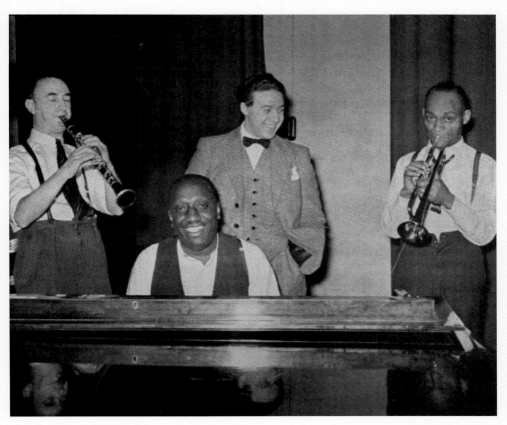

in a backyard, on which Kubrick himself briefly sat in at the drums. Bill Russell also recorded (as later producers of such discs as Riverside's Living Legends or Barry Martyn's Mono label would do) in domestic backyards and in historic New Orleans venues, and these were also featured in record-sleeve artwork. The photographs—particularly for the "Climax" sessions that were sublicensed to Blue Note—were often accompanied by graphics that looked like late-nineteenth-century theatrical billboards. To add to the visual impression, Russell was a pioneer of pressing his American Music records on brightly colored vinyl. This was actually out of necessity, as shellac was in short supply during the war, but the Muzak company had pioneered using vinyl, and, as Russell recalled, "It was a better surface than shellac even . . . the first ones were on a red translucent, or some would say transparent, substance that you could even see through."

In contrast to Russell's presentation of old masters in old settings, albeit on new material, the young white imitators created an entirely new style of imagery to go with their music. They wanted to evoke the wildness of the Jazz Age, and also to suggest to buttoned-up postwar America (and later Europe) that their music was fun, different, and zany. This craze really took off in the San Francisco Bay Area, where, in the wake of Lu Watters's Yerba Buena Jazz Band, which was modeled musically on 1920s Chicago, bands got crazier and wilder. Watters's original trombonist, Turk Murphy, led a succession of groups that played up the eccentric good-time image, and they played clubs with what seemed at the time to be outlandish names, such as Earthquake McGoon's, Hambone Kelly's, the Club Hangover, and the Tin Angel. Other groups included Bob Scobey's Frisco Jazz Band, the Social Polecats (who rather confusingly wore zebra-striped shirts), and Bob Mielke's Barbary Coast Stompers.

While this revivalism was coming to fruition, the AFM instituted its recording ban, which ran from 1943 to 1945. Only private recordings, or those made for the armed forces' V-Disc label, could be made, so we only have intermittent aural snapshots of how the emergence of the new style of jazz—bebop—sounded as it was being developed. We can only guess at what was being played in the copious photographs of bebop pioneers in New York's 52nd Street clubs or after-hours in Harlem. What we do see, in the surviving picture evidence, is a new visual language evolving alongside the musical. Barry Ulanov put it well in 1950, when he wrote, "All over America young boppers who had never worn hats donned the Dizzy cap; young boppers who had never been able to raise sufficient hirsute covering to prove their age struggled with chin fuzz in an effort to build the Gillespie goatee; young boppers with their own little bands began to lead from the waist and the rump; some with perfectly good eyesight, affected the heavy spectacles."

This was no accident, but rather the result of a campaign coordinated by Gillespie's manager, Billy Shaw, that rivaled Irving Mills's Ellingtonian promotions for thoroughness and vision. The historian David Stowe has advanced the theory that bebop was the last hurrah of the swing era, and indeed, with a movie like Gillespie's *Jivin' in Bebop* from 1946, what we are seeing is a standard vaudeville variety show, albeit with very hip music. His double-breasted suit with wide tie and flashy tiepin looks more casual than the tuxedos of his band, yet his singing and dancing, and his stage persona, owe more to his old bosses, Lucky Millinder and Cab Calloway, than they do to Monk or Parker. The Gillespie big band was, as Scott Deveaux put it, "the latest in a long series of name bands to parlay some striking idiosyncrasy into instant recognizability."

Whereas Gillespie had been relatively well known before the mid-1940s, having recorded with Calloway, Teddy Hill, Lionel Hampton, and Lucky Millinder, Charlie Parker was relatively unknown outside musicians' circles. Despite his prodigious influence on the development of bebop, he was away from New York during 1946, the latter part of which he spent confined to the Camarillo State Mental Hospital in California. While Dizzy's management had made the most of promotional opportunities, and his striking appearance became so closely identified with the new music that for many he epitomized it, Parker's iconography did not really take off until the 1950s. Then, once he began to be promoted by the entrepreneur and record producer Norman Granz (as we shall see in chapter 7), record sleeves and posters made the most of his "Bird" nickname. Before this, there are plenty of atmospheric nightclub photographs of Parker—especially after his return to New York from California in 1947—but nothing to compare to the more widespread visual imagery of Gillespie and Monk.

"Gillespie's big band . . . demonstrated that the improvisatory energy of bebop could be adapted to a larger ensemble."

Patrick Burke, *Come in and Hear the Truth* **(University of Chicago Press, 2008)**

BELOW LEFT: The poster for *Jivin' in Bebop* underlines that it was an old-fashioned variety or vaudeville show. Yet it really is "hummin' with hit tunes," as the new staples of the bebop repertoire that Gillespie would popularize feature in the movie, including the vocals "Salt Peanuts" and "Oop-Bop-Sh'Bam," and the dazzling instrumental "Things to Come."

TOP RIGHT: Muggsy Spanier's Ragtime Band (pictured here at Chicago's Panther Room) only recorded eight 78 rpm records, and the sixteen sides became known by record collectors of revivalist jazz as "The Great 16," setting a benchmark for Chicagoan Dixieland.

BOTTOM RIGHT: New Orleans veterans like trombonist Jim Robinson never expected to become international stars, but the revival brought him to Britain (where this picture was taken at London's Marquee Club) with the George Lewis Band, and he later traveled the world with the Preservation Hall Jazz Band until weeks before his death, in 1976, aged eighty-three.

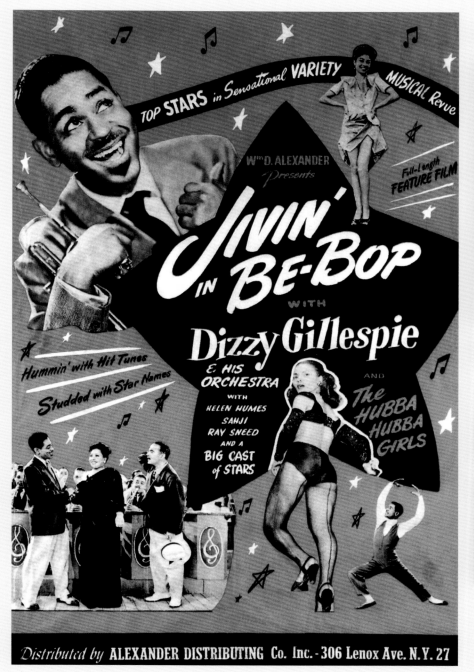

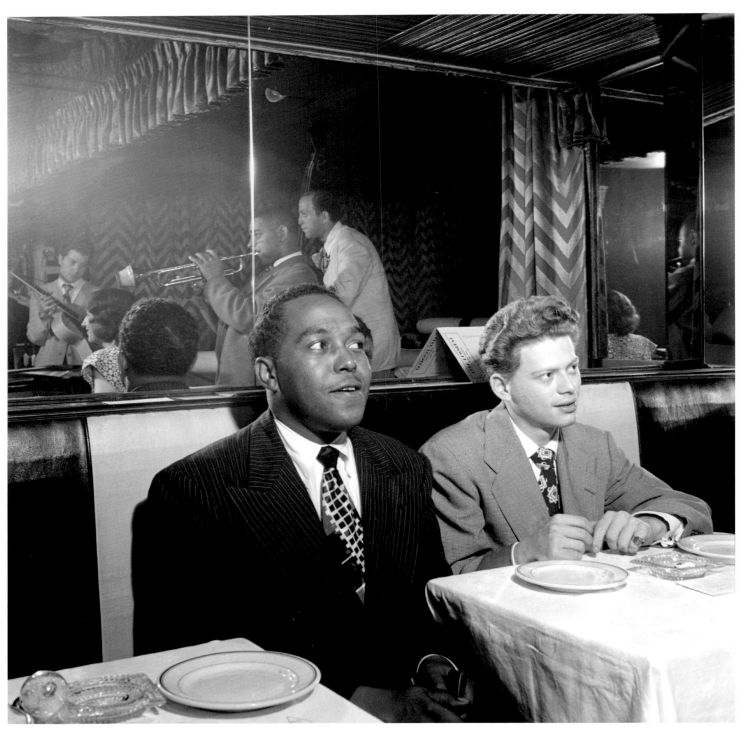

The Art of Jazz

BELOW LEFT: **Although none of the music by Monk's long-running quartet with tenorist Charlie Rouse, bassist Ben Riley, and drummer Larry Gales on** *Underground* **reflects the violent images here, photographers Steve Horn and Norm Griner set up this (in more than one sense) explosive shot to convey the unique angularity and non-mainstream nature of Monk's music.**

BELOW RIGHT: **In a similar visual attempt to convey Monk's musical individuality, designer Paul Bacon used this painting,** *The Seer*, **by the Greece-born Italian painter Giorgio de Chirico. It dates from his 1914 "metaphysical" period, which was hugely influential on surrealism, and uses what art historian Marc LaFountain calls "gratuitous combinations to produce unforeseen meanings."**

BELOW LEFT: In another of his photographs capturing the birth of modern jazz on 52nd Street, William Gottlieb reveals alto saxophonist Charlie Parker in action at the Three Deuces, along with bassist Tommy Potter, drummer Max Roach, and twenty-one-year old trumpeter Miles Davis.

TOP RIGHT: "Kid" Ory was a jazz pioneer in Louis Armstrong's Hot Five (see page 45). After the Wall Street Crash, he moved to California and ran a chicken farm. He returned to music in 1944 as a key figure in the New Orleans revival. This publicity portrait dates from when he started fronting his traditional band, which he led until the mid-1960s.

BOTTOM RIGHT: Paul Bacon (who also designed *Misterioso*, as shown on the previous spread) pioneered ten-inch LP album design. He produced numerous examples, including this famous Milt Jackson cover, for Blue Note, while also working at a New York graphics company. Bacon was a jazz fan, writing reviews for magazines and playing the comb and tissue paper in various bluesy jug bands.

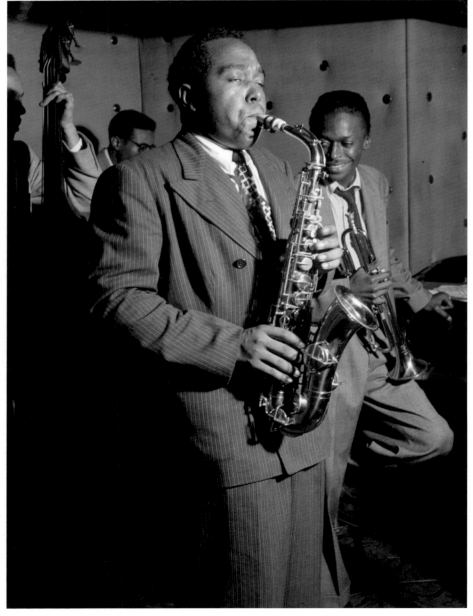

BELOW: Sonny Stitt was a brilliant alto and tenor saxophonist, but his 1940s style was based on Charlie Parker's innovations. On this album, Stitt made the connection explicit by interpreting eight of Parker's compositions (plus one other track). Painter and Atlantic Records art director Marvin Israel produced this remarkable portrait, signifying the fragmentary phrases and rhythms of bebop.

The byword of the New Orleans jazz revival in the United States and Europe was "authenticity." Shunning what was seen as the "commercial" nature of the swing era, and the esoteric harmonies and rapid-fire melodies of bebop, revivalists sought the innocence of an earlier age. And in May 1949, when the soprano saxophonist and clarinetist Sidney Bechet (1897–1959) set foot on French soil to appear at the Festival International de Jazz in Paris, he became authenticity personified. Although he was only fifty-four years old, the familiar images of him in press photos and on record sleeves tended to give the impression he was far older. For some years he had looked prematurely aged, with a bald pate fringed by gray hair, and this fostered the idea that he was one of the fathers of the music.

Born in New Orleans, and one of the first generation of jazz musicians from the city, he had recorded with Clarence Williams and Louis Armstrong in 1920s New York but, equally significantly, he had also been a pioneer of bringing jazz to Europe. Bechet came to the continent with Will Marion Cook's Southern Syncopated Orchestra in 1919, and indeed he found his trademark soprano saxophone while he was in London in 1920. His European sojourns were not without incident—his rough, tough behavior led to deportation in one instance and imprisonment in another. But he left an indelible impression in Europe as a founding father of traditional jazz, and he left plenty of pictures, posters, and other mementos of his early times outside the United States scattered about the continent.

In America, after recording under his own name and touring with Noble Sissle's big band in the 1930s, Bechet gradually became identified with the New Orleans revival, helped by the records he made with Jelly Roll Morton in 1939. Sought out and recorded the previous year by the French discographer Hugues Panassié, and then featured on a long sequence of old-style records by the clarinetist Mezz Mezzrow for his King Jazz label, Bechet was perceived by enthusiasts as embodying a return to traditional values. The Blue Note record label (run by German expatriates Alfred Lion and Frank Wolff) recorded him in a number of sessions with New Orleans and Chicagoan colleagues, and he had a minor hit with George Gershwin's "Summertime."

Shortly after his reappearance in France, Bechet came to London and appeared in concert and on record (contravening a Musicians' Union ban on visiting Americans) with Humphrey Lyttelton. The British trumpeter wrote, "Of all the great American masters, Sidney Bechet seems to have realized most the nature and significance of the New Orleans revival and his responsibilities towards the young musicians engaged in it."

In France, the clarinetist Claude Luter would become Bechet's main disciple. He and his contemporary, André Rewéliotty, provided his main backing bands all over the continent. Luter recalled, "The personality of Bechet is extraordinary . . . it is he who takes on the cornet part in the last choruses, and wipes everybody out. He's a musician who possesses a great power of attack, and an awesome punch."

Luter's enthusiasm for all things Bechet was shared—despite his equal passion for modern jazz—by the critic and entrepreneur Charles Delauney, who lured Bechet back to France on a more permanent basis. The saxophonist would go on to live in the country for most of his final decade, becoming the grand old man of European revivalism.

On October 14, 1949, Bechet and Luter produced a hit record, "Les Oignons," based on a Creole nursery song, punctuated by silent breaks in which audiences would shout "Oignons!" The record sold over a million copies during the course of the next decade and underpinned Bechet's remarkable Indian summer as a performer until his death in May 1959. His popularity in France was unmatched in traditional jazz, and in 1955, a vastly oversubscribed concert at L'Olympia in Paris led to injuries and unrest when riot police were called in to control the thousands of fans unable to get in to hear his music.

Bechet's French recordings include plenty of local source material, or pieces from his earlier career suitably adapted and given francophone titles. Hence "Au clair de la lune," "Ce mossieu qui parle," "Dans les rues d'Antibes," "Promenade aux Champs-Elysées," "Un coup de cafard," and many other such songs became the backbone of his repertoire. This assimilation into Gallic life was reflected, too, in the way he was presented visually—as a master, standing out from his local accompanists, but often associated with French artifacts and culture, to reinforce the idea of his Creole heritage.

Sidney Bechet

"Of all the great American masters, Sidney Bechet seems to have realized most the nature and significance of the New Orleans revival and his responsibilities towards the young musicians engaged in it."

Humphrey Lyttelton, *I Play as I Please* (McGibbon and Kee, 1954)

BELOW LEFT: **For this issue by Vogue of music by Bechet from his 1950s French period, Charles Delauney—better known as a critic, initiator of the Hot Club of France, and Vogue's founder—produced a scraperboard image of Bechet in action. Both his parents were well-known painters of abstract "Orphism" canvases, but Charles favored realism in his drawings and designs.**

TOP RIGHT: **The first ever jazz "albums" consisted of 78 rpm discs in a bound sleeve, presented like a book. This is Jim Flora's 1948 outer design for Columbia's "Jazz Masterwork" issue, containing music by Bechet's own quartet and four sides on which he appears with Bob Wilber's Wildcats.**

BOTTOM RIGHT: **Bechet's Parisian period included a number of stage productions. Here he is in the show *New Orleans* (for which he wrote the music) in Paris in 1958. Billy Tamper (trombone), Sonny Grey (trumpet), and Kansas Fields (drums) were in the onstage band, plus a cast of seventy-two, but unfortunately it was a box-office flop.**

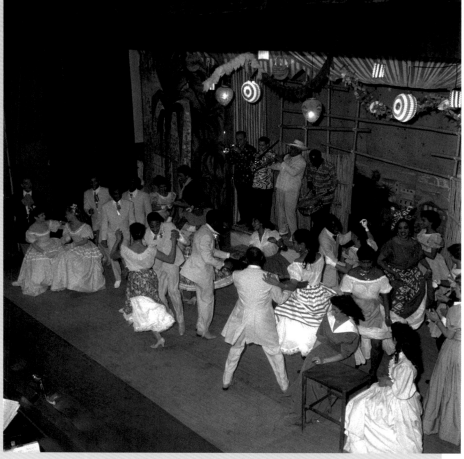

GEORGE LEWIS NEW ORLEANS JAZZ BAND

Souvenir Programme : Two Shillings

OPPOSITE: **The front cover of the concert program for the touring band led by clarinetist George Lewis that came to Britain in 1959. Lewis had previously visited the UK as a soloist with Ken Colyer, and this marks the moment he returned with his entire band—the first complete New Orleans group to appear all over the country, at venues from Southampton to Glasgow.**

BOTTOM LEFT: **George Lewis became a figurehead of the New Orleans revival through his work with trumpeter Bunk Johnson, seen here during the band's 1946 residency at the Stuyvesant Casino in Manhattan. An atmospheric touch is the band's overcoats and hats piled precariously on Don Ewell's piano. At this point, drummer Baby Dodds had been replaced by swing player Alphonse Steele.**

TOP RIGHT: **Bunk Johnson and George Lewis at the Stuyvesant Casino, also taken in 1946. Johnson had returned from farming in New Iberia, Louisiana, and, equipped with a set of new teeth funded by jazz enthusiasts, began playing the trumpet again. He made some unsubstantiated claims about his background with Buddy Bolden, but played in an assertive pre–Louis Armstrong style.**

BOTTOM RIGHT: **After Bunk Johnson's death in 1949, George Lewis assumed his mantle as an "authentic" New Orleans player, and continued to work in the 1950s and early '60s with some of the musicians who had played with Bunk, including Jim Robinson, pianist Alton Purnell, and bassist Slow Drag Pavageau.**

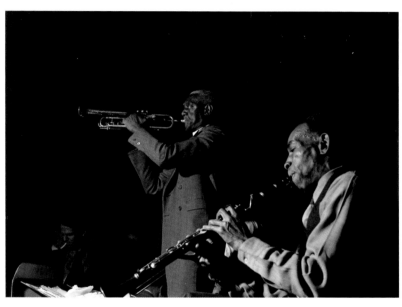

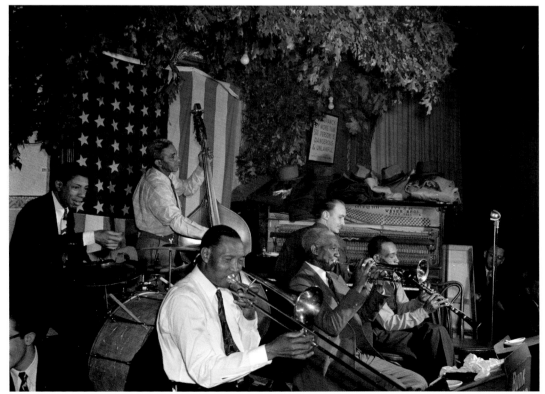

BELOW: **A year after Bunk Johnson's death, Stanley Kubrick arrived in New Orleans to photograph the George Lewis Band in action as "keepers of the flame" for revivalist jazz. In this shot, Kubrick himself entrusts the camera to a local, and sits in on drums with the band.**

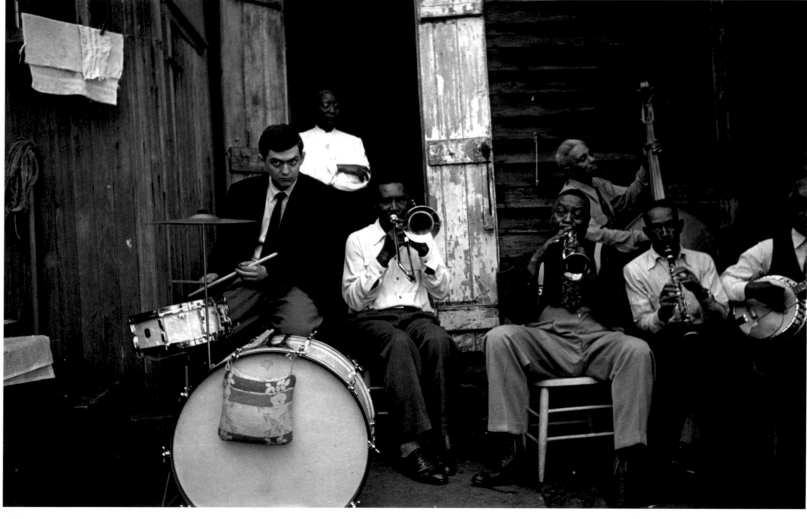

The Art of Jazz

BELOW LEFT: **With his genius for capturing the moment on film, this is one of Kubrick's most memorable photographs from his 1950 visit, as two neighbors spontaneously dance in the backyard to the George Lewis Band.**

BELOW RIGHT: **One of several pictures by Kubrick of children dancing to the George Lewis Band, featuring Joe Watkins (drums), Jim Robinson (trombone), Elmer "Coo Coo" Talbert (trumpet), "Slow Drag" Pavageau (bass), Lewis himself (clarinet), and Lawrence Marrero (banjo).**

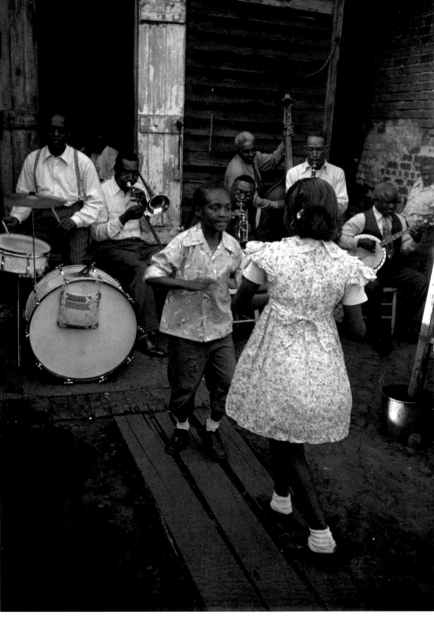

In the 1940s, while Lu Watters, Turk Murphy, and Bob Scobey were spearheading the traditional jazz revival in the United States, and veterans from Bunk Johnson to Kid Ory were being "rediscovered," a distinctively British dialect began to emerge in UK versions of New Orleans jazz. This combined visual quirks drawn from the British Isles' rich live entertainment tradition, with music that explored the United Kingdom's native musical heritage.

Humphrey Lyttelton pioneered using thematic material drawn from Britain. He later wrote, "From the start, jazz has constantly borrowed from European music. Good jazz has assimilated it, bad jazz has been diluted by it." Hence we find the gradual emergence from the revivalist chrysalis of a music with distinctly confused national identity, the resultant butterfly stretching wings with a Union Jack flag discernible upon them. Musicians whose initial aim was to recreate early New Orleans jazz began to bring in ideas that were some distance from the repertoire of Oliver and Morton.

A good example is Lyttelton's own One-Man Band. Echoing Sidney Bechet's overdubbed "Sheik of Araby," Humph plays piano, clarinet, washboard, and trumpet on the old folksong "One Man Went to Mow." Instead of adding to the menagerie, like "Old Macdonald's Farm," and extending the form of the song, Lyttelton applies a little jazz structure to it. But this—like his full band's "Suffolk Air"—shows his absorption of British folksong and dance material, while in some of his drawings, Lyttelton, an accomplished cartoonist, depicted himself and his band very much in terms of the British Music Hall circuit.

Chris Barber started out as a schoolboy fan of Lyttelton before launching his first amateur band in the late 1940s. His professional band, after a year of being led by Ken Colyer on his return from New Orleans, formally came into being in 1954. While with Colyer, the band's clarinetist, Monty Sunshine (who like Lyttelton and his clarinetist, Wally Fawkes, was a trained graphic artist), designed the cover of Colyer's first two LPs. Sunshine and guitarist Diz Disley, who also worked with Colyer, became prolific sleeve designers in the 1950s.

Barber cast his musical net far wider than most revivalists. The very first piece his own band recorded had its origins in both British folksong and the nursery, being the rhyme "Bobby Shaftoe" (1954).

It is a commonly held view that when the Beatles emerged a decade later, there was a standoff between jazz and pop musicians. "We were amused by certain aspects of what we felt to be a totally absurd phenomenon," writes jazz singer George Melly in his cultural analysis of the 1960s. But Chris Barber saw it differently. He spent much of the 1950s bringing in to Britain the progenitors of R&B—Sonny Terry and Brownie McGhee, Muddy Waters, Howlin' Wolf, and so on. And just as on their visits he had absorbed the blues into his band's work, along with "Bobby Shaftoe," he now annexed the Beatles' repertoire, seeing Lennon and McCartney's compositions as ideal material for the New Orleans Brass Band format. Barber's Eagle Brass Band made an EP of Beatles songs in October 1965. Later, he absorbed the visual nuances of rock, from the style of the band's name on the bass drum to the tie-dye T-shirts and flared trousers of flower power. After touring extensively in the United States and appearing on *The Ed Sullivan Show* in 1959 (four years before the Beatles), Barber became known as "the man who took 'trad' back to America."

The biggest success of the "trad" boom that followed Colyer and Barber's lead—Acker Bilk—used a marketing campaign that played up his British identity. George Melly writes astutely of the work of his agent, Peter Leslie: "[He] imposed the obligatory 'Mr.' on all billings, dressed the product in striped waistcoats and bowler hats, and couched its publicity in elephantine pastiche of Victorian advertising prose, larded with unbearable puns."

In the mid-sixties, after recording a set of jazzed-up British military marches, Bilk lived up to his bowler-hatted music-hall image with the "Chelsea Cake Walk," but he also nodded toward African highlife on "Nairobi Knees Up." In the British trad boom, other images conjured up to sell the product were just as bizarre as those of Peter Leslie and Acker Bilk. The Bob Wallis Storyville Jazzmen dressed as Southern gamblers; Doc Stanton's Professors of Jazz displayed gowns and mortarboards. There was more than a shade of tartan around Forrie Cairns and the Clansmen, while contentiously, Bobby Mickleburgh's Confederates—most likely out of a degree of ignorance about American history—chose a name and uniform that echoed, in W. E. B. Dubois's words, "Robert E. Lee's war to perpetuate human slavery."

British trad bands—principally Barber's—became a significant export to Europe in the sixties and seventies, and at least some German and Dutch groups—including Berlin's White Eagle Band and the Dutch Swing College—incorporated what was being made in Britain, as well as looking back at the American roots of the music. In France, the leading band to combine revivalism with a local accent—in this case Gallic humor—was Les Haricots Rouges, who formed in 1963 and became wildly successful, with sales in excess of a million records (maybe up to double that number, if cassettes are taken into account). Their stage shows involved authentically played New Orleans jazz, plus music from the Francophone Creole world, the méringue, zouk, and ska influences of the Caribbean. But they also involved visual comedy, tumbling, acrobatics, and a remarkable ability to play one another's instruments simultaneously. Again, a European entertainment tradition had crept into music that was allegedly authentic traditional jazz.

Trad in Europe

"While rock and roll, swing, ballad rock, cha cha and the twist come and go, trad goes on from strength to strength."

Ivan Berg and Ian Yeomans, *Trad* (Foulsham, 1962)

The Art of Jazz

BELOW LEFT: **Although clarinetist Monty Sunshine had left Ken Colyer's band when this 1954 Decca LP was recorded, he was retained to draw the cover picture, as he had for the band's previous album, *New Orleans to London*. A former student at Camberwell College of Art, Sunshine continued to design record covers through the 1950s.**

TOP RIGHT: **Two of Britain's most popular "trad" bandleaders, in line drawings by guitarist and banjo player Diz Disley. With a talent for accurate portraiture and distinctive penmanship, Disley created comparable artwork for dozens of LPs in every style of jazz. He was also an accomplished broadcaster, and later played a big role in relaunching Stéphane Grappelli's career during the 1970s.**

BOTTOM RIGHT: **A cartoon by Trog (whose work also appears on page 99) showing veteran bass saxophonist Harry Gold. Harry had been drawn to jazz by seeing the Original Dixieland Jazz Band in London in 1919, and led his Pieces of Eight from the 1930s to the 1980s. Trog's subtle criticism of the honking sound of the bass sax is that it emanates from Gold's nose.**

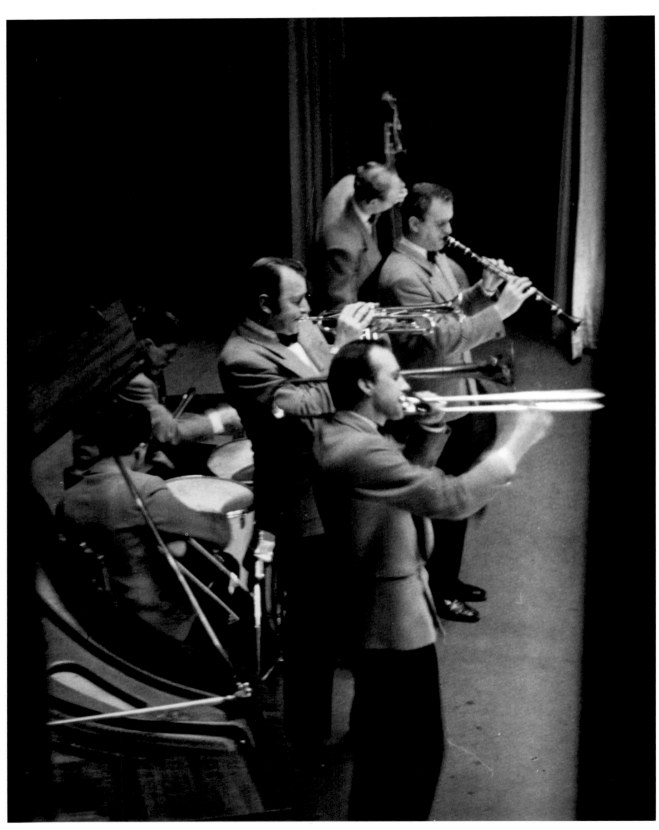

The Art of Jazz

LEFT: **One of the most influential of all British traditional bands, led by trumpeter, writer, and broadcaster Humphrey Lyttelton, photographed in 1956. Left to right: Freddy Legon (guitar), Stan Greig (drums), Lyttelton (trumpet), Jim Bray (bass), John Picard (trombone), and Wally Fawkes (a.k.a. cartoonist "Trog") on clarinet.**

BOTTOM LEFT: **Cartoonist Joe Mathieu is best known for illustrating over 150 children's books, most famously the series associated with** *The Muppet Show*. **But when Bob Erdos set up Stomp Off records to present traditional jazz, Mathieu became his main cover designer, as for this release by trombonist Daniel Barda and his Paris Washboard band.**

TOP RIGHT: **For five years in the early 1950s, French artist Pierre Merlin brought his delicate line drawings to discs of American jazz rereleased for Europe on the French Vogue label. After designing dozens of covers, like this one for Lu Watters's West Coast revivalists, he forsook illustration for industrial design, and created some of France's most distinctive railway stations!**

BOTTOM RIGHT: **One of Joe Mathieu's great skills was to caricature legendary American musicians alongside Europeans who played their music. The Hot Antic band from Nimes in the South of France not only toured with 1920s trumpet star Jabbo Smith in 1982, but painstakingly recreated the style and sound of his Rhythm Aces.**

On the wall of the Royal Roost club in New York City, at 1674 Broadway, was a sign that read, "The House That 'Bop' Built." While that statement is not strictly true, in that various other clubs made an equally significant contribution, the caricature below the caption on the banner is a beret-wearing, bespectacled, goateed face.

This universal identification with Dizzy Gillespie's carefully contrived image and bebop carried over into general journalism. For the issue of *Life* magazine dated October 11, 1948, Dizzy and his one-time bandleader Benny Carter were photographed in a strip of four frames demonstrating a "bebop greeting." There is the initial greeting; the "sign of the flatted fifth" (one of the distinctive harmonies of bebop jazz); the shout "Eel-ya-dah"; and finally "the grip," which looks like a particularly athletic version of a secret society's handshake. "Beboppers can now converse," runs the caption to the final shot. Other pictures in the article show Dizzy displaying his "ostrich leather shoes" to a representative of the AFM; surrounded by female fans wearing spectacles, berets, and false beards; and in a staged jam session with pianist Mel Powell.

Many of these ideas are rooted in the swing era, and the promotion for Gillespie's former boss, Cab Calloway, whose white tail–coated 1930s persona formed the basis for characters in various *Betty Boop* cartoon films, and whose 1940s zoot suit has already been mentioned. Gillespie knew that memorable visual cues were a vital way of fixing his image in the public imagination—hence, in 1954, he adopted a trumpet which had its bell angled upward at an angle of forty-five degrees. Now, with his puffed-out cheeks, his upturned instrument, his spectacles, and his beret, Dizzy had arrived at the image he would retain throughout his career. And even if, in later years, the headgear altered a little, and he sometimes abandoned the eyeglasses, the turban-wearing Dizzy on *The Muppet Show* in January 1980, playing "Swing Low, Sweet Cadillac," is instantly as recognizable from his visual image as he is from his immediately identifiable singing and playing.

In the mid-forties, however, the bebop uniform was not restricted to Dizzy. In 1943, Mary Lou Williams recalled Thelonious Monk ordering a pair of "heavy framed sunglasses" similar to a style of ladies' spectacles. "He had," she wrote, "been wearing a beret with a small piano clip in it for some years previous to this. Now he started wearing the glasses and beret and others copied him." Photographer William Gottlieb recalled that Monk's spectacle frames differed from the normal horn-rimmed design because "his were done half in gold." But what had been—at least initially—a settled appearance for Dizzy was nothing of the sort for Monk. As his fame and income grew, he developed a taste for fine suits and tailored shirts, but his collection of headgear grew exponentially. A biographer, the French pianist Laurent De Wilde, would comment, "In the course of his travels he had accumulated a vast collection—oval, round, pointed, felt, fur, shiny, or soft ones. Monk had hats for all occasions. His headgear was as much a bebop trademark as Dizzy's beret and glasses."

Some elements of this new visual appearance were absorbed into artistic representations of the "new jazz" very swiftly. So, for example, the Harlem-born, African American painter Norman Lewis captured the angularity of bebop's phrasing and rhythms in his *Jazz Musicians* of 1946 but just as accurately caught the atmosphere of one of the Harlem after-hours clubs in which bebop was born in his *Harlem Jazz Jamboree* of 1943. Lewis's painting career had a trajectory that stretched from affectionate realism in twenties Harlem to the complete abstract expressionism of Jackson Pollock, with whom he exhibited. A work like his later *Phantasy II* conjoins his depiction of bebop in line with the aesthetic of Pollock. At the same time, Stuart Davis, who had chronicled jazz in his work to date, began producing work, like *The Mellow Pad* (1946–1951), that embodied a bebop sense of rhythm.

Later artists, including the widely syndicated Gil Mayers and the short-lived but dazzling Jean-Michel Basquiat, looked back at this era for inspiration. Basquiat in particular used images of Gillespie and Charlie Parker to evoke the essence of African American music of the period. Central to his depiction of these two musicians in his work of the 1980s, such as *The Horn Players* (1983), is a reference back to the "bebop uniform" of the 1940s.

Bebop Fashion

"Dizzy sought his individuality in manifold ways. He didn't stop at the forms and formulas of bebop, clear as they were, associated with him as they were. He went on to develop a visual personality."

Barry Ulanov, *A History of Jazz in America* (Hutchinson, 1950)

BELOW LEFT: This image by William Gottlieb removes Dizzy Gillespie's physical presence to focus on nothing more than what Barry Ulanov called his "visual personality." It parallels the Royal Roost image mentioned in the text, and became the template for bebop fans the world over.

BELOW RIGHT: Female fans adopt the garb of beret, spectacles, and goatee as they queue for Gillespie's autograph.

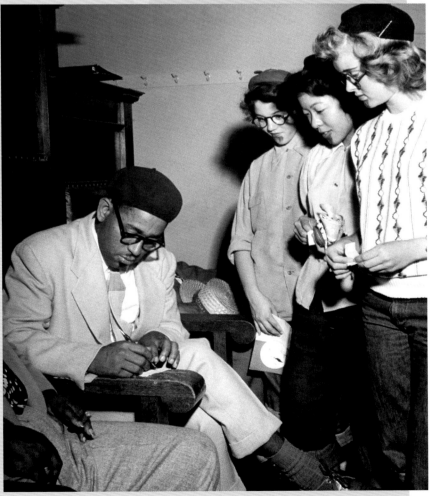

BELOW: **This untitled 1945
abstract by Norman Lewis,
generally known as** *Jazz
Club*, **marks his movement
into abstract expressionism.
He was the first African
American painter in this
group, many of his canvases
reflecting his preoccupation
with racial politics. Here,
however, we see a set of
coded images, from the
piano to dancing feet and
fleeting glimpses of guitar
frets and trumpet valves.**

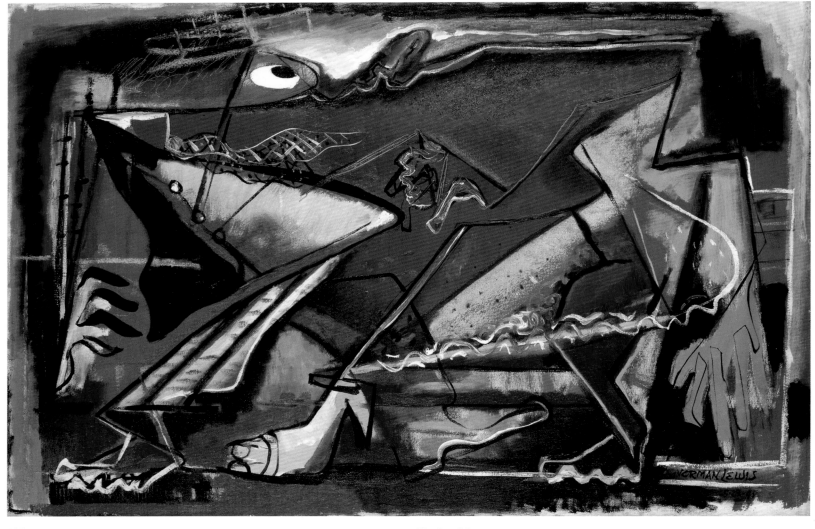

The Art of Jazz

RIGHT: Two images from *Life* magazine's 1948 "bebop greeting" feature. Above, see Benny Carter and Dizzy Gillespie demonstrate "the grip"; below, the sign of the "flatted fifth." The right-hand five fingers are extended to show the first five notes of the major scale, and the left lies below, indicating that the fifth will be flattened by a semitone, a key harmonic device in bebop.

BELOW: Minton's club in Harlem was one of the venues where bebop was first developed in the early 1940s. An after-hours club where musicians gathered after their regular gigs to jam and experiment with new harmonies and rhythms, the house band was led for a time by Thelonious Monk, seen here at Minton's with pioneer bebop trumpeter Howard McGhee.

The Art of Jazz

TOP: A fine image of Dexter Gordon, who had recorded with Dizzy Gillespie's sextet in 1945, before going on to establish himself as one of the major tenor saxophone soloists in jazz. Using light reflected from the lacquer on a saxophone or trumpet to suggest movement became a stock in trade for jazz photographers.

BOTTOM: This atmospheric shot of New York's 52nd Street by William Gottlieb, who chronicled its many clubs and musicians, shows how closely the venues were packed into the street's basements, each vying to attract customers with the greatest names in jazz.

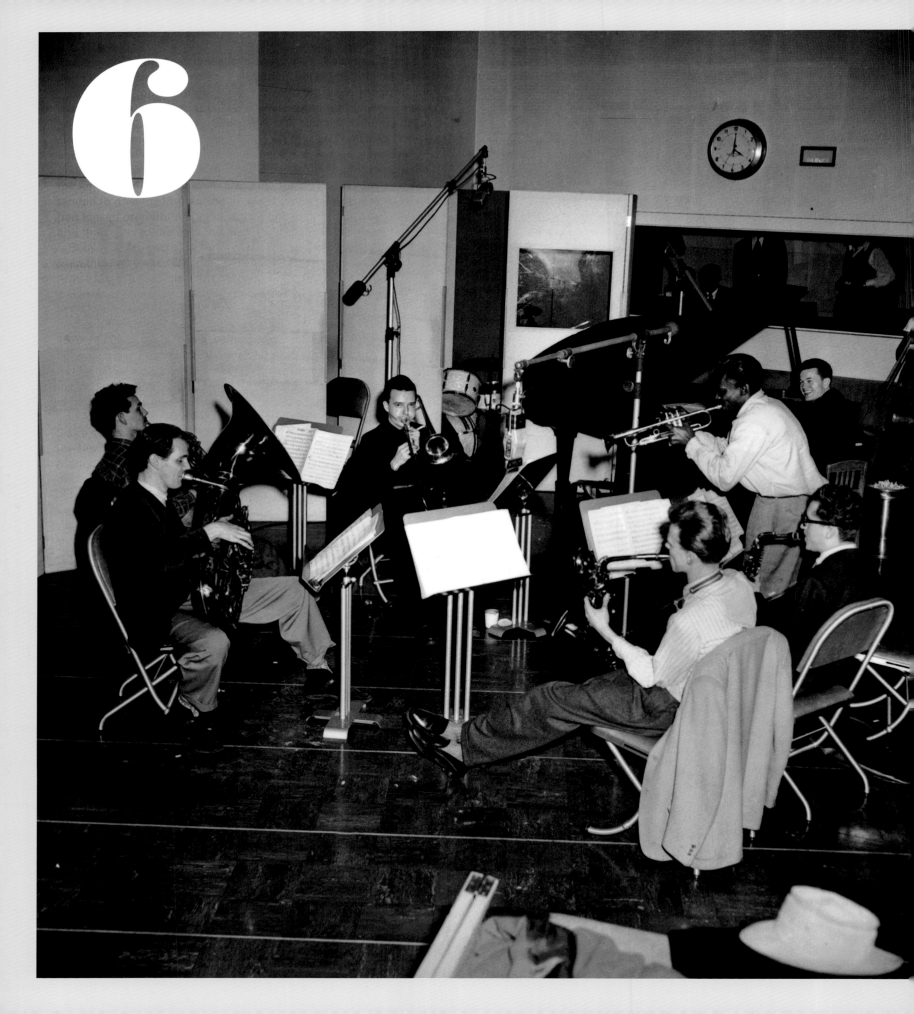

Birth of the Cool and West Coast Jazz

"Perfect intonation, great execution, everything clean and neat"

The first images of Miles Davis as a bandleader in his own right show a move away from the eccentricities of bebop fashion. Apart from a few pictures dating from his early years in St. Louis, Miles first appears regularly in images of the Charlie Parker quintet from 1947–1948. In publicity photographs immediately following the time he left Parker, Miles is clad in neat Italian suits or sports jackets. And as photographers such as Herman Leonard began to take an interest in him—such as in Leonard's famous portrait from the Royal Roost in 1948, taken around the time that the "Birth of the Cool" nonet played there—the image is one of understated sophistication. And that, indeed, is what the nonet was all about.

Davis's biographer, Ian Carr, suggests that the impulse that inspired Miles's collaborators Gil Evans and Gerry Mulligan came from the "gentler and more contemplative" expression in Charlie Parker's playing. They aimed to create "a much more organic role" between individual soloists and the smallest practicable ensemble needed to retain the range of orchestral colors they had previously explored in their writing for larger bands. Miles himself used a characteristically visual metaphor to explain his move from the fast-paced, jagged lines of bebop improvisation with Parker to the sounds of his own nonet: "It's just like clothes. All of a sudden you decide you don't have to wear a flower up here and spats, you know? You wear the flower and leave off the spats and pretty soon you leave off both of them."

According to most members of the nonet, although the underlying ideas were developed collectively, it was Miles who drew everything together. And although the Royal Roost bookings in September 1948 did not create the kind of publicity stir that the musicians might have hoped for, Miles nonetheless was signed to Capitol to record twelve pieces, each to occupy one side of a 78 rpm disc. The resulting sessions took place in January and April 1949, with a final one in March 1950. Only eight sides were issued at the time as single releases, and these subsequently appeared on a ten-inch LP as *Classics in Jazz* in 1954. But it took until 1957 for the entire output to come out on a twelve-inch LP, which is when the title *Birth of the Cool* was first used.

By this time, Miles himself had moved on musically, and as well as leading his quintet with John Coltrane—with whom he made the albums *Steamin'*, *Cookin'*, *Relaxin'*, and *Workin'* for Prestige—he had begun a series of records alongside the Gil Evans Orchestra with *Miles Ahead*,

recorded in May 1957. Yet his own development in those intervening seven years, despite the ups and downs of heroin addiction in the early 1950s, had underlined his essential qualities of *cool*. And the work of the musicians who played with him on the nonet recordings—notably saxophonists Gerry Mulligan and Lee Konitz, and pianist John Lewis—had, by 1957, further delved into the contemplative territory of "cool" jazz. One aspect of "cool" that remained with Miles was a growing interest in visual arts, and in his later years he became a fine graphic artist and painter in oils; he published a book of his work, and there have been several exhibitions (including an acclaimed posthumous retrospective in London in 2010). One of his own paintings adorns the sleeve of his 1983 album *Star People*.

Mulligan, having worked as an arranger and saxophonist for several bands in the East, moved to California after his time in the Davis nonet. And some of the sound world that he had created with Miles—notably the interplay between his baritone saxophone and Miles's open trumpet—became the basis for the quartet that he started in Los Angeles in 1952, and which played at the tiny Haig club on Wilshire Boulevard. The trumpet playing of Chet Baker evoked the clear, vibratoless sound of late-1940s Miles, and the particularly light feel of the rhythm section was because there was no piano or guitar to provide the harmonies, just bass, to add a counterpoint to the horns, and drums, to underline the rhythm. "No one else at that time even thought of it," recalled the band's drummer, Chico Hamilton, "that idea of not having a chordal instrument. But Gerry was cool."

In fact, Mulligan had borrowed the idea from a New York–based percussionist, Gail Madden, with whom he had worked briefly before heading west, but it was the infectious musical chemistry of his new band that made the idea work commercially. After the quartet cut their first informally produced but musically definitive records to launch Richard Bock's Pacific Jazz label, and followed that up during a short trip to San Francisco with a session for Fantasy Records, their cool sound and image caught on. Ironically, their first LP predated the Davis *Classics in Jazz* LP by almost two years, so those listeners still unaware of the Davis 78 singles might have thought of Mulligan as an even greater originator than he actually was. The Haig club was soon packed, and *Time* magazine ran a profile of the Mulligan quartet in February 1953, pointing out that their posed, contrapuntal, elegant music was a huge contrast to "the frantic extremes of bop."

Birth of the Cool and West Coast Jazz

PREVIOUS SPREAD: The first *Birth of the Cool* recording session, January 1949. Left to right: Junior Collins (French horn), Bill Barber (tuba), Kai Winding (trombone), Max Roach (drums, behind window), Gerry Mulligan (baritone saxophone), Miles Davis (trumpet), Lee Konitz (alto saxophone), Al Haig (piano), and Joe Shulman (bass).

BELOW LEFT: The liner notes to Miles Davis's *Star People* album say Davis is responsible for "all drawings, color concepts and basic attitudes." Designer Janet Perr and Columbia's art director John Berg used Miles's sketches of dancing and trumpeting figures on both front and back of the 1983 LP cover, and chose a palette that reflected the colors of the artwork.

TOP RIGHT: The famous cover of the eventual 1957 twelve-inch LP release that gathered all the *Birth of the Cool* tracks into one album. Miles is the understated epitome of cool from his shaded spectacles to the smart sports shirt.

BOTTOM RIGHT: From his series of artfully posed photographs of Miles Davis working on his 1958 Gil Evans collaboration *Porgy and Bess*, Don Hunstein uses several favorite devices of jazz photographers, from the strategically placed microphone to the published piano score of "Oh Bess, Oh Where's My Bess" (positioned to inform the viewer), plus the curling cigarette smoke, Marlboro pack, and low studio lights.

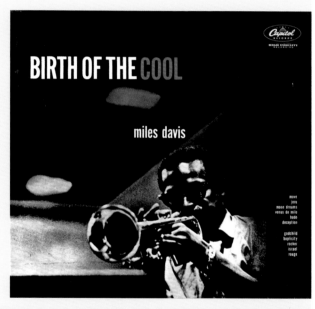

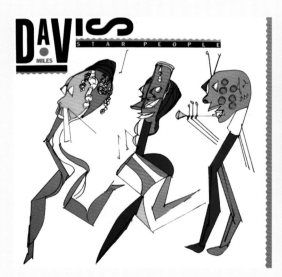

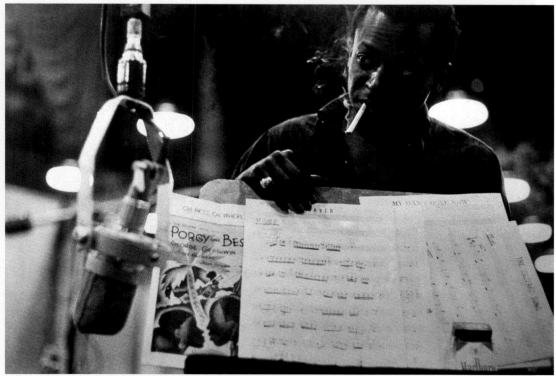

The visual appearance of the band intensified the "cool" label. Baker's biographer, James Gavin, quotes the singer Mark Murphy as observing, "To show enthusiasm was 'not cool.' You had to act like you didn't care." So, even though informal attendees at the recording sessions noticed Chet and Gerry expressing joy at each other's playing, this was not something that their club or concert audiences saw. At the Haig, Chet stared at his feet while not playing, and Gerry—whose eyes were often shut while he blew—observed the world though half-closed eyelids. Photos from the time show them smartly suited, both apparently lost in the music. Retrospectively, it is clear that this was—at least in part—because the two men were heroin users. But until Mulligan's arrest in late 1953 for drug offenses, they typified something new in American life: a "live-for-the-moment" attitude that cared little for the future, and was all about rebelling against the conservative social mores of postwar America. The cover of their first LP for Pacific, from 1952, also features an overhead portrait shot of the group that shows they were racially mixed. Before the civil rights legislation and social change of the 1960s, this was still a controversial image, and together with the ineffably cool photographs of William Claxton, taken at the Haig, which typified their public personae, these elements helped to cement the group's visual image. When Lee Konitz sat in with the quartet and recorded an album, Dick Bock decided to go for a cover design that reflected the linear abstract art seen earlier with Mondrian and Van Doesburg.

There's more about Chet Baker, who got his own *Time* feature a year after Mulligan's, a little later in this section, but the other key band in creating the image of West Coast Cool in the early 1950s was the Dave Brubeck Quartet.

A composition pupil of the classical musician Darius Milhaud at Mills College, Brubeck followed a route to jazz that was quite unlike those who had come up through the big bands. His early octet explored very different ideas from the Davis nonet, owing more to contemporary European tone color, rhythms, and structure. But it was Brubeck's quartet—formed in 1951, with the alto saxophonist Paul Desmond— that forged his rise to fame. The band targeted the college market,

playing to the very same adolescent crowd that liked the "live for now" attitude of Mulligan and Baker. Touring to play—and just as importantly to record—on campuses across the United States meant that, for many college students, the Brubeck quartet was the first live jazz they heard, and the resulting albums became often-played mementos of student days, creating a long-term loyal audience for the future. When *Time* featured him on its cover on November 8, 1954, his portrait was accompanied by artwork showing the hands of the band at work, but also, maybe more significantly for his reputation, the legend, "The joints are really flipping!" By contrast, maybe aiming to capture the pure simplicity of Desmond's tone as he tackled a standard ballad, Pierre Merlin's artwork for the French Vogue release of the quartet's first album reduced it to basics—a single piano key, a bass bridge, an African drum, and a quarter note to represent the alto saxophone.

The other notable contributor to the "cool" movement who had been in the "Birth of the Cool" nonet was East Coast–based pianist John Lewis. Before his connection with Davis, he had played in the Dizzy Gillespie Big Band, alongside vibes player Milt Jackson, bassist Ray Brown, and drummer Kenny Clarke. This rhythm section often played short sets during Dizzy's big-band shows, just to give the brass players a break from the strenuous arrangements. "Since we got to doing this every night," recalled Brown, "we started putting some stuff together." And thus the Modern Jazz Quartet (initially known as the Milt Jackson Quartet) was born.

In due course, Brown and Clarke left, to be replaced by bassist Percy Heath and drummer Connie Kay, but the essential sound of the band remained consistent. Lewis produced compositions and arrangements that explored the counterpoint and clarity of baroque music, yet everything was suffused with the bluesy phrasing of Jackson's vibes playing. With their tuxedos, or tailored suits and silk ties, the quartet took jazz from the club to the concert hall. Images abound of their urbane appearance, but few catch the ineffable coolness of the group as effectively as Herman Leonard's atmospheric shots of the band playing in Paris in 1957, or Franz Hubmann's from the same year in Germany.

"The people couldn't tell the part that was improvised and the part that wasn't. Because the group eventually became so tight-knit, it got so we could breathe together."

Milt Jackson interviewed about the Modern Jazz Quartet on BBC Radio, 1976

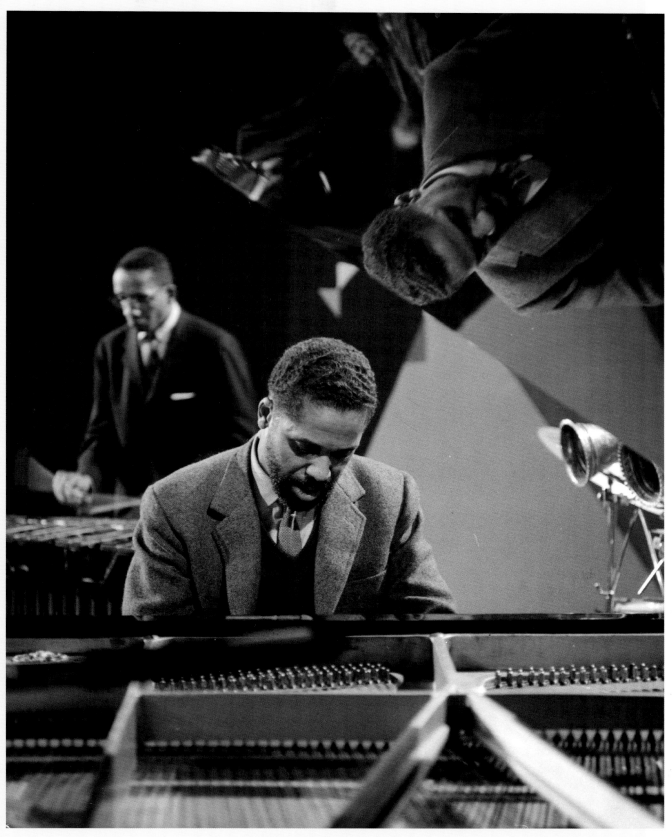

TOP LEFT: **Bob Willoughby's** action shots of the Brubeck Quartet performing during their tour of American college campuses in 1954 are presented on the resulting record as a cross between a contact sheet and a photo album. The idea was to resonate with the students who had experienced the band live and create a long-term memento.

TOP RIGHT: **Brubeck strikes** his immediately recognizable playing pose in the catalog for Fantasy, which issued his first discs in the early 1950s. Below the photograph is an encomium from critic and record producer John Hammond.

BOTTOM LEFT: **Painter Bob** Parker produced artwork for several concert sets that Columbia recorded at the 1958 Newport Jazz Festival, including Mahalia Jackson, the Duke Ellington Orchestra, and Marshall Brown's International Youth Band. His most memorable caricature is of the Brubeck Quartet.

BOTTOM RIGHT: **When French** Vogue released a selection of Brubeck's work for the European market, once again it was Pierre Merlin's minimalist artwork (as shown on page 123) that adorned the sleeve, reducing the quartet to essentials.

BELOW: S. Neil Fujita joined Columbia to build on the design work of Alex Steinweiss, with the intention of rivaling the cover art of Blue Note and the nascent Verve label. This 1959 album is one of his own most memorable and dazzling designs, adopting images from Brubeck's Native American heritage but also referencing the unusual time signatures of every track.

BELOW LEFT: **The photographs by William Claxton on this French Swing issue show the Gerry Mulligan Quartet's original sharp-suited appearance, caught in action at the Haig Club in Los Angeles around the time the group first recorded for Pacific Jazz.**

BELOW RIGHT: **Just as Bill Gottlieb chronicled the 52nd Street scene in New York, William Claxton was on hand to document the emergence of West Coast Cool. The 1954 book advertised here, with eighty pages of his monochrome prints, was one of the first collections of jazz photographs ever published.**

BERNIE'S TUNE
WALKIN' SHOES
NIGHTS AT THE TURNTABLE
LULLABY OF THE LEAVES

FRENESI
FREEWAY
SOFT SHOE
AREN'T YOU GLAD YOU'RE YOU

Gerry Mulligan, baritone sax. Chet Baker, trumpet. Carson Smith, bass. Forrest "Chico" Hamilton, drums.

THE GERRY MULLIGAN QUARTET vol. 2

Recording Supervision by RICHARD BOCK for PACIFIC JAZZ Records

MICROGROOVE
*S*WING

M. 33.305

announcing *jazz west coast*

an exciting documentary collection of photographs by William Claxton covering the West Coast jazz scene $2.50

→ *articles*
→ *discography*
→ *history of West Coast jazz by Nesuhi Ertegun.*

DAVE BRUBECK SHORTY ROGERS
GERRY MULLIGAN PAUL DESMOND
CHET BAKER SHELLY MANNE
RUSS FREEMAN CAL TJADER
BARNEY KESSEL BOB COOPER
LIGHTHOUSE ALL-STARS
JIMMY GIUFFRE MAX ROACH
CLIFFORD BROWN STAN GETZ
STAN KENTON AND MANY MORE

ORDER NOW SEND CASH, CHECK, OR MONEY ORDER TO:
LINEAR PUBLICATIONS 6124 SANTA MONICA BOULEVARD HOLLYWOOD 38, CALIFORNIA

PACIFIC JAZZ *Enterprises, Inc.* *Hollywood, Calif.*

BELOW: **In 1960, the Mulligan quartet appeared in the movie *The Subterraneans*. Gerry played a saxophone-wielding priest, wooing beatniks toward a godly life via jazz. Scenes like this, with trumpeter Art Farmer, bassist Buddy Clark, and drummer Dave Bailey, capture the moment when "underground" jazz appealed to American youth. This photo was the cover shot of the French soundtrack LP, entitled *Les rats de cave*.**

When Gerry Mulligan was sent to the Sheriff's Honor Farm—a California prison for low-risk inmates—in 1953, Chet Baker began to change his image. This was precipitated by Pacific Jazz producer Dick Bock urging Chet to record with his own quartet, which featured the young pianist Russ Freeman, who had recently quit heroin and was on the point of producing some of the best playing of his life. Bock recorded the quartet extensively, also making discs with slightly larger groups, and—in a coproduction with producer George Avakian at Columbia—presenting Chet with a string orchestra. From the suited, floor-gazing member of Mulligan's quartet (the image used again on Pacific's very first Baker Quartet album), Chet was gradually transformed into a T-shirt-wearing matinee idol, thanks to the dazzling photography and record sleeve design of William Claxton. The *Chet Baker and Strings* album cover (the topmost image in the *Jazz West Coast* flyer on page 138) was transitional in this process of becoming less formal. It shows him in a striped sports shirt, sitting pensively in the studio, clearly intensely involved in the recording experience.

When Mulligan was released from jail, Chet immediately confronted him with demands for more money, and they parted company. The days of the original Mulligan quartet were over for good. Gerry headed east to form his next band, with valve trombonist Bob Brookmeyer, and Chet settled with his own quartet.

As Baker's career developed, the T-shirted, innocent boy was the dominant image. Even so, because of a missing tooth, he was invariably depicted with his mouth closed, or with a microphone strategically placed to cover the gap. In the decade before the Beach Boys, many of the record-sleeve photographs suggested the Californian surf and sun life, with Baker at his most extroverted in Claxton's sailing-boat picture for the 1956 Pacific album *Chet Baker and Crew*. Again, like the Mulligan quartet photos, this record cover shows an interracial band, with African American pianist Bobby Timmons and bassist Jimmy Bond pictured alongside Chet, saxophonist Phil Urso, and drummer Peter Littman.

Alternatively, Pacific's album art would focus on the love exemplified in the lyrics Baker sang, by attempting to convey something of the romance in his close-miked, intimate style. William Claxton captured Chet in poses with his wife, Halema Alli, and later there were similarly romantic shots with his European friend Lilian Cukier. Other depictions of Baker borrowed from Hollywood images of the time, particularly the romantic rebel imagery associated with James Dean. Shot in grainy monochrome, in brooding close-up (as in a mid-1950s photograph published in *Metronome*),

these have obvious similarities to the cinematography and advertising material for movies such as Dean's 1955 *Rebel Without a Cause*. The parallels did not end there, as Baker performed on the soundtrack to the 1957 documentary *The James Dean Story*. The cover art for the Pacific release of that music was designed by Woody Woodward and features a photograph of Dean taken by Roy Schatt.

When Chet moved east in 1958 and signed to Riverside records, the label used two aspects of his established image to present its new recordings with the cream of New York–based musicians, including the rhythm team of bassist Paul Chambers and drummer Philly Joe Jones. On the one hand, on *Chet in New York*, he wears a smart jacket and tie with impeccably groomed hair, looking like a mature, prosperous man rather than the beach character of the earlier discs. But on *Chet*—although it contains none of his breathy romantic vocals—he is clad in a cashmere sweater, with his trumpet in hand, and shown once more in female company. The urbane outward appearance of Baker on both albums is at odds with what was actually happening in his life, as he slid deeper into addiction, before finally being convicted and sent to Rikers Island prison in 1959. From then on, until his mysterious death, falling from an Amsterdam hotel window in May 1988, the poster boy of West Coast Cool is seen in cover after cover and photo after photo in which his face maps his inexorable physical decline. When fellow West Coast trumpeter Jack Sheldon met him some years later and asked about the deeply etched lines in Chet's face, Baker replied, "They're laugh lines." Sheldon's instant response was, "Nothing in life is that funny."

Baker's photogenic looks and his wistful, fragile, romantic ballad playing helped him to top the *Downbeat* polls and, in the 1950s, to receive regular well-paid club work and plenty of recording opportunities. This did not go unnoticed by African American musicians, who nicknamed Baker "the Great White Hope" and felt that he traded on music that black Americans had not only created but played better. West Coast trumpeter Art Farmer observed that "the music is not really accepted until a white person comes along and can do it." Nat Adderley described Baker as a "poor imitation of Miles," and Roy Eldridge simply said, "I don't dig that type of trumpet player." Davis himself, whose visual image was altered and updated almost as often as his musical personality, was more forthright. Maybe remembering a time in May 1954 when he and Chet were booked opposite one another as twin attractions at Birdland in New York, Davis wrote in his autobiography, "Him and me knew that he had copied a lot of shit from me."

Chet Baker

"It was a different style—soft, melodic. I think people were wanting and needing something like that and it just happened that at the time I came along with it and it caught on."

Chet Baker quoted in Robert Gordon, *Jazz West Coast* (Quartet, 1986)

TOP LEFT: John Altoon's line drawing of Chet Baker and Russ Freeman catches the musical connection between the T-shirted trumpeter now playing upward and outward (as opposed to the floor-pointing days with Mulligan) and the more introspective pianist. Altoon was a prominent West Coast artist who also drew covers for Oscar Peterson and Duke Ellington.

BOTTOM LEFT: The earliest of three images shown here to chart the changing image of Chet Baker. This French Swing label issue presents the smart-suited young trumpeter against a collage of international images.

BELOW RIGHT: One of a series of brooding portraits of Chet Baker and his wife Halema Alli by William Claxton, this marks the final stage of his transformation to James Dean–style matinee idol. Bruce Weber used the shot in this poster to promote his biopic of Baker, which, according to *Entertainment Weekly*, touched "the secret sadness at the heart of the man."

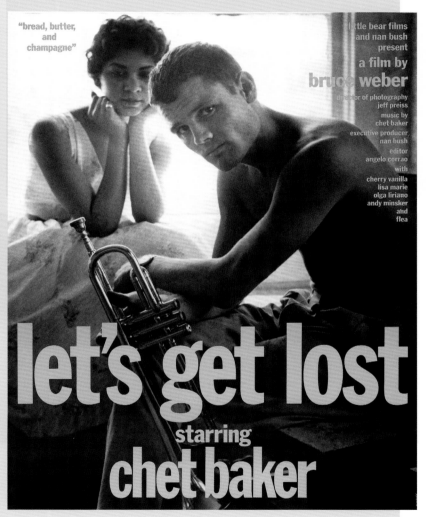

BELOW LEFT: A series of cut-out photographs by William Claxton forms his own design for this album by drummer Chico Hamilton. The band was unusual in that Fred Katz played cello in the lineup, and Buddy Collette played flute, clarinet, plus both alto and tenor saxophones, giving a huge variety of textures. Jim Hall was the guitarist and Carson Smith the bassist.

BELOW RIGHT: Exploring the same visual language, Claxton produced this photograph of the all-star band that bassist Howard Rumsey led at the Lighthouse Club, Hermosa Beach, California. Altoist Bud Shank (left) recalled the sand on which they're pictured blowing up to the club doorway, though pianist Claude Williamson looks discomfited with his toy piano!

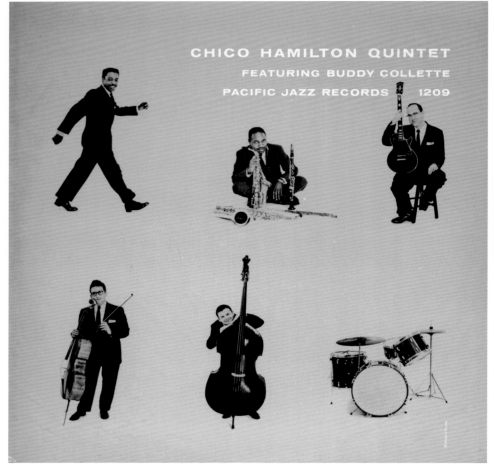

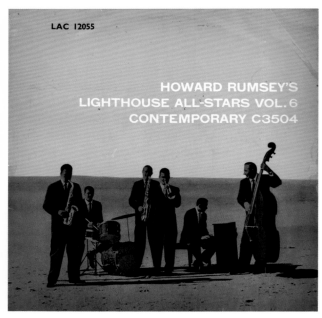

The Art of Jazz

BELOW LEFT: **Once again promoting the beach life of California, William Claxton set up this 1957 shot on a beach near Los Angeles. In a nod to the nascent sponsorship culture, the swimwear was credited on the sleeve to Rudi Gernreich, the controversial leisure-clothing designer who introduced the thong and the monokini.**

TOP RIGHT: **The West Coast jazz scene was not a male-only preserve. Anita O'Day personified cool in this 1959 album for Verve with clarinetist, saxophonist, and arranger Jimmy Giuffre. Later, Giuffre would be a key figure in the avant-garde, but he had acquired a great reputation as a bebop musician in the California-based bands of Woody Herman and Shorty Rogers.**

BOTTOM RIGHT: **Few albums capture the pre–Beach Boys surf culture better than Bud Shank's soundtrack to Bruce Brown's 1961 film about catching the wave. On the disc, Shank (left in the bottom photo), tenorist Bob Cooper, and trumpeter Carmell Jones expand the movie's music cues to full-length pieces.**

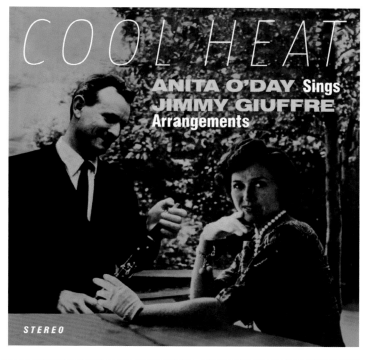

In its issue dated November 4, 1953, *Downbeat* carried a full-page advertisement from RCA, mainly focused on the music of trumpeter and arranger Shorty Rogers. With the strapline "Modern Jazz by the Man and the Band Who Make It Best," it referred readers to two of Rogers's albums, *Cool and Crazy* and *The Giants*, plus an EP plugging the forthcoming Columbia movie *Hot Blood* (even though everything about it, from the cover image to the tune "Blues for Brando," shows that it was in fact hastily rebranded from an earlier tie-in to Marlon Brando's *The Wild One*, even down to the cast photograph!) There was also a puff for a compilation LP called *Crazy and Cool*, linked visually and by title to Rogers's album but featuring other contemporary players in RCA's stable.

Rogers was well known as a former trumpeter and arranger for Woody Herman and Stan Kenton, and had been based in Los Angeles for some time, writing for the Hollywood studios, arranging jazz where he could (including part of Chet Baker's album with strings), and leading his small band, the Giants. His small-band arranging took forward many of the ideas in the Miles Davis nonet; his big-band writing developed out of his time with Kenton. Yet as the 1950s went on, Rogers, with his impish grin and short beard, became the unlikely focus of the cool movement. This was due more than anything to the marketing department at RCA, which initially had no intention of signing him. He recalled that he was helped by a colleague who had worked on his earlier Capitol album *Modern Sounds*:

> Jack Lewis went to RCA and told them they should record Shorty Rogers. They said, "Gee we don't know about that, but we have a title, and we'd love to get the album made. We don't know who to do it with."
>
> He said, "What's the title?"
> They said, "*Cool and Crazy*."
> Jack spoke on my behalf and then it wound up being me.

This big-band album compounded the zaniness of its cartoon cover with enigmatic song titles (many of them dreamed up by trombonist Milt Bernhardt and drummer Shelly Manne) that emphasized the *Cool and Crazy* idea, such as "Tales of an African Lobster," "Sweetheart of Sigmund Freud," "Infinity Promenade," and "Coup de Graas" (named after the band's French horn player, John Graas). "We had fun with the titles," recalled Shorty, "and it became a fun thing to have the title say more than 'I'm a tune'!"

A residency for his small band led not only to one of the most famous of Rogers's tunes, but also to an album that gave his record labels plenty of visual ideas for marketing. Playing at a nightclub called Zardi's, where the band had a residency of several months, the graffiti "Martians Go Home" had been written on the men's room wall. Shorty recalled:

> Someone told the girls who were waitresses about it, so it became a funny thing for the people that worked there. They'd say to one another, "Martians go home," and everyone would laugh. It became like a stone rolling down hill, and the thing was getting larger and larger, so we got on the bandstand one night, and I said, "Everyone listen, we have a new original we're going to play now for the first time, and it's entitled 'Martians Go Home.'"
>
> The bartender fell down laughing, and all the people working there were laughing, too. And the audience was wondering what all these crazy people were laughing at. I told the rhythm section, "Just play a blues in F," and while they were playing, I sang a little riff to Jimmy Giuffre, and we played this simple little repetitive melody. We had our little joke, and we thought that was the end of it. But the next night, we got to work, and before we got up on the bandstand, people were saying, "Play that 'Martians Go Home' thing." So it just became something associated with us.

On the French issue of the first album featuring the tune, there is a motif of a Martian spacecraft (looking suspiciously like a ride cymbal!) next to a boomerang (to symbolize the return home). More Martian tunes followed by public request, and when the band moved from RCA to the Atlantic label, their first album was *Martians Come Back*. For this, Shorty posed in a transparent plastic space helmet. It fit the image of being both cool and slightly crazy, and even when Rogers was touring internationally in the nineties, with the Lighthouse All Stars, audiences still came up requesting the "Martian" tunes, at least in part prompted by memories of those original record sleeves.

Shorty Rogers

"The original ten-inch LP version of *Cool and Crazy* is a prized collector's item . . . every performance is memorable. . . . Seldom have big bands swung so hard or produced such a joyous sound."

Robert Gordon, *Jazz West Coast* (Quartet, 1986)

The Art of Jazz

BOTTOM LEFT: **It was William Claxton who set up the photo shoot for Shorty Rogers in this improvised spaceman's headgear plus formal suit jacket and tie. As Shorty told the author, "I don't normally wander around wearing a space helmet."**

TOP: **The cartoon that RCA's design department added to** *Cool and Crazy* **pepped up the zany image of the record title, and bore little relationship to the music— there is, for example, no guitar on the record, despite the character second from the right!**

BOTTOM RIGHT: **A classic of Jim Flora's record-cover designs, this seems incredibly busy, yet the only two musicians actually depicted are Shorty with his trumpet on the left, and the central figure of Count Basie (whose music is interpreted on the album) at the whimsical piano.**

BELOW: Bert Stern's movie *Jazz on a Summer's Day* was actually shot at the festival in Newport, Rhode Island, on the East Coast, but the film poster loops in the sense of West Coast beach culture with the figures of Gerry Mulligan (top left) and Chico Hamilton (top right), both of whom appeared at this 1958 event. Many other great figures in jazz also appeared in the picture, including Jack Teagarden and Louis Armstrong, both seen here.

"Central Avenue was one of the swingingest streets I've ever been on," recalled pianist Fletcher Smith, talking of the hub of the downtown Los Angeles jazz scene, which lasted from the 1920s into the 1950s. "People are stiff in New York. People out here swing. They're casual. A man put on a sweater and a pair of pants and some house shoes and would go out and party." While the white press—and to a large extent West Coast labels like Pacific Jazz—focused on the white scene, Los Angeles was home to one of the most fertile areas of African American jazz in the country. In the immediate postwar period, Central Avenue saw residencies from trumpeter Howard McGhee and saxophonist Teddy Edwards, from drummer Roy Porter and younger, up-and-coming players like bassist Charles Mingus, multi-instrumentalist Eric Dolphy, and trumpeter Art Farmer.

Although trumpeter Clifford Brown and drummer Max Roach came from the East, their famous quintet was born in the West, after Max played at the Lighthouse Club on Hermosa Beach. Their formation came at the suggestion of disc jockey, concert promoter, and future record-label boss Gene Norman. Performing first with Teddy Edwards and then a young tenor player named Harold Land, the band also brought in local bassist George Morrow and Bud Powell's brother Richie on piano. In August 1954, they cut their first records in Los Angeles, for the Emarcy label. Morrow and Land had been regulars in long jam sessions with Eric Dolphy, and they were well prepared for the dazzling brilliance of Brown and Roach.

Dolphy himself played in a quintet led by Gerry Mulligan's one-time drummer Chico Hamilton. This band had begun working at a club called Strollers, on Long Beach, some twenty miles south of downtown Los Angeles. At first, their saxophonist was Buddy Collette, and the group's sound was built around the interplay between his tenor and the cello of Fred Katz. Guitarist Jim Hall and bassist Carson Smith completed the lineup. In due course, Dolphy replaced Collette, playing flute and bass clarinet as well as alto saxophone, and when the group appeared at the Newport Jazz Festival in 1958 (including a spot in the film *Jazz on a Summer's Day*), the glistening waterfront images combined with their sound to cement the image of a band born in a sun-drenched seaside climate.

The Black West Coast Scene

"Los Angeles became tagged as the home of the West Coast Cool sound—a label in many ways misleading about the music of Los Angeles, especially black Los Angeles. . . . The emergence of cool on the West Coast coincided with independent and very different 'hot' goings on."

Steven Isoardi, *Central Avenue Sounds* (University of California Press, 1998)

The Art of Jazz

TOP LEFT: Buddy Collette was famous as the reed player in Chico Hamilton's quintet, but he also became well known as the first African American musician to play in a Hollywood studio orchestra by breaking the color bar on *The Groucho Marx Show* for national TV in 1949.

TOP RIGHT: As well as his partnership with Howard McGhee, Teddy Edwards led his own quartet in Los Angeles until shortly before his death in 2003. This is one of that group's best records, from 1960.

BOTTOM LEFT: Howard McGhee had come to Los Angeles in 1945 with Coleman Hawkins, and was playing bebop there before Parker and Gillespie arrived. His band with Teddy Edwards and drummer Roy Porter was a pioneer modern jazz group, and here we see that front line reunited in 1961.

BOTTOM RIGHT: Hampton Hawes was a remarkable pianist, imbuing everything he played with a sense of swing and excitement. He worked with Shorty Rogers and Art Pepper, and recorded prolifically under his own name from 1951. Imprisoned for drug offenses in 1961, he resumed his career in 1963 after being given a presidential pardon by President Kennedy.

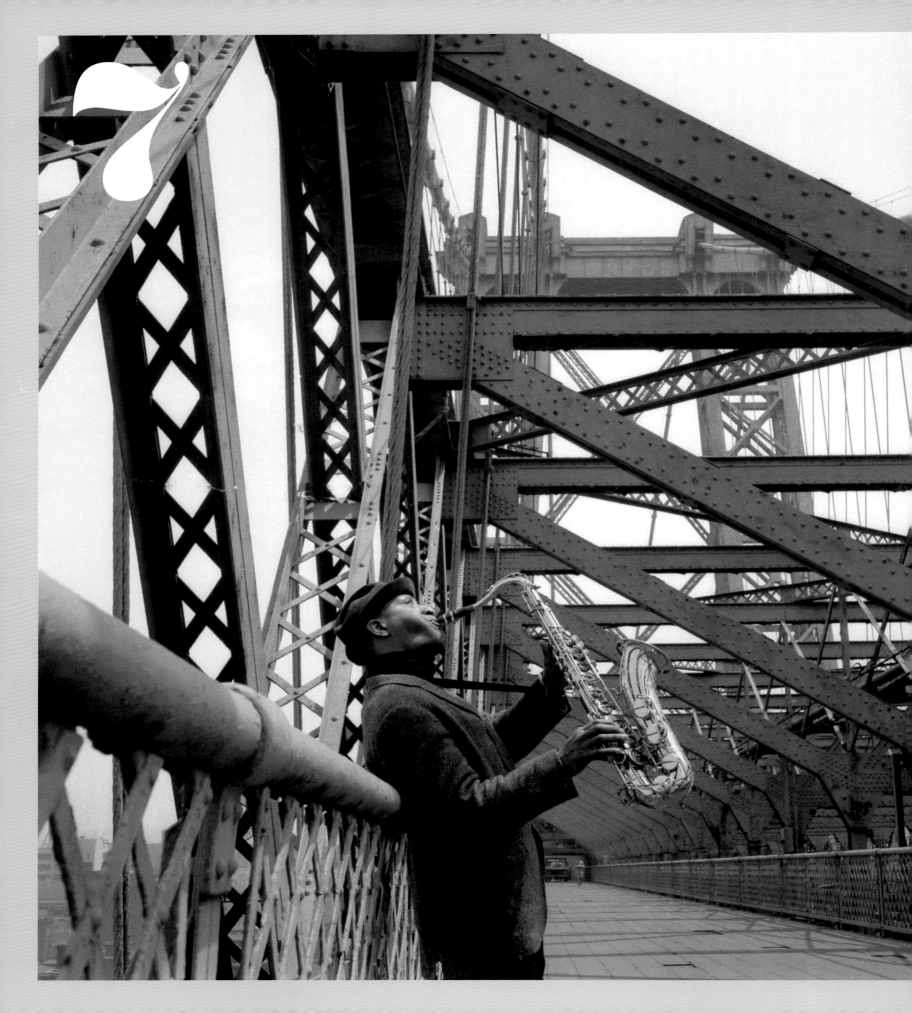

The New Mainstream

"A seamless organic continuum"

Although from the 1940s onward critics and many fans saw a divide between modern jazz and more traditional forms of the music, this was not necessarily how musicians saw it. When *Esquire* magazine decided, in August 1958, to run a feature on jazz musicians, its art director, Robert Benton, hired the young designer Art Kane to coordinate the photography. Kane proposed a group photograph in Harlem at what was—for musicians who worked late into the evenings—the antisocial hour of ten o'clock in the morning. Word spread through the grapevine, and fifty-eight musicians turned up.

What made the resulting photograph exceptional was that there were no stylistic ghettoes. New Orleans pioneers such as Henry "Red" Allen and Zutty Singleton mixed with bebop players such as Dizzy Gillespie and Thelonious Monk. Chicagoan traditionalists, including Pee Wee Russell and Bud Freeman, rubbed shoulders with swing players, including Buck Clayton and Lester Young. The great arranger and pianist Mary Lou Williams chatted to British expatriate Marian McPartland, and innovators from all periods—from Coleman Hawkins to Johnny Griffin—mingled with players who harked back to ragtime, such as stride pianists Luckey Roberts and Willie "The Lion" Smith.

Just as this picture showed New York–based jazz players as a community far more united than artificial barriers might have suggested, musically, the 1950s also saw a coming-together of styles, in which innovation flourished at the same time as players reconnected with a broader public. The bebop revolution spearheaded by Dizzy Gillespie, Charlie Parker, Thelonious Monk, and Max Roach in the mid-1940s led to a more populist style of music known as "hard bop." With an accessible accompanying rhythm, emphasizing the offbeat, and incorporating some elements of gospel into a slight simplification of the harmonies, hard bop became one of the last moments when jazz was truly still a form of black popular music. For example, Lee Morgan's 1963 album *The Sidewinder* ended up climbing the *Billboard* charts to no. 25; Blue Note's initial pressing of four thousand copies, consistent with normal levels of sale, was exhausted within a few days, and it went on to be one of the company's bestsellers.

(Indeed, according to some accounts, this was its bestselling album ever.) At a time when small labels were struggling to survive, it helped keep Blue Note afloat financially.

The initial protagonists of the hard-bop movement were pianist Horace Silver and drummer Art Blakey, with their cooperative band the Jazz Messengers. Catchy numbers such as Silver's "The Preacher," or later pieces (once Blakey had taken over the group) like Bobby Timmons's "Moanin'," had obvious resonances with gospel and church music, but additionally the band reflected some aspects of the New Orleans tradition in pieces such as saxophonist Benny Golson's "Blues March." Yet they also had a clear connection to the bebop innovations of Parker and Gillespie, both in terms of their quintet format and the general style of solo playing. Contemporary accounts tell of Blue Note singles or EPs of popular hard-bop numbers blaring out from jukeboxes in African American neighborhoods, and the music became the sidewalk soundtrack to an era, until the rise of rhythm and blues and the British pop invasion of the mid-1960s finally eclipsed it.

The visual imagery of hard bop owed much to the work of Blue Note's principal designer, Reid Miles, who used rectangular grids, sans-serif type, and simple, bold text, often combined with grainy monochrome photos taken by the label's cofounder, Francis Wolff. Following in the footsteps of his business partner, Alfred Lion, Wolff had left Nazi Germany just before the outbreak of World War II. After arriving in the United States, where he began coproducing sessions with Lion, he became a master of the informal studio photograph, capturing intimate moments in the creation of the label's recorded work with a rare empathy for the musicians involved.

The record labels that were printed for the company's first 78s in 1939 reflect the clean lines and angular designs of the prewar German Bauhaus movement, and these connections became more obvious when, at the start of the 1950s, Blue Note began to issue ten-inch LPs. The principal designer they first recruited was John Hermansader, who had attended the New Bauhaus school of design in Chicago (founded in 1938 by László Moholy-Nagy, who had taught with Bauhaus founder Walter Gropius in

The New Mainstream

PREVIOUS: **Sonny Rollins, photographed around 1960, when he took a sabbatical from professional music and went to the pedestrian walkway on Manhattan's Williamsburg Bridge every day to practice outdoors. He returned to full-time performing and recording in 1961, and the following year recorded *The Bridge*, an album that marked him out as the finest modern jazz saxophonist of the early 1960s.**

BELOW: **This is Art Kane's "Great Day in Harlem" photograph, taken at ten in the morning at 17 East 126th Street, between Fifth and Madison Avenues, on August 12, 1958. In that era, musicians generally wore jackets and ties, and some here—probably on their way home from a late-night gig—are in tuxedos. Kane's inclusion of children, in front and at the window, added to the authenticity of the scene.**

"This is pure American cultural history, capturing not just a day, but an era."

Philip Elwood, *San Francisco Examiner*

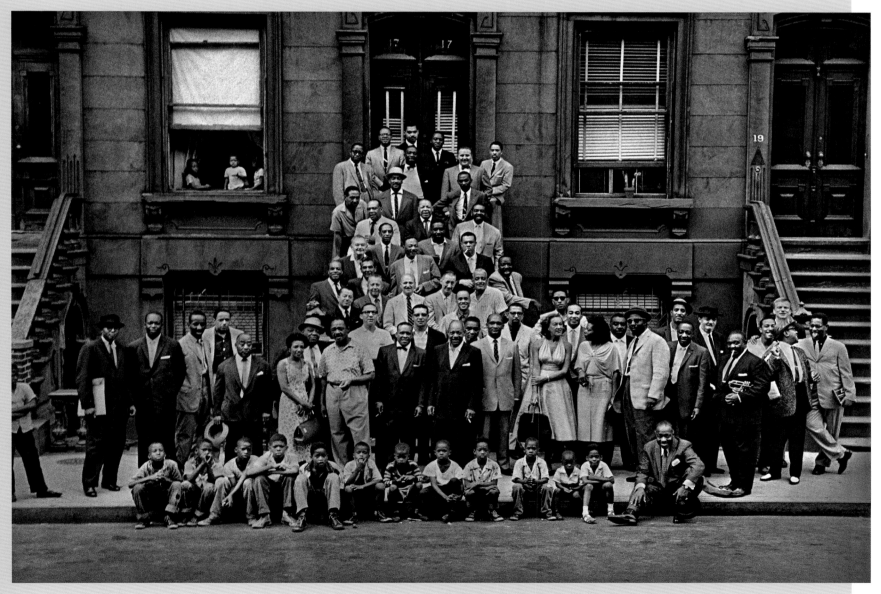

Weimar). Together with fellow designers Paul Bacon and Gil Mellé (who also recorded for the label as a saxophonist), Hermansader worked toward an even balance between image and typography on the record covers, which would lay the groundwork for Blue Note's subsequent distinctive designs.

Hermansader had previously worked with Reid Miles on *Esquire*, allegedly giving Miles his first overcoat after the young designer arrived in New York from California, unaware of the fierce cold of the winters. This personal connection ultimately led Wolff to recruit Miles as Blue Note's main designer in 1955. Whereas Hermansader was an abstract expressionist painter in his own right, and a keen, knowledgeable jazz fan, Miles was not particularly interested in the music, preferring the classics. He used the verbal descriptions given to him by Lion, who produced the majority of sessions, as the trigger for his graphic interpretations. Over time, however, because Miles was keenly interested in art, there developed a symbiotic relationship between Blue Note's designs (and the work Miles also did for rival label Prestige) and the wider visual art world. At both labels, Miles worked with the emerging artist Andy Warhol, whose work is covered later in this chapter. But Miles also moved from Bauhaus to abstract expressionism.

Before his early death, aged forty-four, in 1956, the painter Jackson Pollock was a regular at New York jazz clubs, although he favored slightly earlier styles of the music than the emergent hard bop. Nonetheless, he absorbed much of the rhythmic energy of jazz into his major paintings from the early 1950s. As these works began to be shown and discussed, we find the influence working in reverse, as Miles (and other record sleeve designers) started to mimic some aspects of Pollock's work in the visuals for their covers. For Art Blakey's 1959 album *At the Jazz Corner of the World*, Wolff photographed a grainy, slightly out-of-focus street scene, and Miles ran the text as a strip across the bottom, leaving the diffused street lighting, neon signs, and blurry window lamps as the main, Pollock-like image. A couple of years earlier, working with the same band for Columbia on the album *Hard Bop*, Rudy de Harak had used a comparable blurred image of a contemporary candelabra to create an effect very similar to Pollock's "drip" paintings.

Miles was also quick to catch on to the emerging imagery of Harlem's "Black Is Beautiful" movement in the mid-1960s. His interest was piqued when the photographer Kwame Brathwaite and his brother, Elombe Brath, formed the African Jazz-Art Society (AJAS) and began photographing jazz musicians such as the singer Abbey Lincoln. The society then added its own studios, becoming AJASS, which could, according to Tanisha C. Ford, "create a black beauty and style brand that could be emulated throughout the African diaspora." As Blue Note moved into soul-jazz, Miles worked with Brathwaite and used his photographs of members of the "Black Is Beautiful" movement known as Grandassa models for the covers of albums by Lou Donaldson, Freddie Roach, and Big John Patton. Among them, Clara Lewis is featured in Brathwaite's close-up shot on Roach's *Brown Sugar*, and Rose Nelms unconcernedly reads a magazine as Lou Donaldson casts an admiring glance back over his shoulder on his album *Good Gracious*.

Blue Note successfully promoted soul-jazz, and Miles and Brathwaite helped move album covers into the realms of art, spreading "a vision of African blackness." Yet Miles was also interested in typography as an end in itself. Several of his covers play games with lettering, such as the four lines of cut capitals on Freddie Hubbard's *Here to Stay*, which repeat "FREDDIE HUBBARD" in alternate blue and red, below a small photograph of the trumpeter and the personnel listing. Using just three color plates, he created a dramatic burst of vivid movement. Equally, using just two colors in each case, he covered the front of Jackie McLean's *It's Time!* with exclamation marks, and he warped the words of *The Rumproller* by Lee Morgan to make it seem as though a giant road roller had squashed them out of shape. In all, as the design historians Steven Heller and Greg D'Onofrio point out, he had an "instinctive understanding of how design could be used to communicate (and sell) the music." He also had a client who was prepared to give him the means to try, and in the process help create the visual image of modern jazz.

"John Hermansader in particular balanced the concerns of photography and type in a way which would mirror the concerns of the Blue Note of the years ahead."

Richard Cook, *Blue Note Records: The Biography*
(Justin, Charles & Co., 2003)

The Art of Jazz

BELOW LEFT: **Producer George Avakian brought together Coleman Hawkins, the "father of the jazz saxophone," and Sonny Rollins, "the boss of modern tenor sax," in this summit meeting for RCA. Paul Freeman's abstract impressionist cover catches the album's mixture of edginess and musical integration, an atmosphere created in the studio by the presence of the innovative Canadian pianist Paul Bley.**

BOTTOM RIGHT: **Many jazz historians view trumpeter Roy Eldridge as the vital link between swing jazz and bebop. A dazzling and exciting player, he was as at home playing small-group swing as he was jousting with bebop innovator Dizzy Gillespie. Their competitive jousts were a highlight of the 1950s Jazz at the Philharmonic concerts.**

TOP RIGHT: *Untitled (Sonny Rollins at the Five Spot)* **(1964–1965) by African American painter Bob Thompson. Rollins's own appearance was a work of art—he moved from the style shown on page 150 to the "Mohican" hair and beard seen here. Later he would adopt a shaven head, and then all manner of hairstyles, continually reinventing his image.**

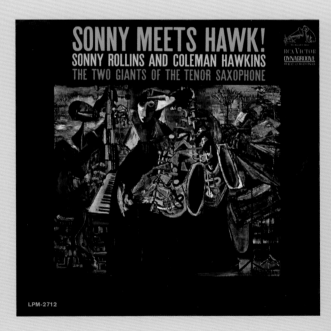

BOTTOM LEFT: **A very untypical picture by the usually very precise Frank Wolff is the basis for Reid Miles's design for this Art Blakey album. The blurry multiple image of the original Birdland site at 1678 Broadway (the club that advertised itself as "the Jazz Corner of the World") becomes the photographic equivalent of a Jackson Pollock painting.**

BOTTOM RIGHT: **Reid Miles himself took this atmospheric cover shot of Wayne Shorter and his then wife, Irene Nakagami, for what is now recognized as one of Shorter's finest Blue Note albums. The blue wash, dividing the cover in two, is a classic Miles design gambit, as is the almost throwaway detail of the lipstick smear.**

TOP RIGHT: **This Kwame Brathwaite shot of Rose Nelms for Reid Miles's design for _Good Gracious!_ is one of a number of his photographs used by Blue Note, not only for Lou Donaldson albums but also for discs by Horace Parlan, Big John Patton, and Freddie Roach.**

BELOW: One of the finest examples of Reid Miles's purely typographic covers, this also alludes to the cut-paper designs from the early years of jazz such as the Fletcher Henderson–inspired artwork shown in chapter 2, save that the flora and fauna there are replaced here by Arabic numerals.

BELOW: **It was relatively rare for Reid Miles to use a line drawing as a full-size record cover, but Paula Donohue catches Horace Silver's keyboard posture so perfectly in this ink-and-wash drawing that he is immediately recognizable, even without his face in view.**

BELOW LEFT: **Maybe the most famous example—and certainly the bestselling— of the partnership of Reid Miles's designs and Frank Wolff's photography for Blue Note. This was a much-emulated style, with the photograph, all-capital *sans serif* type, and a blank space each occupying one of three horizontal sectors of the cover.**

BOTTOM RIGHT: **Although Miles designed for Prestige as well as Blue Note, for this 1957 recording the rival label used a different designer, Esmond Edwards, who both took the portrait photo and designed the cover. The later Coltrane covers (as described in the next chapter) took their cue from this kind of formal portrait.**

TOP RIGHT: **Another of the Miles/Wolff templates, this 1960 release has the artist's details as a banner at the top, uses a beautifully framed action photograph, and then employs the album title to link the two segments of the design.**

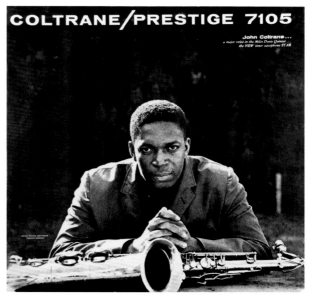

One major designer of 1950s record sleeves for RCA Victor, Blue Note, Epic, and Prestige—and who went on to create seminal rock album covers for the Velvet Underground and the Rolling Stones—was the future pop-art pioneer Andy Warhol. After training as a commercial artist at what was then the Carnegie Institute of Technology, in Pittsburgh, he arrived in New York in 1949 and established himself as a graphic artist, specializing in illustrations that avoided photorealism, but whose hand-drawn style was distinctively recognizable both for the way in which his images captured their subjects and for the idiosyncrasies of the style itself.

His work was soon appearing in *Harper's Bazaar* and *Vanity Fair*, but record covers allowed him a degree more freedom, and a good example of that balance between subject and style is his 1955 cover for RCA's album simply titled *Count Basie*. Focusing in on Basie's eyes, wrinkled brow, and moustache, with a cigarette hanging languidly from the left side of his mouth, Warhol just hints at the pianist's hat, collar, and coat. Yet this is the Basie whom all fans would recognize from his short films or press photos, and somehow the image captures the laconic style of his solo piano introductions to the full power of his big band. One technique Warhol used to capture such images was to project a photograph onto drawing paper using an epidiascope, and then create his characteristically rough-hewn images. He would return to this style of cover in the 1970s, with Paul Anka's *The Painter* (which also drew on his screen-printing techniques), and in the 1980s, with Diana Ross's *Silk Electric*.

Other elements of Warhol's later work are present in his 1950s album covers. For example, the Joe Newman Octet's RCA disc *I'm Still Swinging*, from 1956, is a tentative venture into collage, with a photograph of Newman peeping out from behind a characteristic Warhol line drawing of his trumpet on a chair. The typography of the musicians' names is worked around a music stand—the order of billing adjusted to fit the space so that pianist Dick Katz (who would normally head the rhythm section) is placed last, as his name has the fewest characters.

Typography—or rather lettering—was also an abiding interest of Warhol's, in that he adopted a particularly distinctive style of italic handwriting for many of his designs. In fact, this was the writing of his mother, the Slovakian-born Julia Warhola, who had arrived in New York in 1951 to take care of her son. She was to win awards in her own right for her decorative writing, but on the 1954 Prestige album *Monk*, her writing is used to name sidemen Sonny Rollins and Frank Foster in characters that snake around the huge sans-serif letters of Monk's name in a collaborative design between Warhol and Reid Miles. She also produced the text-based cover for Warhol's sleeve design for *Story of Moondog* (music by the blind musician, composer, and inventor Louis Hardin) on Prestige.

The same label was also the home of another type of design that would recur in Warhol's later work—repeated variants on an image. For *Trombone by Three* (1956), which features Jay Jay Johnson, Kai Winding, and Bennie Green, Warhol produced a trio of androgynous shawm players—vaguely medieval, vaguely monkish, and absolutely nothing to do with trombones. There had been a precedent a month or two earlier in the same label's album of collected trumpeters—Bernie Glow, Conte Candoli, Nick Travis, and others—that came out under the title *Cool Gabriels*. Here, seven winged and haloed angels blowing trumpets adorn the cover, three dancing and four swooping around in flight.

The technique that Warhol had used for Count Basie could be applied to fuller-scale portraits than just the face. Indeed, two of his most celebrated covers omit the face entirely, yet they capture the essence of the artist involved. These were both produced for Blue Note, as part of a number of designs from 1956–1958. First, Johnny Griffin's *The Congregation* (recorded in October 1957) shows just the saxophonist's colorful Hawaiian shirt and the upper segment of his tenor saxophone, yet it portrays the mixture of swagger and relaxation that can be heard on Griffin's playing with the Sonny Clark Trio. Equally, the previous year's eponymous *Kenny Burrell* shows the guitarist's hands and (almost hidden beneath the typography) just enough of a look of rapt concentration on his face to catch the intensity of his solos. Yet the work that connects more than almost any other to Warhol's wider career is the two-volume *Blue Lights*, by Burrell, from 1958. For the previous three years, Warhol had drawn a weekly advertisement for the top shoe store I. Miller, which appeared in the Sunday edition of the *New York Times*. These had won him considerable acclaim and three awards from the Art Directors' Club. For *Blue Lights*, we see one of Warhol's female muses, lying down across the sleeve, looking up at the viewer. Her only visible articles of clothing are a pair of shoes with stiletto heels, a stylistic and content bridge between Warhol's earlier shoe advertisements and his 1980s prints such as "Diamond Dust Shoes" and "There She Goes."

Andy Warhol

"Warhol's mission was to deliver something with charm and pizzazz, and he had a gift for doing this again and again."

Trevor Fairbrother quoted in Andy Warhol, *The Philosophy of Andy Warhol: From A to B and Back Again* (Harvest / Harcourt, 1975)

BELOW LEFT: Andy Warhol in the 1970s at his studio —the original Factory on East 47th Street—where a few years earlier he had produced the record covers in this section. As well as the epidiascope he used to work on his drawings, he was fascinated by other film and projection equipment, including this 1920s hand-cranked movie camera.

TOP RIGHT: The lines inscribed here by Andy Warhol's mother were from a poem about Moondog written by Stewart Preston. Apparently her writing tended to slope up to the right, so Warhol painstakingly cut up her text and re-laid it as a collage to create the verbal visual of the record sleeve.

BOTTOM RIGHT: This Warhol image of Basie does everything described in the main text, but turn the page upside down and you will see that Warhol has amused himself by producing a second facial image—a private joke of the kind so often embedded in his artwork.

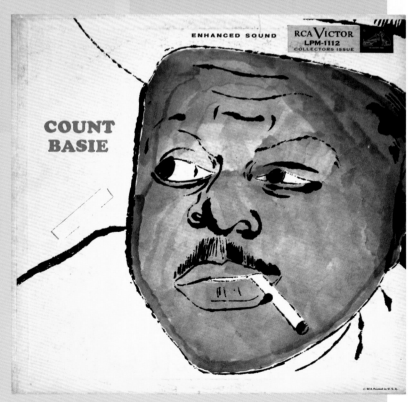

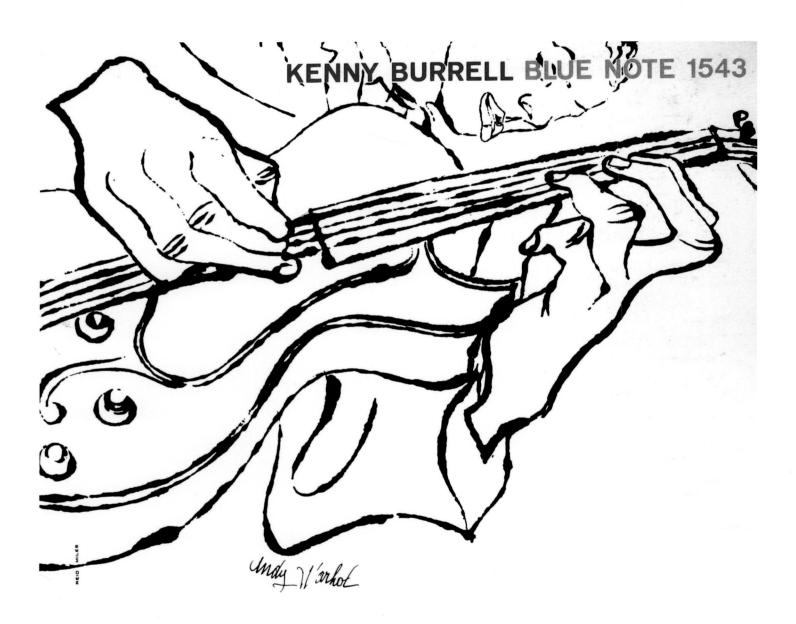

BOTTOM LEFT: "Frank Wolff always hated it when I cropped one of his photographs of his artists through the forehead," recalled designer Reid Miles. So, for Johnny Griffin's final Blue Note album, Miles engaged Warhol to make this three-color print, based on a Wolff photo but focusing on the instrument rather than the player!

TOP RIGHT: A real collector's item, this album from Prestige was made for the short-lived 16-rpm long-playing system, which fitted twenty-four tracks onto the album. Only two thousand copies were pressed. Ignoring the modern trombone, Warhol used medieval cornetts for his image, based on an illumination in the eighth-century Vespasian Psalter.

BOTTOM RIGHT: This is Warhol's most famous Blue Note cover image, used on both volumes of *Blue Lights*. The records are studio jam sessions, and growly slow numbers like the opening "Yes Baby," "Scotch Blues," or ballads like "Autumn in New York" chime with the 1950s idea of a seductive female form (an image Warhol partially borrowed from Otto Cesana's contemporaneous LP *Ecstasy* for Columbia).

JAZZ COMPOSER AND SAXOPHONIST

32 USA

COLEMAN HAWKINS

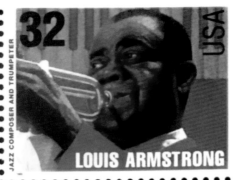

JAZZ COMPOSER AND TRUMPETER

32 USA

LOUIS ARMSTRONG

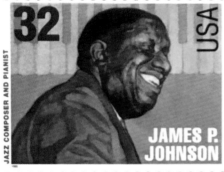

JAZZ COMPOSER AND PIANIST

32 USA

JAMES P. JOHNSON

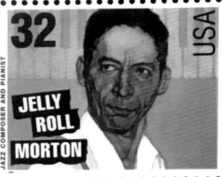

JAZZ COMPOSER AND PIANIST

32 USA

JELLY ROLL MORTON

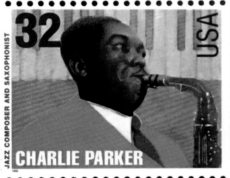

JAZZ COMPOSER AND SAXOPHONIST

32 USA

CHARLIE PARKER

JAZZ COMPOSER AND PIANIST

32 USA

EUBIE BLAKE

JAZZ COMPOSER AND BASSIST

32 USA

CHARLES MINGUS

JAZZ COMPOSER AND PIANIST

32 USA

THELONIOUS MONK

JAZZ COMPOSER AND SAXOPHONIST

USA 32

JOHN COLTRANE

JAZZ COMPOSER AND PIANIST

32 USA

ERROLL GARNER

LEFT: **In 1995, the United States Postal Service released a set of jazz-related stamps in its "Legends of American Music" series. This included originators like Blake and Morton, hugely influential musicians like Armstrong and Parker, and more recent players such as Mingus and Monk, yet it seemed acceptable in 1995 that all twenty images in the full set are of male musicians!**

The Art of Jazz

**This painting from
1969–1970 by the jazz-
inspired artist William
T. Williams is titled**
Hawk's Return. **Coleman
Hawkins died in 1969,
aged sixty-four, but this
celebrates the fact that
his playing remained
current throughout his
life, from his Fletcher
Henderson days in the
1920s right through to his
final decade, where he
recorded some startlingly
contemporary music.**

At the same time as Lion and Wolff were bringing Bauhaus ideas into Blue Note's label and cover design, the entrepreneur Norman Granz, having established his Jazz at the Philharmonic (JATP) concerts in July 1944, went on to set up a number of record labels, culminating in his best-known venture, Verve. For his first label, Clef, founded in 1946, he took the view that as jazz was itself an art form, the record sleeves would also be works of art. Indeed, Granz believed that his concerts would help to change public perceptions of jazz, writing in the first JATP program note, "Jazz which heretofore has been an italicized art will attain capital definition and stature."

The graphic artist whom Granz principally employed was David Stone Martin, who had already done some work for the producer Moe Asch (whose eponymous label licensed the first JATP issues), and it was Martin's singular talent that, from 1945, created the visual style for all of the JATP records and concert programs. His iconic line drawing of a trumpeter embellished everything from posters to record labels, from press ads to concert tickets, and meant that wherever the concert troupe toured, it was immediately recognizable from its advance publicity, while souvenirs such as records and programs reinforced the same image after the event was over.

However, Granz took things further. He offered a set of prints by the photographer and filmmaker Gjon Mili in his 1949 *Jazz at Carnegie Hall* album, which was marketed at the then-astronomical price of $25 (around $260 today). An even more expensive package was his 1953 four-LP set with Fred Astaire and Oscar Peterson, which included a set of Martin's drawings on art paper, plus more photographs by Mili, and which retailed at $100.

In October 1949, JATP was featured on the cover of *Downbeat*, with Martin's trumpeter image discreetly shown behind photos of Ella Fitzgerald, Flip Phillips, and Coleman Hawkins, as well as Granz himself. The magazine drew attention to the meticulous attention paid to promotion of the concerts, although it did single out Ella's repertoire, saying it included "crummy" songs. Yet while Martin's trumpeter was used consistently, the sheer imaginative range of his other designs and drawings is astonishing, not least when one realizes he was essentially a self-taught artist. On the one hand, there are lovingly crafted portraits of the likes of saxophonists Flip Phillips and Lester Young or blues singer Big Bill Broonzy; on the other, there are graphics of Edwardian bandstands, the Leaning Tower of Pisa, or, in the case of a Charlie Barnet EP, a fishmonger with a giant crab on the window of his store. Meanwhile, Lester Young inspired a mysterious cloaked figure; Lionel Hampton's quintet album is adorned with dancers and percussionists that evoked Aaron Douglas's huge Harlem Renaissance canvases; and the EP of Slim Gaillard's *Opera in Vout* and *Groove Juice Symphony* shows Gaillard and bassist Bam Brown in a messy living room surrounded by cats, with a horde of mice, kittens, and opened juice cans emerging from an old upright piano. Drummer Gene Krupa is an immediately recognizable half-caricature, while the idea of hands and drumsticks on that cover was transferred to a semiabstract profile of drummer Sonny Payne on the front of a Count Basie album. But Martin's pièce de résistance was his transmogrification of Charlie Parker into his nickname, "Bird," in pictures that show him surrounded by avian life.

Martin ceased to be Verve's art director when Granz sold the label to MGM in 1961, but in sixteen years of working with Granz on Verve and his other labels, Clef and Norgran, Martin had succeeded in putting graphic art center stage in what would become some of the most enduring recordings of the time. Granz's successor at Verve was Creed Taylor, who succeeded in his six years there in establishing a new vogue and a new style of art-related cover to go with it. With guitarist Charlie Byrd, saxophonist Stan Getz, and then Brazilians Antonio Carlos Jobim and Joao Gilberto, Verve launched the craze for bossa nova and samba. The Puerto Rican artist Olga Albizu's paintings adorn the covers of albums such as *Getz/Gilberto* and *Jazz Samba*, and her brand of brightly colored abstract impressionism was ideal for this acoustically based feel-good music.

The artist who followed most closely in Stone Martin's footsteps was the German-born Leo Meiersdorff. At the age of twenty-three, he entered a poster-design competition for a JATP concert in Berlin in 1957; he won and subsequently moved to the United States, where his paintings not only sold well through galleries but were used as cover artwork for more than a hundred albums. His most famous work is the sleeve for the Thad Jones–Mel Lewis big-band album *Consummation* (1970).

Jazz at the Philharmonic and Verve

"The music on Verve will never die, it documents the lifeblood of our culture."

Herbie Hancock quoted in Richard Havers, *Verve— The Sound of America* (Thames and Hudson, 2013)

BELOW LEFT: **The program cover for Jazz at the Philharmonic's inaugural tour of Britain in 1957, with a characteristic David Stone Martin drawing. Like much of his work, it is an ambiguous, haunting image: the trumpeter perhaps looking out at the incoming audience for the next house, as programs and a billboard for the previous concert lie at his feet.**

BELOW RIGHT: **Graphic artist David Stone Martin produced around two hundred album covers for Norman Granz's Verve, Norgran, and Mercury imprints, and approximately the same number again for other labels. This portrait photo by William Gottlieb dates from 1947.**

BELOW LEFT: **More than any other artist it was Stone Martin who immortalized Charlie Parker as "Bird," adding wings to his saxophone on many drawings, as he does here, while keeping Dizzy's trademark goatee in sight as well.**

TOP RIGHT: **Sleeve-note writer Leonard Feather talked of Billie Holiday's "tremendous emotion" on this album, and Stone Martin's tragic image mirrors her strength of feeling in such songs on the record as "The Man I Love," "Billie's Blues," and "Gee Baby, Ain't I Good to You."**

BOTTOM RIGHT: **This is just one of several Lester Young albums that Martin designed, usually depicting his "porkpie" hat and emphasizing the angle at which he held his tenor saxophone. Here, though, along with two of his trademark hats, Young is seen as a magician or sorcerer.**

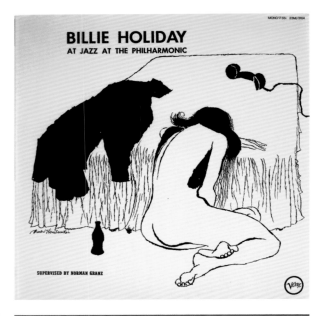

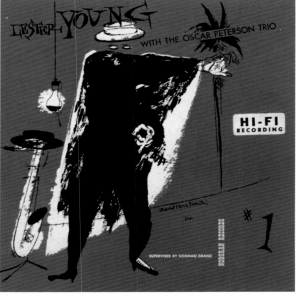

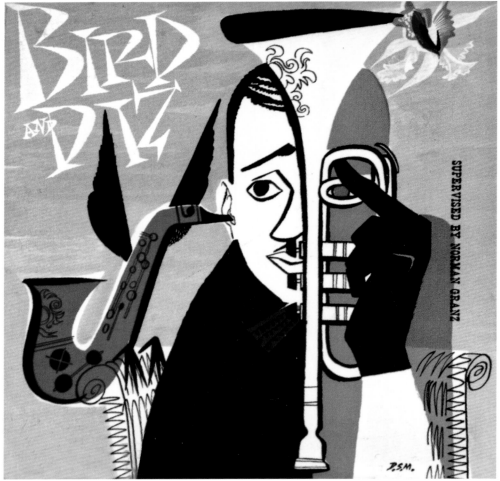

The Art of Jazz

Because Miles Davis evolved through several different styles and bands from the late 1940s until the dawn of jazz-rock at the end of the 1960s, he can be seen as a one-man trajectory through the visual design of those two decades. As the 1950s began, he was recording for both Prestige and Blue Note. In the early days at Prestige, he was photographed by label owner Bob Weinstock, and on a record like *Miles Davis with Sonny Rollins*, from 1954, designer Don Schlitten used three of Weinstock's prints of Miles (in a white cap, plaid shirt, and white trousers) as a collage. For Blue Note's almost contemporaneous two-volume twelve-inch LP set, John Hermansader divided the covers horizontally in two, putting a photograph of an elegantly suited Miles below the halfway line, with the trumpeter's name in color across the middle. Weinstock's equally elegant, shadowy shot of Miles for the Prestige album *Dig* sees him suited and hatted in a design that divides vertically. But the designer in this case was the jazz photographer Bob Parent, who also produced a characteristically inventive design using a negative of one of his own prints for *Blue Moods*, Miles's sole 1955 foray onto the Debut label, owned and run by musicians Max Roach and Charles Mingus.

Before Miles finally left Prestige, lured away by producer George Avakian at Columbia, his work received Reid Miles's attention. So an album like *Bag's Groove*, released in 1957 after the trumpeter had officially left Prestige, is one of Reid's purely typographical covers, using just two tints of green and carrying titles and record details in capitals, with the band members' names squeezed between them in lowercase, like a verbal sandwich. Meanwhile, Davis's farewell to the label—the aforementioned set of *Cookin'*, *Relaxin'*, *Steamin'*, and *Workin'*—uses a variety of visual experiments.

Avakian had a point to prove when he signed Miles Davis in 1955, before his Prestige contract had formally ended. "Columbia were concerned he was a former drug addict, might go back on the stuff and die before they had a chance to sell any discs," he said. "I told them Miles was straight, and so good he was going to be another Dizzy Gillespie." Although Avakian himself had no doubts—and indeed, Miles's long association with Columbia was such that he eventually outsold Gillespie by a considerable amount—he was careful to promote Miles's image in as positive a way as possible. So *'Round About Midnight* (the quintet's debut for the label) shows Miles suited, shaded, and holding his trumpet; *Milestones* has him in an easy chair in a sports shirt, again with the trumpet, an image subtly reflected in the follow-up with Gil Evans's orchestra on *Porgy and Bess*, where what could be Miles at the same photo session (but the heads of the models are cropped away) has a woman's hand reaching across and holding the end of the trumpet. The images convey an element of prosperity and relaxation, reinforced by the brilliant close-up of Miles by Jay Maisel for the cover of his all-time bestselling album, 1959's *Kind of Blue*, which completely refuted any lingering doubts Columbia might have had about its star, and which presented an image that would change dramatically as the jazz-rock era began.

The Changing Image of Miles Davis

"Columbia began some systematic image-building, projecting Miles as the Byronic black man, the 'mean, moody and magnificent' jazz musician."

Ian Carr, *Miles Davis: The Definitive Biography* (Harper Collins, 1998)

BELOW LEFT: **John Hermansader's** design for the two-volume Miles Davis set on Blue Note (jointly credited on the sleeve to Reid Miles) shows the suited Davis of the early 1950s. At this point he was still in the grip of heroin addiction, but he used his smart sartorial appearance to disguise his use, before quitting, cold turkey, in 1955.

TOP RIGHT: **African American** artist Esmond Edwards's line drawing on *Relaxin'* was one of the four contrasting images used for Davis's final set of albums on Prestige and recorded to fulfill the contract with Bob Weinstock's label after he had already signed with Columbia. The others are shown overleaf.

BOTTOM RIGHT: **George Avakian,** the producer at Columbia Records who signed Miles to the company, where the trumpeter would stay for thirty years until 1985. Avakian also produced other jazz talents as varied as Louis Armstrong, Duke Ellington (notably the 1956 *Ellington at Newport* album), and Dave Brubeck, as well as classical ventures with John Cage.

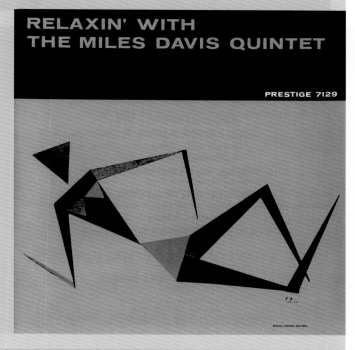

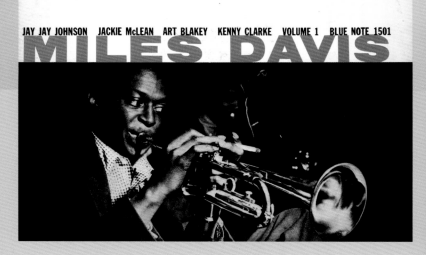

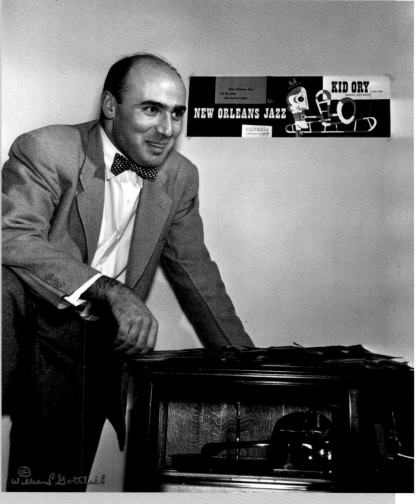

TOP LEFT: Photographer Esmond Edwards originally joined Prestige to take pictures for covers, as here on *Workin'*, with its subtle placement of Miles against the road roller; but he would also work as a recording engineer, and subsequently producer. He went on to be a pioneer African American recording executive, becoming vice president of Chess Records.

BOTTOM LEFT: Although *Steamin'* was recorded at the same 1956 session as the other albums on this and the previous page, it was not released until 1961, by which time Columbia had taken Miles's image in hand, so the (uncredited) photo and design here by Don Schlitten is firmly in the more informal territory created under Avakian's management at Columbia.

BELOW RIGHT: Reid Miles's design for *Cookin'* used Phil Hays's picture of a trumpeter's hands and view of the instrument from the mouthpiece much as he deployed Andy Warhol's drawings on the Burrell and Griffin albums for Blue Note. It was a variation on his own artwork for Prestige's earlier release *Three Trumpets*, featuring Donald Byrd, Art Farmer, and Idrees Sulieman.

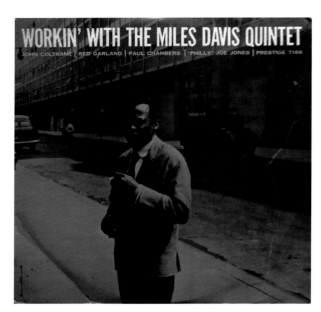

The Art of Jazz

BELOW LEFT: The best-selling jazz album of all time, *Kind of Blue* actually reverted to Miles's appearance as concert- or club-goers would see it. Jay Maisel's photograph nonetheless captured the intimacy and feeling of tracks on the album like "All Blues," "Blue in Green," and "So What."

TOP RIGHT: *'Round About Midnight*, named for the Thelonious Monk tune that had encouraged Avakian to sign Miles when he heard him playing it at Newport, was the quintet's debut for Columbia. Marvin Koner's monochrome photo, washed in red, was, according to the critic in *Cadence*, central to the "careful packaging and exquisite artistry" that went on to "create a legend."

BOTTOM RIGHT: Denis Stock's photograph for *Milestones* achieved exactly the kind of customer-focused informality that Columbia aimed for in its image branding of Davis. This "Man in the Green Shirt" image inspired Joe Zawinul's composition about Miles, but ironically it was very much at odds with Davis's continuing sharp-suited appearance at live gigs.

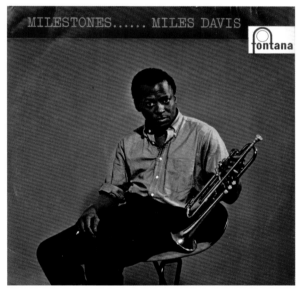

BELOW LEFT: In the wake of their successful promotion of JATP concerts, the Harold Davison Agency brought other US acts to Britain, having mastered the complex system of exchanges demanded by the Musicians' Union, whereby British musicians traveled to America to "balance" the incoming US players. This Shearing/Williams program from 1962 mirrors the Stone Martin designs used by Norman Granz.

TOP RIGHT: This David Stone Martin drawing for Anita O'Day's 1953 album takes its cue from songs in the running order, including "Love For Sale," "No Soap, No Hope Blues," and "The Lady Is a Tramp."

BOTTOM RIGHT: Mary Lou Williams, one of the great female instrumentalists in jazz, moved to Europe from 1952 to 1954, settling first in London and then Paris. She became part of an artistic circle in France that included writer James Baldwin and actor Canada Lee, as well as fellow jazz musicians Annie Ross and Eartha Kitt.

OPPOSITE: In the late 1950s, Ornette Coleman began challenging the jazz orthodoxy, though his 1958 debut album, *Somethin' Else!!!!*, was the closest he came to conventional bebop. Bob Thompson's painting *Ornette*, from 1960, shows the saxophonist looking in four directions from a central vantage point, maybe taking in the past, present, and future of jazz.

The Art of Jazz

Changing Landscape—Mingus, Coltrane, and Coleman

"Intense lyricism often accentuated by saxophone cries and wails"

Arguably the three musicians who did most to change the landscape of jazz in the late 1950s and early 1960s were Charles Mingus, John Coltrane, and Ornette Coleman. Mingus used extended composition and a workshop environment in which he dictated rather than notated much of his work, so that even his most through-composed pieces retained a freshness, owing to their liberation from the written score. Coltrane pushed forward the boundaries for improvisation in a settled and comparatively long-lived quartet that allowed him to take forward the modal basis for soloing that he had worked on with Miles Davis, and also to develop ideas over a much longer space of time than most soloists. Coleman rewrote the rule book about small-group collective improvisation, in particular through the adoption of his system of "harmolodics," which abandoned much of the conventional approach to harmony and structure. In their different ways, each sought a kind of freedom that had been absent from jazz until this period, and this freedom was picked up and reflected in various ways in the visual depiction of the musicians and their music.

The image of bassist Charles Mingus—from the suited, short-haired musician who worked in the Red Norvo Trio in 1950–1951 to the tousle-haired, bearded, cigar-smoking jazz patriarch of his final years, before Lou Gehrig's disease prevented him from playing—offered plenty of scope to photographers and graphic artists. Hence we see him in formal portraits by jazz photographers of the early 1950s right through to late-1970s paintings by the rock artist David Oxtoby (an art-school contemporary of David Hockney). The huge spectrum of his musical creativity, and the fact that at the height of his powers, in the late 1950 and early 1960s, he was recording for several labels—including the majors, Columbia, RCA Victor, and Atlantic, for whom Coltrane and Coleman also recorded—means that in material connected with those LPs we can see him in various perspectives. As well as being a composer, bandleader, and bassist, Mingus was also a pianist, and some record covers show him in this guise, notably *Charles Mingus Presents Charles Mingus*, made for the Candid label, which at the time was run by his friend and supporter Nat Hentoff.

Columbia was keen to keep up with the design innovations that Blue Note had originated. Consequently, in 1954, the company hired the Japanese-American designer S. Neil Fujita to take charge of and reorganize the department previously headed by Alex Steinweiss, who was now freelancing for several companies. One of Fujita's most famous cover designs was for the 1959 album *Mingus Ah Um*, which uses an abstract design incorporating insects, birds, stars, tents, and an image of the moon. (Fujita had also designed Brubeck's *Time Out* the same year with a similar stylistic palette, only this time using imagery that referred back to Brubeck's Native American ancestry.)

Columbia's follow-up swapped the Latin declension pun of "ah-um" for an even more esoteric pun on Chinese history, which works if you know that Mingus's nickname for a time was "Ming"—hence *Mingus Dynasty*. Here, Bob Parent photographed Mingus in Chinese costume against a background of *chinoiserie*, for an album that was supposed to hark back to the fact that Mingus was genetically one quarter Chinese. At the same session, New York photographer Don Hunstein captured a particularly well-known monochrome image of Mingus, wearing a cap, working in the studio. The subsequent large-ensemble Columbia album *Let My Children Hear Music* from 1972 returns to abstraction, with Ed Lee's painting of what appears to be a cross between an astrolabe and Christmas tree baubles.

The RCA Victor images for Mingus's work are quite different from the pun-based and visual fantasies for Columbia, and pick up more directly on subject matter. *Tijuana Moods* had been recorded in 1957, but RCA (following a lawsuit from Mingus) did not release it until 1962. Some of the music was inspired by a road trip that Mingus and his long-term colleague, drummer Dannie Richmond, had taken to Mexico. To remind them of what they had heard (and to pay tribute to dancer and castanet player Ysabel Morel, who plays on the record), the cover shows a vintage Wurlitzer jukebox and a Mexican dancer, hoisting her dress high with one hand, to reveal a floral garter, and holding a cigarette in the other. (The inside cover of recent reissues also includes a stock RCA photograph of a crew-cut Mingus looking pensive as he holds his "lion's head" bass—named after the carved scroll on his instrument, built by Ernst Heinrich Roth in Germany in the late 1920s.)

But by far the most adventurous and memorable Mingus images are to be found on his work for Atlantic, starting with Julio de Diego's revamp of prehistoric cave paintings for *Pithecanthropus Erectus* in 1956. Mingus

Changing Landscape—Mingus, Coltrane, and Coleman

PREVIOUS SPREAD: **Another painting by Bob Thompson, this time borrowing his palette from Gauguin, this is** *Ornette Coleman in the Garden of Music.* **We see (left to right) Ornette, cornetist Don Cherry, John Coltrane, Sonny Rollins, drummer Ed Blackwell, and, balancing his bass above him, Charlie Haden, all of them key figures in the new jazz of the 1960s.**

BELOW LEFT: **For the bulk of his performing career as a bandleader, Coltrane adopted formal dress, as in this typical portrait from the early years of his quartet with McCoy Tyner, Jimmy Garrison, and Elvin Jones.**

TOP RIGHT: *A Love Supreme,* **arguably Coltrane's most influential album for Impulse!, had one of the company's most conservative covers, barely hinting at the spiritual depth of the music it contains. This has remained the principal image for the record right through to twenty-first-century reissues.**

BOTTOM RIGHT: **The most abstract of the designs produced by Atlantic Records during Coltrane's affiliation with the label (aside from a portrait by Marvin Israel for** *Coltrane's Sound,* **which is similar to the Sonny Stitt cover on page 113). Here, Bob Slutzky and Marty Norman play visual games—is the shape on the left an arm, a record pickup, or a saxophone mouthpiece?**

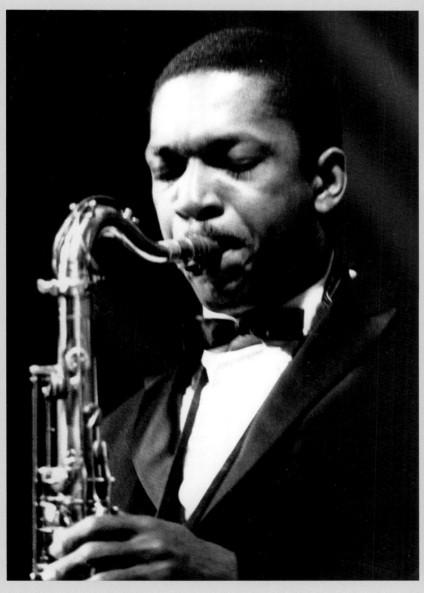

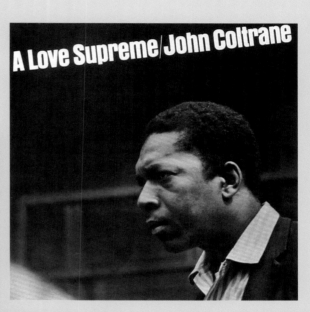

also appears on vibraphonist Teddy Charles's *Word from Bird* (made for Atlantic the following year), which features an abstract painting by Marvin Israel. There might be segments of the word "jazz" incorporated in the images, but the viewer's eye also conjures up a fleeting, moving image of a vibraphone player. That same year, Israel designed Mingus's album *The Clown*, the title track of which involves music improvised to Jean Shepherd's narration of a tragic story in which audiences laugh at a clown's misfortunes rather than his jokes, until the final laugh as he accidentally breaks his neck when a rope snaps. ("A lot of people," said Mingus, "interpreted 'The Clown' as being a parallel of myself.") Rather than being overcome by them, Mingus challenged those audiences who appeared indifferent to his music, but there is something of the comic tragedian in the cover's full-face photograph of a circus clown in makeup, taken by New York–based photographer George Pickow. There's some symmetry in these Atlantic designs, too, because the full-color cover of 1960's *Blues and Roots* is a portrait photo of Mingus and his Roth bass, looking as tranquil as the clown looks tragicomic.

On *Oh Yeah!*, from 1962, Mingus plays piano throughout, with Doug Watkins doing an admirable job on bass, and the cartoonish cover shows designer Loring Eutemey's whimsical interpretations of the song titles. Two years later, for *Tonight at Noon*, Marvin Israel again came up with a truly inventive cover, using a photograph of Mingus as the basis for a painting packed with fleeting images, including just a hint of the American flag, albeit in very different colors. Later records for other labels would show Mingus in a variety of contexts, but little matches this period of invention from Columbia, RCA, and Atlantic.

For many listeners, the broadly similar gatefold orange covers of John Coltrane's Impulse! recordings offered little clue of the rapid musical development in his music. Almost all of them offered serious portrait photographs of Coltrane, usually suited and either sitting contemplatively or playing intensely. They took their cue from Reid Miles's cover for *Blue Train* on Blue Note, using a Frank Wolff photo with a distinctive blue tint, and from Esmond Edwards's portrait on the 1957 Prestige album simply entitled *Coltrane*. By contrast, the period during which Coltrane recorded for Atlantic (between Prestige and Impulse!) produced a slightly greater variety of visual material.

Marty Norman's artwork and Bob Slutzky's design for *Coltrane Plays the Blues* is a case in point, its strong purple backdrop playing host to a kind of abstract collage of what might be urban shapes, or perhaps a horizon with sun beyond, or just paper detritus, including a glimpse of a numbered ticket stub. Even when Atlantic followed the portrait route, *My Favorite Things* focused on the soprano saxophone in a full-color photograph, emphasizing the (then) unusual instrument of the title track. The hugely influential *Giant Steps* uses a portrait taken from almost the same below-the-front-of-the-stage angle as Impulse!'s *Coltrane*, but inventively framed in red and white.

The first few Atlantic albums by Ornette Coleman presented quite orthodox portraits, maybe to reassure listeners new to his music that it was more approachable than titles such as *The Shape of Jazz to Come* (1959) and *Change of the Century* (1960) suggested. For the sequel, *This Is Our Music* (1961), the entire quartet (with drummer Ed Blackwell shown in place of founder member Billy Higgins) is presented in a group portrait. However, after *Free Jazz* (discussed later in this section), Atlantic abandoned the portrait style of covers for the typographic. *Ornette!* by John Jagel, from 1962, is a good example, as is Bob Slutzky's *Ornette on Tenor*, from the same year, where the "O" of Ornette is also used for the downward-pointing word "on." The most adventurous design—perhaps catching more of the spirit of Ornette's music than those others mentioned here—is Haig Adishian's artwork for the retrospective issue in 1970 of previously unheard quartet tracks, *The Art of the Improvisers*, which takes its theme from the track entitled "The Circle with a Hole in the Middle." With dancers, possibly musicians, ghosts, and a swathe of color, it looks like a most inviting kind of jazz pizza!

The innovations of these three musicians are presented with a mix of conventional formality and some refreshingly novel graphic and illustrative ideas. As the 1960s progressed, further fresh graphic and illustrative ideas from other branches of music would find their way into jazz and match more closely the innovations of the musicians themselves.

"I'd rather take my chances and truly play and see if a person really liked it than try to figure out something people are likely to like."

Ornette Coleman quoted in Martin Williams, *Jazz Changes*
(Oxford University Press, 1993)

TOP: *This is Our Music*, cut in July/August 1960, was the first album the Coleman Quartet recorded after moving from California to New York. Their music was causing controversy in the city's musical establishment, who did not know what to make of their free approach. "You hear the pure emotion," Ornette told *Metronome* magazine.

BOTTOM: Jazz photographer Chuck Stewart catches a more contemplative Ornette Coleman for this 1982 issue of material recorded in 1971–1972 and unreleased at the time. As well as tracks by his reunited quartet, some of the music is by a larger ensemble with pianist Cedar Walton and guitarist Jim Hall.

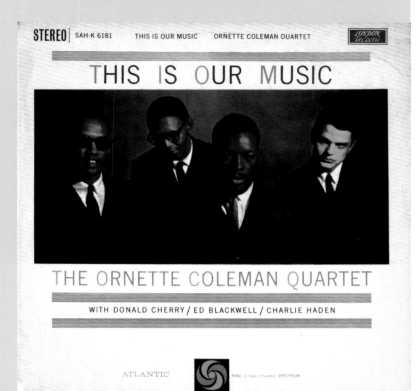

STEREO | SAH-K 6181 THIS IS OUR MUSIC ORNETTE COLEMAN QUARTET LONDON ATLANTIC

THIS IS OUR MUSIC

THE ORNETTE COLEMAN QUARTET

WITH DONALD CHERRY / ED BLACKWELL / CHARLIE HADEN

ATLANTIC FULL frequency SPECTRUM

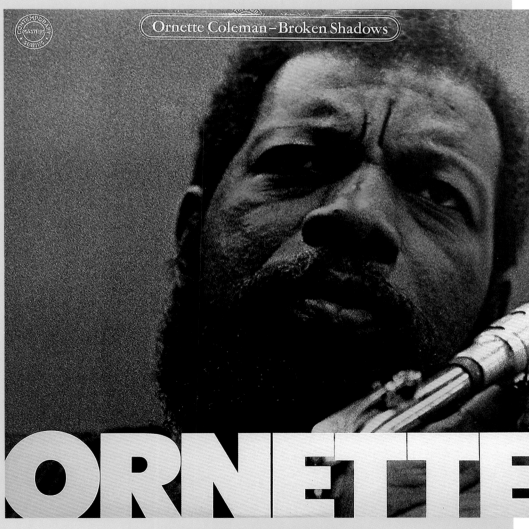

Ornette Coleman – Broken Shadows

ORNETTE

BELOW LEFT: **Although the** *Pithecanthropus erectus* **pre-human "missing link" came from Java, Julio de Diego's 1956 design adopts images from the Lascaux cave paintings in South West France. These had been in the news during 1955 when increased lichen and damp, a byproduct of public access, threatened to destroy the prehistoric paintings, eventually leading to the caves' closure.**

TOP RIGHT: **George Pickow's evocative photograph formed the center of this design by Marvin Israel for Atlantic, and the picture cleverly pictures the sadness in the clown's eyes and mouth, despite the forced jollity of the makeup.**

BOTTOM RIGHT: **Bob Parent was, like William Gottlieb, one of the photographers who chronicled the New York jazz scene, but for this picture he is far from the clubs and concerts of Manhattan. Instead he has Mingus posed in his studio to create the elaborate visual pun on "Ming Dynasty."**

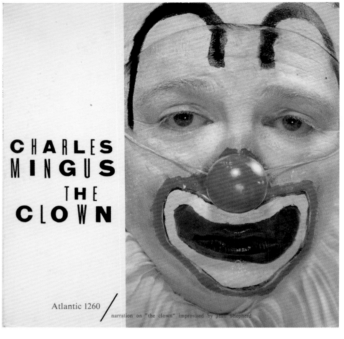

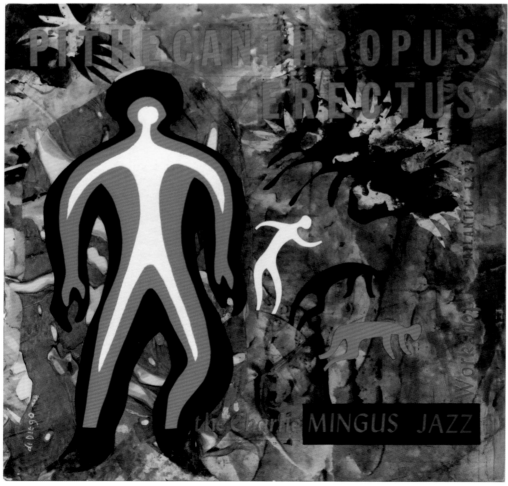

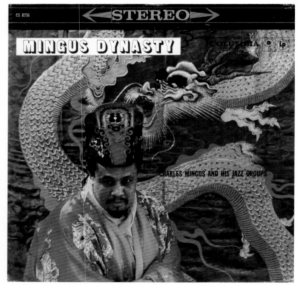

The Art of Jazz

BELOW: In another of S. Neil Fujita's Columbia LP sleeves from 1959, using a similar concept to Brubeck's *Time Out* (as shown on page 137), he again adopts a linear design running across the middle of the front panel, this time incorporating images redolent of the Native American art of the Navajo and Hopi from Arizona, the state where Mingus was born.

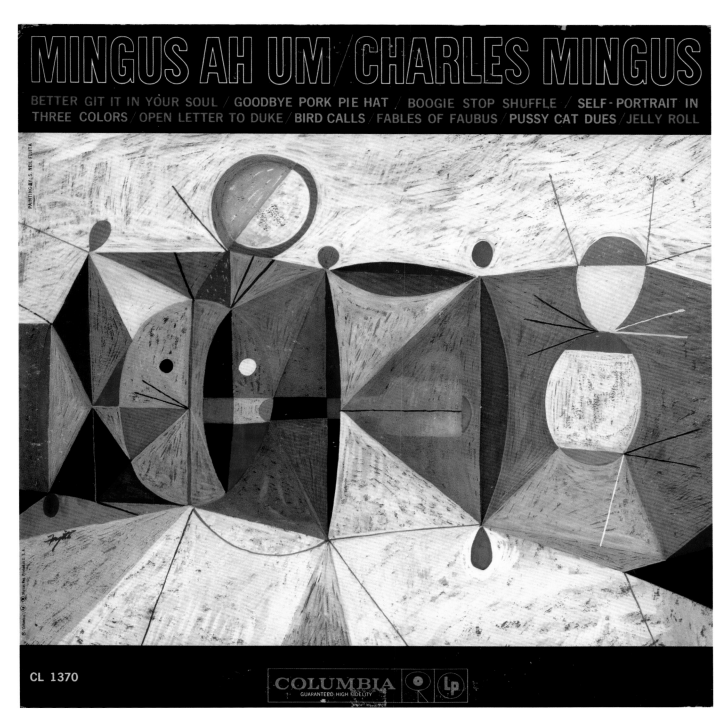

TOP LEFT: **Alex Steinweiss is considered to be the "father" of album cover art, having worked with Columbia in the 1940s to create packaging for LPs that would protect their fragile microgrooves. He designed over 2,500 sleeves, and, after stepping down as Columbia's head of design, he worked for numerous other labels, including Decca and London.**

TOP RIGHT: **This album by Teddy Charles—one of the most long-lived vibraphonists in jazz, with a career that stretched from 1950 to 2011—has a cover by Marvin Israel. Mingus is a guest artist on the record, and the cover's abstract design hints at many ideas, including the word "jazz."**

BOTTOM: **While Mingus, Coltrane, and Coleman were emergent musical forces in the late 1950s, Sun Ra was active in Chicago. He was a larger-than-life character, wearing outlandish costumes, and (as can be seen from the decoration on his garments here) he claimed a connection to Saturn.**

The Art of Jazz

"There is a continuity of expression, certain continually evolving strands of thought that link all my compositions together. Maybe it's like the paintings of Jackson Pollock," writes Ornette Coleman in his notes to the album *Change of the Century*, recorded in October 1959. After he came to make his double-quartet album *Free Jazz*, consisting of two long takes made between eight in the evening on December 21, 1960, and the small hours of the following morning, the image selected for the cover was the 1954 painting *White Light* by Jackson Pollock, created two years before the artist died. It is possible that Pollock, a fan of New Orleans polyphonic improvisation and the songs of Billie Holiday, might not have thought much of Coleman's music. But Coleman remained a lifelong admirer of Pollock, and at the time his quartet came to New York, toward the end of 1959, Pollock and the abstract impressionists of the New York School were being drawn into the art world's establishment. The unorthodox methods that Pollock used to create many of his canvases, including dripping and splashing paint onto them, could be used to describe Coleman's music more directly than the different approaches of, say, Mark Rothko or Barnett Newman.

Indeed, music critics quickly resorted to such similes, not least because Coleman himself had given them a strong lead in that earlier liner-note statement. Bandleader and composer Don Heckman wrote, "Like action painting, it is the very act of improvisation that becomes significant." Coleman sought to create music that was free of the existing "theme—solos—theme" structure of most jazz by breaking the "frame" in which it was placed; the designers at Atlantic Records colluded with the idea of subverting the "frame" of a performance. On the album's mainly typographical cover, a small window is cut on the right side, through which part of Pollock's painting is visible. If the record buyer opens the sleeve, the inner liner presents the complete painting.

One reason for Coleman and his record company's deliberate association with a visual art movement that was in vogue in 1960 is that his music was highly controversial. The jazz critical establishment was split, with writers like Stanley Dance or George Hoefer dismissing what they heard, while others, such as Whitney Balliett, Martin Williams, and Gunther Schuller, praised Coleman's work. Amid the storm of words that greeted the band's East Coast residency at New York's Five Spot, it was the British social historian Eric Hobsbawm who pointed out that Coleman was not reaching the potentially sizeable African American audience for his work, but was—at this stage—being fêted by young white intellectuals. This would change over time, but not before Coleman had brought his subsequent trio to Britain and Scandinavia, where he was similarly praised by lovers of avant-garde art in all its forms.

His 1965 recordings from the Golden Circle Club in Stockholm include his first ventures into playing the trumpet and violin in place of the alto saxophone, his deliberately untutored style intended to draw out new ideas from those instruments. Blue Note's covers for the resulting two albums show Coleman with bassist David Izenson and drummer Charles Moffett, attired in formal hats and overcoats in a snowy woodland setting. The photograph is by Francis Wolff, but in a very different mood from his informal studio portraits.

The trio's next album, *The Empty Foxhole*, recorded at Rudy Van Gelder's New Jersey studio, features Ornette's ten-year-old son, Denardo Coleman, on drums, but shows a reversion to ideas drawn from contemporary painting in the bright abstract image in Bob Fuentes's cover design. Ornette's subsequent work—particularly with his fusion band Prime Time and the collaboration with Howard Shore and the Master Musicians of Jujouka for the soundtrack to David Cronenberg's film *Naked Lunch*—saw more inventive art and design work. But the underlying philosophy for Coleman in his music and the work around it was based on his philosophy of harmolodics: "Most musicians follow maps to improvise. I prefer musicians who are seeking something freer, easier, more enjoyable. The main thing that makes toward music perfection is the will to make it better instantly."

Ornette Coleman and Free Jazz

"Free Jazz is a rare feat and noisy joy, its crosshatched strains of melody, blends and rhythms laying out manifold webs of interaction, modulation, harmonization and agreeable rather than competitive correspondence."

Howard Mandel, *Miles, Ornette, Cecil, Jazz Beyond Jazz* (Routledge, 2010)

BELOW LEFT: **Ornette Coleman began designing and making his own clothes in the 1960s. This picture shows a relatively conservative hat and jacket ensemble, but some of his garments included dazzling patterns, and according to his biographer, Claire O'Neal, the** *Village Voice* **ran an entire feature in 1987 on his self-designed wardrobe.**

TOP RIGHT: **As well as designing his own clothes, Ornette Coleman turned his hand to painting, and he produced the cover artwork on this 1966 album for Blue Note designer Bob Fuentes. It caused a stir on release as the drummer Denardo Coleman was Ornette's ten-year-old son.**

BOTTOM RIGHT: *The Shape of Jazz to Come* **(1959) was Ornette's debut for Atlantic and the first official release by his working quartet with Don Cherry, Charlie Haden, and Billy Higgins.**

The Art of Jazz

For the first of three dramatically different pieces of album art for Ornette Coleman, Francis Wolff took this photo for *Love Call*, **featuring Coleman with Jimmy Garrison and Elvin Jones —half of John Coltrane's quartet—the year after Coltrane's death. Also including Coleman's fellow Fort Worth musician Dewey Redman, the hard-edged music seems at odds with Wolff's picture.**

BOTTOM LEFT: **Francis Wolff himself produced the Coleman trio's live recordings at Stockholm's Golden Circle Club in December 1965. He also took this atmospheric shot of bassist David Izenson, Ornette, and drummer Charles Moffett standing in the Scandinavian winter, used here in one of Reid Miles's most striking Blue Note designs.**

BELOW RIGHT: **Dorothy Baer's design for this album, recorded between 1973 and 1976 by Coleman's fusion band Prime Time and the Master Musicians of Joujouka, uses the same visual pun as Andy Warhol's** *Basie* **on page 161. Flip the image upside down and the smiling woman becomes a bearded sage.**

Changing Landscape—Mingus, Coltrane, and Coleman

189

BELOW: The Cedar Tavern on University Place, Manhattan, was the hangout for abstract expressionist painters in the 1950s and 1960s. Judith Lindbloom was a young, gay artist from Detroit, and she regularly met there with artists like Rothko and Pollock. She loved jazz, and her work was used on numerous album covers, particularly by multi-instrumentalist Joe McPhee and soprano saxophonist Steve Lacy.

STEVE LACY & JOE McPHEE

THE REST

BELOW LEFT: **Both Don Cherry and Charlie Haden left Ornette Coleman's band to pursue their own careers, as exemplified on this page. The painting on** *Where Is Brooklyn?* **is by Cherry's Swedish wife Monika ("Moqui") Cherry. This 1966 Blue Note recording featured Don and Ed Blackwell, from Coleman's band, with bassist Henry Grimes and saxophonist Pharoah Sanders.**

TOP RIGHT: **The year before his death, John Coltrane joined Don Cherry for this quartet album. The spectacular painting, by Turkish artist Abidin Dino, is ambiguous. Is it a sleeping lion, a dying fox, a still life, or a landscape? It borrows from all those ideas in earlier art, just as the music collates sounds from earlier periods of jazz.**

BOTTOM RIGHT: **Cherry (seated) and Haden (right) both appear in Chuck Stewart's photograph for the inaugural 1971 album by the Liberation Music Orchestra. Playing revolutionary songs arranged by pianist Carla Bley (left), the band continued to tour after Haden's death in 2014 under Bley's direction.**

The name "new thing" came to be applied to a subset of the music played in the mid-1960s by the circle of musicians associated with John Coltrane. More recently, the term has become synonymous with "free jazz." But back in 1965, after a Newport Festival concert by Coltrane's quartet and a contrasting group led by tenorist Archie Shepp, released under the title *The New Thing at Newport*, the term was very much associated with those players. Shepp's band, with vibes player Bobby Hutcherson, bassist Barre Phillips, and drummer Joe Chambers, produced music that was far more abstract than Coltrane's, with spaces, screeches, and honks from the saxophone, apparently random notes and chords from the vibes, and an essentially arrhythmic backing of constant activity from the bass and drums.

As if to contrast with the unorthodox nature of his music, Shepp was pictured on the cover bedecked in conservative sartorial elegance: a white shirt and tie, a check sports jacket, and a neat, cream-colored linen cap. He holds sheet music in his hand so as to emphasize the formal elements that many listeners struggled to hear in the music. Behind him is the paling fence of the artists' enclosure, and he leans on one of the bleachers—a sight familiar to anyone who knew Bert Stern's film *Jazz on a Summer's Day*, with its images of the 1958 Newport event, Impulse!, the record label, thus using the cover to play on the viewer's subconscious in order to convey a sense of familiarity in the most unfamiliar music. Later, Shepp was to go on to include spoken-word excerpts in his concerts and records, and he also began to focus on material with direct African connections.

Four days before the Newport concert, Coltrane had gone into the studio with a large ensemble to make his album *Ascension*. It features several of the "new thing" musicians, including the trumpeter Freddie Hubbard, alto saxophonists John Tchicai and Marion Brown, fellow tenorists Shepp and Pharoah Sanders, and an additional bass player, Art Davis, plus Coltrane's regular colleagues McCoy Tyner (piano), Jimmy Garrison (bass), and Elvin Jones (drums). Each of these musicians would spearhead a slightly different direction for the new thing. "Trane was very sensitive to the musicians that followed—younger musicians like myself," recalled Archie Shepp. "He always had his ear to the ground for new ideas."

Tchicai was from Denmark, and had only arrived in New York two years before. When he eventually returned to his native country, he worked in jazz education, but he also consistently performed and recorded the kind of free music he had played in America. After a brief return to the States in the 1980s, he settled in France. Marion Brown also spent the last part of the 1960s in France, but he had already recorded with Shepp, even before the "new thing" concert, on an album called *Fire Music*. A track from their work together also appears on an anthology of like-minded performers, *The New Wave in Jazz*. In the same way that Shepp had been presented in formal attire on the front of the Newport album, on this anthology Coltrane is depicted wearing a suit and tie, albeit blowing his saxophone ferociously. As well as continuing the exploration of avant-garde sounds, *Fire Music* was an explicit homage to Malcolm X, with a track called "Malcolm, Malcolm, Semper Malcolm."

Pharoah Sanders has had as long and distinguished career as those of Shepp and pianist McCoy Tyner. He is a most technically brilliant saxophonist whose resources as a player allow him to play in a stratospherically high register, to produce harmonics accurately and clearly, and to present a gimmick in which the saxophone appears to go on playing itself after he has finished blowing into it. (This clever trick involves using the vibrating column of air in the instrument to continue moving, and then close-miking his fingers to amplify the notes.) Sanders and Tchicai both adopted clothes that evoke images of Africa: dyed robes and striking hats.

Although their work was geographically and stylistically distinct from that of the musicians so far discussed, the Art Ensemble of Chicago also adopted African robes and face paints. Their saxophonist, Joseph Jarman, likened the face paint to a mask that allows them to present themselves differently from the way they would look if they had "just come off the sidewalk." Meanwhile, their African costumes were the brainchild of the bassist Malachi Favors Maghoustus, who said, "Since it was in my ancestry, I felt it belonged."

The New Thing at Newport

"Shepp appeared at the Beat Festival in Chicago with Coltrane and widened his circle of admirers. He also appeared at the Newport Festival and proved that the avant-garde style was more than just a passing fad."

David Dicaire, *Jazz Musicians 1945 to the Present* (McFarland, 2015)

TOP LEFT: **The stark simplicity of the Chuck Stewart photograph in Robert Flynn's minimal cover design for Coltrane's *Ascension* is in total contrast to the visceral energy of the collective improvisation by Coltrane's eleven-piece ensemble on the album.**

BOTTOM LEFT: **Twenty-eight-year-old Archie Shepp photographed as described in the text at Newport by Joe Alper, and incorporated into yet another design by Impulse!'s Robert Flynn. This image was on the back of the original record but has formed the front of some later releases.**

TOP RIGHT: **The burning image of *Fire Music* has the same color palette as the original front-cover design for *New Thing at Newport*, which showed Coltrane in action, shot through a red filter. There was a clear family resemblance between Impulse!'s various avant-garde releases of the mid-1960s, as can be seen in the vignette of Shepp that echoes several Coltrane covers.**

BOTTOM RIGHT: **This shot from the Newport Jazz Festival shows Gerry Mulligan (left) and Miles Davis (second from right) in the very same setting as the Shepp photograph.**

The Art of Jazz

The Art Ensemble of Chicago was another hugely influential band that emerged from the social unrest of the 1960s through the cultural impetus of the Association for the Advancement of Creative Musicians (AACM) in Chicago. In Isio Saba's 1978 photo we see, from left to right, Joseph Jarman, Malachi Favors Maghoustus, Roscoe Mitchell, Famadou Don Moye, and Lester Bowie.

BOTTOM: **Famadou Don Moye—who met and joined the Art Ensemble during a period when the band was living and working in Paris—in full face paint and stage costume at the International Jazz Festival in Willisau, Lucerne, Switzerland, in August 1976.**

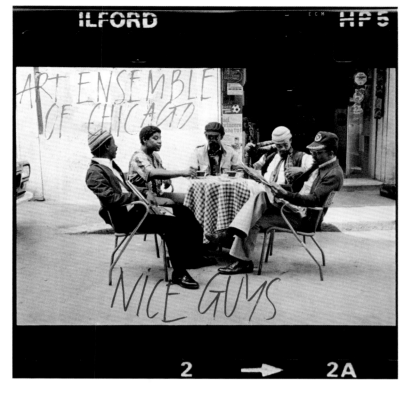

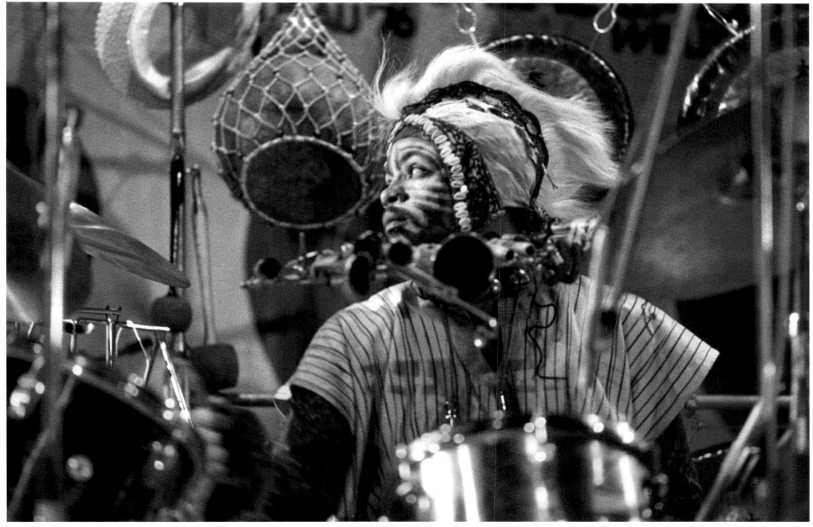

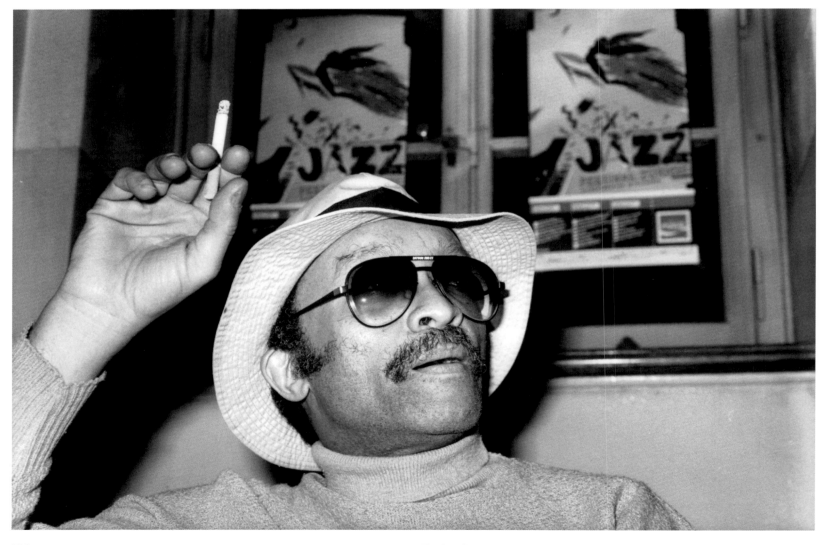

The Art of Jazz

BELOW LEFT: **The third of Pharoah Sanders's albums for Impulse! also contains a very lengthy track, "Hum-Allah-Hum-Allah-Hum-Allah," featuring the semi-yodeled vocals of Leon Thomas. Sanders, in a career that has spanned seventy years, cannily merged avant-garde intensity with memorable and popular tracks, plus stupendous technical mastery of the tenor saxophone.**

TOP RIGHT: **Reid Miles's design for Cecil Taylor's inaugural album for Blue Note in 1966 used a single Francis Wolff photograph in numerous permutations of color, thereby reflecting the almost mathematical complexity of the music. This is at its most intense in the seventeen-minute title track.**

BOTTOM RIGHT: **Howard Bernstein's drawing of Albert Ayler is one of the most memorable images of the period in the 1960s when free jazz was being forged. The design by Jordan Matthews is one of a series of covers he produced for the Manhattan-based new-music specialist label ESP Disc, founded by Bernard Stollman.**

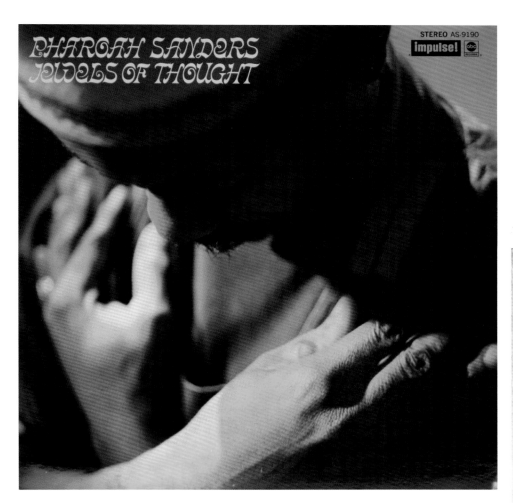

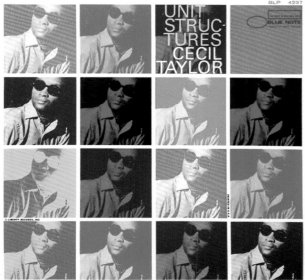

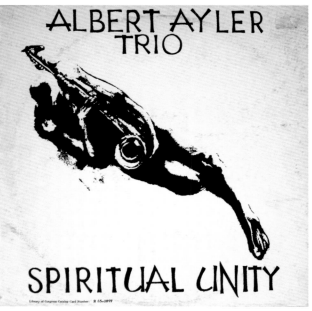

Jazz Fusions
"Funk cats who knew how to play jazz"

From the airbrushed paintings of Miles Davis's *Bitches Brew* to the psychedelic worlds of Tony Williams's Lifetime, from UK pioneers like Jon Hiseman and Ian Carr to the work of Mike Gibbs and Gary Burton, as the 1960s became the 1970s, jazz-rock was a titanic clash of musical cultures across the world. Much of the photography, graphics, and typography of rock made its way into jazz. But it was also a period when other musical genres merged with jazz, notably in South Africa, South America, and Eastern Europe.

In the mid-1960s, much of the most innovative rock and pop record design was happening in the UK. The Beatles' albums are a case in point, with Klaus Voorman's line drawings for *Revolver* (1966), Peter Blake's colorful collage of *Sgt. Pepper's Lonely Hearts Club Band* (1967), and Richard Hamilton's minimalist "White Album" (1968). When Storm Thorgerson and Aubrey Powell formed the design partnership Hipgnosis in 1968, they brought fresh thinking to the appearance of LPs by, among others, Pink Floyd (*Saucerful of Secrets*, 1968; *More*, 1969; and, in particular, the trick perspective of *Ummagumma*, 1969), plus the self-titled *Quatermass* (1970), the Pretty Things' *Parachute* (1970), the Nice's *Five Bridges* (1970), and the insect world of Syd Barrett's *Barrett* (1970). The range of visual ideas they produced in a short timespan across several interconnected genres of rock was remarkable.

Those American jazz musicians (and their labels) who were taking notice of the design revolution tended to be those whose work was closest to what was going on in the rock world. So, for example, Jim Fasso's design for Gary Burton and Carla Bley's *A Genuine Tong Funeral* (RCA, 1968) has the outline of a body molded into a landscape below a huge sunset, divided horizontally by orange lines. Equally, we find pop-art graphics on Dick Luppi's cover for Chick Corea's *Tones for Joan's Bones* (Atlantic, 1968); and a Brechtian cityscape on Corea's *Is*, from 1969, painted by Hans Weingaertner, whose work was also being used in the rock world, such as on the same year's eponymous *Damnation of Adam Blessing*. Soon, Miles Davis emerged as the dominant figure in jazz-rock, notably with the appearance in 1970 of *Bitches Brew*, which uses Mati Klarwein's dazzling pop art for the gatefold sleeve.

But just as Miles was to recognize what was happening musically in Europe, and in so doing bring British jazz-rock musicians John McLaughlin and Dave Holland into his recording projects (and, in Holland's case, into his working band), the British groups that were experimenting with fusing musical ideas of rock with jazz were trying an equally wide range of ideas concerning the way their albums looked. "I think *Bitches Brew* was such a big event in that era," recalled Zimbabwe-born arranger and composer Mike Gibbs. "We were all striving for the new, and felt we were supposed to be moving in that direction." The multicolored floral tree that adorned Gibbs's 1971 UK album *Tanglewood 63* borrowed ideas from the rock records of the flower-power era that had appeared during his time at Berklee College of Music in Boston.

Gibbs's friend and contemporary Ian Carr, leader of the UK fusion band Nucleus, was clear that there was a drive to search out the blues origins of jazz and to combine the "rock thing . . . with the roots of the music." When Nucleus came to New York in the summer of 1970 (after winning the Montreux Jazz Festival band contest and appearing at the Newport Jazz Festival), they played a short engagement at the Village Gate in Manhattan. Although *Bitches Brew* had been on release for a few weeks, Carr remembered puzzled members of the Greenwich Village audience, unused to the newly emerging sounds of jazz-rock, shouting, "What do you call this music?" The difference at this stage in the development of fusion is that, whereas Miles had been working on the *Bitches Brew* music in the studio, Nucleus had been playing material that appeared on their debut album, *Elastic Rock*, in clubs and on the road for almost a year.

The *Elastic Rock* album cover, designed by prog-rock artist Roger Dean (who would also work for Yes and Osibisa), involves a color photograph of an open crater on a volcano, full of glowing magma, which is seen through a small circular hole (with an additional smaller hole to the bottom right) in the outer sleeve. The image appears to be a blast furnace or smelting works, until the cover is lifted, revealing the very different volcanic picture. The Vertigo company's op-art design on the center of each record, which moves intriguingly as the disc spins at 33 ⅓ rpm, owed plenty to the graphics of Bridget Riley, and the band photograph looks as if it might have been drawn by Klaus Voorman.

Within a very short space of time, Nucleus produced a number of other albums. Dean's use of a photo of armed marksmen on a barricade adorns

Jazz Fusions

PREVIOUS SPREAD: **Jim Fasso's** linear drawing for Gary Burton's *A Genuine Tong Funeral*, recorded for RCA in 1967 and released the following year, is one of the covers that marks the turning point of jazz album design, where influences shared with the rock world became the norm for jazz-rock fusion.

BELOW LEFT: **Dick Luppi** produced several covers for fusion albums in the late 1960s, for players as varied as Herbie Mann, Roy Ayers, and Dave Pike, but this is his best-known, for Chick Corea's debut, recorded in 1966 and released shortly before he joined Miles Davis in the fall of 1968.

TOP RIGHT: **Pink Floyd's** *Ummagumma*, designed by UK partnership Hipgnosis in 1969, was a paradigm for jazz-rock fusion and later sleeve designs (see page 225) using the so-called Droste effect, where a picture appears within itself, often, as here, in multiple receding versions.

BOTTOM RIGHT: **Mati** Klarwein's image for the 1970 record *Bitches Brew* is arguably the most significant fusion record design. As Miles Davis moved completely into fusion he would set not only the musical but also the visual pace for the period that followed.

We'll Talk About It Later, whereas B. E. Ltd, which designed 1971's *Solar Plexus*, created a complex web of images that run (as for *Elastic Rock*) from outside to inside the packaging. A frayed Chinese hat seen from above looks as if it might be an exploding planet or an ovum being penetrated by a sperm, and inside the liner is a repeated image of an unfurling flower.

Designer Keith Davis (who had produced covers for everyone from Count Basie to James Last) ventured into comic art for Nucleus's *Labyrinth*, and the same year he produced a pop-art cartoon involving a giant green robot for the band's *Roots*. Davis also designed the related cover for Carr's book about contemporary British jazz, *Music Outside*. Carr was not alone in creating imaginative covers for albums that sat at the junction of free jazz, rock, and postbop. His British contemporary Graham Collier essayed fisheye lens photography (*Down Another Road*, 1969), multiple exposure photography (*Songs for My Father*, 1969), and abstract painting (*Mosaics*, 1970). Jon Hiseman's Colosseum produced two covers for *Those Who Are About to Die Salute You* (1969): the UK release has a semi-ironic group portrait, while a more prosaic issue for the American market shows the band in action in a photomontage.

This fertile period in British music produced one genuine crossover label, Georgio Gomelski's Marmalade records. On the one hand, Gomelski (who had been closely involved with early promotion of the Rolling Stones and managed the Yardbirds) produced albums by singer Julie Driscoll, the psychedelic-rock band Blossom Toes, and the blues singer Sonny Boy Williamson; on the other, he produced cutting-edge jazz by the guitarist John McLaughlin. His *Extrapolation* (1969), with its out-of-focus sleeve photograph, paved the way for many a 1970s crossover design.

British musicians McLaughlin and Dave Holland had both appeared on Miles Davis's *In a Silent Way* and *Bitches Brew*, and McLaughlin (who was not a member of Davis's regular touring band) went on to appear on the next few Davis albums, *Jack Johnson*, *Live-Evil*, *On the Corner*, and *Big Fun*. Just as the musicians who worked on these albums subsequently went on independently of Davis to create much of the fusion movement, visually these records became cornerstones of 1970s jazz-rock album design.

Jack Johnson (a tribute to the famous boxer) initially appeared with a pop-art picture of Johnson driving several female friends in a vintage automobile in a painting by Paul Davis (no relation), who had previously designed a stylistically similar cover for Thelonious Monk's *Solo*, showing Monk attired as a pilot in a primitive aircraft. Miles disliked the painting, and for later issues it was replaced by a famous side-view photograph of him playing trumpet and leaning backward—in the form of a similar line drawing used on the 1960 *Sketches of Spain*. This was in effect to become the "Miles Davis brand" logo. Meanwhile, *Live-Evil* returns to the fantasy artwork of Mati Klarwein, this time with a pregnant woman taking center stage on the front, and—at Miles's suggestion—a huge toad on the back, apparently based on J. Edgar Hoover. By contrast, *On the Corner* features a cartoon by Corky McCoy of an urban African American street scene in a style that came to be known at the time as "ghettodelic," an idea that would surface again on Miles's 1976 retrospective album *Water Babies* (a set of previously unheard tracks from the late 1960s) and on the crowd painting on the live 1972 *In Concert* album (which also had further McCoy paintings on the inside cover). McCoy also produced the more abstract design of the trumpet and female form on the cover of *Big Fun* (1974). His urban cartoons would be used again in the hip-hop era of the 1990s, as on Ugly Duckling's debut album *Fresh Mode*, while the graphic ideas from Miles's 1970s work would form the basis of the designs for future albums by Herbie Hancock, Chick Corea, and Weather Report (with ex-Davis colleagues Wayne Shorter and Joe Zawinul).

"*Bitches Brew* was released as a double LP with a surreally beautiful gatefold sleeve. The artist Mati Klarwein was a former student of Ferdinand Leger and friend of Salvador Dali. He grew up in Palestine, the son of refugees from Nazi Germany, and his work often evokes exile and journeying."

Brian Morton, *Miles Davis* (Haus, 2005)

TOP LEFT: Artist Corky McCoy shared an apartment with Miles Davis on New York's West 77th Street, so when Miles wanted an album to reflect (as he writes in his autobiography) "everyone dressing kind of 'out street' . . . platform shoes that were yellow . . . handkerchiefs around the neck, headbands, rawhide vests . . . real tight dresses," McCoy was asked to make it happen.

BOTTOM LEFT: This final album from 1969 by Miles's great quintet of the 1960s has a cover photograph by Japanese-American fashion photographer Hiro (Yasuhiro Wakabayashi). The subject is Davis's then wife, the model Betty Mabry, nineteen years younger than him, who introduced him to Jimi Hendrix and Sly Stone. She played a major role in moving Miles toward fusion.

TOP RIGHT: Paul Davis's cover for Miles's soundtrack to William Cayton's film about Jack Johnson. Paul Davis was a highly versatile illustrator, producing excellent portraits of Clifford Brown and Leadbelly, although his finest album design reproduces Emanuel Leutze's 1851 painting of Washington crossing the Delaware, but on a cheeseburger instead of a barge, for the New York Rock & Roll Ensemble's 1972 LP *Freedomburger.*

BOTTOM RIGHT: This transitional 1969 album carries an atmospheric picture of Miles by the celebrated jazz photographer Lee Friedlander, whose pictures appeared on hundreds of albums from the mid-1950s onward, covering subjects from New Orleans jazz to the avant-garde.

Jazz Fusions

The Art of Jazz

BELOW: **Mati Klarwein also produced the artwork for this double LP, picking up Davis's theme of duality. So, just as the album title and the tracks "Selim" and "Sivad" reverse words, and other tracks such as "Double Image" and "Gemini" explore contradictory emotions, this positive painting of pregnancy blessed by a spirit is countered by the ugly toad on the reverse.**

BELOW LEFT: **Roger Dean's design for** *Elastic Rock* **uses a similar window device in the outer sleeve to Ornette Coleman's** *Free Jazz*, **but instead of revealing a Jackson Pollock painting, the gatefold opens to show the molten heart of a volcanic eruption.**

TOP RIGHT: **British trumpeter Ian Carr was greatly influenced by Miles Davis, and his jazz-rock band Nucleus evolved at the same time as Davis moved into fusion. For this 1973 album, Polydor designer Keith Davis drew on comic art, and added (alongside the robot) references similar to Corky McCoy's, showing platform heels and contemporary fashion in the futuristic apartment setting.**

BOTTOM RIGHT: **Keith Davis's second Nucleus design draws on the contemporaneous "Bronze Age" of US comic books. In the manner of Neal Adams and Jack Kirby, it depicts Theseus slaying the minotaur, representing the heroic role of Kenny Wheeler's trumpet in Carr's extended composition** *Labyrinth*. **On the back cover, Ariadne, in the same pose, watches Theseus's ship row away from Naxos.**

The band that John McLaughlin crossed the Atlantic to join, Tony Williams's Lifetime, did not at first show the kind of originality in their visual presentation that had been shown either by Miles Davis or the Marmalade label in the UK. The band's first LPs from 1969—*Emergency*, volumes 1 and 2—showed rather prosaic photographs of the leader or his drumming. But suddenly, from 1970's *Turn It Over*, the band's graphics became as exciting as its concerts. Trumpeter Ian Carr described the band as "incredibly loud," and this is borne out by the cover to this album. Once one has obeyed the instruction to turn over the otherwise blank black front cover of the LP, the spiral of credits on the back (surrounding a picture of Williams in a flower-power-era shirt) includes the capital-letter instructions to "PLAY IT LOUD" and "PLAY IT VERY VERY LOUD." By the following year, McLaughlin and Jack Bruce—the former Cream bassist who had played with McLaughlin in Graham Bond's band—had left Lifetime, but the group's next album, *Ego* (cut with different musicians, including bassist Ron Carter and guitarist Ted Dunbar), is a tour de force of creative graphics.

On the front is a painting by Michael Gross of Williams's torso, hands, and drumsticks. On the back, there's an inverted picture of his head by the same artist with various items, including a car, dice, a pool of blood, and a fish, emerging from his scalp. The band's 1973 swan song, recorded with a completely different cast, has a cartoon by the graphics partnership Camouflage that resembles Corky McCoy's work for Miles Davis, as Williams and his drums are thrown out of a bar in *The Old Bum's Rush*.

Meanwhile McLaughlin, after leaving Lifetime, had gone on to found his Mahavishnu Orchestra in 1971. The group's debut, *The Inner Mounting Flame*, had a cover by Columbia's prolific designer Ron Coro, who produced work for artists as varied as Gary Puckett and the Union Gap and the Philadelphia Orchestra under Eugene Ormandy (though the connection here is with the work he had done for Ravi Shankar, on albums such as *Chappaqua* from 1966), with Coro superimposing an exterior shot of the band onto the image of a flame. This band was in tune with the times to a remarkable extent, mixing heady jazz-rock with tenets of Eastern thinking and living. This interest of McLaughlin's extended back to Graham Bond, who had introduced the guitarist to Indian philosophy and religion. Under the guidance of guru Sri Chinmoy, McLaughlin adopted the name Mahavishnu, which means "divine

compassion, power, justice." Dressed in white, his hair cropped short, and publicly disassociating himself from drugs and alcohol, McLaughlin advocated clean living and the power of meditation. His study of Indian music had an increasingly noticeable effect on the sound of his groups as the 1970s went on.

The Mahavishnu Orchestra captured the mood of the "flower power" generation, and they became immensely popular on the world festival circuit, becoming what Ian Carr described as "the greatest jazz-rock band." At this time, McLaughlin also started playing an unorthodox guitar with two necks, one with twelve strings and one with six, to allow him to alternate immediately between different types of instrumental effect. Supported by drummer Billy Cobham's complex rhythms and the power of keyboard player Jan Hammer, the band also featured a violinist, Jerry Goodman. A slightly later lineup from 1974—after the original group became a victim of its own success—featured French violinist Jean-Luc Ponty. Columbia used related designs with ethereal free-flying birds for the albums *Birds of Fire* and *Visions of the Emerald Beyond*.

By this time, in complete musical contrast, McLaughlin had formed Shakti, an acoustic group with Indian violinist L. Shankar and tabla player Zakir Hussein. With their name developing into an enduring logo, they became an extremely popular crossover band, pioneering the fusion of jazz and Indian music and building on earlier experiments in Europe by Joe Harriott and John Mayer's Indo-Jazz Fusions and Manfred Schoof's work with the Swiss pianist Irene Schweizer. Shakti Revisited, with almost the same lineup, has toured frequently since, proving the durability and popularity of the formula. From the late 1970s, McLaughlin tried various short-lived lineups while working on his technique and stylistic range. The most successful involved fellow guitarists Paco De Lucia and Al Di Meola.

In 1984, McLaughlin again played for Miles Davis on the album *You're Under Arrest*, as well as contributing to Davis's 1985 disc *Aura*. Shortly after these dates, he appeared in Bertrand Tavernier's film *Round Midnight*, which seemed to have a revitalizing effect on his career (as it did for his fellow stars Dexter Gordon, Herbie Hancock, and Wayne Shorter). In the second decade of the twenty-first century, McLaughlin has consolidated his position as one of the most versatile and accomplished guitarists in jazz (on both the electric and acoustic instruments) and as a leading pioneer of jazz-rock fusion and of integrating jazz with elements of world music.

John McLaughlin

"McLaughlin had a superb harmonic sense and melodic flair, and his playing was notable for both sensitivity and power; also he was steeped in both the jazz and rhythm and blues traditions."

Ian Carr, *Miles Davis: The Definitive Biography* (Harper Collins, 1999)

TOP LEFT: Gene Greif's design for this Columbia album from 1978 harks back to McLaughlin's early days in Britain, but apart from fellow British musician Jack Bruce, all the other players on the album are colleagues from the early American era of McLaughlin's career.

BOTTOM LEFT: The inaugural album of the Mahavishnu Orchestra, designed by Ron Coro, with Anthony Hixon's band photograph showing Jan Hammer (keyboards), Rick Laird (bass), Jerry Goodman (violin), Billy Cobham (drums), and John McLaughlin (guitar).

BELOW RIGHT: John McLaughlin in a twenty-first-century shot by British jazz photographer John Watson, showing him playing his violin-wood PRS Private Stock guitar. It was custom-built especially for him, and has become one of his favorite instruments, showing that the term "art of jazz" can accurately be applied to the craft of luthier.

BELOW LEFT: **For Bertrand Tavernier's film** *Round Midnight,* **starring Dexter Gordon and François Cluzet in roles loosely based on Bud Powell and his friend and biographer Francis Paudras, musical director Herbie Hancock assembled an all-star cast of musicians, including John McLaughlin, to recreate the sounds of the Blue Note club in Paris as it had been in the late 1950s.**

TOP AND BOTTOM RIGHT: **The front and back designs of** *Ego,* **the most artistically adventurous cover of the handful of albums by Tony Williams's Lifetime. As described in the text, the artwork is by Michael Gross, at that time art director of** *National Lampoon,* **who also designed record sleeves for artists as different as Arthur Fiedler, John Lennon, and Ornette Coleman!**

The Art of Jazz

TOP: **Al Di Meola is a guitarist who, like McLaughlin, crosses many stylistic boundaries. The cover for *Soaring Through a Dream* was created in 1985 by ex-CBS designer Paula Scher, who had recently set up a new company with fellow designer Terry Koppel. This photomontage is redolent of their mid-1980s work for Blue Note, and on other issues for Manhattan, which released this album.**

BOTTOM: **Another cover by Koppel and Scher, created during the partnership's six-year life in the 1980s, neatly encapsulates the "heaven and earth" idea of Di Meola's album title.**

STEREO MHS-61708

BELOW: **One of the most iconic of all fusion designs, Victor Moscoso's 1973 cover for *Head Hunters* shows Herbie Hancock in headgear loosely based on an Ivory Coast *kple kple* mask, but made up of components from a studio device to demagnetize tape heads. Left to right: Harvey Mason (drums), Paul Jackson (bass), Hancock, Bennie Maupin (saxophones), and Bill Summers (percussion).**

The Art of Jazz

BELOW LEFT: **Chick Corea's first project after leaving Miles Davis was the free-improvisation band Circle, with Dave Holland and Anthony Braxton. But he soon followed Hancock and Shorter into fusion, and Return to Forever has been one of the longest-lived jazz-rock bands. This atmospheric cover is by Scottish-born painter Wilson McLean.**

TOP RIGHT: **Just as Herbie Hancock forged a career after working with Miles Davis, so too did keyboard player Joe Zawinul and saxophonist Wayne Shorter. Their band Weather Report's eponymous first album appeared in 1971, with a suitably enigmatic cover from Columbia's designer Ed Lee and house photographer Ed Freeman.**

BOTTOM RIGHT: **"Father of fusion guitar" Larry Coryell's self-titled album from 1969 is full of not-so-coded messages. The pastoral photograph by Chappie Diederich, which shows Coryell and his then wife Julie Nathanson, fronts a record that includes the tracks "Beautiful Woman," "Sex," and "Morning Sickness."**

Jazz had been played in South Africa since the early days of the music, but in the 1950s a distinctly local variety began to emerge, and a band formed late in the decade, the Jazz Epistles—among them trumpeter Hugh Masekela, trombonist Jonas Gwangwa, pianist Abdullah Ibrahim, and saxophonist Kippie Moeketsi—became the first to fuse the sounds of bebop with traditional South African dance rhythms and harmonies. In 1959, they produced what augured to be a highly successful record, *Jazz Epistle—Verse 1*, for the local Gallo company, with a simple but effective graphic cover designed by Johannesburg's Design Centre. But although it sold really well on its initial release, it was not to be the lasting breakthrough that they or their public expected, as Masekela explained: "We were only able to do one album and it was a massive success. We were the first group of our kind and the first to make an LP in South Africa. And we had a sold-out upcoming tour when the Sharpeville massacre happened and gatherings of more than ten people were disallowed." In effect, following the killing of sixty-nine unarmed protesters outside a police station in Gauteng province, the restrictions of the South African regime of apartheid intervened, putting an end to the possibility of audiences attending a concert by African musicians. Before long, Masekela and Ibrahim had left the country to forge careers elsewhere.

In late 1960, after a short spell at London's Guildhall School of Music, Masekela arrived in the United States and formed a quartet, recording *The Americanization of Ooga Booga* in 1965 for MGM. The title satirizes the perceptions some Americans had of an African musician. It took on the kind of nonsense language that Tarzan spoke in movies, and the cover (designed by Acy Lehman) reflects this theme of the "Westernized African," as Masekela poses in a dapper suit and tie, with a hat and attaché case in his hand, yet below the knee he is standing barefoot on the jungle floor. The follow-up, *Hugh Masekela's Next Album*, saw MGM keep the same theme going, with Hugh again barefoot in a smart suit, with case and trumpet, but this time posing in Manhattan, with a life-size model zebra and an assegai. (There's no designer credit on the record, but the zebra was supplied by the New York toy store FAO Schwartz.) When he came to make the follow-up album, *Grrr*, for Mercury in 1966 (with Bob Prokup's photo of a lion cub and Hugh's trumpet on the cover), he came under the wing of older musicians like Dizzy Gillespie. Looking back, he recalled being mentored in the United States, just as Kippie Moeketsi had mentored him in South Africa. "Evolve as much as you can and then pass it all on" was the maxim.

While Masekela and Ibrahim (who was still recording under his original performing name of Dollar Brand) launched careers in America, a whole generation of their South African peers moved to Britain. There, Masekela subsequently worked with several who took a slightly different musical direction from his own. "I did a very enjoyable album in London in 1970, with Dudu Pukwana, called *Home Is Where the Music Is*," he said. "It was a double album, and it's one of the things that I'm really proudest of, because for us it was a revival of where we came from. Dudu came over to the UK and we planned to have more or less the same kind of band as the Blue Notes who came over with Chris McGregor, Louis Moholo, Johnny Dyani and Mongezi Feza." The cover for *Home Is Where the Music Is* presents an interesting study in packaging. The original release on Blue Thumb in 1972 included a strong set of drawings and paintings by the antiapartheid activist artist Dumile Feni, but they were revealed by opening a folding sleeve that had a Westernized photograph of Masekela and his flugelhorn on one gatefold and simple, capital-letter typography on the other. It seems that the very duality in the public perception of the music that those original MGM covers satirized was still a design trope over a decade later.

South Africa

"Only one recording of the Jazz Epistles survives . . . its language is recognizably bebop, its idiom unmistakably South African."

Gwen Ansell, *Soweto Blues* **(Continuum, 2005)**

The Art of Jazz

BELOW LEFT: Acy Lehman's cover for Hugh Masekela's *Americanization of Ooga Booga* riffs on the idea of the African in urban America. The record dates from 1966, two years after Masekela completed his studies at Manhattan School of Music.

TOP RIGHT: New Yorkers would immediately have recognized the giant advertisement for Gordon's gin that sat atop Bond's clothing store in Times Square. Complete with zebra, assegai spear, and bare feet, Masekela is ready to conquer Manhattan.

BOTTOM RIGHT: Dorkay House in Johannesburg was a meeting place for African musicians and artists in the apartheid era. Here we see two members of the Jazz Epistles, trumpeter Hugh Masekela and trombonist Jonas Gwangwa, jamming with saxophonist Gwigwi Mwrebi.

BELOW: Recorded live in the Jazzhus Montmartre club in Copenhagen during 1969, this wasn't Abdullah Ibrahim's first solo record after leaving South Africa (that was *Reflections*, from 1965), but it was the one that established his formidable solo reputation. It contains some of his best-loved pieces, including "Bra Joe from Kilimanjaro" and "Tintiyana."

abdullah ibrahim · african piano

The Art of Jazz

BELOW LEFT: This design by Keith MacMillan for the first Brotherhood of Breath album in 1971 created an enduring image, with the two female African figures on the front cover. These are mirrored by further photographs of traditional male statuary inside the sleeve, plus a portrait of Chris McGregor in traditional dress. MacMillan (under the name "Keef") also designed for David Bowie and Black Sabbath.

TOP RIGHT: McGregor's Brotherhood of Breath combined South African exiles Dudu Pukwana, Mongezi Feza, Harry Miller, and Louis Moholo, plus McGregor himself, with cutting-edge British players. Swiss designer Niklaus Troxler—who worked on several Willisau Festival albums—here uses the image of hands reaching out across the world from the tree of jazz.

BOTTOM RIGHT: George and Lilli Hallet's graphic for *Procession* from 1977 combines elements from the two other designs on this page. The African figures are derived from the band's debut (shown left), while the tree and hand motifs appear in the repeated surround, this time with leaves sprouting from outstretched hands.

Unlike anything so far discussed in this book, the jazz recordings issued by the Polish state record company, Polskie Nagrania Muza, have a design uniformity about them that is distinct yet still has a whiff of totalitarian control. The words "Polish Jazz" appear in the top left-hand quarter of each record sleeve, while the music spans everything from the New Orleans revivalism of the Warsaw Stompers via the Polish Radio Big Band (with a collage cover by Rosław Szaybo) to new music by Andrzej Trazskowski and Krzysztof Komeda. The trumpeter Tomasz Stanko appears on discs by Trazskowski and Komeda, but has said that Komeda, whose record was titled Astigmatic, was the biggest influence on the new Polish jazz movement of the 1960s. "He was a very famous music guy, perhaps for me the best person in the 'jazz gang' in Poland," Stanko recalled, "He was a very shy, very silent small guy, but you can feel his image and personality in that record. He was my first jazz guru, in the way that people like Miles or Coltrane were to others, and he was really very important for me. The music we played was very much like his piece 'Svantetic' which is on the record, and it was actually for him the first time he composed this larger form music for jazz band."

Stanko was to go on, in a variety of contexts, to fuse his very distinctive Polish jazz voice with musicians from his home country and (among other places) Sweden, Iceland, and the United States. Yet he maintained a strong interest in the visual aspects of his recordings, and many of his recorded works have very distinctive covers. His 1984 LP Lady Go has a threatening graphic portrait of a suited man with a shark's head, by W. J. Kukla; his 1994 album Balladyna carries a fine portrait of Stanko painted by the German artist Heinrich Römisch, who specializes in jazz artworks; and the same year's Matka Joanna is a quartet improvisation around Stanko's compositions based on the 1961 film Matka Joanna od Aniołów ("Mother Joan of the Angels"), and features stills from Jerzy Kawalerowicz's movie.

Whereas Polish musicians were able to record in Poland, and—as Stanko's career, and that of fellow musicians like Urszula Dudziak and Michał Urbaniak, took off—elsewhere in Europe and the United States, other Eastern bloc players were not so fortunate. It took until the late 1960s for East German pianist Joachim Kühn to record under his own name in Berlin and Hamburg, but his albums quickly developed a visual personality as distinctive as Stanko's, not least in the fine artwork selected to adorn them. Hence Monday Morning (1969) has Ekkehard Sachse's evocative photograph of an alarm clock swathed in polythene; Piano Solo (1972) has a fine female portrait by Hub Prower; and This Way Out (1977) has an evocative photograph of an escape through broken glass by Bernhard Wetz, which carries a not-so-well-hidden message about leaving the East.

Russian musicians had an equally difficult time bringing their fusion of American jazz ideas and free improvisation to the West. The Ganelin Trio made one of their first records in Poland, its cover showing a semisilhouetted portrait of Wiaczeslav Ganelin that quite deliberately evoked Komeda from his Astigmatic album. Much of their later work was released by the UK-based Leo Records, where Leo Feigin, the company's owner, specialized in bringing music from the other side of the Iron Curtain to the West. He was largely responsible for introducing British and American listeners to such artists as the pianist Sergey Kuryokhin, the violinist Valentina Goncharova, and the saxophonist Alexander Sakurov.

Eastern Europe

"Jazz enabled entry into a dream world where people were free to forget about the reality of life in the Polish People's Republic, however temporarily. Second, jazz was the music of youthful rebellion."

Krystian Brodacki, "Poland," in Francesco Martinelli (ed.), *The History of European Jazz* (Equinox, 2018)

TOP LEFT: **An atmospheric still from Jerzy Kawalerowicz's movie, referred to in the text, which inspired Tomasz Stanko's compositions. The trumpeter also drew inspiration elsewhere from literary sources, including the controversial and surrealistic imagery in the Comte de Lautreamont's** *Chants de Maldoror* **that in the poet's words "sings of despair."**

BOTTOM LEFT: *Litania* **pays homage to Stanko's mentor and earliest influence, Krzysztof Komeda. The seascape is the work of German photographer Sascha Kleis, whose landscapes would become an integral part of the ECM design imagery (as shown in the next chapter) on albums by Bill Frisell, Kenny Wheeler, John Surman, and Edward Vesala, among others.**

BELOW RIGHT: **Stanko onstage, photographed by John Watson, and clearly showing his unorthodox tilted mouthpiece, which gave him a pensive stance even when he was apparently playing outward toward his audience.**

Tomasz Stanko Quartet / Matka Joanna

LITANIA
Music of Krzysztof Komeda
Tomasz Stanko Septet

Postmodern Jazz

"It's the act of constant creation
that's important"

Right up until the appearance of jazz-rock fusion, jazz had been in a continuous process of development. One movement led to another, and the visual art that reflected the music followed the course of each new trend as it appeared. But with the rapid adoption of the compact disc, as international standards for manufacture settled in the late 1980s and early 1990s, suddenly the whole recorded history of jazz began to be available in a depth that had never been the case before —even at the height of LP reissues. Now, musicians could dip into the historical continuum and begin to explore earlier periods of the music in new ways. Cover designers had a field day creating images to represent music from previous eras of jazz for a new public.

Leading the way was RCA's Bluebird label, for which reissue producer Steve Backer commissioned new cover paintings from contemporary artists for a series that was issued from the late 1980s onward in both LP and CD formats. For example, the Cuban-born portraitist Joel Spector produced a fine image of Artie Shaw for the *Personal Best* album, and an atmospheric picture of songwriter and vocalist Hoagy Carmichael, wearing his trademark trilby hat at the keyboard, for *Stardust and Much More*. Patti Mollica, the New York–based artist wife of jazz musician Mark Hagan, created an impressionistic study of the Fletcher Henderson band for *Hocus Pocus*, and the well-known children's book illustrator Raul Colon created a fine full-face portrait of Duke Ellington for the *Jungle Nights in Harlem* anthology. Yet such examples of newly commissioned fine art were not just the preserve of reissues of historical treasures from the 1920s and 1930s. Backer's series also commissioned the New York commercial artist Carmine Coppola to create portraits of, among others, Chet Baker, Lonnie Liston Smith, Gil Scott Heron, and Sonny Rollins. Memphis-based painter John Robinette covered historical recordings, with affectionate portraits of King Oliver, Bix Beiderbecke, and Bunny Berigan, but also tackled more recent music from Sonny Rollins and drummer Joe Morello. Other labels also commissioned new work, but the range and consistency of the Bluebird series marked it out as having as keen a visual aesthetic as it had musical taste.

The jazz music itself of the 1980s and 1990s became a smorgasbord of earlier references within a framework of new performance, while also recognizing the commercial reality that commemorative or tribute albums could sell well to fans of the original artist. So, to pick a few examples at random, we find McCoy Tyner revisiting John Coltrane's music, with Pharoah Sanders and David Murray taking the saxophonist's role by turns. We find pianist Jason Moran—over a long period that ran well into the twenty-first century—exploring themes as diverse as Thelonious Monk, Fats Waller, and the Harlem Hellfighters, with performances of his Waller

program involving him wearing an elaborately constructed Waller mask. We find French guitarists from the Manouche gypsy heritage, Boulu and Elios Ferré, celebrating Django Reinhardt, but on a disc that also contains music by saxophonist Warne Marsh and Beatle Paul McCartney.

Maybe the most widely known examples of dipping into the heritage of jazz involve the brothers Wynton and Branford Marsalis. Wynton's music moved from collaborations in his early days with legendary figures such as Herbie Hancock and Art Blakey to his own bands exploring everything from the New Orleans heritage to Duke Ellington's music. With the Lincoln Center Jazz Orchestra, of which he became artistic director in 1991, he has explored swathes of the jazz repertory, as well as creating celebrated large-scale works of his own, which are discussed later in this section. But both he and Branford have taken Coltrane's *A Love Supreme* as a jumping off point for new exploration, Wynton in a full orchestral treatment, and Branford as the basis for some coruscating quartet improvising.

As the 1990s continued, a host of different movements developed in jazz that reflected the fragmentary nature of the postmodern world. There were fusions with African, Indian, Latin American, Cuban, and even Alpine music, as well as crossovers into the classical, hip-hop, and free-improvisation genres. In visual terms, this variety is perhaps most visible in some of the street art and graffiti that present selective elements of jazz history, much as Jean-Michel Basquiat (as previously discussed) used images from earlier periods of the music in his work.

The epicenter for street art is New York City, with everything from commissioned ceramic murals of jazz musicians on the subway to unofficial paintings in numerous different styles from the Bowery to Brooklyn. By far the biggest and most effective is a double portrait of Dizzy Gillespie at 229 West 135th Street in Harlem, painted by Brandan "B. Mike" Odums from New Orleans (already famous for painting on many derelict or abandoned buildings in his hometown) and Marthalicia Matarrita from Harlem. One shows Gillespie with beard, beret, and straight trumpet in his late-1940s guise; the other, from a later stage in his life, shows the bent-upward trumpet, with Gillespie playing above a table of schoolchildren. The project was commissioned by Education Is Not a Crime, an organization founded to draw attention to the need for education among the Baha'i community in Iran, which has created nineteen huge artworks in Harlem, on wall spaces donated by the local chamber of commerce. Gillespie himself was a well-known advocate of the Baha'i faith.

One well-known example of street art on the West Coast of the United States is Bill Weber's giant mural on Broadway Street in San Francisco's North Beach area, which became a landmark. Depicting the Benny Goodman Trio—featuring Goodman, pianist Teddy Wilson, and drummer

Postmodern Jazz

PREVIOUS SPREAD: Jean-Michel Basquiat in St. Moritz, Switzerland, in 1983, five years before his death. From his origins as a graffiti artist, known as Samo, living on a park bench in Tomkins Square Park, he came to international fame following an exhibit of alternative art in New York during 1980. One of his paintings broke Sotheby's record for a US artist in 2017, at $110,487,500.

TOP RIGHT: Bob Thompson's drawing *Untitled (Sonny Rollins at the Five Spot)* is a sister piece to the one on page 155. Here, comic-book ideas form part of the art. Are these ideas emanating from Rollins like musical speech bubbles? Or do they represent the crowded club audience? Rollins continued to perform from the 1980s to 2000s, as documented in his *Road Shows* albums.

BELOW LEFT: A typical example of the artwork specially commissioned by Bluebird for its late-1980s series of reissues by key RCA artists. This cover is one of a series (listed in the main text) by Carmine Coppola, who had graduated from New York's School of Visual Arts and who was also producing graphics for the *New Yorker*, the *Village Voice*, and *Time*.

BOTTOM RIGHT: The poster for John Scheinfeld's 2016 documentary film uses the painting *A Love Supreme* by Rudy Gutierrez, originally painted for Gary Golio's book *Spirit Seeker*. Scheinfeld told the author, "We felt the painting communicated powerful feelings about Coltrane as a musician, as a spiritual individual, and as a human being (especially with his heart coming out of his saxophone)."

Gene Krupa in their later years—it mingles their images with locals from the city who have played a part in its history and its cultural development. But it also signifies the way that, in the postmodern era, music from any part of jazz history can be appropriated by today's artists and musicians.

In Los Angeles, perhaps the most exceptional piece of street art is the wall adjacent to the Capitol Records tower, designed by Richard Wyatt in 1990, with images of jazz recording stars. Focused around Nat King Cole—and with other musicians including Duke Ellington, the Gerry Mulligan Quartet, Charlie Parker, Miles Davis, Ella Fitzgerald, and Billie Holiday—it was in danger of being obliterated by the vicissitudes of the climate and air pollution. However, in 2011, a three-year restoration project began in which the original was photographed and then transferred to glazed ceramic tiles, thereby preserving it for future generations. A huge mural also decorated the side of the city's Amoeba Music store at 6400 Sunset Boulevard, with figures from early jazz, including Ma Rainey, Bessie Smith, and Louis Armstrong, as well as swing-era stars Benny Goodman and Ella Fitzgerald, who is shown standing outside the New York Cotton Club.

Dating from the 1980s, Ray Walker's equivalent London mural was based on the 1983 Hackney Peace Carnival. Opposite the then recently opened East London Line underground railway station, it is seen by thousands of travelers every year; it shows a carnival jazz band, reflecting London's rich ethnic and cultural diversity, but locates that band directly in a politicized landscape, showing various visual protests against nuclear weapons.

Just as wall art and graffiti have encompassed the whole range of jazz that is now accessible, festival posters have reflected the same thing. Of all the world's jazz festivals, Montreux in Switzerland has charted a succession of artistic movements in jazz (as well as embracing rock and pop in its more recent programs). While the sexist poster of a nude female model holding a trumpet for the 1969 edition is an exception, the majority of Montreux posters have become increasingly creative. From 1967's monochrome photograph of a saxophonist, via a pop-art floral gramophone in 1968, we arrive, in 1970, at Roberto Cabra's striking image of a face with a cornet superimposed on the forehead. In successive years, we see a bird doubling as a horn, with musicians in its wings and flags emerging

from the bell; a jukebox in full color; a busy botanical design for 1973; a clever design for 1974's "Blues and Jazz" edition, with the side of a guitar doubling as Lac Leman (Lake Geneva), with steamboats, water-skiers, the mountains, and Montreux itself emerging from the design; and then an Aubrey Beardsley–inspired female festivalgoer in 1976–1977.

As time went on, Montreux commissioned original work from well-known artists to reflect the scope of the festival, notably Keith Haring's pop-art design of 1983; François Boisrond's distinctive work in 1987, with multiracial faces surrounding an array of instruments and notes; and Tomi Ungerer's jazz cat from 1993. Even after the death of its founder, Claude Nobs, in 2013, the festival has continued to pursue this artistic policy, with 2017's *Danseuses* by Malika Favre being a fine example.

The array of musicians whose work might be covered in this period has grown exponentially from earlier eras of jazz, so rather than attempting to look across dozens of players and their visual representation, the example of just one pianist, Brad Mehldau, shows a consistent awareness of art and design. Most of his regular trio albums (including his multivolume *Art of the Trio* set) involve straightforward portraiture. But his forays into wider genres, such as *Largo*, his 2002 collaboration with the producer Jon Brion, show conscious echoes of other designs. For that album, designer Lawrence Azerrad and photographer Tina Tyrell deliberately harked back to the multiple perspective of the Hipgnosis Pink Floyd *Ummagumma* cover, with Mehldau facing both forward and back and a further portrait superimposed on the back of his head, an idea that is carried further in photographs inside the CD booklet. The same designer uses a 1987 photograph of a drive-in movie theater in Las Vegas by Richard Misrach to set the scene for *Highway Rider*, while fellow designer John Gall draws on Charles Sheeler's famous painting *Classic Landscape* for *Modern Music*, the 2011 album of Mehldau's piano duets with Kevin Hays. In the same way that Mehldau draws on ideas from the musical tradition in albums such as *After Bach* (2018), using the Anna Magdalena notebook (and with a fine stairwell photograph on the cover by Peter Marlow suggesting an infinite descent into the music), his catalog of album designs shows a similar awareness of mining artistic possibilities from past and present.

"Like jazz, street art opens onto a collaborative, participatory generative process, a dialogic engine for intuitive improvisations."

The Routledge Companion to Remix Studies (Routledge, 2014)

The Art of Jazz

Originally next to an equally powerful mural of singer Shirley Horn, Alonso Tamayo's images of Miles Davis sit behind the historic site of the Bohemian Caverns jazz club at 11th and U Street in Washington, DC. The artist used spray paint, freestyling over four weekends, and the crumbling wall added to the effect.

BOTTOM: **This mural by Bill Weber and Tony Klaas at the junction of Columbus and Broadway in San Francisco is now listed in every walking guide to the city. As well as the Goodman trio, we see the old Italian fishing community of the area, and, in the group on the left, the celebrated local journalist Herb Caen.**

Postmodern Jazz

BELOW: **Jason Moran wearing his Fats Waller mask, designed by Didier Civil, for a concert celebrating his 2014 album** *All Rise (A Joyful Elegy for Fats Waller)*. **Most of these events were what Moran called "dance parties," with both onstage lindy-hoppers and the audience joining in. "I dance much more when I have my mask on," the normally reserved Moran told** *Los Angeles* **magazine.**

The Art of Jazz

BELOW LEFT: *Classic Landscape* (1931) is by Charles Sheeler (1883–1965), a realist painter who described his own work as "precisionism." Its evocation of the industrialization of the American countryside, typical of the area where Sheeler lived and worked near Philadelphia, chimes with Patrick Zimmerli's fusion of jazz and classical ideas in the album's music.

TOP RIGHT: Here, Lawrence Azerrad's album design plays games with the Droste effect seen on page 201. On the back cover, we see these images reversed, so Mehldau looks at us full face, but below the median line, the back of his coat appears. The interior liner-note design plays similar visual games, using the windows of the building just visible on the right.

BOTTOM RIGHT: Richard Misrach (born 1949) pioneered the use of color for fine-art photography in the United States during the 1970s. His pictures capture the landscape from western deserts to the conurbations of the East, and he has been concerned with documenting environmental change. This vast drive-in movie screen chimes with Mehldau's theme for this orchestral album, covering themes of peregrination.

The use of fine art has been a feature of many albums by Wynton Marsalis. His *Portraits by Ellington*, with the Lincoln Center Jazz Orchestra, is one of several that has a cover painting by the leading New York artist Romare Bearden (who had studied with George Grosz). Because he focused on his own African American community, and had at one point been a social worker, Bearden dealt with themes in society. His biographer, Mary Schmidt Campbell, points out that he "appropriated the rhythms and images of city life." He was a founder of the 1960s artistic civil rights movement the Spiral.

Consequently, Bearden's work—which consists of collages, paintings, and drawings—has been used by many jazz musicians, including Branford Marsalis, whose 2003 album *Romare Bearden Revealed* not only features one of the artist's inventive collages of musicians but also includes a famous standard tune that Bearden co-composed, "Sea Breeze." Bearden saw his artistic work as playing with the concept of time, particularly his collages, which bring images from the past into newly created pieces. Thereby he produced visuals that were perfectly in tune with the idea of jazz musicians themselves delving into jazz history and creating something new, drawing on sources from across the whole history of jazz.

Bearden's cover art can be found on albums by other artists from all periods of the music, from Billie Holiday (*The Original Recordings*) to Clifford Brown and Max Roach (*Pure Genius*), and from Donald Byrd (*Thank You . . . for F.U.M.L.*) to Ricky Ford (*Loxodonta Africana*), as well as four further albums by Wynton Marsalis, starting with *J Mood* in 1986. Of these, the three-volume set of *Soul Gestures in Southern Blue* (1991) gives a hint of the range of Bearden's work, and his ability to match Marsalis's evocation of *Thick in the South*, *Uptown Ruler*, and *Levee Low Moan*. In some ways, these albums were making up for lost time. Marsalis himself came late to a real appreciation of the music that had been all around him in New Orleans as he was growing up, initially preferring the fashionable styles of the stars of the time, such as Freddie Hubbard and Herbie Hancock. "Deep down I liked the New Orleans style," he said. "I just wouldn't allow myself to like it, because it wasn't socially acceptable." His subsequent work, and what he calls his "deep development," has been a voyage back to explore what the entire jazz tradition can offer open-minded contemporary players.

Bearden's paintings are just one element of a consistently inventive set of design ideas to complement Wynton's music. Gary Heery's photograph of a small boy in a classroom eying a trumpet on the teacher's desk, with a blackboard reading "Black Codes (from the Underground)," was the indelible image associated with the 1986 Marsalis sextet album of the same name. Ken Nahoum's portrait of the trumpeter for the following year's *Standard Time* might have adorned one of Marsalis's classical records, which suggests a cleverly ambiguous sense of design from Columbia's Josephine DiDonato. *The Majesty of the Blues* (1989) uses one of Henri Matisse's "jazz" cutouts, part of the great French artist's 1947 series of jazz-inspired shapes that had been "an explosion of expression" when they were first published.

DiDonato was again the art director for Marsalis's jazz opera, *Blood on the Fields*, which was recorded in 1995, released in 1997, and won its composer the first ever Pulitzer Prize for jazz. Her designs incorporate plantation photographs from the New York Historical Society and images of the "Old Glory" flag of the United States, in the stripes of which red symbolizes courage and sacrifice, whereas white is about pure intentions and high ideals. These are key elements in a libretto that deals with the journey to freedom of the enslaved Jesse and Leona.

Giulio Turturro's inspired cover for Marsalis's equally large-scale work *All Rise* creates the dove of peace out of handprints, and later works, including *From the Plantation to the Penitentiary* and the soundtrack to *Bolden*, have continued the idea that the visual element of the record is a vital component of the whole.

Wynton Marsalis

"Art and artists truly make us 'the family of man,' and most of the greatest jazz musicians embody that consciousness."

Wynton Marsalis, *Moving to the Higher Ground* (Random House, 2008)

TOP LEFT: For *The Majesty of the Blues*, Wynton Marsalis drew on Jazz, the series of paper cutouts by the French artist Henri Matisse, first published in 1947. This joyous collection of cut-paper collages and colorful ideas came about when an eye complaint restricted the artist's painting skills, and it became one of the most celebrated sets of jazz imagery.

BOTTOM LEFT: **Romare Bearden (1911–1988)** in his studio. The work on the easel, which reworks a Madonna image drawn from Byzantine icon painting, shows how he managed to infuse even the most traditional subjects with an African American sensibility.

TOP RIGHT: *J Mood*, recorded in 1985, carries a characteristic Romare Bearden painting, but in this case there is a direct link to the Matisse cutout on this page in the form of the dancing figure emerging from Wynton's trumpet.

BOTTOM RIGHT: **Wynton Marsalis** playing a trumpet made for him by Dave Monette in Portland, Oregon. The PRANA 3 model that he began playing in 2009 is not only a work of art, but has hidden details, including the star image from the Matisse cutout (top left), and Wynton's nickname, "Skain," engraved into the lower tube, plus a fleur-de-lis symbolizing New Orleans on the valve casing.

BELOW LEFT: **The Paris-based trio of saxophonist/ clarinettist Louis Sclavis, bassist Henri Texier, and drummer Aldo Romano made several tours of Africa over the years, often collaborating with the photographer Guy Le Querrec. This album draws together music inspired by a retrospective collection of his atmospheric pictures, including the cover image.**

BELOW RIGHT: **The French composer and pianist Martial Solal has a lifelong interest in the art of cinema. He has composed the music for over forty motion pictures, starting with Jean-Luc Godard's 1960 movie** *À bout de souffle,* **and his albums include** *Silent Cinema* **and** *Jazz 'n (E)motion,* **improvisations on movie scores (both 1998).**

The Art of Jazz

TOP LEFT: **Postmodern jazz has seen a great number of female musicians acquiring international fame as instrumentalists. Particularly important in this is drummer Terri Lyne Carrington, who has worked tirelessly to promote her female colleagues.**

BOTTOM LEFT: **Carrington's *Mosaic* project from 2011 united a dazzling backing band of female soloists (including trumpeter Ingrid Jensen, pianist Geri Allen, and bassists Mimi Jones and Esperanza Spalding) with a selection of great singers—Dianne Reeves, Dee Dee Bridgewater, Gretchen Parlato, and Cassandra Wilson among them.**

BELOW RIGHT: **Pianist Geri Allen's 1991 album *The Nurturer* has a cover by New York–based artist Michael Kelly Williams, who was at the height of his local fame as a painter, printmaker, and sculptor at the time. He had recently produced two widely acclaimed mosaic murals for New York subway stations in the Bronx, so was an ideal choice for this album cover.**

Although Manfred Eicher founded the ECM (Edition of Contemporary Music) label in 1969, its consistent and prolific output of jazz during the 1980s and 1990s, along with world and classical music, exemplifies what one might think of as the "postfusion" coming-together of musical ideas from different continents and backgrounds. Indeed, this is the very philosophy of Eicher himself, who wrote from his base in Munich, "Those who are serious about culture will position themselves at the periphery and see how they are mirrored from there. The meaning of a culture reveals itself in its plenitude only through encounter and contact with a culture different, even alien, to it. The dialogue that develops between them by far transcends the realm of the self-contained and unambiguous. We ask an alien culture questions it would not ask itself, and in doing so, we look for answers to questions that are our own."

Paradoxically, Eicher's label, which has brought together disparate music ingredients in ensembles from many parts of the globe, has unified them by imposing an immediately discernible aesthetic of its own. This is partly due to the sound of the music, described by jazz scholar Barry Kernfeld as "strongly orientated towards the jazz avant-garde but . . . with an overriding sense of politeness, delicacy and spaciousness." Yet in addition to the sonic aesthetic of the label, there is an equally all-pervading visual control over the entire output. With the majority of covers using sans-serif type, immediately identifiable graphics and—where they are used—photographs that enhance, complement, or extend the imagery of music or title, ECM more than any other record label has created a house design style, and one that has persisted for half a century.

One of the principal design influences on the label was the partnership of Barbara and Burkhart Wojirsch, and even after Burkhart's premature death in the early 1970s, Barbara continued to produce ECM covers until her retirement in the 1990s. There is a school of thought that sees a decline in the overall standard and uniformity of the output, described by the online art criticism magazine the *Eye* as lacking "inventive flair and creative sensitivity" following her departure, so the period from 1970 to 1999 is maybe the best on which to focus.

For example, the output of the saxophonist Jan Garbarek, whose association with the label goes back almost to its foundation, incorporates several visual themes that would be fundamental to its design language. *Afric Pepperbird*, designed by the Wojirsch partnership in 1970, has uppercase type laid over a close-up photograph of a rumpled piece of fabric, lit from the side to create sharp shadows. It bears no relation to any particular track, yet it seems somehow to embody what the whole album is about. Such textural images would become an ECM trademark. By contrast, the following year's *SART* is purely typographical, although the decision to justify the type appears to give undue prominence to guitarist Terje Rypdal, as his name has fewer characters than the others! A similar device was used on *Triptykon*, two years later.

Barbara Wojirsch did the graphics for the first of Garbarek's collaborations with Keith Jarrett, as part of his "European Quartet" in 1974, but this time the cover bursts into full color, with a photograph by Tadayuki Naito showing four balloons floating on water. Two blue ones represent the Norwegians, Garbarek and drummer Jon Christensen, while a green and a mauve balloon represent the Swedish bassist Palle Danielsson and the American pianist Jarrett. When the two principals collaborated again in 1975, with Garbarek improvising to Jarrett's compositions for strings on *Luminessence*, the cover would allude to ECM's sister series of contemporary classical releases, with only the key musicians' names in type, and the remaining information embossed on the front.

It is not impossible that Wojirsch was aware of Riverside's aforementioned *Living Legends* series from the 1960s and their combination of distinctive typography with grainy photographs of street scenes or architectural details in New Orleans and Chicago. Her design for Garbarek's *Places* (1978) uses a virtually identical design grid, but this time framing a sumptuous photograph of a rural landscape by Klaus Knaup. Several of the same musicians appeared on the same year's *Waves* by Rypdal and *Dear Wan* by Kenny Wheeler, both of which use similar grids and feature equally evocative Knaup pictures (although, perhaps perversely, *Waves* shows trees rather than anything aquatic).

Dear Wan also has a back-cover photograph by Roberto Masotti, showing Wheeler confronted by a forest of microphones. It was Masotti who produced perhaps ECM's best-known photographic image, the cobwebbed and heavily weathered stone statue of a youth that adorns *Officium*, Garbarek's first collaboration with the Hilliard Ensemble.

Masotti was included along with Knaup and several other equally atmospheric photographers in ECM's retrospective exhibition of its cover photography, held at the Palazzo Massari in Ferrara, Italy, in 1990. Summing up two decades of astonishingly innovative design, and titled "Se brami vedere, ascolta" ("If you want to see, listen"), the exhibition was a rarity among jazz record labels—something that would still be true today, in that ECM was already a company whose visual aesthetic matched its musical endeavor at every stage.

The Art of ECM

"Most ECM covers these days are moody and elemental photographs that tack toward the abstract: melancholy Bergmanesque cityscapes and landscapes swaddled in fog, waterscapes and skyscapes."

Dana Jennings, *New York Times*, December 26, 2012

BELOW LEFT: Roberto Masotti's evocative photograph combining old and new in Barbara Wojirsch's cover for ECM's best-selling 1994 album *Officium*, in which Jan Garbarek's skirling saxophone meets the voices of the Hilliard Ensemble.

TOP RIGHT: Hans Paysan's 1973 photograph, with its clever balance between the golden orb of the sun against the different color palette of the landscape, led to a series of comparable photos and designs from the Wojirsch partnership, including Ralph Towner's *Trios / Solos* from the same year.

BOTTOM RIGHT: Barbara Wojirsch created several purely graphic covers for ECM, often—as here—reverting to the kind of three-color simplicity that earlier designers like Reid Miles brought to record sleeves.

CRYSTAL SILENCE GARY BURTON ECM
 CHICK COREA

Officium

Jan Garbarek
The Hilliard Ensemble

ECM NEW SERIES

If You Look Far Enough

Arild Andersen
Ralph Towner
Nana Vasconcelos

ECM

BELOW LEFT: **Thomas Wunsch specialized in moody urban monochrome photographs, as on this Paul Motian trio record. His work also appears on ECM albums by John Taylor, Arild Andersen, and Keith Jarrett, as well as on the label's classical New Series, with Leonidas Kavakos, Christian Wallumrød, and Heinz Holliger.**

TOP RIGHT: **An atypical Barbara Wojirsch cover in that unusually the typography of the musicians' names takes second place to the quasi-handwritten font of the album title.**

BOTTOM RIGHT: **Taking its cue from Mark Feldman's title track composition, Peter Neusser's elevated view of a cityscape harks back to the work of Francis Wolff and Reid Miles in emulating the abstract expressionist of Jackson Pollock.**

BELOW LEFT: The partnership between Carla Bley and Steve Swallow's WATT label and ECM has led to some different and humorous designs that lie outside Manfred Eicher's strong visual aesthetics. Designer David Cohen brings an irreverence that matches the music, to this and to albums like Swallow's *Deconstructed*, which snips up a photograph of the bassist in the manner of a jigsaw.

TOP RIGHT: ECM has always made use of exceptional photographers and the Italian cameraman Guiseppe Pino, who emigrated to New York for some years in the 1970s, winning an award from Art Direction magazine, and documenting jazz and other music festivals, produced this fine shot of Enrico Rava's trumpet. The album appeared in 1975.

BOTTOM RIGHT: This 1975 recording by Keith Jarrett sold over three and a half million copies and cemented the financial fortunes of ECM. Barbara Wojirsch's simple, elegant design pairs perfectly with Wolfgang Frankenstein's portrait, which catches Jarrett (who famously dislikes anyone photographing his playing) in a pose that any attendee at one of his concerts would instantly recognize.

BELOW LEFT: Composer, pianist, and bandleader Maria Schneider grew up in Windom, Minnesota, and her 2015 album *The Thompson Fields* evokes the wide-open feel of the landscape, in music named for her former neighbors' farm. Photographer Briene Lermitte traveled back with Maria to that landscape for the cover and publicity pictures for the album.

BELOW RIGHT: Another portrait of Maria Schneider by Lermitte that—as in the other picture here—uses a palette inspired by the rust color of the truck and the rocky backdrop. It was a visual trope used (with a decrepit vintage Graham automobile) in 1970 by designer Dean Torrence for Harry Nilsson's album *Nilsson Sings Newman*.

The Art of Jazz

BELOW LEFT: **Tim Berne told the *New York Times* that having one of his photographs on his first ECM release "was almost more exciting than making the record." When he founded his own Screwgun label, he wanted a distinctive design style, and this was created by Steve Byrum. This release by Berne's band Science Friction is a typical example of Byrum's work.**

TOP RIGHT: **The blue line drawing on British pianist Django Bates's album by his group Quiet Nights is by Betsy Berne, but it sits in another of Steve Byrum's designs, which not only has the credits wound around the red robot head, but also includes some mysterious recipes for "new pie" on the inner sleeve.**

BOTTOM RIGHT: **One of a series of posters for Ars Nova concerts at the revived Five Spot Club in Bank Street, New York, this carries Tim Berne's Screwgun label's visual style into advertisements for live concerts. In this case, the band is Berne's trio Paraphrase, which records for the label.**

Twenty-First-Century Jazz

"Commandingly cool"

As jazz approached its hundredth birthday, the first two decades of the twenty-first century saw two distinct trends. First was the ongoing celebration of work by surviving titans of the music, and second was the emergence of new bands, drawing in elements from many other areas of music.

The first trend is exemplified most notably by the quartet led by saxophonist Wayne Shorter, with Panamanian pianist Danilo Pérez, bassist John Patitucci, and drummer Brian Blade. This group formed in 2000, and it has performed together ever since, winning the 2019 "Jazz Instrumental Album" Grammy for the record *Emanon*. With this band, Shorter has continued to innovate, yet his fluid, seamless group improvisations often refer back, even quite tangentially, to his own compositions, written at all stages in his long career.

Until his effective retirement in 2012, Sonny Rollins was equally significant, and the series of live albums from his later career that he has released under the *Road Shows* title on his own Doxy label demonstrate his continued prowess and remarkable talent for extended improvisation into old age. When he appeared at the Barbican, London, in 2007, billed as "the world's greatest living jazzman," my review for *The Times* said, "The first set closed with a riotous calypso, Rollins's own 'Nice Lady,' in which he produced umpteen choruses of stirring, positive improvisation. The extreme speed of his 1960s playing has given way to a more considered pace, but the torrents of invention, the repetitive jabbing phrases that cross the underlying rhythm of the drums, and the bleak but imperious tone were all vintage Rollins. As he left to a standing ovation he had more than lived up to a billing that was the simple truth."

Other former associates of Miles Davis have been similarly active, including Herbie Hancock, Ron Carter, and Jimmy Cobb. Meanwhile, former John Coltrane band members such as McCoy Tyner and Reggie Workman have continued to keep Coltrane's memory alive. Workman in particular has fed this homage through to jazz education with his repertory group, the Music of John Coltrane Ensemble, at the New School in Manhattan, where he presents an annual concert exploring the legacy of his mentor.

Just as survivors of the swing era kept their music alive in concert halls and festivals in the 1980s and 1990s, the early twenty-first century has seen similar endeavors by the generation who developed bebop and hard bop. Blue Note Records pioneer Lou Donaldson (who first recorded in 1950) continued to play up to and beyond the time of his recognition as a National Endowment for the Arts Jazz Master in 2012. Equally, Dick Hyman, famous as the pianist on the only surviving film footage of Dizzy Gillespie and Charlie Parker playing together (in 1952), was still performing in 2019, at the age of ninety-two. And the British jazz singer Cleo Laine, famous as one of the few people in history to win nominations in the popular, jazz, and classical Grammy award categories, has continued performing well into her nineties. Her UK-born counterpart, the pianist Marian McPartland, who commenced her American recording career in 1951, presented one of the longest-running radio jazz programs in history, *Piano Jazz* on NPR, from 1978 to 2011. She continued to perform until her death in 2013.

The second trend is more diffuse, and involves bands from many areas and regions. For example, the French accordionist Vincent Pierani is extending the improvisational language developed for the instrument by his fellow countryman Richard Galliano, and creating new ensembles with such players as the saxophonists Emile Parisien and Michel Portal. The violinist Alice Zawadzki has worked in duo with the Korean flautist Hyelim Kim, creating music with an ambient texture that is still clearly based in jazz and improvisation. The harpist Alina Bzhezhinska, trained both in Warsaw and at the University of Arizona, is dedicated to furthering the idea of jazz harp, exploring on the one hand the repertoire of Alice Coltrane, and on the other the swing harpist Dorothy Ashby, but she is equally at home with her contemporary HipHarp Collective, combining the harp with electronics.

Bzhezhinska's decision to take starting points from different places in the tradition and develop from there has been a key component in the music of trumpeter Christian Scott aTunde Adjuah. The nephew of New Orleans–born saxophonist Donald Harrison (a one-time member of Art Blakey's Jazz Messengers), Scott grew up in the tradition of the New Orleans marching societies, the Mardi Gras Indians, and this influence was a jumping-off point for some of his earliest explorations, but his music quickly developed to take in Coltrane and Miles Davis. This took him onto the international stage when he was just nineteen, playing with his uncle on the 2002 touring project Kind of New, in which, from his

Twenty-First-Century Jazz

PREVIOUS SPREAD: On Kamasi Washington's *The Epic* (2015), the background painting is by the Los Angeles–based African American artist Patrick Henry Johnson, whose art ranges from murals to photo-realist portraits of musicians in action. *The Elixir* is a huge mural in the city's Crenshaw Boulevard, and includes the inscription, "Have we forgotten that we are spiritual beings having a human experience?"

BELOW LEFT: The front cover artwork for British-born keyboard player Bill Laurance's 2019 album *Cables* is by the Op Art pioneer Michael Kidner RA (1917–2009). Exploring the intersection between mathematical theory and art, this is part of a long series of Kidner's 1960s works investigating wave patterns, three of which are in London's Tate Modern's permanent collection.

TOP RIGHT: Bill Laurance has been a long-term member of the band Snarky Puppy. For the sleeve design of this 2015 solo album, which he coproduced with the band's bassist and leader Michael League, Laurance enlisted the help of artist Emília Canas Mendes, who had worked on several Snarky releases.

BOTTOM RIGHT: Boundary-crossing saxophonist Donny McCaslin is pictured here in London while touring with his quartet, with whom he appears on David Bowie's final album, *Blackstar*. In 2016, the quartet with Jason Lindner (keyboards), Tim Lefebvre (bass), and Mark Giuliana (drums) recorded a response to the Bowie album called *Beyond Now*, and they included material from this in the music they played on the road.

bell-like open tone to his tight Harmon-muted solos, Scott knew how to nod in the direction of Miles, yet his playing was packed with nuances drawn from other great trumpeters, including Freddie Hubbard and Clifford Brown, all wrapped into a convincing language of his own. His later projects, including developing unconventionally shaped instruments, have seen him very much go his own way. His New Orleans compatriots Nicholas Payton and Abram Wilson (who died tragically young in 2012, at the age of thirty-eight) explored links between jazz and hip hop, fertile territory also explored by trumpeter Keyon Harrold, who collaborated with keyboard player Robert Glasper on the soundtrack to the 2016 movie *Miles Ahead*, starring and directed by Don Cheadle.

The rock repertoire was a starting point for the piano trio the Bad Plus, whose eponymous first album (also known from its cover art as *Motel*) from 2001 includes versions of songs by Kurt Cobain and Abba. Their follow-up, *These Are the Vistas*, explores material from the Blondie and Aphex Twin repertoire. This fertile ground for material to explore in improvisation continued up until 2016 and the album *It's Hard* (with songs from Peter Gabriel and Cindy Lauper), which was followed by the departure of founding pianist Ethan Iverson. The trio has since moved on to focus on original compositions with new pianist Orrin Evans, but Iverson continues to explore territory on the edge of jazz, and has consistently written engagingly about jazz history and performance on his blog, *Do the Math*.

Other trios to have explored repertoire from the rock and pop world include those of Brad Mehldau, the Swedish pianist Esbjörn Svensson (prior to his death in a drowning accident in 2008, his trio's original works drew from many areas of contemporary music after early investigations of Thelonious Monk's writing), and the Norwegian pianist Tord Gustavsen. The latter is interesting, given his long association with the crossover jazz-pop singer Silje Nergaard, followed by work with other singers, including the German-Afghan Simin Tander and Norwegian jazz vocalist Solveig Slettahjell.

A feature of the twenty-first-century scene is the jazz version of the jam band, an outgrowth of fusion, with extensive workouts on repetitive rhythmic or chordal backdrops. The best known, perhaps, is the multi-Grammy-Award-winning Snarky Puppy, founded in 2004 by bassist Michael League and using between nine and nineteen musicians, but built around a core of players based in the fertile music scene in Brooklyn. Just as guitarist Pat Metheny took his band on the road extensively during his early days in the 1970s and 1980s, Snarky Puppy has traveled consistently, combining concerts with workshops and master classes, and building an international audience through personal contact. Equally, that aesthetic applies to the trio of Medeski, Martin & Wood, who in addition to featuring lengthy onstage jams, were one of the first bands to encourage social media interaction with their audiences, overturning the traditional ban on concert photography to urge their fans to share everything from photos to sound clips and video footage. With guitarist John Scofield, as well as their own projects, they have worked on many international jazz festivals every bit as effectively as on the jam-band circuit on which they began in the 1990s, supporting the rock band Phish.

These two trends in jazz have been significant in maintaining audiences for both live and recorded areas of the music. At a time when streaming and online music services are calling the conventional economy of recorded music into question, the significance of festival and concert performances in stimulating the market cannot be overstated. What is heartening is that in the world's major jazz festivals—Montreal, New Orleans, Montreux, London, North Sea, and Cape Town, for example—both venerable musicians from the tradition and new young bands play side by side. One hundred years on, it is possible to hear many of the musicians mentioned in this chapter playing in the same events, as well as other veterans, such as singer Sheila Jordan, blues pioneer Buddy Guy, Chick Corea, and gypsy guitarist Biréli Lagrène; a range of vocalists such as Melody Gardot, Norah Jones, Dianne Reeves, and Madeleine Peyroux; second-generation players such as Ravi Coltrane and Joshua Redman; and new arrivals such as the multi-instrumentalist and master of electronics Jacob Collier, or the versatile singer Nikki Yanofsky. Jazz at the end of the second decade of the twenty-first century is in very good health.

"Michael League is well-known as the leader of Snarky Puppy, a charismatic individual who through sheer force of will managed to bring the band to global prominence without the support of a major record company."

Peter Elsdon, in Elaine King, Caroline Waddington (eds.), *Music and Empathy* (Taylor and Francis, 2017)

TOP LEFT: **Christian Scott aTunde Adjuah** playing his reverse flugelhorn, an instrument designed by him and built by Miel Adams. It is an innovative example of the instrument-maker's art, taking the mouthpiece tube below rather than above the valves as is customary. It has what Scott calls a "darker" sound than a conventional flugelhorn, but also a pure and clear upper register.

TOP RIGHT: **For her 2008 debut album,** *Entry*, recorded the year she arrived in the United States, Australian/Chinese bassist Linda May Han Oh opted for a cover design that draws on the Japanese manga comic art tradition. In the background we see the Manhattan skyline, and on the right the illuminated Ed Koch Queensboro Bridge.

BOTTOM: **Snarky Puppy** in concert: a band of fluid personnel whose genre-breaking style has drawn a whole new audience to jazz, yet all the band members are deeply rooted in the jazz tradition.

Linda Oh Trio

Entry

On January 5, 2019, *The Times* of London reported of the United States' former president, "In a list of the music he most enjoyed listening to in 2018, Barack Obama mentions the track 'Disco Yes' by two young London jazz musicians, Tom Misch and Poppy Ajudha. It's a welcome endorsement of an exciting and fresh cultural movement." The newspaper went on to point out that Obama, in drawing attention to these two musicians for his fifty-three million Facebook followers and twenty million Instagram fans, was taking note of a burgeoning interest in jazz in London, supported by both a growing community of musicians and numerous emergent live venues. Yet it also underlines the huge significance of social media and streaming services in spreading the word about jazz.

In terms of the visual representation of the music, it is no longer just a question of the innovative design of vinyl-only labels like Gearbox and their promotion of young artists, such as the saxophone and drums duo Binker and Moses; or Ubuntu Records' memorable CD covers for jazz harpist Alina Bzhezhinska, saxophonist Camilla George, Scottish Young Jazz Musician of the Year Helena Kay, pianist Andrew McCormack, or Leeds-based band Wandering Monster. Now, a musician's online presence and the design of everything from websites to YouTube videos is an essential part of the visual arsenal needed to create and maintain a public following, which might be anywhere on the globe. The *Times* report also noted that in 2018 there was 108 percent growth in listeners under thirty streaming jazz on Spotify and similar services.

In a BBC interview, Binker Golding and Moses Boyd (a.k.a. Binker and Moses) made clear that a young crowd no longer frequents traditional venues for jazz, such as Ronnie Scott's jazz club in Soho. Instead, standing-room only crowds of under-thirties frequent clubs such as Mau Mau in West London, run by the collective Jazz Re:Freshed, or Steam Down, under the railway arches South of the River Thames. At Steam Down, young Londoners such as the Ezra Collective or the saxophonist Nubya Garcia can be heard jamming with the likes of Kamasi Washington, when he is in town. This is multicultural music, burgeoning as a result of both the plentiful jazz degree courses offered at London's four conservatories (and several universities) and also the mature output of long-term community jazz projects such as Tomorrow's Warriors, which has run for over two decades. As T. J. Koleoso, one of the Ezra Collective musicians, put it, "We're going to rebrand what young London looks like!"

The New London Scene

"There's an accessible, anti-hero energy that feels like sweet vindication for a music that should be for everyone, but has felt locked away and preserved only for a few. They've liberated the sound."

Broadcaster Teju Adeleye, the *Guardian*, April 8, 2018

BELOW LEFT: Crystal Compton's artwork for the record *When We Are*, released on vinyl only in 2018 by the British rising star saxophonist Nubya Garcia. The *Guardian* newspaper critic John Lewis says that she represents "the first generation of British musicians making jazz that is distinctly, defiantly, gleefully post-American."

TOP RIGHT: **Nubya Garcia's 2017 prequel to** *When We Are* **features several of the rising stars of the contemporary London scene, including drummer Moses Boyd, pianist Joe Armon-Jones, and the trumpeter Sheila Maurice Grey.**

BOTTOM RIGHT: **Violinist, singer, and composer Alice Zawadzki, of Anglo-Polish heritage, is one of the most creative musicians on the twenty-first-century London music scene, having played New Orleans jazz with the singer Lillian Boutté, before bringing her own original music to venues as varied as Taipei, Ottawa, Massachusetts, Rio De Janiero, Italy, Taiwan, Osaka, and St. Petersburg.**

BELOW LEFT: **Designer Daniel Richter** produced this cover for the German pianist Michael Wollny and his collaboration with bassist Eva Kruse and drummer Eric Schaefer. Producer Siggi Loch has created a visual style for his ACT label that is as distinctive as those for ECM, Verve, or Blue Note.

TOP RIGHT: **Singer Cécile McLorin Salvant** is as involved in the visual appearance of her recordings as she is in the music and sounds they contain. She was the art director for her 2017 album *Dreams and Daggers*, which contains her drawings, and this portrait photograph by Mark Fitton—the mirror casing cunningly evoking her trademark spectacles.

BOTTOM RIGHT: **Cécile McLorin Salvant's** own artwork for her 2018 record *The Window* picks up themes from the titles of the songs, including "The Peacocks," "A Clef," "One Step Ahead," "Visions," and "By Myself."

Michael Wollny's [em]
Wasted & Wanted
Eva Kruse
Eric Schaefer

ACT

The Art of Jazz

BELOW: **The Amsterdam-based trio Tin Men and the Telephone has taken interactive performance to new levels, using a cellphone app through which the audience controls the performance by choosing key, harmony, and melodic fragments, as well as governing the back projection. The trio consists of Tony Roe (keyboards), Pat Cleaver (bass), and Bobby Petrov (drums).**

Born in 1982, the tenor saxophonist Kamasi Washington has spearheaded not only a new interest in jazz among younger listeners, but also, with the appearance of his 2015 album *The Epic*, epitomized a parallel visual style that covers his own appearance and that of his musicians onstage, and also all the record covers, posters, and related marketing material that goes with his work. The *Epic* cover itself is a startlingly direct image, with Mike Park's portrait photograph of Washington in front of Patrick Henry Johnson's street mural *The Elixir*. Reinforced by Adam Stover and Sol Washington's overall design for the four-album set, and including material from a related graphic novel, every aspect of the design is carefully planned, on a scale every bit as epic as the music, which involves choir and string orchestra.

Although Washington has most astutely brought together all these elements, there are clear antecedents in jazz. In the early 1970s, for example, African American bands such as Herbie Hancock's groups of the *Mwandishi* period sported dashikis, afro hairstyles, and shades, and Robert Springett's artwork for Hancock's albums prefigures Washington's. Hancock's *The Crossing*, from 1972, shows ancestral African figures akin to some of the internal artwork in *The Epic*, and Springett's painting for the *Sextant* album in 1973 created a precedent for the Washington style of planetary cover design, using a low horizon with dancers in African garb in the foreground. Equally, in the 1980s, the British

musician Courtney Pine, once he had shed the suits and ties of his early days, espoused dashikis and dreadlocks and used brightly colored clothing and his extrovert appearance to complement the fierce power of his playing. His subsequent album covers, such as *Devotion* (2003) and *Europa* (2011), project this image, but without the complete suite of design features that characterize *The Epic* and its follow-up work.

Washington also drew a new public into jazz from his association with the rapper Kendrick Lamar and his appearance on the album *To Pimp a Butterfly*. But despite the musical connections, there is little visual connection between that album and Washington's assured control of his imagery. Given the horizons and the impression of a watery surface in some of the graphics, there is perhaps a more direct—if subliminal— connection with Washington and Lamar's regular colleague, the bassist Thundercat, and the sleeve of his album *Drunk*, by photographer Eddie Alcazar and designer Zack Fox, which shows Stephen Bruner (Thundercat) nose deep in water.

Washington has built on such precedents, creating a durable international image that is immediately identifiable. His 2018 follow-up to *The Epic* is *Heaven and Earth*, which again features an exotic Mike Park cover photo, showing the saxophonist apparently walking on water. On this record, the entire art direction is by Washington himself, showing again his concern for mastering visual as well as musical detail.

Kamasi Washington

"When Kamasi Washington released his 2015 debut *The Epic*, he was perhaps the single most exciting figure to emerge in L.A. jazz in at least a decade."

August Brown, *Los Angeles Times*, June 29, 2018

BELOW: Mike Park's photograph for *Heaven and Earth* typifies Kamasi Washington's attention to the visual and aural aspects of the record. As *Rolling Stone* said in its review, "What really lingers is Washington's commitment to seeing every last idea through. His work might not be the best indicator of where jazz as a whole is, but his vast, refreshingly lavish sound-world is well worth getting lost in."

Bibliography

Christina L. Baade, *Victory Through Harmony: The BBC and Popular Music in World War II* (Oxford University Press, 2012)

Jean Bach, liner notes to *A Great Day in Harlem* (Universal DVD 06025-2716031-3, 2005)

Paul Balmer, *Stéphane Grappelli, With and Without Django* (Sanctuary, 2003)

Jayna Brown, *Babylon Girls: Black Women Performers and the Shaping of the Modern* (Duke University Press, 2009)

Ian Carr, *Music Outside* (Latimer New Directions, 1973)

Samuel B. Charters, *Jazz New Orleans: 1885–1963* (Oak Publications, 1963)

Samuel B. Charters and Leonard Kunstadt, *Jazz—A History of the New York Scene* (Doubleday, 1962)

Sarah D. Coffin and Stephen Harrison, *The Jazz Age: American Style in the 1920s* (Cleveland Museum of Art / Yale University Press, 2017)

Harvey G. Cohen, *Duke Ellington's America* (Chicago University Press, 2010)

James Lincoln Collier, *Benny Goodman and the Swing Era* (Oxford University Press, 1989)

James Lincoln Collier, *The Making of Jazz* (Macmillan, 1981)

Jim Cox, *Musicmakers of Network Radio: 24 Entertainers, 1926–1962* (McFarland, 2012)

Michael Danzi, *American Musician in Berlin* (Norbert Ruecker, 1986)

Michael Dregni, *Gypsy Jazz* (Oxford University Press, 2008)

Ross Firestone, *Swing, Swing, Swing: The Life and Times of Benny Goodman* (Hodder and Stoughton, 1993)

Kurt Gänzl, *The Encyclopedia of Musical Theatre* (Blackwell, 1994)

Robert Gordon, *Jazz West Coast* (Quartet, 1986)

Jeffery Green, Rainer E. Lotz, and Howard Rye, *Black Europe* (Bear Family, 2013)

Pekka Gronow and Ilpo Saunio, *An International History of the Recording Industry* (Cassell, 1998)

Ulrike Groos, *I Got Rhythm: Art and Jazz Since 1920* (Prestel, 2015)

Richard Havers, *Verve: The Sound of America* (Thames and Hudson, 2013)

Steven Heller and Greg D'Onofrio, *The Moderns: Midcentury American Graphic Design* (Abrams, 2017)

Nat Hentoff, "Dizzy Designs New Trumpet: Claims Improvement in Tone," *Downbeat*, July 11, 1954

Robin Houston, "Henry Hall's Gestapo Nights," *The Oldie*, May 1, 2015

Gary Indiana, *Andy Warhol and the Can That Sold the World* (Basic Books, 2010)

Steve Lake and Paul Griffiths, *Horizons Touched: The Music of ECM* (Granta, 2007)

Horst H. Lange, *The Fabulous Fives* (Uhle and Kleimann, 1959)

Peter J. Levinson, *Tommy Dorsey: Livin' in a Great Big Way—A Biography* (Hachette, 2009)

Paul Marechal, *Andy Warhol: The Record Covers 1949–1987 Catalogue Raisonné* (Montreal Museum of Fine Arts / Prestel, 2008)

Graham Marsh, Glyn Callingham, *The Cover Art of Blue Note Records* (Collins and Brown, 2010)

George Melly, *Revolt Into Style: The Pop Arts in Britain* (Penguin, 1970)

John Fass Morton, *Backstory in Blue: Ellington at Newport '56* (Rutgers University Press, 2008)

Peter C. Muir, *Long Lost Blues: Popular Blues in America 1850–1920* (Illinois University Press, 2010)

Eleanor Nairne and Dieter Buchhart, *Basquiat: Boom For Real* (Barbican Centre, 2017)

Tom Nolan, *Artie Shaw, King of the Clarinet—His Life and Times* (W. W. Norton, 2011)

Eduardo Obregón Pagán, *Murder at the Sleepy Lagoon: Zoot Suits, Race and Riots in Wartime L.A.* (Accessible Publishing, 2008)

Ross Porter, *The Essential Jazz Recordings* (McClelland and Stewart, 2008)

Larry Portis, *French Frenzies: A Social History of Pop Music in France* (Virtualbookworm.com, 2004)

Howard Reich and William Gaines, *Jelly's Blues* (Da Capo, 2003)

William J. Schafer, *Brass Bands and New Orleans Jazz* (Louisiana State University Press, 1977)

William A. Shack, *Harlem in Montmartre* (University of California Press, 2001)

Alyn Shipton, "Donald Harrison," *The Times*, November 11, 2002

Alyn Shipton, *Groovin' High: The Life of Dizzy Gillespie* (Oxford University Press, 1999)

Alyn Shipton, *I Feel a Song Coming On: The Life of Jimmy McHugh* (Illinois University Press, 2009)

Daniel Soutif: *La siècle du jazz: Art, cinéma, musique et photographie de Picasso à Basquiat* (Flammarion, 2009)

John Szwed, *So What: The Life of Miles Davis* (Simon and Schuster, 2004)

Catherine Tackley: *Rhythm and Reaction: The Age of Jazz In Britain* (Two Temple Place, 2018)

Barry Ulanov, "Moldy Figs vs. Modernists," *Metronome*, November 1947

Alexy Viegas, "Stravinsky's *Ragtime for Eleven Instruments*: Historical and Stylistic Considerations" (PhD thesis), University of São Paulo, 2018

Paul Whiteman and Mary Margaret McBride, *Jazz* (J. H. Sears, 1926)

Endnotes

Introduction

Page 10, "huge cake over six feet in height…"
Marva Carter, *Swing Along: The Musical Life of Will Marion Cook* (Oxford University Press, 2008)

Page 13, "Dancing with Vernon was as easy as…"
Eve Golden, *Vernon and Irene Castle's Ragtime Revolution* (University Press of Kentucky, 2007)

Chapter 1: Jazz Begins

Page 15, "We must begin with its roots"
William J. Schafer, *Brass Bands and New Orleans Jazz* (Louisiana State University Press, 1977)

Page 16, "New Orleans was very organization-minded…"
Jelly Roll Morton quoted in Alan Lomax, *Mister Jelly Roll* (University of California Press, 2001 reprint)

Page 17, "had a low-pitched voice with a natural sob…"
James Weldon Johnson, *Along This Way: The Autobiography of James Weldon Johnson* (Viking Press, 1933)

Page 18, "cloudlike tulle, hatbands of the finest grosgrain ribbon…"
Henry Louis Gates, "The Chitlin Circuit," in Harry J. Elam and David Krasner (eds.), *African American Performance and Theater History: A Critical Reader* (Oxford University Press, 2001)

Page 18, "Never has such a large and efficient body…"
Quoted in Samuel B. Charters and Leonard Kunstadt, *Jazz—A History of the New York Scene* (Doubleday, 1962)

Page 22, "He was an inspiration to us all…"
Arthur Marshall quoted in Edward A. Berlin, *King of Ragtime—Scott Joplin and His Era* (Oxford University Press, 1994)

Page 26, "Everybody wanted to go there…"
Willie "The Lion" Smith with George Hoefer, *Music on My Mind* (Doubleday, 1964)

Page 28, "perhaps the way the whole world will swing…"
Ernest Ansermet, "C'est peut-être la grande route où le monde s'engouffrera demain" in "Southern Syncopated Orchestra," *La Revue Romande*, October 1919

Page 30, "The jazz players were forced upon me…"
Aldous Huxley quoted in Roger Pryor Dodge, "Consider the Critics," in *Hot Jazz and Jazz Dance* (Oxford University Press, 1995)

Page 30, "Ragtime-evolved music is symbolic…"
Quoted in Edward A. Berlin, *King of Ragtime—Scott Joplin and His Era* (Oxford University Press, 1994)

Chapter 2: The Jazz Age

Page 37, "The key to mass appeal"
Gunther Schuller, *Early Jazz* (Oxford University Press, 1968)

Page 38, "wriggling the shoulders, shaking the hips…" and "noisy ragtime, the jangle of the jazz band…"
Louise DeKoven Bowen quoted in William Howland Kenney, *Chicago Jazz—A Cultural History, 1904–1930* (Oxford University Press, 1993)

Page 38, "the blatant scream of the imported…"
Quoted in Richard M. Sudhalter, *Lost Chords: White Musicians and Their Contribution to Jazz 1915–1945* (Oxford University Press, 1999)

Page 40, "All I did was to orchestrate jazz…"
Paul Whiteman quoted in Joshua Berrett, *Louis Armstrong and Paul Whiteman: Two Kings of Jazz* (Yale University Press, 2004)

Page 40, "the significance of amusement."
Zelda Fitzgerald quoted in Sarah Churchwell, *Careless People: Murder, Mayhem, and the Invention of The Great Gatsby* (Virago, 2013)

Page 45, "I dropped the paper with the lyrics…"
Thomas Brothers (ed.), *Louis Armstrong in His Own Words* (Oxford University Press, 1999)

Page 46, "I made his importance as an artist…"
Irving Mills quoted in Harvey G. Cohen, *Duke Ellington's America* (Chicago University Press, 2010)

Page 46, "Every time we opened up…"
Sonny Greer quoted in Harvey G. Cohen, *Duke Ellington's America* (Chicago University Press, 2010)

Page 50, "exotic entertainment…"
Sterling Brown quoted in James E. Smethurst, "The Strong Men Gittin' Stronger, Sterling Brown's *Southern Road*," in Heather Hathaway, Josef Jarab, Jeffrey Melnick (eds.), *Race and the Modern Artist* (Oxford University Press, 2003)

Page 54, "step out of the line and stop…"
Willie Smith quoted in Mark Miller, *High Hat, Trumpet and Rhythm—The Life and Music of Valaida Snow* (Mercury Press, 2007)

Page 54, "She could scarcely have been more amiable…"
Carl Van Vechten quoted in Chris Albertson, *Bessie—Empress of the Blues* (Abacus, 1975)

Page 55, "had the dynamic range of an opera singer…"
Teddy Wilson with Arie Ligthart and Humphrey Van Loo, *Teddy Wilson Talks Jazz* (Cassell, 1996)

Page 56, "She will not appear dressed only…"
Clement Vautel, reported in *Baltimore Afro-American*, March 3, 1928

Page 57, "one of the first big-time colored acts…"
Rex Stewart, *Boy Meets Horn* (Bayou Press, 1991)

Chapter 3: The Swing Era

Page 61, "Jazz was synonymous with popular music"
Gunther Schuller, *The Swing Era* (Oxford University Press, 1989)

Page 62, "The night spots were run by politicians and hoodlums…"
Mary Lou Williams quoted in Max Jones, *Talking Jazz* (Macmillan, 1987)

Page 62, "It was not the kind of show they thought…"
Count Basie, *Good Morning Blues: The Autobiography of Count Basie as Told to Albert Murray* (William Heinemann, 1986)

Page 64, "not a cough in a carload!"
Quoted in Joshua Berrett, *Louis Armstrong and Paul Whiteman: Two Kings of Jazz* (Yale University Press, 2004)

Page 66, "I came round the corner and there were all these clubs…"
Ray Brown quoted in Alyn Shipton, *Groovin' High: The Life of Dizzy Gillespie* (Oxford University Press, 1999)

Page 76, "on a foggy morning the musicians wended their way…"
Charles Delauney (translated by Michael James), *Django Reinhardt* (Cassell, 1961)

Page 80, "a whole new universe of jazzy patterns…"
Holland Cotter, "Stuart Davis: A Little Matisse, a Lot of Jazz, All American," *New York Times*, June 9, 2016

Page 80, "George's technique was quite sophisticated…"
Bob Wilber with Derek Webster, *Music Was Not Enough* (Macmillan, 1987)

Page 80, "Now paint!"
Mary Russell quoted in Robert Hilbert, *Pee Wee Russell* (Oxford University Press, 1993)

Page 80, "If attention is drawn to the middle of the painting…"
Pee Wee Russell quoted in Robert Hilbert, *Pee Wee Russell* (Oxford University Press, 1993)

Chapter 4: World War II

Page 83, "Jazz epitomized a spirit of rebellion"
From the "jazz" entry in *The Palgrave Dictionary of Transnational History* (Springer, 2016)

Page 84, "an avenue leading to the thing you want most of all…" and "bespectacled and scholarly looking"
Quoted in Lewis A. Erenberg, *Swingin' the Dream: Big Band Jazz and the Rebirth of American Culture* (University of Chicago Press, 1998)

Page 84, "For the land that I love, I sustain the wings…"
Glenn Miller, Chummy McGregor, Sol Meyer, and Norman Leyden, "I Sustain The Wings" in *Glenn Miller's Dance Folio Songbook* (Mutual Music Society, 1943)

Page 84, "next to a letter from home…"
James H. Doolittle quoted in Geoffrey Butcher, liner notes to *Glenn Miller: The Lost Recordings* (Happy Days Records 75605 52401 2, 1996)

Page 86, "any number of air raids"
Artie Shaw, *The Trouble with Cinderella: An Outline of Identity* (Da Capo, 1979)

Page 86, "They sent us out by plane…" and "I blew like a madman…"
Max Kaminsky, *My Life in Jazz* (Jazz Book Club, 1965)

Page 86, "We played performances for soldiers…"
Marshal Royal, *Jazz Survivor* (Cassell, 1996)

Page 86, "a professional storm that would have frightened…"
Quoted in Nichole T. Rustin and Sherrie Tucker (eds.), *Big Ears: Listening For Gender in Jazz Studies* (Duke University Press, 2010)

Page 92, "From a dance hall there met me…"
Herman Hesse (translated by Basil Creighton), *Steppenwolf* (Henry Holt, 1929)

Page 92, "My sensitive nerves revolt against…"
Christopher Isherwood, *Mr. Norris Changes Trains* (Penguin, 1942)

Page 92, "SS Clubs, Officers' parties and upmarket brothels"
Michael Russell, "Three Hatreds Drove Him, the English, the Jews and De Valera," *Irish Times*, May 15, 2017

Chapter 5: Bebop and Modern Jazz Versus the New Orleans Revival

Page 105, "Fistfights … even lawsuits took place between the two camps"
Krin Gabbard, *Jammin' at the Margins* (University of Chicago Press, 1996)

Page 106, "They seemed to like our music best for dancing…"
Rod Cless quoted in Bert Whyatt, *Muggsy Spanier: Lonesome Road* (Jazzology Press, 1995)

Page 106, "big-band factory…"
Bud Freeman with Robert Wolf, *Crazeology, The Autobiography of a Chicago Jazz Man* (Bayou Press, 1989)

Page 106, "We used Dixieland as more or less a trade name…"
Eddie Miller quoted in John Chilton, *Stomp Off! Let's Go: The Story of Bob Crosby's Bob Cats and Big Band* (Jazz Book Service, 1983)

Page 108, "It was a better surface than shellac…"
William Russell quoted in Ray Smith and Mike Pointon, *Bill Russell and the New Orleans Jazz Revival* (Sheffield, Equinox, 2018)

Page 108, "All over America young boppers…"
Barry Ulanov, "Bop," in *A History of Jazz in America* (Hutchinson, 1950)

Page 108, "The latest in a long series of name bands…"
Scott Deveaux, *The Birth of Bebop* (University of California Press, 1997)

Page 111, "gratuitous combinations to produce unforeseen meanings"
Marc LaFountain, *Dali and Postmodernism: This Is Not an Essence* (SUNY Press, 1997)

Page 114, "Of all the great American masters…"
Humphrey Lyttelton, *I Play as I Please* (McGibbon and Kee, 1954)

Page 114, "The personality of Bechet is extraordinary…"
Claude Luter (translated by Alyn Shipton), "Quatre Clarinettistes," *Jazz Hot*, November 1948

Page 120, "From the start, jazz has constantly borrowed…"
Humphrey Lyttelton, "The Frankenstein Monster," in *Second Chorus* (McGibbon and Kee, 1958)

Page 120, "We were amused by certain aspects…"
George Melly, *Revolt Into Style: The Pop Arts in Britain* (Penguin, 1970)

Page 120, "The man who took 'trad' back to America"
Brian Matthew, *Trad Mad* (Consul, 1962)

Page 120, "He imposed the obligatory 'Mr.' on all billings…"
George Melly, *Revolt Into Style: The Pop Arts in Britain* (Penguin, 1970)

Page 124, "He had been wearing a beret…"
Mary Lou Williams, "Then Came Zombie Music and the Mad Monk," in Rob van der Bliek, *The Thelonious Monk Reader* (Oxford University Press, 2001)

Page 124, "His were done half in gold"
William Gottlieb, "Thelonious Monk—Genius of Bop," in Rob van der Bliek, *The Thelonious Monk Reader* (Oxford University Press, 2001)

Page 124, "In the course of his travels he had…"
Laurent De Wilde (translated by Jonathan Dickinson), *Monk* (Marlowe, 1997)

Page 125, "visual personality"
Barry Ulanov, *A History of Jazz in America* (Viking Press, 1952)

Chapter 6: Birth of the Cool and West Coast Jazz

Page 131, "Perfect intonation, great execution, everything clean and neat"
Joe Castro quoted in James Gavin, *Deep in a Dream: The Long Night of Chet Baker* (Chatto and Windus, 2002)

Page 132, "It's just like clothes…"
Miles Davis quoted in Ian Carr: *Miles Davis: The Definitive Biography* (Harper Collins, second edition 1998)

Page 132, "No one else at that time even thought of it…"
Chico Hamilton interviewed by the author, November 2002

Page 132, "the frantic extremes of bop"
Time, February 2, 1953

Page 134, "to show enthusiasm was 'not cool'…"
Mark Murphy quoted in James Gavin, *Deep in a Dream: The Long Night of Chet Baker* (Chatto and Windus, 2002)

Page 134, "Since we got to doing this every night…"
Ray Brown interviewed by the author, November 19, 1995

Page 140, "They're laugh lines…"
Chet Baker quoted in liner notes to *Chet Baker— The Collection* (EMI 09463 593832-6, 2006)

Page 141, "the secret sadness at the heart of the man"
Owen Gleibermann, "Let's Get Lost," *Entertainment Weekly*, June 13, 2007

Page 144, "Jake Lewis went to RCA and told them…" "We had fun with the titles…" and "Someone told the girls who were waitresses…"
Shorty Rogers interviewed by the author, January 8, 1992

Page 145, "I don't usually wander around wearing a space helmet"
Shorty Rogers interviewed by the author, January 8, 1992

Page 148, "Central Avenue was one of the swingingest streets…"
Fletcher Smith quoted in Clora Bryant et al., *Central Avenue Sounds: Jazz in Los Angeles* (University of California Press, 1998)

Chapter 7: The New Mainstream

Page 151, "A seamless organic continuum"
Ronald M. Radano quoted in John Gennari, *Blowin' Hot and Cold: Jazz and Its Critics* (University of Chicago Press, 2010)

Page 154, "create a black beauty and style brand…" and "a vision of African blackness"
Tanisha C. Ford, *Liberated Threads: Black Women, Style, and the Global Politics of Soul* (University of North Carolina Press, 2015)

Page 154, "instinctive understanding of how design could be used…"
Steven Heller and Greg D'Onofrio, *The Moderns: Midcentury American Graphic Design* (Abrams, 2017)

Page 163, "Frank Wolff always hated it when…"
Reid Miles, quoted in Kenny Mathieson, *Giant Steps: Bebop and the Creators of Modern Jazz 1945–65* (Canongate, 2012)

Page 166, "Jazz which heretofore has been an italicised art…"
Richard Havers, *Verve: The Sound of America* (Thames and Hudson, 2013)

Page 170, "Columbia … were concerned he was a former drug addict…"
George Avakian interviewed by the author, February 24, 1999

Page 173, "careful packaging and exquisite artistry…"
Round About Midnight reviewed by Bob Rusch, *Cadence*, Vol. 13, 1987

Chapter 8: Changing Landscape—Mingus, Coltrane, and Coleman

Page 177, "Intense lyricism often accentuated by saxophone cries and wails"
Eric Nisenson, *Ascension: John Coltrane and His Quest* (St Martin's Press, 1993)

Page 180, "A lot of people…"
Charles Mingus quoted in Mario Dunkel, *Aesthetics of Resistance: Charles Mingus and the Civil Rights Movement* (LIT Verlag, 2012)

Page 181, "You hear the pure emotion…"
Ornette Coleman quoted in *Metronome*, September 1960

Page 186, "Like action paining it is the very act…"
Don Heckman quoted in Iain Anderson, *This Is Our Music: Free Jazz, the Sixties, and American Culture* (University of Pennsylvania Press, 2012)

Page 186, "Most musicians follow maps to improvise…"
Ornette Coleman interviewed by the author, July 1997

Page 192, "Trane was very sensitive to the musicians that followed…"
Archie Shepp interviewed by the author, April 13, 2000

Chapter 9: Jazz Fusions

Page 199, "Funk cats who knew how to play jazz"
Herbie Hancock quoted in Stuart Nicholson, *Jazz Rock* (Canongate, 1998)

Page 200, "I think *Bitches Brew* was such a big event…"
Mike Gibbs interviewed by the author, July 2017

Page 200, "rock thing…" and "What do you call this music?"
Ian Carr quoted in Alyn Shipton, liner notes to *Leon Thomas with Nucleus* (Gearbox GB 1529, 2014)

Page 203, "everyone dressing kind of 'out street'…"
Miles Davis, Quincy Troupe, *Miles: The Autobiography* (Simon and Schuster, 1990)

Page 206, "incredibly loud" and "the greatest jazz-rock band"
Ian Carr interviewed by the author, UK National Sound Archive (C1291), 2007

Page 212, "We were only able to do one album…" "Evolve as much as you can…" and "I did a very enjoyable album in London in 1970…"
Hugh Masekela interviewed by the author, May 4, 2000

Page 216, "He was a very famous music guy…"
Tomasz Stanko, interviewed by the author for BBC Radio, broadcast October 5, 2008

Chapter 10: Postmodern Jazz

Page 219, "It's the act of constant creation that's important"
Branford Marsalis interviewed by the author, November 2, 2004

Page 221, "We felt the painting communicated powerful feelings…"
John Scheinfeld letter to the author, October 8, 2019

Page 224, "I dance much more when I have my mask on…"
Jason Moran quoted in Craig Byrd, "For Jazz Pianist Jason Moran, the Future of Jazz Includes Fats Waller," *Los Angeles*, February 5, 2016

Page 226, "appropriated the rhythms and images of city life…"
Mary Schmidt Campbell, *An American Odyssey: The Life and Work of Romare Bearden* (Oxford University Press, 2018)

Page 226, "Deep down I liked the New Orleans style…"
Wynton Marsalis interviewed by the author, February 9, 2001

Page 226, "an explosion of expression"
Stuart Nicholson, *Jazz Culture in a Global Age* (Northeastern University Press, 2014)

Page 230, "Those who are serious about culture…"
Manfred Eicher, "The Periphery and the Centre," in Steve Lake and Paul Griffiths, *Horizons Touched: The Music of ECM* (Granta, 2007)

Page 230, "strongly orientated towards the jazz avant-garde…"
Barry Kernfeld, "ECM," in *The New Grove Dictionary of Jazz* (Macmillan, second edition 2002)

Page 230, "inventive flair and creative sensitivity"
Adrian Shaughnessy ,"One Man Brand," *Eye*, summer 2010

Page 235, "was almost more exciting than making the record"
Tim Berne quoted in Dana Jennings, "CDs Know That Ears Have Eyes," *New York Times*, December 26, 2012

Chapter 11: Twenty-First-Century Jazz

Page 237, "Commandingly cool"
Kate Hutchinson, "The British Jazz Explosion," *The Observer*, April 8, 2018

Page 238, "The first set closed with a riotous calypso…"
Alyn Shipton, "Sonny Rollins," *The Times*, November 27, 2007

Page 242, "In a list of the music he most enjoyed listening to…"
Editorial, *The Times*, January 5, 2019

Page 242, "We're going to rebrand what young London looks like!"
Kate Hutchinson, "A Sweaty Night Out in London's New Jazz Scene," *New York Times*, October 19, 2018

Page 242, "a young crowd no longer frequents traditional venues for jazz"
Binker and Moses interviewed by Emma Smith, *Jazz Now*, BBC Radio 3, April 2016

Page 243, "The first generation of British musicians…"
John Lewis, "History-making Jazz in a London Accent," *The Guardian*, March 9, 2019

Page 247, "What really lingers is Washington's commitment…"
Hank Shteamer, "Kamasi Washington's New 'Heaven and Earth' Is Another Sprawling, Style-Hopping Epic," *Rolling Stone*, June 21, 2018

Picture Credits

Every effort has been made to trace the copyright holders of the artworks in this book. In order for any errors or omissions to be corrected in future editions, please contact Elephant Book Company.

Courtesy 33RPM collection: 71BR, 141TL, 142L, 156L, 156TR, 159L, 161BR, 168L, 168TR, 168BR, 174TR, 189TL, 189R, 191L, 191BR, 194, 197L, 197BR, 201BR, 201T, 203TL, 203TR, 203BR, 204, 205TL, 205BL, 208TR, 208BR, 210, 211TL, 211BL, 228L;

Abramorama: 221BR;

© **ADAGP**, Paris and DACS, London 2019, photo courtesy of Akg-images: 36;

AKG-images: 20L, 34, 56R, 56L, 63B, 66L, 66TR, 66BR, 75T, 77B, 79, 82, 94, 102B, 133BR, 161L; /20th Century Fox: 91, 97L; /Africa Media Online: 213BR; / Paul Almasy: 78BR, 115BR; /Florilegius: 11TR; /Imagno/Franz Hubmann: 135; / Imagno/Votava: 179L; /Interfoto: 87BR; /Jazz Archiv Hamburg /Marion Kalter: 228R; /Keystone: 195B; /MGM: 97TR; / picture-alliance /dpa: 185; /Hardy Schiffler: 184B; /Sputnik: 95B; / Niklaus Stauss: 196; /TT News Agency /SVT: 74L, 109BR, 129T; /ullstein bild: 38TR, 95TR; /Universal Images Group /Underwood Archives: 97BR; /WARNER BROTHERS: 208L;

Alamy/Chronicle: 89TR, 223B; /Craig Lovell/Eagle Visions Photography: 224; /Everett Collection: 78T, 78BL, 139, 141R, 193BR; /Rob Lacey: 187L; /Pictorial Press: 47BR; /Records: 172R; /Krista Rossow: 223T; /Granamour Weems Collection: 191TR;

Collection of the Birmingham Museum of Art, Alabama; Museum purchase with funds provided by the Junior Patrons of the Birmingham Museum of Art. Photo by Sean Pathasema. With permission courtesy of Michael Rosenfeld Gallery: 175;

Brown University library: 20TR;

Terri Lyne Carrington: 229BL, (photo by John Watson) 229TL;

Chicago Defender Newspaper: 44T, 45T;

© **DACS 2019**, photo courtesy of Akg-images / Erich Lessing: 32R;

© **Estate of J E Dunham**/courtesy of Bridgeman Images/Manchester Art Gallery: 29;

ECM Records: 195T, 214, 217TL, 217BL, 231L, 231TR, 231BR, 232L, 232BR, 233L, 233TR, 233BR;

© **The Heirs of James Flora**
Illustrations by James Flora; Image restorations by Barbara Economon; Thanks to Irwin Chusid/JimFlora.com: 145BR; *Fletcher Henderson*, tempera on paper, 1942. From the collection of Eric Kohler: 53; *Sidney Bechet*, issued by Columbia Records, 1948: 115TR; *This is Benny Goodman and His Orchestra* rejected cover illustration, tempera on board, 1955. From the collection of Angelynn Grant: 72T;

Nubya Garcia: 243L, 243TR;

Getty Images /Archive Photos/Anthony Barboza: 227BL; /Donaldson Collection /Michael Ochs Archives: 52B, 130; /Hulton Archive: 42R, 218; /The LIFE Picture Collection/Allan Grant: 125R, 127L, 127R; /LMPC: 42L, 109L, 146, 147; /Michael Ochs Archives: 19TR; /Moviepix: 49R, 51R, 67; /NY Daily News Archive/ David McLane: 150; /Redferns: 55R; /Rykoff Collection/ Corbis Historical: 87L, /Roger Viollet/ Harlingue: 101R;

The Solomon R. Guggenheim Foundation Peggy Guggenheim Collection, Venice, 1976 *Composition in Gray (Rag-time)*, 1919 Oil on canvas, 38 x 23 1/4 inches (96.5 x 59.1 cm): 32L;

Heritage Image Partnership: 93, 95TL; /Alan John Ainsworth: 239BR; /National Jazz Archive: 89L, 107T, 122, 174L; /National Jazz Archive, with permission courtesy of Wally (Trog) Fawkes: 99TR , 121BR;

Hogan Jazz Archive, Tulane University; 17B, 28B, 38TL, 45B;

Chris James Collection: 43R, 47T, 49TL, 49BL, 50L, 65BR, 69BL, 72BL, 73, 85TL, 98, 107BL, 112BL, 117BR, 136TR, 138R, 169;

© **Art Kane**, reproduced by courtesy of the Art Kane Archive: 153;

Bill Laurence/Mike Chadwick Management: 239L, 239TR;

Library of Congress: (image 2010647805) 9T, (image 97502075) 14, (image 2013562464) 27TL (image 2016651602) 27BR; /William Gottlieb Collection: (image 01041) 51L, (image 00461) 60, (image 02091) 69TL, (image 07771) 71T, (image 00731) 71BL, (image 09061) 81TL, (image 07591) 81TR, (image 13751) 89BR, (image 03151) 104, (image 06861) 110, (image 06941) 112TL, (image 04561) 117BL, (image 05631) 117T, (image 03101) 125L, (image 06251) 128, (image 02771)

129B, (image 02261) 155BR, (image 06111) 167R, (image 09261) 174BR, (image 08121) 184TL; Library of Congress/Notated Music Collection: (image 200035803) 21 BL, (image 200029069) 21R, (image 200033247) 23R, (image 200033252) 23TL, (image 200033246) 23BL, (image 200033249) 24L, (image 200033262) 24TR, (image 200033279) 24TR, (image 200033254) 25, (image 100010152) 41; /Minstrel Poster Collection: (image 2014637013) 13BL; /Look Magazine Collection, Jazz Story 1950, photo by Stanley Kubrick: 118, 119L, 119R;

London Jazz Collector, Andrew Wilk: 111L, 111R, 113, 133TR, 136TL, 137, 142R, 145L, 145BR, 149TL, 149BL, 149TR, 149BR, 155L, 157, 158, 159TR, 163L, 171L, 173BR, 173BL, 179TR, 181T, 182TL, 182BR, 183, 187BR, 188, 193TL, 197TR, 203BL, 215L;

Dennis Loren/Jazz Age Editions: 63T, 65BL;

© **Humphrey Lyttelton**, courtesy Stephen Lyttelton: 5;

Mary Evans Picture Library/ILN Collection: 102T, 103; /Retrograph Collection: 121L;

Joe Mathieu: 123L, 123BR;

Used with permission of the Estate of Jan Matulka and McCormick Gallery, Chicago. Photo courtesy of Michael Rosenfeld Gallery: 69R;

Cecile McLorin Salvant: 244T, 244BR;

Brad Mehldau/Nonesuch Records: 225BR, 225TR;

National Archives and Records Administration/ARC id 533616: 27BL;

The New York Public Library /Music Division: 19BR, 21TL, 13BR, 20BR, 171BR; /Rare Book Division: 50R; /The Schomburg Collection of Negro Literature: 58; /Schomburg Center for Research in Black Culture, Art And Artefacts Division: 9B, 35, 57L;

© **Charles Peterson**, courtesy Don Peterson: 7, 48B, 75B;

© **Succession Picasso/DACS**, London 2019, Localisation : Paris, musée national Picasso – Paris: 31;

Private Collection: 28T, 57R, 65TR, 72BR, 77T, 90L, 90R, 107BR, 109TR, 112BR, 116, 121TR, 133L, 136BL, 143TR, 143L, 143BR, 145TR, 159BR, 161TR, 162, 163BR, 163TR, 171TR, 172TR, 172BL, 173T, 179BR, 181B, 182R, 184TR, 187 TR, 189BL, 193TR,

193BL, 201BL, 207TL, 207BL, 211R, 213L, 213TR, 215TR, 215BR, 221L, 227TL, 227TR, 241TR, 241TL;

Public Domain, from *Maud Cuney Hare: Negro Musicians and their Music* 1936: 19L;

Hal Rammel: 52T;

Roararatorio Records: 190;

Rose and Souchon 1978: 17T;

Michael Rosenfeld Gallery: 59, 81B, 126, 155TR, 165, 221TR;

Scala Archives, Florence/The Museum of Modern Art, New York: 33;

Maria Schneider/Briene Lermitte: 234L; /Jimmy Katz: 234R;

Screwgun Records: 235L, 235TR, 235BR;

Sherman Jazz Museum: 68BR;

Alyn Shipton Collection: 38B, 43L, 44B, 48T, 55TL, 74R, 85TR, 85B, 87TR, 99L, 99BR, 115L, 123TR, 136BR, 138L, 141BL, 156BR, 167L, 198, 209T, 209B, 236; /Danny Barker: 47BL;

Snarky Puppy/photo by Stella K: 241B;

The Outline Press: 68TL, 68TR, 68BL, 164;

Tin Men & the Telephone: 245;

Courtesy of University of Texas Press *The Zoot-Suit Riots: The Psychology of Symbolic Annihilation* by Mauricio Mazón, Copyright © 1984,: 101L;

©**Van Vechten Trust**, photo by Carl Van Vechten, courtesy of Beinecke Library , Yale: 11BR, 55BL;

Wadsworth Athenaeum/Michael Rosenfeld Gallery: 176;

Kamasi Washington/Young Turks: 247;

Copyright John Watson/jazzcamera. co.uk: 207R, 217R, 227BR;

Wisconsin Center for Film and Theater Research: 11BL;

Michael Wollny/ACT Music: 244BL;

Alice Zawadzki/Stephen Jay: 243BR.

Index

Acknowlegments

This book would not have got started had it not been for a meeting with Jo De Vries in the shadow of Blenheim Palace, when she suggested I might combine my interests in jazz and the visual arts in the form of a book. She introduced me to Laura Ward and Will Steeds of Elephant Book Company, London, who have encouraged the project through thick and thin, and they in turn led to the book's publisher, Imagine, and its enthusiastic and committed editorial director, Kevin Stevens, whose insightful suggestions have greatly improved it.

I would like to single out the tremendous help it has been to have an academic colleague with whom to discuss every aspect of the work in progress, namely Professor Catherine Tackley, Head of the Music Department at the University of Liverpool, who has gone out of her way to help. It was a privilege to be involved in the "Rhythm and Reaction" exhibition at Two Temple Place, London, which Catherine curated, and I'd like to thank Florian Schweitzer for commissioning me to write a pilot study of some of this material in the form of an article for the *Art Society Magazine* of Autumn 2017. Professor Tim Jones at the Royal Academy of Music and the research committee there have also supported my work on the project in many ways.

Making the BBC Radio documentary *Home to Harlem* with producer Felix Carey in 2001 introduced me to Howard Dodson, then the curator of the Schomburg Center at NYPL, who gave generously of his time exploring the work of Aaron Douglas and other Harlem Renaissance painters and writers. The 2009 series *Harlem Timeline*, which I made with Soweto Kinch and Terry Carter, took the process further.

No book like this could exist without the diligence of an outstanding picture researcher, and Sally Claxton has done her utmost to find even the most obscure images that I suggested. Sally has been helped by the following collectors and specialists: Chris James; Don Peterson (son of the late Charles Peterson); Dan Munn of the Michael Rosenfeld Gallery; David Nathan of the UK National Jazz Archive; Andrew Wilk (a London jazz collector); Penélope and José Alves of 33RPM Collection; David Fraser and Michael Schmitt of ECM Records; Matthew Rankin at Nonesuch Records; Irwin Chusid of JimFlora.com; the Carl Van Vechten Trust; Sue Handley of Mike Chadwick Management (for Bill Laurance artworks); and John Wilson and Digby Fairweather at the Jazz Centre UK.

Paul Palmer-Edwards has been a great colleague in realizing the visual appearance of the book so imaginatively.

I'd like to single out a few individuals: firstly Wally (Trog) Fawkes with whom I have had the pleasure not only of playing music, but who many years ago drew a wonderful cover for a book by our mutual friend Max Jones; secondly Stephen Lyttelton, the son of my old friend, mentor, fellow BBC broadcaster, and marvelous musician, Humphrey Lyttelton; and Django Bates, who enthused about Tim Berne and Steve Byram of Screwgun Records, who have kindly allowed us to reproduce their work.

In addition I am most grateful to the following collections, individuals, and archives: the New York Public Library; the Library of Congress (in particular the peerless Collection of William Gottlieb, with whom I had the pleasure of discussing his work at a dinner on Long Island in 2000); the Wisconsin Historical Society; Hal Rammel; Joe Mathieu; the William Ransom Hogan Jazz Archive at Tulane University, New Orleans; the Birmingham Museum of Art, Alabama; the Wadsworth Athenaeum Museum of Art; the McCormick Gallery, Chicago; and the Manchester Art Gallery, UK.

Finally Tom Seabrook has been an exemplary editor with whom it has been a great pleasure to share the creation of this book.

Alyn Shipton
Royal Academy of Music
London

Alyn Shipton
Alyn Shipton is a biographer, music historian, and a radio host for the BBC in London, having won the Willis Conover/Marian McPartland Award for Lifetime Achievement in jazz broadcasting from the Jazz Journalists' Association in New York. He won an ASCAP Deems Taylor/Virgil Thomson Award for his biography of singer Harry Nilsson, and his monumental *New History of Jazz*, first published in 2001, was named Jazz Journalists' Book of the Year. He has also received two Association of Record Sound Collections awards for excellence in musical research. He is currently a Research Fellow at the Royal Academy of Music in London. He has published numerous oral histories, including the life stories of musicians as diverse as Sir George Shearing, New Orleans guitarist Danny Barker, and pop singer Billy J. Kramer. He is also an accomplished jazz bassist and currently leads the Buck Clayton Legacy Band.

John Edward Hasse
During his thirty-three-year tenure at the Smithsonian Institution's National Museum of American History, Curator Emeritus John Edward Hasse curated exhibitions on Duke Ellington, Ella Fitzgerald, Frank Sinatra, and Ray Charles. He also founded the Smithsonian Jazz Masterworks Orchestra and the international Jazz Appreciation Month. His books include *Beyond Category: The Life and Genius of Duke Ellington*, *Ragtime* (editor), *Discover Jazz* (coauthor), and *Jazz: The Smithsonian Anthology* (coauthor). A contributor to the *Washington Post*, the *Wall Street Journal*, and eight encyclopedias, Hasse has received two honorary doctorates, two Grammy Award nominations, and two ASCAP Deems Taylor Awards for excellence in writing on music. He has lectured on leadership, the arts, and music in twenty-five countries on six continents.